MW01125565

HOLLYWOOD BLACKOUT

HOLLYWOOD BLACKOUT

THE BATTLE FOR INCLUSION AT THE OSCARS

BEN AROGUNDADE

First published in Great Britain in 2025 by Cassell, an imprint of
Octopus Publishing Group Ltd
Carmelite House
50 Victoria Embankment
London EC4Y 0DZ
www.octopusbooks.co.uk
www.octopusbooksusa.com

An Hachette UK Company
www.hachette.co.uk

The authorized representative in the EEA is Hachette Ireland,
8 Castlecourt Centre, Dublin 15, D15 XTP3, Ireland
email: info@hbgi.ie

Copyright © Octopus Publishing Group 2025
Text copyright © Ben Arogundade 2025

Distributed in the US by Hachette Book Group
1290 Avenue of the Americas, 4th and 5th Floors
New York, NY 10104

Distributed in Canada by Canadian Manda Group
664 Annette St., Toronto, Ontario, Canada M6S 2C8

All rights reserved. No part of this work may be reproduced or utilized in any form or by any means,
electronic or mechanical, including photocopying, recording or by any information storage and retrieval system,
without the prior written permission of the publisher.

Ben Arogundade asserts the moral right to be identified as the author of this work.

ISBN 978-1-78840-549-2

Typeset in 12/16pt Garamond Premier Pro by Jouve (UK), Milton Keynes
Printed and bound in Great Britain by Clays Ltd, Elcograf S.p.A.

10 9 8 7 6 5 4 3 2 1

Publisher: Trevor Davies
Senior Editor: Alex Stetter
Copy Editor: Jenny Wilson
Creative Director: Mel Four
Picture Research Manager: Giulia Hetherington
Production Controller: Sarah Parry

This FSC® label means that materials used for the product have been responsibly sourced.

'Oscar' and 'Academy Awards' are registered trademarks of the Academy of Motion Picture Arts and Sciences.
This book is neither authorized nor endorsed by the Academy of Motion Picture Arts and Sciences.

For George Floyd, Michael Brown,
Eric Garner, Breonna Taylor and the others.

CONTENTS

INTRODUCTION

This is not the book I intended to write. That one was angrier. It was conceived in the wake of the murder of George Floyd, on 25 May 2020, after which I, like millions of others globally, was consumed by outrage and sadness. I started writing that book, which was a response to Floyd's demise and its aftermath. Very soon I had a few thousand words of something without a title or clear structure. As I read the text back to myself, I saw that it was laced with the anger that was coursing through my body at the time. So I stopped writing. A psychotherapist friend warned me of the possible traumatizing effects of the overconsumption of upsetting images of Black men being brutalized on the news by so-called police officers, which I had been watching daily. I took her advice, turning off the news and detaching from social media. It was only then that I started to calm down. This digital detox became my ultimate act of self-care during this tricky period. I decided that I needed to take a step back, and to just sit with the subject for a while, and stare out of my window, and not write anything, and just think, and ponder, and just be – and then get even calmer, and more silent, and more measured in my perspective. This mode of contemplation and self-reflection was beginning to happen already, as the world was immersed in lockdown due to the coronavirus pandemic. During that time I learned the important life lesson of *pausing before action*, so that when I did act, I would do so in a more careful manner, and one that I was less likely to regret later.

Two years passed, and I had become busy on other projects, but I still felt the drive to do something to mark that raw and turbulent time in history, and to express how I felt about it, having now stepped back. I wanted to write something that commemorated not just the significance of Floyd's demise, but all the other Black victims of unjust police violence – Eric Garner, Michael Brown, Breonna Taylor and the thousands of others over many decades, whose names are known and not known, and whose murders were not captured live on a smartphone.

Out of this, a different book emerged, and on a different subject. I first had the idea for *Hollywood Blackout* ten years ago. At that time it was conceived as an illustrated coffee-table hardback – a visual celebration of Black actors at the Oscars. It was originally intended as the follow-up to another illustrated book about Black culture that I had written previously, called *Black Beauty*. After a conversation with my publisher, I changed the format for the proposed new title, in favour of a full-blown literary narrative. One of the fundamental things that interested me about the story was the question: how does a Black person in the West navigate life and success when they exist at the behest of a discriminating, dominant culture? This was a relevant societal question, as well as one that affected Black artists of film, who work within a system which openly marginalizes them. How much of oneself, one's beliefs, identity and principles, does a person have to compromise, or abandon, in order to secure the role that might catapult them onto the Oscars podium?

The new outline for the book focused solely on the experiences of Black artists at the Oscars. But as soon as I began my research I came across similar stories of exclusion from women, East Asians, Latinos, South Asians, Native Americans and other indigenous peoples. I decided it would make for a richer, more compelling story if I brought their experiences into the narrative as well, and wove them all together. This made sense to me, because everybody's human experiences, good or bad, are connected in some way. It also felt like the right approach in terms of establishing that 'diversity' doesn't just mean 'Black', but everybody in fair and shared proportion. So, even though the book's primary subject is the Black Hollywood experience at the Oscars, I hope the other stories will broaden its appeal and perspective for you.

The narrative illuminates the struggles that people of colour and other minorities have undergone to secure the film roles that would get them the nominations, that would then get them to the coveted Oscars. Their successes have not come easily, and they have been ushered along by boycotts, civil rights protests, war, social media activism and murder in the street. The scope of the journey moves across the diverse historical landscapes of actors of colour as well as women, from Hattie McDaniel to Denzel Washington; from Merle Oberon

to Ben Kingsley; from Anthony Quinn to America Ferrera; from Miyoshi Umeki to Michelle Yeoh; from Lina Wertmüller to Kathryn Bigelow; and from Chief Dan George to Lily Gladstone.

The last decade has seen the Academy of Motion Picture Arts and Sciences embrace the reform of its voting membership, plus its eligibility rules for submitting films for the Oscars – all in the hope of creating a fairer and more diverse network which is reflective both of the Hollywood film community and the international movie-watching public. If the Oscars were a team sport, one might say that they were taking a leaf out of the playbook of the European football (soccer) leagues, which have proved that the best teams in the game comprise of players from all over the world striving together – and this is not altruism, but simply good business.

THE TAINT OF TINSELTOWN (1898–1929)

'*The movie industry is like the Rocky Mountains: the higher you get,
the whiter it gets.*'
Reverend Al Sharpton, National Action Network,
15 January 2015

Twenty-nine seconds. That was the length of *Something Good – Negro Kiss*, the world's first known film featuring a Black cast. It had only two actors, Saint Suttle and Gertie Brown, who were also part of a vaudeville quartet called The Rag-Time Four. The silent film was shot in 1898 by William Selig, a white vaudeville performer and film pioneer from Chicago. The action is simple and direct, featuring a well-to-do couple kissing and cuddling against a curtained backdrop. They then step away from each other amid joyful smiles and hand-holding, before coming together again and kissing. They repeat this ritual seven times. The scene, though straightforward, is extraordinary in its characterization of Blacks as a loving, romantic, humanized people, at a time when they were not perceived as such within post-slavery America. Their positive portrayal was far in advance of the harsh lens through which Hollywood first framed them when the industry launched in Los Angeles, California, in 1911. By contrast, they were rendered in racist caricatures and outmoded stereotypes, in which expressions of love and intimacy were all but eradicated.

Hollywood's breakout blockbuster, *The Birth of a Nation* (1915), set the tone. An epic drama about the American Civil War, Reconstruction and the rise of the Ku Klux Klan, it depicted African Americans either as dumb, contented

servants or as brutish renegades seeking violent retribution against whites, and sexual pleasure from unassuming white women. Blacks were visualized as a menace to society, at the same time as they were not considered to be a part of society. In this regard, the new culture of cinema was not simply a form of entertainment; it was also a powerful propaganda tool. Directed by acclaimed filmmaker D W Griffiths, *The Birth of a Nation*, though lauded for its cinematic virtuosity and technical brilliance, revealed that Black culture and its national representation on screen had become the property of white movie-makers. During the era of slavery that had preceded this, whites had owned Black bodies – and now, in Hollywood, they owned their stories too.

During the industry's start-up period, Black actors were prohibited from playing any meaningful roles in the framing of these stories. America was in the grip of institutionalized segregation, whose restrictions were collectively referred to as the Jim Crow laws (named after a blackface minstrel character popularized in the 1830s by white stage performer Thomas Dartmouth Rice). These laws were first introduced in the Southern states during the 1870s, and were formally sanctioned across the country in 1896. They created separate facilities for Blacks and whites – water fountains, restrooms, restaurants, hotels, lodging, transportation, schools and workplaces. American society was divided into something akin to a network of private members clubs. Blacks resided outside its glass walls, and were only allowed in temporarily, as labourers or as entertainers – after which they vacated these whites-only spaces and returned to their designated zones. The legislation was designed not simply to keep Blacks and whites apart, but to stop African Americans from participating equally within society, thereby condemning them to a life of perpetual second-class citizenship. They were cast as outsiders, long before such a thing was considered 'cool'. With the end of slavery in 1865, African Americans believed that the great hand of American democracy would treat them fairly, and that their era of suffering and misfortune had finally come to a close. But, in reality, that hand of democracy curled into a fist that plunged down upon their heads.

Jim Crow permeated every aspect of Hollywood life, too. Even the Memorial Park Cemetery, where its deceased actors were buried, was segregated – a stark

reminder that, even in death, Black and white bodies were to be kept apart. Meanwhile, above ground, the main method by which Blacks were excluded was for parts intended to represent them to be assigned to white actors in *blackface* – a term that described white performers darkening their faces with make-up made from burnt cork ash mixed with animal fat, in order to mimic and ridicule the perceived culture, dialect and mannerisms of African Americans. These caricatures first became popular forms of entertainment in the minstrel shows of the 1820s, in which white theatre actors mimicked the song-and-dance style of the archetypal, dark-skinned, Southern male plantation slave performer. Minstrelsy was the artistic branch of white supremacy. With the advent of Hollywood, white actors in blackface featured in lead roles in early Hollywood productions such as *The Birth of a Nation* and Al Jolson's *The Jazz Singer* (1927). As the industry's dominant players, white actors held the prerogative to usurp such parts. It was the beginning of Hollywood's version of 'white privilege', which may be described as – *a white actor's right to claim any role, regardless of its ethnic specificity*. For a white actor to appear in blackface, therefore, was to *own blackness*. To wear it like a coat.

Hollywood's white privilege also prevailed over other actors of colour, who were subject to the equivalent of blackface, at the hands of more marketable European actors. In the 1915 production of *Madame Butterfly*, white actress Mary Pickford was cast in yellowface to play Japanese geisha Cho-Cho-San. Similarly, in *The Heart of an Indian* (1912), its Native American leads were played in redface by white actors Francis Ford and Ann Little. In *The Greaser's Gauntlet* (1908), Mexican lead, Jose, was played by white actor Wilfred Lucas. But why did any of this matter, if the films in question were all racist? Why would minority actors want lead roles in this trash? The answer is that, at the time, the primary issue at stake was about *equality, not quality*.

Women's roles were appropriated in similar fashion within early Hollywood. Charlie Chaplin and Stan Laurel dressed up as females in their productions, as did actor Wallace Beery, who appeared as Sweedie, a Swedish maid, in a series of comedies from 1914 to 1916. In all cases, women were portrayed as ridiculous, witless clowns who existed to serve male prerogatives – and this would rapidly enshrine itself within Hollywood's depiction of female characters. Statistically,

the manner in which women's progress has been stunted by the Hollywood patriarchy has been revealed in research. A 2020 report by Northwestern University analysed 26,000 movies made between 1910 and 2010. It found that roles for females increased from 1910 to 1920. At their peak, women comprised roughly 40 per cent of actors, wrote 20 per cent of the screenplays, produced 12 per cent of the films and directed 5 per cent. But these numbers fell away sharply after 1920. By 1930 acting roles for women had halved, while producing and directing roles dropped to almost zero.[1] Why? The studio system emerged. Between 1915 and 1920 a diverse collection of independent studios that were spread across the country consolidated into five major Hollywood players: MGM, Warner Bros, Paramount, Fox and RKO Pictures. They held all the power, and so the decisions about who got hired fell under the control of a small group of white men – who decided that they did not want to hire women. The same period of studio consolidation also saw an increase in servile roles played by African Americans. Approximately half of all the parts surveyed by *Variety* in 2016 were maids and butlers, and 74 per cent of those film characters were identified via demeaning one-word nicknames. These numbers increased further in the 1920s, as servile roles reached 80 per cent.[2]

At the same time as whitewashing was imprinting itself upon the Hollywood aesthetic, the first Native American and Asian stars of the silent era were nevertheless emerging. In 1914 Lilian St Cyr became the first Native American actor to feature in a major role when she starred in director Cecil B DeMille's Western, *The Squaw Man*, about a Native American maiden from the Ute nation, caught in an ill-fated marriage to an Englishman. Born on a Nebraska reservation, St Cyr, whose mother, Julia Decora, was from the Winnebago tribe, while her father, Michael St Cyr, was white, performed under the name 'Red Wing'. Five years earlier, DeMille had also cast her in a bit-part in *The Mended Lute*, opposite Mary Pickford, who played the Native American lead in redface. Red Wing was married to another pioneering indigenous actor, James Young Deer, from the Nanticoke nation of Delaware. Beginning in 1909 he also worked as a director on a series of silent shorts for a New York film company. In 1910 he joined the French-based film company Pathé Frères, where he quickly became

head of production of the West Coast studio, overseeing its slate of Westerns from 1911 to 1914.

The first Asian star to emerge was Kintarō Hayakawa (known professionally as Sessue Hayakawa). He was born into a wealthy aristocratic and military family in Chiba, Japan, in 1886. His parents wanted him to become an officer in the Imperial Japanese Navy, but he failed the medical and duly moved to California, where he was drawn to acting after attending a Japanese theatre show in Little Tokyo, Los Angeles. In 1913, while performing in a play, he was spotted by Hollywood film producer Thomas H Ince, who had been invited to the performance by Hayakawa's wife, Tsuru Aoki. Ince recognized Hayakawa's talent and immediately offered him a movie contract, which he only signed after Ince agreed to pay him an incredible $500 per week ($15,000 today). Hayakawa became an instant hit in two films released in 1914 – *The Wrath of the Gods* and *The Typhoon*. His global breakout role came the following year, when he starred in Cecil B DeMille's *The Cheat*, as a villainous merchant who lusts after a white society matron, played by Fannie Ward. The role immediately transformed Hayakawa into a matinee idol who was as popular as the era's major white stars, including Charlie Chaplin and Douglas Fairbanks Sr. Hollywood's first Asian star was born.

Hayakawa's rise was perhaps the most radical event of Hollywood's opening decade. Why was his part not played by a white actor in yellowface, as such roles were everywhere else in the industry? It was also unusual that he, as an 'Other', was permitted to play a lead role opposite a white woman, in a drama that hinted at interracial sex, at a time when such interactions were deeply frowned upon. The film was made before Hollywood's so-called 'Production Code', which formally banned miscegenation in film. Nevertheless, without seeming to try, Hayakawa defied the era's stringent conventions – the same ones that Black actors at that time were not permitted to breach. Asian male sexuality was evidently seen as less threatening than that of Black men.

Hayakawa's American fans did not care about the taboos he broke; in fact, they loved him for them. He commanded a huge fan base consisting of mostly young white females, who swooned over the villainous 'forbidden lover' archetype he represented. According to Japanese photographer Tōyō Miyatake,

who lived in Little Tokyo at the time, Hayakawa once stepped out of a limousine at a movie premiere he was attending, and frowned slightly as he noticed a puddle on the ground before him. Suddenly, a group of adoring white female fans dashed forward and threw their fur coats over the puddle, so that he wouldn't get his feet wet as he stepped out.

The first Black stars of the period came from the world of vaudeville and minstrel shows, where actors were already established successes. In 1914, actor, singer and musician Sam Lucas starred in a full-length adaptation of Harriet Beecher Stowe's bestselling 1852 novel, *Uncle Tom's Cabin*, which recounted the misfortunes of a slave in the antebellum South. The novel was frequently adapted for the screen after 1900, and these productions usually featured white actors in blackface. This was the first feature-length film to have a Black lead actor. In 1913, another vaudeville star, the light-skinned Bert Williams, appeared in an unreleased, untitled short film uncovered by researchers at New York's Museum of Modern Art (MoMA) in September 2014.[3] Williams was America's best-known, and highest-paid, African American blackface actor, mime artist and recording star, noted for the hit song, 'Nobody'. The independently produced film, a middle-class romantic comedy, features Williams in blackface and a curly-haired wig, among an all-Black cast from Harlem. Little is known about the production, which had three nameless directors – one Black and two white.

By 1914 Hollywood began to open its doors more widely to Black performers, initially as 'extras'. Their job was to populate the background of a scene, and to make it appear natural, while the stars in the foreground dominated the action. The rules of American society were replicated in these set pieces, just as they were within the literary and theatrical traditions that preceded them. Although slavery was over, the desire to retain its 'master and servant' hierarchy remained potent. Blacks and other minorities would only be permitted to play *yessum* roles consistent with their position as America's underclass. They could not be lawyers, doctors, business moguls or people in love. These archetypes, although present within their own segregated communities, were not prevalent within mainstream American society, and so they were absent from the cultural psyche of

Hollywood's white filmmakers and, crucially, its white cinema audiences. In their closed-off world, fuelled by nostalgia for slavery's crusty old tropes, they saw no Black middle-class professionals, and so to cast one in a motion picture seemed both implausible and dangerous. But they did see minorities as servants, and in other low-status, reductive roles. And so, when represented on screen, Latinos played bandits, philanderers and 'greasers'; Asians played laundry workers, cleaners and shopkeepers; and Blacks played smiling waiters, chauffeurs, sharecroppers, simple-minded clowns and mammies (the latter were sexless domestic carers or servants to white families). These minorities were shocked and bemused that this was how the new entertainment form chose to represent them. They were modernized now, and these narrow stereotypes were stale phantasms from an oppressed past they had left behind.

Some minority extras parts were subcontracted out to actors of other ethnicities. Light-skinned African Americans were hired to play roles in redface, yellowface and other guises. In *Where East is East* (1929) they featured in yellowface together with Chinese and Filipino extras, as natives of Indo-China. In other productions they were deployed as stand-ins for Eskimos and Malays. Noble Johnson, whose Hollywood career began in 1916 and ran for 34 years, played Native Americans in at least 12 movies, as well as Chinese, Arab, Mexican and South Asian characters. He was aesthetically malleable, like an artist's muse, which resulted in him working more than many of his darker-skinned African American counterparts.

Mexican-born José Ramón Gil Samaniego was another multicultural actor. He moved to Los Angeles with his family in 1916, fleeing the Mexican Revolution. The following year he started working as a Hollywood extra, while supplementing his income as a dancer and singing waiter. He became friendly with the Irish director and producer Rex Ingram, who persuaded him to change his name to Ramon Novarro. With his Mediterranean good looks, he was fashioned as a rival to Italian star Rudolph Valentino, and was promoted by MGM as the archetypal 'Latin lover'. His light skin and racially ambiguous features allowed him to shape-shift in the roles he played. In *Scaramouche* (1923) he was cast as a white French lawyer; in *Ben-Hur* (1925) he played the title role of the Middle Eastern Jewish

prince; in *The Pagan* (1929) he played a Pacific Islander; in *The Son-Daughter* (1932) he played a Chinese man; and in *The Barbarian* (1933) he played an Egyptian.

As early as 1915, despite the limited and derisory roles on offer, acting had become a tentative profession for a chosen few African Americans who managed to secure consistent extras work. In response, various support services began to spring up along Central Avenue – Los Angeles's main African American neighbourhood. One of the first Black acting and music coaches, Lillian Jeter Davis, advertised her services in the Black newspaper *The California Eagle* that year. At the same time, the first wave of African American extras were being hired by local agents acting on behalf of individual studios. Actor, promoter and agent Jimmie Smith set up his own casting business in 1915, serving both fledgling Black film companies and Hollywood studios alike. Typically, studio bosses would give the agent a breakdown of the physical types sought, and the representative would venture out into the Black neighbourhoods around South Central Los Angeles to cast the parts. Alongside those supplied by specialist agencies, others were gathered by Black 'fixers' retained by individual studios. Oscar Smith (Paramount) and Harold Garrison (MGM) combined this role with multiple side hustles. Garrison also ran a shoeshine stand inside MGM, and worked as a chauffeur for its executives.

The era also saw the first minorities feature in behind-the-scenes, non-acting roles within Hollywood. In 1925 Ray Mala – born in Candle, Alaska, to an Inupiat Native American mother and Russian Jewish father – made his way to Hollywood, where he secured a job as a cameraman with Fox Film Corporation. In September 1929, Pennsylvania-born Black theatre composer Will Vodery signed a three-year contract as arranger and musical director for Fox, in a deal worth an extraordinary $26,000 per year ($450,000 today). It was the biggest contract ever for an African American in a non-acting role. Thirteen years earlier, hairstylist Hattie Wilson Tabourne had begun working for the Triangle Film Corporation, on *The Flame of the Yukon* (released in 1917). Born in Nebraska in 1880, she had worked as a professional hairdresser since the age of 17. In the early 1900s her family moved to Los Angeles and settled on East 9th Street and Central Avenue. She secured a job at a downtown hairdressing salon, where her artistry

caught the eye of Hollywood starlet Julia Faye, who had just started working with Cecil B DeMille. Faye made an introduction, and Tabourne was signed to an incredible seven-year contract with the Players-Lasky Studio, producers of DeMille's films. She headed the studio's hairdressing department, with a dozen assistants under her tutelage. She styled the hair of many of Hollywood's greats, including Pola Negri, Rudolph Valentino and Gloria Swanson, for whom she was credited with creating her signature hairstyle, the 'Gloria Bob'.

Despite the individual successes of these early professionals, two forces of resistance were busy campaigning against the industry's treatment of African American actors and the demeaning narratives enshrined within its storytelling. The first were the Black newspapers that began publishing in the late 19th century. Led by *The California Eagle*, founded in 1879, four other publications – *The Chicago Defender*, *The Pittsburgh Courier*, *The Philadelphia Tribune* and *The Amsterdam News* – ran regular, eagerly devoured columns about the plight of Hollywood's Black actors, raising hopes that one day the roles offered to them would transform in scope and style. The year 1909 also saw the launch of a bold new civil rights and social justice organization: the National Association for the Advancement of Colored People (NAACP). The catalyst for its existence was a deadly anti-Black race riot that took place in Springfield, Illinois, in which many Blacks were assaulted and lynched. Appalled by this event, a group of 53 white liberals and seven African Americans united to form a new organization dedicated to equality, and the eradication of race prejudice and discrimination, within American society. They rapidly set up branch offices around the country, and founded their own journal, *The Crisis*, under the direction of the group's most prominent African American member, W E B Du Bois.

Black actors badly needed these advocates, as they were otherwise powerless in their quest for better and more numerous film roles. They were vulnerable and easily replaced, and so they learned to keep their mouths shut and to do as they were told, while quietly imploding with frustration at their powerlessness. 'What's an actor supposed to do?' pondered African American actor Willie Best. 'Either you do it, or get out.'[4] The NAACP and the Black press, like tribal elders watching from afar, were free to lobby and criticize on behalf of their Black

thespians, despite the fact that the latter didn't always agree on the stances they took, and many of Hollywood's biggest Black stars clashed with their advocates' ideals. These organizations became the spearhead of Black racial consciousness, as they directed their energies in opposition to Hollywood's racist tropes. Direct action in the form of picket lines, verbal protestations and adverse newspaper headlines was intended not only to generate negative publicity that could damage a film's chances at the box office, but also to force Hollywood into abandoning its racist narratives altogether.

In February 1915, just prior to the release of *The Birth of a Nation*, the NAACP took the production's film studio to court, contending that the book upon which the film was based – *The Clansman*, by Thomas Dixon – had stirred riots in Pennsylvania, and that the film adaptation would likely do the same. Meanwhile, local branches of the NAACP organized protest marches and petitions denouncing the movie. Simultaneously, throughout the spring of the film's release, *The California Eagle* kept up a barrage of attacks within its pages, which included protesting to the board of film censors. Although their efforts ultimately failed to stop the movie from being distributed, the power and the influence of both groups were on the rise, and Hollywood would increasingly be forced to take their protestations very seriously.

Simultaneously, other minorities were also lobbying Hollywood for better representation. In 1915 sections of the Japanese American community were outraged at director Cecil B DeMille's derisory portrayal of Asians in *The Cheat*. They attempted to have the movie banned when it was re-released in 1918. Latinos were also unhappy about their portrayals in movies. In 1922 letters of protest were sent to the studios by the governments of Mexico, Honduras and Costa Rica. Mexican president Álvaro Obregón went as far as banning the import of Hollywood films that derided its citizens. Even American president Woodrow Wilson reportedly told Hollywood producers, 'Please be a little kinder to the Mexicans.'[5] On 6 November 1922, the Motion Picture Producers and Distributors of America signed an agreement pledging not to offend Mexicans and other Latinos. However, the deal did not put an end to their negative portrayals.

*

As the First World War drew to a close, millions of immigrants and minorities were on the move within America. The so-called 'Great Migration' saw six million African Americans relocate from the small towns, villages and farms of the south to the cities of the north, west and mid-west, in search of their slice of the American pie. Black people – like LGBT+ people, Mexicans, Asians and other minorities – were drawn to the big cities because they were looking for a place where they could belong, where they could work, be themselves, feel safe and not be hunted. They came from traumatized backgrounds where they had been abused and terrorized, and they sought to cross the liminal zone between these places and a new settlement somewhere over yonder, where life was sweeter. Many headed for Los Angeles in the hope of finding fortune within the fledgling film industry that was exploding in popularity amid the frenetic optimism of the post-war years. By 1920, 15,000 had made their homes there. In 1924 the *Baltimore Afro-American* reported that 250 African American extras were already working in Hollywood studios.[6] Being an extra was a fragile vocation based on waiting and rejection, but nevertheless it was easy to see what drew people to it. It was not simply the allure of potentially being a part of the world's most exciting and dynamic art form; it was also the fact that by the end of the 1920s Hollywood was America's fourth largest industry, producing over 500 feature-length films per year for a weekly audience of 100 million ticket-holders paying 25 cents each across 23,000 theatres nationwide. The industry was a money machine.

From its earliest productions, Hollywood became the primary vehicle for the dissemination of American culture, and everyone wanted to be a part of that, either as consumers or creators. Even those who found themselves outside the system somehow needed it as a counterpoint, as a focal point to kick against. Rising from the undercurrent of disenfranchised creatives, an independent Black film scene began to flourish outside the Hollywood mainframe, as part of the artistic and cultural revolution known as the Harlem Renaissance, which took off in New York and reverberated into Paris and beyond. Partly galvanized in response to *The Birth of a Nation*, these counter-voices sought to challenge the white monopoly of motion pictures, and to take back

15

control of African American narratives. While the white-owned, Chicago-based Ebony Film Corporation began operations in 1915, the first Black-owned film firm, The Lincoln Motion Picture Company, was founded by actor Noble Johnson in 1916. The scene's biggest player was a writer, director and producer from Illinois called Oscar Micheaux. He founded The Micheaux Book & Film Company in 1919, producing over 40 films with predominantly Black cast members. Meanwhile, in 1922 Kansas City-based Tressie Souders was credited as the first African American female director for her indie-short, *A Woman's Error*. Simultaneously, other minorities recognized the same need to take control of their own narratives, and to portray themselves as contemporary, complex figures. In May 1918, Asian star Sessue Hayakawa quit Paramount studios to form his own production company, The Haworth Pictures Corporation, specializing in Asian-themed movies. The firm created 23 silent films, featuring more expansive storylines, with Hayakawa himself producing and starring. The company made $2 million per year at its height, before folding in 1921.

While Black and Asian film entrepreneurs were busy striving for independence, inside Hollywood the studios were modernizing the extras casting system that would give birth to so many of its Academy Award winners. At that time the studios took care of their own individual casting needs, hiring white extras on the spot from the hordes of wannabes who would eagerly board streetcars every morning and head for the studio gates, where they would congregate in the hope of being chosen. Bribery and sexual favours were not uncommon methods used to procure an opportunity. The system was chaotic, unregulated and corrupt, and the studios' employment practices contravened California's labour laws. The situation began to attract negative press, and the studios became desperate to halt the relentless flow of hopefuls who congregated at its gates. To address this, the Central Casting Corporation was founded on 4 December 1925 by the Motion Picture Producers and Distributors of America (a conglomerate of all the major Hollywood studios), led by its president, William H Hays. The new firm, located at Hollywood Boulevard and Western Avenue, formalized the hiring of extras and bit-part players within Hollywood. In place

of the old system, registered extras looking for work were required to call the switchboard once per hour up to 3pm, and thereafter *every 15 minutes* for the rest of the day. Lines were open from 6am to midnight. The number of incoming calls was so great that the company had to create its own telephone exchange to handle the volume. Very quickly the massed crowds camped outside the studio gates vanished. The *Los Angeles Times* reported that in the first six months of operation the new bureau made 113,837 placements (629 per day) from a roster of 15,000 registered extras.[7] Carole Lombard, Jean Harlow, Clark Gable, John Wayne and Gary Cooper were among those who started their careers there during Hollywood's Golden Age.

The launch of Central Casting was quickly followed by a new system of recognition for Hollywood's key executives. On 4 May 1927 the Academy of Motion Picture Arts and Sciences (AMPAS) was formally incorporated by Louis B Mayer, the legendary head of Metro-Goldwyn-Mayer (MGM), the era's dominant film studio. Its initial concept was not to present awards for excellence in film, but to establish a trade organization to mediate labour disputes, promote the development of new production procedures and technologies, and market the overall image of the motion picture industry. The idea first crystallized over Sunday dinner and cigars at Mayer's Santa Monica beachside residence, during a conversation with director Fred Niblo (who directed *Ben-Hur*), contract actor Conrad Nagel and Fred Beetson, head of the Association of Motion Picture Producers. They envisaged it as a private club for handpicked, important friends from the world of film. They concluded that membership would be open to those engaged in the five branches of the industry: actors, directors, writers, technicians and producers. New entrants were to be chosen by invitation only, and were voted in by the existing membership base. On 11 January 1927, Mayer invited a group of 36 Hollywood executives to the Ambassador Hotel, Los Angeles (the same venue in which Robert F Kennedy was assassinated in 1968), and put the proposal to them. It was greeted with unanimous approval. On 11 May, these founder members were then invited to an inaugural banquet at the Crystal Ballroom of the Biltmore Hotel in downtown Los Angeles. Among the members were Cecil B DeMille, Harold Lloyd, Warner brothers Harry and Jack, and Douglas

Fairbanks, who was enrolled as president. That evening, of the 300 guests in attendance, 230 additional executives joined the Academy, each contributing a cheque for one hundred dollars. This extended list contained more female members, including star actress Gloria Swanson. The Academy's first honorary membership was presented to inventor Thomas Edison, creator of the Kinetograph – a motion picture camera. The list was also significant in featuring its first non-white member: Mexican actor Ramon Novarro. It is unclear why he was admitted, although, despite his ethnic background, he looked European, and had built a career playing major roles as a white person.

Mayer remains a controversial figure within the Academy's history. He made his fortune by being the sole distributor of the virulently racist *The Birth of a Nation* – and from the beginning his new Academy was set up to be discriminatory, like so many American institutions during the era of segregation and rampant sexism. It had been barely six decades since the abolition of slavery, and American women had only won the right to vote in 1920. Unsurprisingly, against this backdrop the institutions created by powerful white men like Mayer were designed exclusively to serve their own prerogatives. Although he stressed the democratic nature of his organization when he stated that membership was open to all those who had contributed 'in a distinguished way to the arts and sciences of motion picture production', in reality it was a club for white men – a private fiefdom of wealthy, cigar-smoking alphas, with their feet up on Hollywood's proverbial desks. Of the Academy's 36 founder members, only three were women (8 per cent): Mary Pickford (who was married to Fairbanks), plus actors/screenwriters Bess Meredyth and Jeanie MacPherson. None were Black. None were Asian, Native American or Latinos. In segregated America, it could be no other way.

Despite this, a new generation of Black actors were pushing for greater inclusion, buoyed by the optimistic energy of the Roaring Twenties. One of them was vaudeville actor and comedian Lincoln Perry. In November 1927 the Florida-born entertainer featured in the silent film *In Old Kentucky*, where he introduced the controversial character known as Stepin Fetchit – a perplexed, lazy, mumbling dimwit. Whites loved the persona, while Blacks were horrified at what they saw

as Perry's perpetuation of a demeaning stereotype. Nevertheless, he turned it into a highly lucrative career. By the mid-1930s he had become Black Hollywood's first millionaire. Though Stepin Fetchit was heavily criticized, Perry did help move African American actors a step closer to reaching the Academy Awards. For his role in the movie he became the first Black actor to receive an on-screen credit in a feature film. This small addition had huge consequences, as it gave formal and public recognition to the roles Black actors played, thereby legitimizing their presence as actors in leading roles. Before Perry, the names of Black actors were not included, but after him this would become standard.

Evolution was also taking place at grassroots level. As the industry expanded and modernized, the demand for African American extras began to grow concurrently, with productions gradually moving away from using white actors in blackface. In early October 1927, Central Casting launched a specialist African American division. Los Angeles agent Charles Butler was hired as Head of Negro Employment by boss Fred Beetson to run it. Butler was 43 years old, and well-known within the industry, having previously worked for local Black casting agencies Cinema Exchange and Cinema Auxiliary, alongside Jimmie Smith. Butler, who was from Saginaw County, Michigan, became one of only a handful of Black Hollywood executives present at that time, and the only African American among all of Central Casting's employees. Jim Crow meant that he was prohibited from working alongside his white colleagues at their Hollywood Boulevard headquarters. Instead, he was based at his existing office at East 12th and Central, in the heart of Los Angeles's Black neighbourhood.

Upon his appointment, all connections and relationships that Black extras and casting agents had previously cultivated with individual Hollywood studios were instantly severed. Butler now had absolute control. Under the wing of Central Casting, he supplied background actors to all 14 Hollywood studios at once. Whenever they sought Black actors for their productions they would pick up the phone to him, and him alone. Butler held the keys to the fortunes and futures of almost all of the industry's Black extras and newcomers. In one move he had become the most powerful African American in Hollywood.

If a Black actor was ever going to break through Hollywood's exclusion zone

and win an Academy Award one day, that person would have to come through Butler at Central Casting. And so, to the acting fraternity based around Central Avenue, *Butler was Hollywood*. Some sections of the Black press complained that he wielded too much power – but perhaps that was the point. The one thing that this generation of Black people, and their slave forebears, had never had in their lives – and that they craved the most – was power.

Did this power go to Butler's head? As well as controlling Black Hollywood, he was financially very well off compared to the actors on his books. A salaried employee, he drove a brand-new car every year, and the agency afforded him a generous expense account, which included all the petrol he needed for the 30,000 miles he clocked up each year, shuttling twice daily between 14 studios spread over a 40-mile radius, delivering casting calls, pay checks and studio passes. There were few other Black people in America at that time with such terms of employment.

However, Butler's power was controlled by his white bosses, upon whom he depended for his status and security. His value to them was only as good as the extras he could procure on demand. So where did he find these golden nuggets of Black talent? He took a daily walk along Central Avenue, the main thoroughfare into downtown Los Angeles, and home to the majority of African Americans living in the South Central district. Segregation had forced them into this cluster, as whites had used restrictive covenants to prevent them from living in, or purchasing property in, the parts of the city they favoured. As a result, numerous Black-owned businesses sprang up next to each other – nightclubs, theatres, cafes and restaurants, hardware stores, banks, beauty parlours, gas stations and markets, many of them clustered between 8th and 12th street, adjacent to Butler's office. Among the enterprises were well-known nightspots the Kentucky Club and premier jazz venue Club Alabam, as well as the offices of *The California Eagle*. The packed theatres of the thoroughfare known as 'Brown Broadway' hosted the best in Black vaudeville and musical comedy, and its movie houses showed the latest Hollywood films. The Somerville Hotel (later renamed The Dunbar) was the focal point for Hollywood's Black celebrities, and the most prestigious place for them to stay within segregated Los Angeles. The venue was

frequented by Duke Ellington, Louis Armstrong, Langston Hughes, Billie Holiday, Lena Horne and Nina Mae McKinney, as well as members of the NAACP.

Central Avenue was also the epicentre of Black Hollywood. Among the area's residents were the first generation of the film industry's Black actors, stylists, hair and make-up artists, composers and cameramen, as well as the chauffeurs, butlers, cooks and maids who serviced Hollywood's elite. To be an African American living or working there at this time was to be aware of a certain *frisson* of possibility crackling in the air. One day a person could be walking down the street minding their own business, and the next they could be under the lights on a Hollywood film set. And with a simple 'yes' or 'no', Butler could make or break these careers. His favourites ended up with regular extras work, and were booked repeatedly on different productions throughout each year. The pay was $7.50 ($130 today) per eight-hour day, plus a box lunch. For most, acting success was measured not by the quality of specific roles, but by the number of days booked, minutes on screen, and cash earned. Getting booked on that first job could turn a person's head. Transformed by their brief illumination in front of the camera, they would suddenly, formally call themselves 'actors', and envisage never having to go back to their day jobs. In reality, most would have to.

Butler would traverse the pavements of Central Avenue's bustling neighbourhood, frequenting its numerous venues, scanning faces and bodies, like a modelling agency scout might do today. African Americans were arriving in Los Angeles every day, and so Butler and his contacts were perpetually on the lookout, checking the influx of fresh talent that had come westward, seduced by the shimmer of Tinseltown. When he was recruiting large numbers of extras, groups would cluster along Central Avenue's street corners, stretching northwards from the Somerville Hotel. Butler would select those that fit the studio's physical specification and send them along to so-called 'cattle calls', via the studios' fleet of buses, parked at East 12th and Central, adjacent to his office. A young actress named Hattie McDaniel later recalled seeing the buses 'drive slowly down Central Avenue and pick up any interesting character who wanted a day's work'.[8] Butler also scoured churches, beauty pageants, jazz clubs and

amateur singing contests – anywhere that Black folks hung out. He was assisted by his wife Sara, an ordained minister from Indiana, who founded the Zion Temple Community Church in Los Angeles. She was formally trained in music, and took charge of the local choir. She ran a popular choral group, Old Time Southern Singers, and so she had a direct line to the neighbourhood's most talented young female singers.

Butler was to discover a number of Hollywood's Black movie stars. One of the first was Louise Beavers, a young singer and actor from Cincinnati, Ohio, who worked as a maid between gigs. She was a member of the Lady Minstrels, a group of Black female stage performers. One night in early 1927, while performing at Loew's State Theatre in downtown Los Angeles, she was spotted by Butler, who was seated in the audience. He offered to send her on movie castings, but she hesitated initially, as she disliked the demeaning roles on offer for African American actors. Butler persisted, and Beavers was eventually cast in the silent drama *Uncle Tom's Cabin* (1927).

With thousands of extras on the books of Central Casting's various divisions, it was vital to create an efficient filing system to keep track of the talent. All extras were collated into a master index, classified by physical 'type', such as 'blonde', 'beautiful', 'ugly', 'Jewish', 'Latin', 'fallen woman', 'fast flapper', and so on. But within the African American division the classifications were exclusively narrow in scope and derogatory in nature – mammy, servant, waiter, porter. Butler's task was to match his extras to their racist stereotypes. Full-figured, dark-skinned women were sent in as mammies, while slim, dark-skinned men were porters and waiters. Light-skinned African Americans were categorized as 'off-types', and were never cast in such roles, due to what was considered to be the ambiguity of their lighter skin and bi-racial countenance. Crucially, all these casting typologies were fixed propositions within the psyche of Hollywood's white decision-makers. By contrast, white extras could harbour reasonable hopes of one day breaking loose from their specified type and into other roles, but for African Americans, a mammy would always be cast as a mammy, and nothing else.

Butler was complicit within this order. He perpetuated Hollywood's derogatory Black stereotypes in the extras he selected for the studios. He could

do nothing to change Hollywood's racism, and so he complied with it. If he hadn't, someone else would have taken his place. He was loyal only to those who paid his wages. 'Charles Butler was more interested in doing the industry's bidding than protecting African American artists,' wrote Jill Watts in *Hattie McDaniel: Black Ambition, White Hollywood*.⁹ His success lay in learning to think like his white bosses – *to think like a racist, while being Black*. It was a persona that he wore to work every day, like a hat. Like a hat he forgot he was wearing.

Nevertheless, thousands of African American extras were very happy to work for Butler. In 1927 he employed them 6,816 times across different productions. They wanted to be in the movies, whether they were favourably portrayed or not. It was easy to see why. By working just six days a month on a film set, an extra could make more money than they could working full-time as a servant. Ironically, the choice was either to play demeaning servants on screen or to become servants in real life.

The launch of Central Casting's Black division coincided with advances in film technology – namely the end of the silent era and the advent of sound in 1927. This innovation extended the scope of the acting profession beyond its solely physical incarnation, and presented the opportunity for artistic emancipation, leading to more substantive roles. For African Americans this meant that their musical talents could now be showcased. Two all-Black musicals, *Hallelujah!* and *Hearts in Dixie*, were commissioned side-by-side by MGM and Fox, and Butler was briefed to seek out actors who could sing and play musical instruments, as well as act. Minor speaking roles were also introduced for Black extras. Those who had bit-parts of dialogue could boost their earnings to $20 per day ($350 today), while others were hired on short contracts and paid weekly for a few lines within different scenes. But these early speaking parts were reserved only for those who could talk in the Southern stereotype 'broken English' so beloved by white directors and producers. Slurred rather than precise speech was the order of the day. In some cases, those trained, educated actors whose vocal styles were considered too refined would receive special instruction from white speech coaches in how to deliver their lines 'authentically'.

By the close of 1928 Butler had placed almost 11,000 extras, with wages totalling $90,000 ($1.6 million today). The demand was so intense during the summer filming schedule of 1929 that Butler was denied his vacation by his bosses at Central Casting. He would often be called upon to mobilize large numbers of African American extras at short notice. For *Hallelujah!* (1929) he recruited 340 of them from local church choirs, and delivered them to the studio in bus loads, first thing on a Sunday morning. The normally packed pews within the neighbourhood's Black churches were suddenly empty that day.

Hallelujah! ushered in the first African American female to play the lead in a Hollywood feature film. Nina Mae McKinney played a wisecracking Jazz Age flapper and con artist who seduces a sharecropper-turned-preacher, and becomes embroiled in a deadly love triangle. McKinney was a precocious talent, first spotted at the age of 16 by the film's director, King Vidor, while performing in the chorus line of a New York Broadway revue in 1928. Vidor, a white Southerner under contract at MGM, had longed to make an all-Black feature, but this was new and uncharted territory for the white conservative studios. MGM bosses Irving Thalberg and Louis B Mayer, along with Nicholas Schenck, who was chairman of Loew's theatres (which owned MGM), balked when Vidor first pitched it to them, fearing that white audiences would never go to see it, and that it would flop. His bosses only relented when Vidor pledged his own salary into the film's funding. In this era, it was often the case that conventions were crossed not by the studios themselves, but by maverick auteurs who pushed for alternative stories that were not driven by white protagonists.

When news broke of the production, and its all-Black cast, with McKinney as lead, *The California Eagle* lobbied MGM to employ African Americans behind the scenes as well. Black musical director Eva Jessye supervised the choral sequences, while Harold Garrison took charge of organizing the Black extras on set. African Americans were also hired as consultants in Arkansas and Tennessee, where parts of the movie were shot. The film turned McKinney into an overnight sensation, drawing rave reviews from the Black press. In 1928 both she and Lincoln Perry were rewarded for their successes, becoming the first Black actors to sign contracts with their respective studios, MGM and Fox. This was a major

milestone in the status of Hollywood's Black actors. But, for McKinney especially, little would come of it. After *Hallelujah!* there were no follow-on roles, and so mainstream stardom eluded her. She ended up touring Europe, appearing in small-time variety shows. For Perry, despite appearing in 44 films between 1927 and 1939, most of his parts were not lead roles, and he was unable to develop into more progressive characters. In another world they would both have been the foremost contenders for Black Hollywood's first Academy Awards, as they were its biggest stars, but within the studio system there was no investment in the development of Black actors. And so eventually they faded away.

<div style="text-align:center">*</div>

Within the entertainment arena, the idea to present gold awards of achievement had its roots in elite sport. The first Olympic medals, designed for the Athens Games of 1896, were created by French sculptor Jules-Clément Chaplain, one of the founders of the Art Nouveau movement. His supersized bas-relief coins were forged at the Paris Mint. First-place winners received a silver medal, an olive branch and a diploma. Those in second place were awarded a bronze/copper medal, a laurel branch and a diploma. The tradition of gold-plating began at the 1904 games in St Louis, USA, with medals designed by New York jewellers Dièges & Clust. Olympic champions have received gold medal awards ever since.

It was at the meeting of the AMPAS founders on 11 May 1927 that Louis B Mayer first tabled his idea of presenting 'Awards of Merit' to select Hollywood professionals each year. He saw it as a means of incentivizing filmmakers. 'I found that the best way to handle [filmmakers] was to hang medals all over them,' he said. 'If I got them cups and awards, they'd kill themselves to produce what I wanted. That's why the Academy Award was created.'[10] At the same event the Academy's now iconic golden statuette was designed by MGM's Irish-born art director Cedric Gibbons. He was one of the Academy's original 36 founder members. Sketching on one of the hotel's white linen napkins, he produced a rough image of a noble, crusading knight, naked and posing like a sentry keeping guard, gripping a downturned sword while standing in front of a reel of film with five spokes – each representing one of the Academy's original five branches. No sketches of live models were used in its conception.

Gibbons's design was immediately approved by the Board of Directors, and featured on the cover of the November 1927 edition of the Academy's magazine. The sculpture fitted in seamlessly with the organization's exclusively white, male ethos. The fact that the figure was masculine suggested that Gibbons was not thinking about the possibility that many of the trophies might be won by women. The inclusion of the sword is also both a phallic symbol – a reference to masculine sexual power – and an emblem of aggression. But aggression against whom? Its sentry-like pose suggests it is guarding the five departments denoted by its film reel base. But who is the enemy it is guarding against? Perhaps those excluded from the Academy?

In early 1928, Gibbons paid 26-year-old Los Angeles sculptor George Stanley $500 to transform his initial sketch into three-dimensional form. Together they discussed the design concept, and Stanley worked up several prototypes, from which Gibbons selected the final edition. Gibbons enlisted his assistant, Fredric Hope, to work up the design of the plinth. The outline of the knight was streamlined to enhance its elegance, while the base, with its film reel motif, was repositioned beneath the figure's feet, as if it were standing triumphantly upon a podium. The first twelve statuettes were cast by Guido Nelli at the California Bronze Foundry. From the second year, production would move to the Southern California Trophy Company, where it would stay until 1960. The firm would make up to 50 units per year, at a cost of $105 per unit. The finished Art Deco statuette – officially referred to as 'the Academy Award of Merit' – consisted of 24-carat gold-plated bronze. It was 13½ inches tall, and weighed a hefty 8½ pounds. Gibbons's final design has hardly been altered since (aside from being fitted with a thicker plinth in 1945). As MGM's art director, Gibbons would end up enjoying a relationship with the trophy he designed that would endure beyond his wildest expectations. During his Hollywood tenure he would be nominated for an Academy Award an incredible 39 times, winning on 11 occasions – a record that stands to this day.

In 1928 there were a total of 362 Academy members. Of the five departments, the Actors Branch was the largest, consisting of 91 members. The directors had 78, the writers 70, the technicians 69 and the producers 34. In the build-up to the

first Academy Awards ceremony in 1929, the members did not actually vote for the subsequent winners. Instead, they submitted a list of nominees who were then narrowed down by Boards of Judges to a maximum of three for each category, with the winners then chosen by the Central Board of Judges, which was composed of one member from each of the five branches. In other words, the winners were picked by five men – Alec Francis (Actors Branch), Frank Lloyd (Directors Branch), Sid Grauman (Producers Branch), Tom Geraghty (Writers Branch) and A George Volck (Technicians Branch). This process would change for subsequent Awards, to prevent board members from showing a bias towards their own films. The final decision on the debut year winners was made on Friday, 15 February 1929. The results were announced to the press on the following Monday, and were printed by the *Los Angeles Times*, three months in advance of the ceremony.

The event took place on 16 May in the Blossom Room of the Hollywood Roosevelt Hotel, Los Angeles. It was a black-tie corporate banquet attended by 270 members and their guests, who paid five dollars each. With few women and almost no minority Academy members, and with Hollywood's leading roles exclusively played by white actors, it was clear who the new system of rewards was designed to celebrate. The only African Americans in attendance on the night were the waiters, porters and kitchen hands. Twelve Awards, plus 20 certificates of honourable mention for the runners-up, were presented by Douglas Fairbanks, for works completed during the 1927–8 season, in a ceremony that lasted just 15 minutes. There were no surprises among the winners, after being informed in advance – so much so that only two of the victors in the acting categories actually turned up to receive their trophies. Swiss-German actor Emil Jannings, who won Best Actor for his roles in both *The Last Command* and *The Way of All Flesh*, picked his up in advance, before heading home to Germany, where he would later campaign for Hitler and the Nazis. There was only one female winner: 22-year-old Janet Gaynor, who won Best Actress for her work in three films during that period – *Seventh Heaven*, *Street Angel* and *Sunrise*. A special Honorary Award was presented to Charlie Chaplin. The pioneering *Jazz Singer* movie was barred from competing in the major categories, as its use of sound was considered an

unfair advantage compared to the silent films in the running. It had to settle for an Honorary Award instead. George Stanley also received a special mention on the night, as the gifted sculptor behind the golden statuette. He was a modest figure who didn't enjoy the limelight, and so he hid behind a tall plant when he heard his name mentioned.

In its fledgling form, the first Academy Awards was a modest affair – a low-key trade show that many within the industry, and outside, didn't really care about. It had no media coverage, no global audience, no red carpet, no fashion focus, no razzmatazz, no suspenseful reveal of the winners from a sealed envelope opened in the moment. African Americans and other minorities were not fighting to be a part of this staid event. But this would soon change as the Awards rapidly established themselves. However, despite the expanding volume of work for actors of colour, one glaring problem remained. As long as they were confined to being extras and bit-part players they would never be nominated for any of the new Academy Awards of Merit. They needed to be cast consistently in leading roles in high-quality productions. From their disenfranchised position this was not easy. The studios were slow to create such parts for non-white actors, and ones that would elevate their status, rather than perpetuate outdated stereotypes. There was no commitment to developing the careers of the best talents. All they had were the transient whims of a few directors with one-off projects. The well-worn pattern – and one that would repeat itself for decades to come – was that a major role for an actor of colour would result in no follow-up, even for those under contract, and so they would eventually crash out of Hollywood in slow motion, gradually phased out by those who had once courted them. Instead, the investment went into nurturing the white stars of the studio system as the most commercially viable and culturally acceptable options. Thus, at the end of the 1920s, the chances of any minorities being nominated for an Academy Award stood at zero. Louis B Mayer's initial choice of the 36 all-white, mainly male founder members was pivotal, as it enshrined the culture of discrimination against women and people of colour in the attainment of Academy Awards, thereby setting the industry up as a battleground for gender and racial equality that would prevail for the next one hundred years.

CHAPTER 2

AMERICAN GOODNESS
(1930–1940)

'Being the first black anything, sucks.'
Chris Rock, *Details* magazine, August 2012

When the phone rang in Charles Butler's Central Avenue office, the voice at the other end made a request that seemed impossible to achieve. It was late October 1933, and Universal Pictures was filming the movie *Imitation of Life*, directed by John M Stahl, with Fredi Washington playing the lead and Louise Beavers supporting. Based on the 1933 bestselling novel of the same name, by Fannie Hurst, the plot tells the story of a struggling widow, Bea, who goes into business with Delilah, a Black domestic servant. Delilah has a very fair-skinned daughter, Peola, who grows up and passes for white, and shuns her mother, who subsequently dies of a broken heart. As the production prepared to shoot Delilah's funeral scene, Butler was told to find extras to play mourners. Delilah was a popular and much-loved philanthropist within the community, and so the studio needed hundreds of African American extras for the climactic scene. They only gave Butler a few hours to find them and get them to the set.

His contacts within the African American film community were extraordinary, but he didn't have time to gather that many actors at such short notice. Instead, rather than cast professionals, he drove around to seven local lodges in South Central Los Angeles, and recruited all their members, including various choral groups – 550 people in total. He loaded them onto a fleet of studio buses and got them all to the set on time, as requested.

As the director finally called 'action' on the scene, and the cameras rolled, one

person stood out among the 550. She was an unknown actress from Wichita, Kansas, named Hattie McDaniel, who was there with her choral group, Old Time Southern Singers. She stood out, not for her presence within the funeral scene – in fact, she was cut from the final edit – but for what would reveal itself later on, when she would inadvertently change the course of Hollywood history.

McDaniel was born on 10 June 1893. She was the youngest of 13 children born to Henry McDaniel and Susan Holbert. Her father was a farm labourer from Virginia, and her mother a domestic worker from Tennessee. The family existed in extreme poverty. Six of her siblings died young, and, according to Hattie, she was malnourished at birth, weighing just 3½ pounds. The family lived in substandard accommodation, without adequate clothing, and the children regularly went without meals.

Henry McDaniel was a Civil War veteran with the Tennessee 12th Colored Infantry Regiment. He fought for the Union at the Battle of Nashville in 1864. Unfortunately he returned home from battle with severe war wounds. He was lame, deaf in one ear, and had sustained a broken jaw which had become an open sore inside his mouth, complete with fragments of bone. He had received little medical treatment, and consequently lived in constant pain. For years afterwards he struggled against the racism of the US government, after their refusal to grant him a service pension or disability payments. Following many rebuttals he was finally granted a reduced state pension in 1902, after 18 years of trying. This, along with the family's struggles against day-to-day racism, job insecurity and the effects of the war, formed a constant, haunting echo within the McDaniel household. But, rather than discouraging the young Hattie, the obstacles only fuelled her determination and drive to succeed.

Her journey to success began with her love of song. She grew up singing wherever she could – in church, at home, in the street, or at school in Denver, Colorado, where the family moved in 1901. One of only two African American students in her class at the 24th Street Elementary School, she became a popular figure among her classmates due to her song-and-dance talents. She had dreamed of being an entertainer since the age of six, and this desire became so strong within her that she dropped out of high school in 1910 to focus on it fully. Over

the next 20 years she performed in touring minstrel shows alongside her siblings, working on the side as a housemaid, aged 15, to make ends meet. 'Mostly, I used to wash dishes, wash clothes, cook the dinner and then mind the baby when the white folks went off after dinner,' she recalled.[1] In between, she performed in vaudeville shows and established herself as an accomplished blues singer-songwriter, as well as a skilled dancer, actor and comedienne. These two decades as a journeyman performer, on stage and on the road, were her apprenticeship years, when she refined her craft night after night, in preparation for her forthcoming role in American history.

Her rise coincided with the stock market crash of 24 October 1929, and the onset of the Great Depression, which saw worldwide gross domestic product fall by 15 per cent, international trade plummet by 50 per cent, and 5,000 US banks fail nationwide. People of all backgrounds became desperate to find work and the means to feed their families. The era jettisoned 13 million people from employment, their labour and skills suddenly useless in the pared-down and desperate wasteland of those sour times. Unemployment in Los Angeles reached an all-time high of 20 per cent, and those within the Black and minority communities were hardest hit. By 1931, 29 per cent of the city's Black population were jobless. Many of the service and hospitality jobs usually designated to them were either scrapped or reassigned to whites. Blacks became the last to be hired, and the first to be fired. They often received substantially less aid than whites from public assistance programmes, while a number of so-called charities barred them from their soup kitchens.

The effects of the crisis were felt deeply in Hollywood. The industry rolled back its productions as revenues shrank, and many actors of colour were dropped from planned feature films. Lincoln Perry was released from his lucrative contract with Fox. Such desperate times led to desperate measures from many African American actors, who became complicit in their own degradation and exploitation within the extras casting process. Beyond mammies and servants, the types of roles scripted for Blacks became more extreme in the era's 'jungle movies'. For the film *Nagana* (1933), a casting call advertisement to recruit African American actors stated that those wishing to be considered had to

'resemble savages'.[2] Four hundred responded to the call. It was the most difficult time to be an actor of colour – knowing that the only roles open to them were racist, and thereby having to rely on racists to get these demeaning parts. For *Tarzan and his Mate* (1934), a similar ad for 'savages' was posted by Charles Butler. It attracted an astonishing 3,000 applicants.[3] There were multiple intentions among the hordes of hopefuls: some sought fame, others wanted adventure or escape, while many were simply hungry and desperate, seeking a way to survive the harsh times. There was no dignity in these roles, but there was money – and that was what they needed most.

Despite the terrible hardships of the age, thousands of aspirants still flocked to Hollywood. Its unshakeable magnetism and mesmeric allure had made it the most famous destination on Earth. Wide-eyed pilgrims journeyed there, in the hope that maybe, just maybe, they might be the one who hits the big time; the one who steps off the carousel of destiny and into the shimmering glare of Tinseltown. In 1931 two of Hattie McDaniel's actor siblings, Sam and Etta, urged her to join these massed ranks and move to Los Angeles, where they were already settled and securing minor film roles. Sam was fresh from a bit-part in the film *Public Enemy* (1931), with James Cagney. Theatre work, for many years Hattie's mainstay, was contracting under the weight of the Great Depression and from the competition from cinema, and so it was exactly the right time for her to pivot. She arrived in early May, one of approximately 17,500 African Americans who lived in South Central Los Angeles at the time. Over the next decade, nearly 25,000 more would join them.

Hattie was broke when she arrived, and she stayed with her siblings initially, before finding her own modest apartment half a block from Central Avenue. Straight away Sam introduced her to some of the area's most prominent figures. She met Harry Levette, actor and journalist for *The California Eagle*, who announced her arrival in his weekly entertainment column. She also met Sara Butler, wife of Central Casting's Charles Butler, who invited her to join her choral group, Old Time Southern Singers, with whom she would regularly sing solos. From there she connected with Charles Butler, who signed her onto Central Casting's books. Simultaneously she

signed with an employment agency, doing washing and ironing for wealthy white Los Angeles families.

McDaniel knew that refashioning her career in Hollywood would not be straightforward. She was 38 years old, when most of the actors she was up against were in their early twenties. The roles on offer were limited, and the numbers reduced as a result of the Depression. Like all extras at Central Casting, McDaniel was cast according to physical type. She was dark-skinned, fuller-figured and not conventionally beautiful. This could only mean one thing in 1930s Hollywood: she would be cast as a mammy. Aesthetically, such figures were stereotyped as overweight, ugly, dark-skinned, and adorned with a signature white headwrap. Compliant and forever loyal to their owners, they validated slavery and white supremacy. They were loud, simple-minded, cantankerous, sexless, and much loved by whites as compliant, comic figures.

Butler sent McDaniel for auditions whenever the studios requested mammies or maids. She fit the mould so well that she immediately started getting booked as an extra, at $7.50 per day ($130 today). Despite the nature of the roles, she was delighted that Butler had got her work. 'A call from Charles Butler at Central Casting was like a letter [from] home,' she recalled.[4] The pay, though unpredictable, was far greater than she earned being a maid, and with it she was able to supplement her Depression-era earnings. In her debut year in Hollywood she featured in eight movies, including an uncredited speaking role in *Blonde Venus* (1932), as Marlene Dietrich's servant. In 1933 she landed her first studio contract and substantial screen role, earning 300 dollars ($7,000 today) for 11 days' work on the film *Judge Priest* (1934) – a racist comedy starring Will Rogers and Lincoln Perry. The following year she was cast in *The Little Colonel*, opposite child star Shirley Temple. The role captured the attention of Hollywood producers and directors, and from then on she received a windfall of offers. By the mid-1930s she had become the most prolific actress in Hollywood, featuring in an incredible 15 films per year between 1935 and 1937. By the end of that year she had become the go-to actress for comedic, servile, but sharp-tongued mammies.

Her success came amid cutbacks that threatened all actors' earnings. Up to

that point AMPAS had been the chief bargaining agent for Hollywood's actors, but relations between both parties soured in March 1933, when AMPAS failed to defend them against the studios' plan to force actors under contract to take a pay cut of up to 50 per cent – a decrease that did not apply to studio executives. In response, six disaffected actors formed their own self-governing union. The Screen Actors Guild (SAG) was incorporated on 30 June 1933. Within a few months Groucho Marx, Spencer Tracy, Gary Cooper and James Cagney were all members. It proved to be more progressive than the Academy in allowing actors of colour to join. Clarence Muse, a well-respected and vocal figure within Black Hollywood, who also wrote a showbusiness column for *The California Eagle*, became the first African American to join during its start-up year. The union initially failed to recruit other Black members, however, many of whom were suspicious of the organization's all-white base. SAG's sole start-up remit was pay, and people of colour were the most underpaid, and were sceptical about the organization's willingness to fight their cause in this regard. SAG executive Aubrey Blair tried to reassure them by promising equality for all members, regardless of their race or ethnicity. Other Black actors hesitated to join for fear that Butler and the studios, in retaliation, would strike them from their rosters, and they would never work again. Butler openly disapproved of Blacks joining the actors' union, or going on strike in pursuit of better pay or acting roles, as it challenged his authority, and reflected badly on him with his white bosses. Nevertheless, Muse, a vigorous advocate for SAG, publicly urged his fellow actors to join up. He recognized how useful the agency could be in terms of credibility, and establishing the rights of Black actors, thereby bringing them a step closer to attaining better roles, and eventually being nominated for the Academy Awards.

By 1934 SAG had become a recognized and influential force within Hollywood, with 3,000 members. Its rules of entry stipulated that actors must resign from the Academy. This triggered a mass of defections, among them many Academy Award winners and nominees. The exodus was so extreme that there were only 95 AMPAS actors left to vote for the nominations for the 1935 Academy Awards.[5] By 1936 Academy membership had fallen from 600 to 40,

with just one member of staff left to run it. SAG also made significant gains for its members across wages, contracts and working conditions. This gave Black actors more confidence in potentially joining, and going against Butler, with whom they were becoming increasingly disillusioned. On 1 October of that year Muse met with Hattie McDaniel, Juanita Moore and 33 other African American actors to discuss how to advance their positions in Hollywood, after which he convinced McDaniel and the others to join up. Suddenly, SAG had dozens of Black members, while AMPAS had none – leaving the Academy looking powerful, but staid. The directing and writing divisions also formed their own guilds, draining even more power from the Academy.

There were still many obstacles to the advancement of Black actors. The Depression era saw Hollywood place strict limits on the types of characters African Americans could play, particularly when it came to the themes of sex and power. The Hays Code ensured that the roles offered to Black actors remained tightly restricted to subservient parts. Set up by William H Hays, president of the Motion Picture Producers and Distributors of America, the code consisted of a set of self-censorship guidelines for what could and could not be shown within Hollywood motion pictures. It operated from 1934 to 1968, and prohibited profanity, nudity, graphic violence, rape and homosexuality, along with other restrictions around depictions of crime, costume, dance, religion and morality. The code also prohibited interracial romance, which was regarded as an obscenity, alongside any behaviours by African Americans that might be deemed threatening to white supremacist ideals. In other words, the code was there to protect against anything that might upset a white, conservative, cinema-going audience, particularly in the Southern states, where Hollywood claimed most of its revenues were made, and where cinemagoers were most loyal to the art form.

Behind the scenes, African Americans were still excluded from Hollywood's creative and technical roles. There were no Black directors, producers or crew members. The vast majority of African Americans who worked on the studio lots were shoe-shiners, waiters, chauffeurs and personal servants to white film stars. Even though they worked inside the studio gates, they resided outside of its actual

productions. The exceptions to this only seemed to be employed episodically. In the 1930s African American playwright and poet Langston Hughes briefly worked on Hollywood screenplays for Paramount and RKO, while composer William Grant Still was hired by Columbia Pictures to produce scores for its movies, but only completed three of the studio's 1936 releases, *Theodora Goes Wild*, *Pennies from Heaven* and *Adventure in Manhattan*. In 1933 Universal Pictures contracted Black make-up artist Marcia Baumann for Louise Beavers's and Fredi Washington's roles in *Imitation of Life*. Time after time, Black talent came in, completed work, and then went out again.

When it was released in November 1934, *Imitation of Life* became a smash hit at the box office across the country, reaching number one in many Southern theatres, and drawing capacity crowds. Charlotta Bass, writing in *The California Eagle*, proclaimed it 'the best picture of the year'.[6] Its success surprised the studios, who were initially sceptical that such a movie would ever make any money. Consequently, it led to a spike in demand for Black actors in Hollywood productions during 1935 and 1936 – not just as extras, but in speaking roles also. However, this enthusiasm proved short-lived. The aftermath of the film proved not to be the watershed moment that many had hoped for, in terms of parts offered to Blacks, and it would be many years before the studios would invest in another such movie fronted by African Americans in progressive roles. Even though the movie thrust Beavers into the spotlight as Hollywood's brightest African American star, her career stalled in its aftermath, and she returned to playing maids and witless house servants.

*

The nickname 'Oscar' is unclear in its origin. One popular story is that Academy librarian, Margaret Herrick, stated on her first day at work in 1931 that the statuette reminded her of her Uncle Oscar, and that the Academy staff subsequently started referring to it by that name. In another rendition, hotly disputed, Hollywood star Bette Davis, upon winning her first statuette in 1935, said that she named the trophy 'Oscar' because its backside resembled that of her then husband, Harmon Oscar Nelson Jr. On 18 March 1934, Hollywood columnist Sidney Skolsky, in reference to Katharine Hepburn's Best Actress win

at the sixth Academy Awards ceremony, referred to the statuette as 'an Oscar' in his column. Whichever version is true, one thing is certain – and that is, by 1935, the word was widely in use, although the Academy itself did not officially adopt the term until 1939.[7]

The nominations for the seventh Academy Awards were announced on 7 February 1935. Claudette Colbert, Grace Moore and Norma Shearer were nominated for Best Actress. As soon as they were announced, however, there was uproar from Academy members and sections of the press after Bette Davis and Myrna Loy were omitted from the nominees for what were considered to be two of the year's standout performances, in *Of Human Bondage* and *The Thin Man*, respectively. It was the first time there had ever been such a negative reaction to the announcement of the list. The outcry was so intense that AMPAS subsequently backtracked. Academy president Howard Estabrook announced a last-minute rule change – that voters could henceforth ignore the printed ballot of nominees, and instead write in the names of their preferred candidates for the second stage of balloting.

While this was going on, there was another name missing from the roll call for Best Actress – that of Louise Beavers, for her role as Delilah in *Imitation of Life*. The emotional scope and gravity of her performance had been widely acclaimed by Black and white critics alike. 'The picture is stolen by the Negress, Beavers, whose performance is masterly,' wrote *Variety* in December 1933. 'This lady can troupe. She takes the whole scale of human emotions from joy to anguish and never sounds a false note.'[8] White columnist and radio broadcaster Jimmie Fidler concurred, calling it 'the finest performance of 1934'.[9] *The Pittsburgh Courier* went further, stating that 'Louise Beavers . . . would be entitled to consideration for the Motion Picture Arts and Science Academy award . . . but, she is black!'[10] There was no outrage within AMPAS about the fact that Beavers's name was not on the ballot, as there had been with white actors Davis and Loy. Beavers's status, as a Black actor, was below theirs. And so, what could have been the first African American Academy Award nomination, and possible win, did not materialize. The Academy's 600 white voters cast their ballots in favour of their own. Beavers was ultimately beaten by timing. In terms of the Academy's

slow evolution away from racism and towards inclusion, she was just five years too early.

Simultaneously, there was an alternate suggestion that Beavers failed to be nominated because the category that fit her role – Best Supporting Actress – did not yet exist. It was first introduced by Academy head Frank Capra in 1936. The press who had canvassed for Beavers's inclusion in the nominations envisaged her in the Best Actress category, holding her own against the best. *The Pittsburgh Courier* noted that Beavers 'stole the picture from her white sister [Colbert] on sheer acting ability. And the honorable judges just couldn't take it – and didn't.'[11]

Even though Beavers didn't make the nomination for the seventh Academy Awards, she established one crucial thing – and that was, if an African American female was to win one of the coveted statuettes for the first time, the role would almost certainly be that of a servant or mammy, because they were the only roles Hollywood regularly assigned to Black women at that time, and even then Black women who were considered to be ugly, fat and very black. There was a plethora of such work for Beavers and McDaniel, who coasted from job to job playing maids and mammies for two decades, building up momentum. This was in sharp contrast to Fredi Washington, for whom there were very few parts, as a slim, conventionally beautiful, pale-skinned African American, and so these so-called 'off-types' were less likely to find their way to the Awards podium. It was perhaps fitting that this first coveted Academy Award would go to the kind of Black woman considered to be the least desirable: the one with the darkest skin, the fattest body, and a face most alien to European beauty values. It was only a matter of time before a major speaking role as a maid or mammy would emerge that would give the right actress the chance to shine. That moment had almost arrived.

*

Other minority actors were also knocking at Hollywood's door at the same time as the African Americans. One of them was a Chinese American actor named Bessie Loo, from Hanford, California. She had booked jobs as an extra since the mid-1930s, earning $5 per day (around $115 today). In 1936 she secured a bit-part in the movie *The Good Earth* (1937), a drama set in northern China about the plight of a struggling farmer. She was bilingual, and on set she acted as an

informal translator and go-between for the large numbers of Chinese extras in the film who barely spoke English. This drew the attention of Central Casting, who subsequently offered her a job as an agent, specializing in Asian extras. Up to this point they had been cast outside of Central Casting by an independent – a white Englishman and Chinatown resident called Tom Gubbins, who was raised in China and spoke fluent Mandarin. He had become unpopular with many Asians, as he charged them commission on their wages, and a fee for the hire of costumes, which he also supplied. With Loo taking over, Asian extras would benefit from the labour laws and practices to which Central Casting adhered. The job offer presented Loo with a way out from the inherent racism and sexism she had encountered as an actor. 'My opportunities were only as an extra or a maid,' she recalled. 'Even in "The Good Earth" I was stuck in the kitchen! The roles for Orientals were very limited as well as stereotyped.'[12] When Loo took the job, she insisted upon working from home, as she had young twins – and so the agency, after she had completed two weeks' training at their offices, set her up with her own phone line in her apartment.

Loo became the most powerful Asian in Hollywood – the equivalent of Charles Butler. Every producer or director looking to hire Asian talent would seek her out. No one else knew all the performers, or where they lived, and could speak fluent Mandarin. She looked after the extras from all the East Asian nations that were based in Los Angeles – Chinese, Japanese, Filipinos and Koreans. Regardless of nationality, they were all seen as a single homogenous group by Hollywood's white executives. 'We were all just called Orientals back then,' said Loo. 'They couldn't tell the difference in casting, nor did they care.' Her tenure at Central Casting didn't last long. Towards the end of 1939 she branched out, setting up the Bessie Loo Talent Agency, with offices on Sunset Boulevard. For many decades it was the sole Hollywood agency specializing in Asian actors, and actively campaigning for their inclusion. She represented Asian stars such as Joan Chen, Beulah Quo and James Hong. 'She did Hollywood a great service,' said Hong, who is now in his nineties and recently starred in the Oscar-winning film *Everything Everywhere All at Once* (2022).[13]

Although Loo was the most influential Asian of Hollywood's Golden Age,

ultimately her power was curtailed by the fact that the studios only cast Asians as extras and bit-part players – never as leads. This was well illustrated in 1935, when the era's first Chinese American star, 30-year-old Anna May Wong, was screen-tested by MGM producer Albert Lewin for the lead role of O-lan, in *The Good Earth*. But Wong, whose career spanned from the silent era right through to the talkies, was rejected in favour of a white actor, Luise Rainer. Louis B Mayer was initially against Rainer taking the part, stating that it was more suited to 'a dismal-looking slave'.[14] The studio used make-up, hairstyling and costume to make Rainer appear Asian. All the film's other major roles were also played by whites in yellowface, while the minor parts were filled by real Asian actors, Loo and her husband among them. Rainer went on to win the Academy Award for Best Actress in 1938. With no way of getting cast in lead roles even within Hollywood's Asian movies, their actors' path to recognition, and winning Academy Awards, was blocked.

What could minority actors do to counteract being shut out like this? Actress Merle Oberon, who was nominated for the Academy Award for Best Actress in the film *Dark Angel* (1935), hid her Anglo-Indian heritage, out of fear of discrimination and the negative impact it would have had on her career. Together with her manager and publicist, she contrived a fake identity, claiming to be from Tasmania, Australia, when in reality she was born in Bombay, India, to a South Asian mother and a British father. Oberon was fair-skinned, and so was able to pass for an upper-class white Englishwoman. Whenever she travelled with her grandmother, Charlotte Selby, who had darker skin, she pretended Selby was her maid. She also altered her accent to erase all traces of her South Asian ancestry. If Oberon had a mantra at this time, it would been: *Fake it till you make it – and then keep on faking it*. Her story reads like a real-life version of Peola's in *Imitation of Life*, played by Fredi Washington. As well as her fair complexion, Washington had naturally straight hair and green eyes. Press releases described her as French- or Italian-looking. Investment banker and arts patron Otto Kahn even tried to persuade her to pass for French in order to ensure her stardom, but she refused to deny her heritage.[15]

The culture of 'passing' seems shocking to our modern sensibilities, but in the

1930s it was simply a practical strategy for those who sought to assimilate into a society that would otherwise reject them unfairly. Across the country, marginalized groups and European immigrants alike were curating alternate identities for themselves, like actors in their own movie of life. For them, self-invention was the key to being American. Nobody wanted to be real, if real meant not getting that job, not getting that money, not getting that house, not getting that husband or wife. Hollywood's minorities had to find a hustle to break through an industry clogged with racism. Games were played, masks were worn, untruths were told. Fredi Washington refused to play this game, and her career hit a wall as a result. Oberon, meanwhile, concealed her true identity, and was nominated for Best Actress in 1936. In this era of deep discrimination, truth did not work. Only lies did.

Charles Butler was part of the supply line for African Americans who were light enough to pass for white. When director John M Stahl began casting for light-skinned girls to play the part of the young Peola in *Imitation of Life*, he turned to Butler, who supplied biracial child actors Sebie Hendricks and Dorothy Black. For over a decade now, Butler had ruled Black Hollywood. In 1935 he booked $460,000 worth of work for African American actors – the equivalent of $8.5 million today. He had built a database of 1,900 registered actors, many of whom he had committed to memory. 'Believe me when I say he knows practically all of them personally,' wrote Harry Levette in *The California Eagle*. 'When a call comes in for ten or a hundred extras he never has to consult their photographs. He has scores of their telephone numbers memorised.'[16]

Nonetheless, there were rumblings of discontent among many African American actors, as well as the Black press, who held the view that Charles Butler had become too powerful. In those days, white talent agents did not accept Black actors onto their rosters, and so Butler subsumed that role himself – setting their daily rates, negotiating their wages and administering their contracts – despite the obvious conflict of interest, in that the same white studio bosses he liaised with also paid his wages. Consequently, the terms he set acted in their favour rather than those of his fellow African Americans. In 1929 he was criticized by *The California Eagle* for trying to save his studio bosses money by restricting the

day rate for Black extras to between $7.50 and $10, instead of the $15 or $25 per day afforded to some. Film historian Thomas Cripps called him 'a roguish hustler',[17] and referred to his division at Central Casting as a 'Jim Crow department'.[18]

Towards the end of the 1930s, Butler's grip on Hollywood's Black extras had begun to loosen. Competition emerged in the form of Ben Carter, an actor, comedian and musician from Iowa, who arrived in Hollywood in 1933 looking for work. Two years later he diversified into being an agent, opening an office on Central Avenue, close to Charles Butler's. Working on 10 per cent commission, he quickly established a reputation, supplying extras to MGM and other studios, and booking jobs for future Hollywood stars Dorothy and Vivian Dandridge. Butler's hegemony would also be challenged by white talent agents. The 1930s saw a small number begin to recognize the commercial potential of Black actors, and, in defiance of segregation, proceed to sign its biggest names: Lincoln Perry and Louise Beavers. In 1937 Hattie McDaniel joined them, signing with top Hollywood agent and talent scout William Meiklejohn. His firm, located on Sunset Boulevard, represented over one hundred actors and writers, including Dorothy Parker, Mickey Rooney, Judy Garland, Lucille Ball, and a young sportscaster from Iowa named Ronald Reagan. McDaniel's appointment was a major turning point in her rise. It constituted a formal breakaway from Charles Butler, and carried with it a big expectation that Meiklejohn, who went by the nickname 'the star-maker', would secure her more money, and, crucially, better roles – ones that might move her closer to an Academy Award nomination.

The catalyst for this began in 1936 when the novel *Gone with the Wind*, written by white Southern journalist Margaret Mitchell, was published. The book, running to 1,000 pages, chronicled the epic journey of a white Southern family, from the beginning of the American Civil War through to Reconstruction. The narrative focuses on the struggles of a young Scarlett O'Hara, a spoilt, petulant, 16-year-old Southern belle and daughter to a well-to-do Georgia plantation owner. A cantankerous house slave called Ruth (referred to as Mammy) works at the plantation where she, aside from her domestic duties, doubles as an escort and confidante to Scarlett. The book became an instant

sensation and a massive bestseller, shifting a million copies in its first six months of sale. It won the Pulitzer Prize for fiction in 1937, and would go on to sell 25 million copies in over 155 editions and translations worldwide. The film rights to the book were initially turned down by every major Hollywood studio, but were finally purchased by producer David O Selznick, of Selznick International, for $50,000. Immediately the company began preparing it for the screen.

From the start the proposed film proved controversial. As soon as word got out that the book had been optioned for the screen, there were protests from the African American press and the NAACP. They objected to the book's sympathetic portrayal of the Ku Klux Klan, and its demeaning portrait of Blacks, including the depiction of slaves as complicit in their own subjugation, and its liberal use of the word 'nigger' to describe them. They were also critical of its rose-tinted and romanticized view of antebellum life, and its side-stepping of the realities of enslavement, oppression and violence against Black people. There were calls for the proposed movie to be scrapped, on the grounds that it would incite greater racial hatred. Selznick tried to appease the concerns of African Americans, promising that the story would be treated sensitively. He took their objections seriously, as he was worried that negative press might harm the film at the box office. NAACP leader, Walter White, wanted an African American advisor on set during filming, to oversee the portrayal of the Black characters, but Selznick, fearing the effects of any interference, rejected this.

Selznick embarked upon a nationwide talent search, which doubled as a publicity stunt to drum up final funding for production, which he did not have at the time. Who was he looking for to play the role of Mammy? Physically, in Mitchell's novel, she was described as 'a huge old woman, with the small, shrewd eyes of an elephant. She was shining black, pure African.'[19] Among the candidates interviewed for the role were Georgette Harvey, who had won acclaim for her performance in the Broadway production of *Porgy and Bess*; Madame Sul-Te-Wan, star of the silent film era; and singer and actress Hattie Noel, who starred in the comedy musical *King for a Day* (1934). There were other candidates, too, including a white actress who proposed to play Mammy in blackface. Well-to-do whites also attended auditions with their own Black servants in tow, demanding

they be screen-tested. The First Lady, Eleanor Roosevelt, put forward her own servant, White House cook Elizabeth McDuffie. Despite the fact that McDuffie had no acting experience, Roosevelt felt that she was 'extremely capable and has a great deal of histrionic ability'.[20] The hot favourite for the role was Louise Beavers. She was more popular than McDaniel, on the back of her acclaimed performance in *Imitation of Life*. Beavers and McDaniel were long-time friends whose lives and careers had crossed on many occasions.

In January 1937, Bing Crosby – who was a good friend of Hattie's brother Sam – first suggested that Selznick cast McDaniel. She coveted the part but suspected she would lose out to Beavers, given that most of her movie portfolio was comedy, with very little drama. Nevertheless, she canvassed hard for it. Eventually she screen-tested on 6 December 1938, together with Vivien Leigh. McDaniel arrived in character, dressed as a typical Southern mammy, which delighted Selznick. (Louise Beavers, by contrast, allegedly attended her audition in furs and jewels.) The pair enacted the famous bedroom scene at the beginning of the movie, where Mammy laces up Scarlett's corset from behind. Selznick was impressed with McDaniel's interpretation, and noted the strong chemistry between the two characters. By the end of the session Selznick had decided – he'd found his Mammy – so much so that he cancelled all the other scheduled auditions for the role. His choice was initially challenged by the film's director, George Cukor, and Susan Myrick, a journalist and close friend of Mitchell, who had hired her as the film's consultant. 'She lacks dignity, age, nobility and so on,' Myrick wrote in reference to McDaniel, in a letter to Mitchell.[21] Nevertheless, Selznick stuck to his guns and eventually got his way.

On 27 January 1939, McDaniel received the life-changing phone call she had been waiting for. Mammy was hers. William Meiklejohn negotiated a fee of $450 per week ($10,000 today) for a 15-week shoot. The part, though racially problematic, presented a chance for McDaniel to star in a major production alongside some of the biggest names in the business. Clark Gable was cast as Rhett Butler (he and McDaniel had been friends since 1935 when they worked together on the film *China Seas*); Vivien Leigh was cast as Scarlett O' Hara; Olivia de Havilland as Melanie Wilkes; and Leslie Howard as Ashley Wilkes.

Selznick had also secured the final funding he needed, courtesy of his father-in-law, Louis B Mayer. It was all systems go.

But protests from the NAACP and the Black press continued. They had a single common objective: they wanted Hollywood to rid itself of negative cinematic stereotypes of Black people. The one they objected to the most was that of the dim-witted, 'happy' slave servant who was devoted to their white masters – like the role McDaniel had accepted. They wanted her, and other Black actors, to refuse to take these demeaning roles, in the hope that white studio bosses would eventually phase them out. But their strategy was flawed, because these roles, and the narratives built around them, were popular with white cinema-goers, and therefore would stay, at least for the time being. In order to force their removal, the impossible would have to happen – that is, every Black actor in America would have to collectively boycott such roles, whereas, in reality, there would always be someone ready to play even the most degrading parts, in the hope of getting their shot at the big time and a decent payday. If McDaniel had refused the role of Mammy, as Walter White and the Black press had wanted, the problem would not have gone away; Selznick would simply have hired someone else, and McDaniel would have missed out. The implication behind turning down the mammy roles for which she was typecast was that her acting career would effectively have been over – and then, ironically, she would have had no choice but to work as a mammy for real. 'I can be a maid for $7-a-week,' she once said, 'or I can play a maid for $700-a-week.'[22]

McDaniel knew she couldn't beat the Hollywood system, and so she decided to take the part and try and make it the best it could be, given the constraints. The dilemma she faced is one that still resonates powerfully today – and that is, to what extent are we prepared to compromise our beliefs in order to get what we want? Are we ready to forego our pride in our race, gender, sexuality, culture, religion or family, in order to attain money and success? For McDaniel, accepting the role of Mammy mattered more to her than the pressure from the Black leaders to reject it. They were powerful figures within the community, and growing in influence outside it. But McDaniel defied them. She was strong in that regard, in that she would not be moved. She took the work, she got paid, she went home,

then took other jobs with the same demeaning characters. 'I have never apologized for the roles I played,' she told *The Hollywood Reporter* in 1947.[23]

Principal photography on *Gone with the Wind* began on 26 January 1939, at Selznick International's studios in Culver City, California. All mentions of the N-word were removed from the shooting script following objections from McDaniel, the Black press and the NAACP. Nevertheless, right from the start, the production was mired in uncertainty. Eighteen days into filming, Selznick, unhappy with the work of director George Cukor, fired him, and installed Victor Fleming instead, who had just finished directing *The Wizard of Oz* for MGM. Fleming then had a nervous breakdown and took three weeks off to rest, while an interim director, Sam Wood, took over. The film's cinematographer, Lee Garmes, was also fired after a month on set. The production went through 16 different screenwriters throughout its planning and production phases, including F Scott Fitzgerald. The disruptions meant that the movie took longer than planned to shoot, and the cast endured a myriad of problems, with many scenes being re-shot and dialogue changed at the last minute. Adversity bonded the group together, Black and white. Hollywood appeared to be ahead of the rest of segregationist America in permitting them to work alongside each other. Photographs taken on the set show Black and white cast members happily mingling and eating side by side. Nevertheless, conditions were far from equal. There were inequalities in the transportation that brought the stars to the set each day. While the studio sent individual limousines for its white actors, its Black principals were picked up in groups. Discrimination was also present on the studio lot. Lennie Bluett, an 18-year-old extra on the film, recalled that when he arrived on set for the first day of shooting there were dozens of portable toilets being erected to accommodate the large numbers who would be on the lot that day. Each had a sign above it, which read, 'Whites only' or 'Colored only'. He couldn't believe it. Immediately he tried to organize a protest with some of the older Black actors, but they were fearful of getting fired, and so they refused. Instead Bluett went straight to Clark Gable's dressing room and knocked on his door – despite the fact that there were strict rules against extras approaching stars. He explained the situation, and led Gable to where the toilets were being

constructed with the offensive signage. Gable was outraged, and immediately telephoned Fleming, saying, 'If you don't get those goddamn signs down, you don't have a Rhett Butler on this film.'[24] The signs came down.

There were racial disputes during filming, too. McDaniel's co-star, Butterfly McQueen, raised objections to her demeaning character, Prissy. She protested by deliberately fluffing her lines, and also demanding an apology from Vivien Leigh after complaining that the English actress deliberately slapped her too hard during one of their scenes. McDaniel, watching this saga unfold, later took McQueen quietly to one side and told her: 'You'll never come back to Hollywood because you complain too much.'[25]

Clark Gable could complain, and he would get things changed – but Black actors could not. They survived by embracing silence, by imploding rather than by speaking out. Their careers were founded on compliance. 'We accepted indignities and the mechanics of the apparatus of oppression without reacting,' wrote Eldridge Cleaver in his book *Soul on Ice*.[26] Those who defied this rule often found themselves ostracized by Hollywood. Actress and singer Hazel Scott's career stalled after she protested against Black actresses being dressed in mammy-style clothing on the set of the film *The Heat's On* (1943). Ethel Waters didn't work for six years after pressing studio bosses for changes to her part in *Cabin in the Sky* (1943). 'I was to discover that winning arguments in Hollywood is costly,' she said.[27]

Nonetheless, the NAACP and the Black press wanted African American actors to be more outspoken, and viewed them as 'sell-outs' when they did not comply. Earl J Morris, writing in *The Pittsburgh Courier*, referred to *Gone with the Wind*'s Black cast members as 'economic slaves', whose participation was tantamount to 'racial suicide'.[28] McDaniel was caught in a spider's web, splayed in two directions simultaneously. On one side was a racist Hollywood that she perpetually tried to appease, and on the other were the African Americans who wanted her to fight against it. But how could she swim against the tide of Hollywood racism, when that tide was a tsunami?

In the minds of the African American press and civil rights leaders, playing servile roles was not what a progressive Black woman should be doing in a

post-slavery America focused upon uplifting the race. But a Black woman has never had the same choices that are enjoyed by men, or by white women – then or now. The question no one dared fire back at these strident male African American intellectuals was: why should a Black patriarchy decide what a Black woman should be?

Slavery and Jim Crow had separated Black from white, and now McDaniel, in accepting the role of Mammy, found herself separated from her own people too. She knew that the only way to win them over was to turn in the performance of her life. 'I naturally felt I could create in it something distinctive and unique,' she told the *New York Amsterdam News*.[29] McDaniel imbued the character with her own ideas from her life and from past theatrical roles she had played. She improvised many of her lines, and carefully crafted each scene, injecting just the right range of dramatic emotion every time. Her standout scene in the movie occurred on the stairs of the Butler household, when Mammy pleaded tearfully with Melanie Wilkes to comfort a grief-stricken Rhett Butler following the sudden death of his daughter Bonnie in a horse-riding accident. Selznick called it the 'high emotional point of the film'.[30] The tears McDaniel cried in the scene were real, drawn from the memories of her poverty-stricken childhood. 'They are honest-to-goodness tears; no skinned onion comes near me, nor any other inducer,' she told a reporter from *The Denver Post* in April 1941. 'If tears are slow to come I get to thinkin' of the meals I missed in my early struggles, and believe you me, they come a gushin'.'[31] The scene was the one place in the movie where McDaniel got to show her skill at portraying sadness and despair. It was a rare opportunity for a Black actor at that time.

Principal photography on the film finished on 1 July 1939. It turned out to be the third most expensive movie ever made at that time, costing $3.85 million ($80 million today). Only *Hell's Angels* ($4 million) and *Ben-Hur* ($4.5 million) cost more. Nevertheless, the mood on the movie was downbeat. After all its difficulties, the studio was convinced it would be a flop. But McDaniel's performance stood out as the production's big surprise. She had elevated the role of Mammy into something that was not written on the page. Rather than playing her as the slow, elderly, lumbering figure depicted in Mitchell's novel, McDaniel

gave her character an astute vigour and energy. She was bossy, loud, feisty and opinionated. Her performance impressed Selznick so much that, in a telegram to his New York publicist Howard Dietz, he called it 'one of the great supporting performances of all time'.[32]

Gone with the Wind's gala world premiere was held on the evening of 15 December 1939, at Loew's Grand Theatre, Peachtree Street, Atlanta – Margaret Mitchell's hometown. But Jim Crow in the Deep South meant that McDaniel and the other African American cast members were barred from attending the event, and all its associated functions. McDaniel's photograph was removed from the film's souvenir programme, despite objections from Selznick, who had planned a series of promotional appearances with the film's Black cast members and Atlanta's African American community. The idea that there would be no Black attendees was completely accepted as the norm. Actress Evelyn Keyes, who played Suellen O'Hara in the film, later confessed: 'It never occurred to me that there was anything unnatural in there not being a single black face at the big premiere.'[33] But McDaniel's absence was a problem for her friend Clark Gable, who, upon hearing about her ban, threatened to boycott the event. She talked him out of it. Eager not to rock the boat, she accepted her exclusion graciously, again deciding not to speak out. Instead, she spent the night celebrating elsewhere with the other African American cast members. Things would be different back in Hollywood, where she did attend the premiere, held at the Fox Carthay Circle Theatre on 28 December 1939. Her picture was also displayed prominently within the programme. This racially integrated event was even more important than the Atlanta launch, because in the audience were the members of AMPAS who, on 15 February 1940, would begin voting for the season's Awards.

Press reviews of the movie were split along racial lines. The film was received with great enthusiasm by the mainstream media. *The New York Times* called it 'the greatest motion mural we have seen and the most ambitious filmmaking venture in Hollywood's spectacular history', while *The Hollywood Reporter* proclaimed Selznick 'the world's greatest motion picture producer'. McDaniel was also singled out for praise. *The New York Times* called her performance '[b]est

of all, perhaps, next to Miss Leigh', while *Variety* stated that it was McDaniel 'who contributes the most moving scene in the film'.[34] By contrast, the African American press were scathing. *The Pittsburgh Courier* slammed McDaniel and her fellow Black performers for playing 'happy house servants' and 'unthinking hapless clods', while *The Chicago Defender* called the film 'a weapon of terror against black America'.[35] African American playwright Carlton Moss dismissed the contention that McDaniel's interpretation of Mammy was innovative, instead claiming that it was simply another clichéd portrayal of demeaning servitude. But at the same time many Southern whites were horrified by what they viewed as McDaniel's creative licence with the role, in particular the familiar and often chastising tone with which she spoke to her white owners. Her opening scene, in which she scolds Scarlett from an upstairs window, was described as 'unfittin'' even by *The New York Times*. Meanwhile, other publications, like *The California Eagle*, were more supportive of McDaniel's performance, praising her 'brilliant work', created within a 'difficult vehicle'.[36]

Some Black newspapers, initially negative about the movie, began to come around to appreciating the artistry of McDaniel's performance. In early February of 1940, McDaniel ventured to David O Selznick's Culver City offices, armed with a selection of press clippings of reviews of the movie, praising her performance – with some calling for her to be nominated for an Academy Award. McDaniel eagerly showed them to Selznick, and urged him to enter her in the new Best Supporting Actress category. Pressure had already been mounting for this to happen from within the mainstream press also. Two months earlier, Edwin Schallert, writing in the *Los Angeles Times*, had described McDaniel's performance in the movie as 'a remarkable achievement' that was 'worthy of Academy Supporting awards'.[37] Simultaneously, African American fans of McDaniel, egged on by local journalists, had been writing to Selznick demanding that she be put forward. But there was a problem. No African American had ever been nominated before. The Academy Awards were not conceived for their inclusion, and they were barred from the venues where the ceremonies took place. McDaniel's request went against the rules of segregation. She was asking for her civil rights at a time when the movement was still in its infancy. What was she

thinking? Did she really think she could get nominated, challenge the supremacy of the white actresses in her category, and possibly even win?

What Selznick did next would turn out to be a pivotal moment in the racial transformation of Hollywood, and perhaps the most important moment ever for Black actors. Glancing at the newspaper cuttings McDaniel had laid before him, he agreed to her request, and the 44-year-old was submitted for the Oscars.

Why did he do it? Perhaps it was because he was Jewish. Adolf Hitler and his antisemitism were on the rise in Europe. Did this soften Selznick's heart towards the plight of Black people? Many of Hollywood's other Jewish executives did not appear to harbour any such sympathies. 'Although many Hollywood producers were Jewish and knew bigotry and persecution first-hand, most identified with the dominant culture's racial ideology,' says Jill Watts in *Hattie McDaniel: Black Ambition, White Hollywood*.[38] Ultimately, perhaps what drove Selznick's action was not an affinity with the African American cause, but simply good business sense. He recognized the quality of McDaniel's performance, and was thinking about the extra publicity her nomination would generate, and how it would help the film gain much needed favour within the African American press and the NAACP, which had been highly critical of it.

The film was nominated for an unprecedented 13 Awards, including Clark Gable for Best Actor, Vivien Leigh for Best Actress and Victor Fleming for Best Director. In the Best Supporting Actress category, McDaniel was up against a coterie of some of the finest actors in the world at that time: her *Gone with the Wind* co-star Olivia de Havilland, Geraldine Fitzgerald (*Wuthering Heights*), Edna May Oliver (*Drums along the Mohawk*) and Maria Ouspenskaya (*Love Affair*). The gossip approaching Award season was that the two actors from *Gone with the Wind* were neck-and-neck favourites to win.

*

On the evening of 29 February 1940, Tinseltown's elite gathered for the twelfth annual Academy Awards ceremony at the famous Cocoanut Grove nightclub at the Ambassador Hotel – a lavish resort spread across 24 acres on Wilshire Boulevard, Los Angeles. A procession of shiny limousines lined the front of the venue, and the guests who alighted were a picture of elegance – the men in classic

black and white tuxedos, and the women in ermines, minks, silks and satins – all primed for the eager attention of the awaiting press. Hattie McDaniel arrived with a beaming smile etched across her face, and stepped out of her vehicle on the arm of a handsome young escort, a young African American named Fernando Yorba. They posed briefly for photographers before making their way inside. They cut a strange figure among the white attendees: two Black people entering a 'no Blacks' venue via the front door.

McDaniel wore a short white fur coat over a flowing full-length turquoise gown and matching rhinestone-beaded jacket. Her neckline was adorned with a large, silver, semi-circular brooch, and she wore teardrop-shaped silver earrings. Her hair was finished in a black headband with a white gardenia attached to its side, Billie Holiday-style, a matching corsage of gardenias draped over her right shoulder like a bandolier.

Meanwhile, seven miles away at his home in Summit Drive, Beverly Hills, David O Selznick and his wife Irene were hosting a pre-Oscars cocktail party for some of his nominees and guests. Clark Gable and his wife Carole Lombard were there, as were Vivien Leigh and Laurence Olivier, plus Olivia de Havilland, film financier Jock Whitney and *New Yorker* columnist Robert Benchley. As they all exchanged pleasantries and sipped cocktails, the phone rang. Selznick answered. He listened in silence. On the other end of the line was a journalist from the *Los Angeles Times*. The paper was about to leak the names of the Academy Award winners in its late edition, and Selznick's inside man had called to tip him off. As the man spoke, Selznick repeated the names of the winners out loud as his guests stood waiting anxiously. 'Victor, Hattie. Er, yes. Vivien,' recalled Olivia de Havilland. Her name was not mentioned. Selznick hung up. Her heart sank.[39]

According to de Havilland, Hattie McDaniel was unaware of her victory at that time, as she was not present at the gathering. 'She didn't know. She was already at the awards,' the actor recalled.[40] Gable, learning that he had not won, decided to duck out of the ceremony altogether, while Selznick rushed Vivien Leigh and some of his other guests into a waiting limo, and sped off to the ceremony, leaving Irene and de Havilland to make their own way. Against the

backdrop of the Oscars, Selznick's marriage was crumbling, and for Irene this act of abandonment would prove to be the final straw.

Back at the Ambassador Hotel, Hattie McDaniel's feet were crossing the threshold into the venue, to a standing ovation from excited onlookers – and in that simple action she became the first African American ever to attend the prestigious ceremony, and 'as a guest rather than a waitress,' noted film critic Anthony Holden.[41] It was one small step for her, and a giant one for Black people. McDaniel was initially barred from entry to the hotel, which was segregated (it would not be officially integrated until 1959). It was a bizarre irony that she could be nominated for an Oscar, but at the same time be prohibited from attending the ceremony to collect it, should she win. In this case, Selznick had to make a special arrangement with the hotel management in order to allow McDaniel and her escort into the building on Awards night. But her entry was conditional upon her sitting separately. Segregation's strict rules meant that she could not be seen mingling with her white co-workers, or be captured in press photographs doing so. As McDaniel entered the ballroom, the white guests were all seated at long banquet tables. She was escorted past the *Gone with the Wind* table in the MGM section, where Selznick would sit with his entourage (colleagues with whom McDaniel had shared the stage, laughed and socialized), and was instead shown to a separate small table at the rear, adjacent to the kitchen – the Hollywood equivalent of being seated 'at the back of the bus'. There she sat with Yorba and her agent, William Meiklejohn. The presence of African Americans in the ballroom was in itself an abnormality, but a white movie executive sitting at a Black table also raised eyebrows.

Allegedly, McDaniel didn't remain seated there for the whole show. According to de Havilland, when Selznick arrived at the venue at 9.30pm and saw where McDaniel was seated, he arranged for her to be brought further forward at the last minute, so that she was closer to the action, knowing she would soon be called to the stage. 'He rearranged things so it was more appropriate, from his point of view,' said de Havilland. 'In those days, it was still a delicate situation.'[42] Those seated in the ballroom now knew McDaniel had won, as the *Los Angeles Times* had broken the embargo and published the winners

in its 8.45pm edition – much to the Academy's dismay. As a consequence, they would later change to the sealed-envelope system.

When the award for the Best Supporting Actress was about to be presented, an excited hush descended over the audience. Actress Fay Bainter, who had won it the previous year, was compere. In her preamble she hinted at a McDaniel win when she spoke of 'an America that almost alone in the world today, recognizes and pays tribute to those who give of their best, regardless of creed, race or color'.[43] Her sentiments, though heartfelt, were a pipe dream, as America was a deeply wounded country still defined by segregation and discrimination. Nevertheless, the big moment had finally arrived. McDaniel's name was called.

'Hallelujah!' she shouted, glancing up to the heavens in gratitude. The 1,200-strong crowd erupted into rapturous applause. She rose proudly to her feet for the walk to the podium that every actor dreams of. In what had been a strong slate of films that year, her competitors had been blessed with better parts and better lines than her in their respective movies – but against all odds, McDaniel, the daughter of slaves, who was born into extreme poverty, had beaten four of the era's most talented actresses to one of Hollywood's most coveted prizes.

Selznick's PR team had pre-prepared McDaniel's acceptance speech, but she either forgot it at the table or deliberately left it behind when she stepped onto the stage to collect the embossed plaque presented to winners in the supporting categories at the time. Instead, without referring to a sheet of paper, she delivered a speech crafted by her friend and publicist, African American writer Ruby Berkley Goodwin. The tone of her 67-second soliloquy was humble, grateful and hopeful. She grew tearful as she spoke: 'I shall always hold it [the Oscar] as a beacon for anything that I may be able to do in the future,' she said. 'I sincerely hope I shall always be a credit to my race and to the motion picture industry.'[44] In her opening remarks, she also made reference to her 'fellow members of the motion picture industry'. In other words, despite segregation, she saw herself as being very much inside the Hollywood club – an accepted part of the establishment. Nonetheless, while she left the stage as the biggest African American movie star in the world, she still returned to a table segregated by law.

But this didn't matter, because she was in the room, at a time when segregation

should have prohibited her from attending the event at all. She had faced segregation at least a dozen times during the filming and promotion of *Gone with the Wind*, and countless times throughout her life and career. She was used to it. It no longer upset her. She had moved beyond resentment. The assumption that she felt humiliated by being made to sit at the back at a separate table when she arrived is a contemporary, post-rationalized assessment of the events of that night. McDaniel never said she felt humiliated. In fact, in photographs taken in the ballroom, she is looking into the camera, smiling proudly. She was happy – because she'd won. She'd beaten the white actresses. She'd beaten white Hollywood. She had won.

If anyone felt humiliated on the night, it was de Havilland, seated in the full glare of the ballroom. As McDaniel, Yorba and Meiklejohn celebrated at their table, she was crying. 'At the table, I was able to keep my composure until it was all over and then one tear started down my cheek,' she said. 'Irene Selznick saw that and said, "Come with me!" and we went into the kitchen and then I really began to cry.' It would take de Havilland two weeks to get over being beaten by McDaniel. 'I was convinced there was no God,' she lamented. Eventually she came to terms with losing. 'I woke up one morning and thought, "That's absolutely wonderful that Hattie got the award!"' she said. 'Hattie deserved it and she got it. I thought, I'd much rather live in a world where a Black actress who gave a marvelous performance got the award instead of me. I'd rather live in that kind of world.'[45]

By the close of the ceremony, *Gone with the Wind* had captured a record eight Oscars from 13 nominations, including Best Picture, Best Director, Best Adapted Screenplay and Best Actress for Vivien Leigh. The movie went on to become a runaway success, selling 60 million tickets in the first four years of its US release – the equivalent of almost half the population. It would go on to take $393 million at the box office. With adjustment for inflation globally, the Guinness World Records puts the film's total revenues at $3.44 billion, making it the highest grossing movie of all time, topping more recent blockbusters such as *Titanic* and *Avatar*.

After the ceremony, and at the request of the hotel management, McDaniel

greeted hundreds of eager fans, well-wishers and members of the press on the Ambassador's mezzanine, where she posed for photographs with Yorba. As she stood before the adoring crowd, this queen of Black talent, this dark meteor who had forced her way through Hollywood's dense atmosphere of exclusion, was at the pinnacle of her life and career. When asked by reporters to comment on how she felt, she replied, 'Well, all I have to say is, I did my best, and God did the rest.'[46] And with that, she waved farewell to the crowds, and went home, smiling.

*

The next morning, newspapers across the country carried the sensational story of McDaniel's historic win, including a number of African American titles that had previously been critical of her role as Mammy, contending that it did nothing to uplift Black people. But ironically, it was this very role that led to her Oscar, which *did* uplift Black people. If she had listened to them, and turned the role down, she would not have won the Oscar they were now so proud of. McDaniel was well aware of how fickle the whole business was. 'I've learned by livin' and watchin' that there is only eighteen inches between a pat on the back and a kick in the seat of the pants,' she said in a 1941 interview with *The Denver Post*.[47]

McDaniel's victory was the first strike of the chisel that began to break down the edifice of the Academy's racism, and to crack open the door for the future nominations and victories of actors of colour, and their attendance as equals on Awards night. Her plight was typical of this era of African American 'firsts' to break through society's exclusionary barriers. Such pioneering torchbearers were atmosphere processors for those that would come after them – and invariably this meant having to endure greater bouts of suffering, humiliation and criticism than those who would succeed them. As comedian Chris Rock once put it: 'Being the first black anything, sucks.'[48]

In the aftermath of her victory, McDaniel's salary did not increase, neither was there was a pile of progressive scripts awaiting her, as was customary for white Oscar winners. Securing an Academy Award would turn out to be easier than getting Hollywood to recognize her as more than just a maid. 'Where does this Negro artist go from here?' asked columnist Jimmie Fidler after reviewing *Gone with the Wind*. 'Why, back to playing incidental comedy maids, of course.'[49] He

was right. McDaniel continued to be typecast, playing this role an incredible 74 times in a 17-year career. 'A very great artist is being wasted,' wrote Fidler. Selznick, after signing McDaniel to an exclusive long-term contract, then failed to procure the roles that would justify her talents. 'It was as if I had done something wrong,' she lamented in 1944.[50] McDaniel and other Black actors were naive in thinking that a studio contract would lead to career development and a pipeline of progressive roles. It did for some white stars, but in the main, these deals were nothing more than a device to prevent rival studios from poaching their talent. To Selznick and the other white Hollywood bosses, McDaniel was a mammy – and that was all she could ever be.

In winning the Oscar she had succeeded in breaking through Hollywood's glass ceiling, only to discover that it was 'double-glazed'; there was a second ceiling beyond it, which she would bang her head against, without the glass breaking. The cold truth was that a Black actress working at that restrictive time in history was never going to get the roles she yearned for. That privileged kind of life was strictly for white folk. Olivia de Havilland, for example, would fare better in the long run than McDaniel. Although inconsolable after losing out to her on Oscar night, de Havilland need not have worried. As well as being a gifted actress, she was white, slim and regarded as beautiful – and so she would go on to secure a raft of major and diverse roles that would culminate in her winning two Academy Awards for Best Actress. McDaniel, by contrast, would only get one chance at an Oscar, and after that her career would slide into the dust.

McDaniel's Oscar triumph was the most extraordinary of all time because, in this so-called 'Golden Age' of Hollywood, she had taken a film role that had not been written to stand out, and was racist and demeaning in nature, and she had turned it into gold. In addition, she made it happen at a time when racism in modern America was at its most intense, and the creative prerogatives of Black actors were thus at their most constricted. Winning within such an environment should have been impossible. Her victory was both startling and futuristic, in that it occurred 30 years before the civil rights decade that forced such changes through.

But McDaniel's propulsion into the annals of Hollywood history did not

happen in a vacuum. She was assisted by political events in the world. While her Oscar was held up as a symbol of the Academy's progressiveness and adherence to liberal, democratic values and fairness, in reality it was the badness of Adolf Hitler that was the catalyst for the goodness of white America in its revisionary treatment of Black people, and in recognizing and rewarding McDaniel's talent on Oscar night. The rise of Aryan supremacy forced white America to look inwardly and confront its own bigotry. How could they oppose Hitler under the fluttering banners of freedom and liberation, when they were denying these same values to African Americans in their own backyard? How could they talk of going to war against the Nazis, when they were already at war against their own Black citizens? Events in Europe acted like a mirror. A racist America seemed to have to witness somebody else's badness in order to recognize and confront its own.

Simultaneously, Nazi aggression in Europe represented a personal and direct threat to every white American, because even though they were living in a country that Hitler could not immediately reach, they were all Europeans. They called themselves 'Americans' but their forebears came from the European countries that Hitler was crushing. It was only when the spectre of death came to them in this way, to those they loved and cared about back home – *to their people* – that they suddenly realized what American Blackness meant: to live under the constant threat of being degraded or destroyed by a relentless, dominating force. When they felt this, they realized why segregation had to end, why discrimination had to be banished, why the Civil Rights Movement was necessary, and why the Academy Awards had to change. At least, some of them did. Enough to make a difference. For a while.

CHAPTER 3

THINK BLACK TO WIN
(1941–1964)

'A crisis happens, and it becomes a catalyst for accelerated change.'
Dawn Hudson, CEO, Academy of Motion Picture Arts and Sciences,
The New York Times, 6 February 2020

On 21 November 1951, a 68-year-old man was found dead in his apartment at 1702 West 23rd Street, Los Angeles. Local police identified him as Charles E Butler, once of Central Casting. His body was discovered by his landlady, who, after knocking repeatedly at his door and receiving no reply, entered to find him seated in the lounge, slumped forward in an armchair. He had passed away quietly while reading the Bible, which was placed in his lap. The holy book lay open at Psalm 88. It read:

> *O lord God of my salvation, I have cried day and night before thee:*
> *Let my prayer come before thee: incline thine ear unto my cry;*
> *For my soul is full of troubles: and my life draweth nigh unto the grave.*
> *I am counted with them that go down into the pit: I am as a man that hath*
> *no strength:*
> *Free among the dead, like the slain that lie in the grave, whom thou*
> *rememberest no more: and they are cut off from thy hand.*
> *Thou hast laid me in the lowest pit, in darkness, in the deeps.*
> *Thy wrath lieth hard upon me, and thou hast afflicted me with all thy waves.*
> *Selah.*

*Thou hast put away mine acquaintance far from me; thou hast made me an
abomination unto them: I am shut up, and I cannot come forth.
Mine eye mourneth by reason of affliction: Lord, I have called daily upon
thee, I have stretched out my hands unto thee.*

Butler's choice of the final words he would read before departing the world
were fitting, as the latter years of his life were marred by regret, loneliness and
tragedy. In early 1940, after ten years of marriage, he had separated from his wife
Sara. She had moved out of the marital home and into a room at a local boarding
house. But tragedy struck at noon on 7 May when Sara was visited at her church
by Caldwell Jones, a 50-year-old real estate broker and columnist for *The
California Eagle*, who also worked as church deacon and treasurer. They went
upstairs to an apartment she held at the church parsonage, and soon afterward
he pulled out a .32-caliber Colt automatic pistol and shot her three times, then
turned the gun on himself and put a single bullet through his temple.

Out in the churchyard, the fatal shots were heard by caretaker Horace Nesby,
who was busy planting spring flowers in the midday sun. He dashed away to get
help, finding Grace Scott, a fellow church member, who immediately called the
police. Patrolman Earl Bledsoe soon arrived at the scene, but found the door to
the apartment locked from the inside. He forced it open and found the two
bodies lying side by side, pools of blood surrounding their punctured skulls. He
surveyed the tragic scene, detecting signs of a quarrel and a scuffle. There were
rumours that the pair had been having an affair, or that Jones was infatuated with
Sara and had made advances, which she had rebuffed. The official county
coroner's register listed the probable cause of the homicide as 'love affair', but a
statement from the church's Board of Directors refuted this, stating that Jones
suffered from a serious mental health condition and was 'of unsound mind' when
he took the life of the 37-year-old minister. The incident made the front pages of
the Black newspapers and shocked the whole community around Central
Avenue. Sara was a popular, well-respected and influential figure, who had
worked tirelessly as a minister and choir leader, as well as a talent scout for her
husband at Central Casting. Her funeral was held at the institution she founded,

the Zion Temple Community Church, at 1315 East Vernon Avenue. The degree to which she was loved was illustrated by the 7,000 mourners who attended.[1]

Charles Butler was deeply affected by Sara's brutal murder, and in its aftermath his own life began to slide into decline. Six months before his death he was fired abruptly by Central Casting, after 24 years of loyal service, and following a lengthy period of illness. His power suddenly gone, people drifted away. Black extras moved on to whoever was next in charge. When Butler finally passed, he was buried at Evergreen Cemetery, Los Angeles, separate from his late wife's grave, and with no family to attend. A local choir sang in his honour, and among the sorrowful pallbearers were a few of the Hollywood friends he had left, including actresses Juanita Moore (who would be Oscar-nominated for the 1959 remake of *Imitation of Life*) and Lena Torrence (who appeared in *Stormy Weather*, and once dated Marlon Brando). In the end, the man who was once the most powerful African American in Hollywood – whom every Black actor wanted to know – died alone, and was buried with hardly a ripple.

His demise drew to a close one of the most important periods in Hollywood history. Butler was a complex figure, both loved and reviled in equal measure among African American actors, members of the press and civil rights leaders. Throughout his career he walked a tightrope between servicing the racist demands of his white bosses and meeting the interests of Black actors and community leaders pushing for progress. Undeniably, he discovered four Black female actors – Louise Beavers, Hattie McDaniel, Juanita Moore and Dorothy Dandridge – who would go on to become Hollywood stars, complete with four Oscar nominations and one win between them. Without him, this might not have happened, and Oscars history might well have been very different.

*

The 1940s started well for Black Hollywood. A few days after Hattie McDaniel's historic Oscar victory, the first African American movie professionals were invited into AMPAS. Actors Harry Levette, Earle Morris and Clarence Muse joined McDaniel in being issued full voting rights. A handful of Black Academy members among the several hundred white voters would do nothing to influence who triumphed on Awards night, but nevertheless the wheels of change had

slowly begun to turn, galvanized by events in Europe. Six months prior to McDaniel's Oscar victory, the Nazis had invaded Poland, triggering the Second World War in Europe. Austrian, German, Czech and Polish Jews were now being rounded up, deported and sent to concentration camps. By April 1940, weeks after the first Black AMPAS members were enrolled, Hitler had invaded Norway and Denmark, and in May the SS established Auschwitz outside the Polish city of Oswiecim, in German-annexed Upper Silesia. The Nazis had influenced the psyche of Hollywood's white powerbrokers, providing them with an *inciting point* for awarding concessions to Black actors. In other words, the actions of Adolf Hitler had made them *think Black*.

David O Selznick – who was Jewish – was one of those whose mindset was affected by the conflict. During the production of *Gone with the Wind* in 1938 he wrote to Walter White, executive director of the NAACP, after the organization had objected to the negative portrayals of African Americans in his film. 'I hasten to assure you that as a member of a race that is suffering very keenly from persecution these days, I am most sensitive to the feelings of minority peoples,' he stated.[2]

The Second World War gave fresh impetus to the African American civil rights struggle, whose leaders knew that the backdrop to the fight against fascism would provide an opportunity for them to lobby for greater improvements at home. The government, desperate to create the appearance of national unity, was concerned about the morale of African Americans in relation to the war effort, and keen to support changes that would keep them onside. Walter White seized this moment to take his case to Hollywood. He sought to forge relationships with the powerful heads of the major studios, and thereby make the case for better roles for Blacks by appealing to them directly and personally. White was well aware that change could not happen from the 'bottom up'; the approach had to be 'top down', affecting filmmaking at its source.

White was born and raised in Atlanta, Georgia. His parents, George and Madeleine, were born into slavery, and he had European and African ancestors on both sides of his family. 'I am a Negro,' he stated plainly in his biography. 'My skin is white, my eyes are blue, my hair is blond. The traits of my race are nowhere

visible upon me.'[3] His appearance meant that he could pass for white, and during his early years with the NAACP he worked as an investigator, infiltrating white racist organizations and exposing violations of civil and human rights. He finally became executive director in 1929, and ran the organization for a quarter of a century.

In February 1942, White travelled from New York to Hollywood with a note from the War Department requesting that Hollywood studios include African American military achievements within their newsreels. He also had a letter of introduction from the First Lady, Eleanor Roosevelt. 'I am interested in this problem [of demeaning Black roles] and hope that Mr. White will meet success,' she wrote.[4] If African Americans were ever going to win any more Oscars after Hattie McDaniel, the first priority was to improve the quality of the roles they were offered. Charles Butler, once the most powerful African American in Hollywood, was powerless in this regard – he simply took orders from his white bosses – but White, by meeting directly with directors and producers, had a better chance. With the official backing of the US government, he was suddenly thrust forward as the new central figure in the advancement of Black actors.

But he still needed an introduction to Hollywood's inner circle. This came in the form of Wendell Willkie. He was a lawyer and Republican nominee, who had lost out to Franklin D Roosevelt in the 1940 presidential election. He had become a well-respected Hollywood insider after representing the studios in a recent Senate probe. Willkie was a progressive on racial issues, and an anti-segregationist, who was as concerned as White about the negative portrayals of Blacks in cinema. Willkie, who held the post of special counsel to the NAACP, opened all of Hollywood's doors for White, who was wined and dined and treated to studio tours, where he met Hollywood stars James Cagney and Jean Muir. Seductive as this was, the studio bosses avoided White's initial requests for meetings. Time went on, and he became increasingly frustrated until finally, on his last day in town, he was summoned to a meeting of Hollywood producers at the Biltmore Hotel. Among them were David O Selznick and Darryl F Zanuck, controlling executive at Twentieth Century Fox. White passionately made his case about the harm being done by Hollywood's perpetual depiction of Blacks

in demeaning and stereotyped roles. White wanted to see Blacks portrayed as normal human beings who were part of society – middle-class professionals, as well as more examples of them within interracial settings. As he spoke, White noted that Zanuck 'marched up and down puffing a cigar, and stopped to exclaim, "I make one-sixth of the pictures made in Hollywood and I never thought about this until you presented the facts."'[5] This may have been Zanuck's personal inciting point, because he would later greenlight a raft of progressive roles for Black actors.

The meeting, however, adjourned with no firm commitments or promises from the studio heads. The executives, while acknowledging the need for change, resisted direct interference in how and when those changes took place, and what they might look like. But significantly, as White shook their hands on his way out, he had made personal inroads and cultivated friendships. He now had a direct line back in for future conversations. The 'prospect of definite progress is bright', he maintained.[6]

White was the perfect point man to front negotiations with the studios' cartel of cigar-smoking white men. He looked like them. He was relatable. Even though by American standards he was a Black man, when in Hollywood circles he moved as if he was white. In Los Angeles he stayed at the Roosevelt Hotel, which was supposedly segregated. He also attended the 1942 Oscars, only two years after Hattie McDaniel had only been let in to collect her Award due to a special arrangement. Courtesy of his new Hollywood friends, and thanks to his capacity to 'pass', White was able to move in and out of these spaces without anyone stopping him at the door.

He returned to Hollywood in July for further talks with its executives. This time he met with a larger contingent – 70 in all, including Selznick, Zanuck, Louis B Mayer, director Frank Capra and SAG's Edward Arnold. A luncheon was hosted by Twentieth Century Fox at the studio commissary, a French restaurant called Café de Paris. Addressing the gathering, White asserted that Hollywood had a duty to support African Americans as part of the war effort, and to boost their morale by changing the way they were depicted in film. 'Restriction of Negroes to roles with rolling eyes, chattering teeth, always scared

of ghosts, or to portrayals of none-too-bright servants perpetuates a stereotype which is doing the Negro infinite harm,' he said.[7]

White cleverly linked his requests into the broader conversation about the war, positioning African Americans as part of the global alliance against fascism. The executives found this difficult to ignore. They were worried that, if they did not act in what the government had now deemed to be the best interests of the country, Washington might intervene in the filmmaking process. The meeting ended with a number of verbal commitments being made. Darryl Zanuck, Fred Beetson and others made public pledges to act on White's suggestion to revise the portrayals of Blacks in line with the realities of contemporary life.

On the surface White appeared to be making progress, but both his trips to Hollywood were not wholly welcomed by some veteran Black actors, including Hattie McDaniel and Clarence Muse. They feared that the studios, in response to his demands, might seek to resolve the issue by phasing them out altogether, resulting in them losing their jobs. They also bridled at White's criticism of the roles they played, which they interpreted as a personal attack upon them as artists. Most of all, they felt disrespected that White had not consulted them on the aims of talks that, after all, were supposed to be for their benefit. No members of Hollywood's Black film community had been invited to either of his meetings with the studio heads. They viewed him as arrogant, patronizing and aloof in this regard. Clarence Muse accused him of being 'a committee of one'.[8]

Nevertheless, after his second meeting, White told delegates and guests at the NAACP's annual national convention in Los Angeles that it had been a success, and that future roles for Black actors would change. He even offered a glimpse of what this change might look like when he brought a young singer and actress from New York to the podium alongside him. Her name was Lena Horne. She was the polar opposite of the maids and mammies of old. Slim, light-skinned and sophisticated, she was more like Fredi Washington than Hattie McDaniel or Louise Beavers. White saw her as the new 'prototype' of the Black Hollywood female. It was only a matter of time before the old servile archetypes, and the actors that played them, would indeed be phased out. Ironically, while Black actors generally agreed that new progressive roles were crucial, simultaneously

many of their careers were dependent upon the preservation of the very same racist stereotypes they criticized. By the mid-1940s, work for the old guard had begun to dry up. In 1947 Hattie McDaniel admitted to not having had any film work for two years. Louise Beavers and Clarence Muse also found that they could no longer rely on regular employment.

So what effect did White have on change in Hollywood? There was evidence of a relaxation of the racial codes that had previously governed Black actors. A handful of films made during the war showed Blacks in new guises. In 1943 *Bataan*, *Sahara* and *Crash Dive* depicted African Americans as soldiers in uniform fighting for their country. But consistent change did not happen overnight. The sticking point was that White had no real leverage with the studios. He could make no demands, only polite requests. But he had planted seeds in the psyche of Hollywood's white liberals. And sometimes seeds take time to germinate – but, eventually, they do grow.

<div align="center">*</div>

Despite the shocks and hardships of the war years, Hollywood continued to celebrate itself, staging Academy Award ceremonies throughout the conflict. The requisitioning of metals to manufacture military equipment led to a shortage, and so for three years the Oscar statuettes were made of painted plaster – which the winners were able to exchange after the war, when they switched back to gold-plated bronze. Among the winners of the war years were James Stewart, Gary Cooper, Ginger Rogers, Joan Fontaine, Greer Garson, James Cagney, Bing Crosby and Ingrid Bergman. The Awards had returned to being a private club for white actors, directors, writers and technical staff. Hattie McDaniel's win now seemed like a distant memory, which did not pave the way for more Black nominations, as many had hoped and assumed. In fact, there were no nominations for people of colour throughout the war years.

But, at the same time, the war had placed the plight of Blacks firmly under the spotlight, and the government, plus other institutions, had reacted to improve conditions for them. For most actors of colour, the end of the war in 1945 proved to be as powerful an inciting point as its beginning, providing a fresh impetus for change. The booming economy of the post-war era ushered in a windfall of

prosperity for millions of Americans. Black people were climbing out of poverty, and forging hopeful new lives defined by education and betterment. Society saw the rise of a small but energized Black middle class, who became a visible part of the professional mainstream. A new generation of people of colour begin to slide through the liminal space between Jim Crow and equality. In 1947 Jackie Robinson shocked American sports by integrating into major league baseball. In Hollywood, for the first time, white producers, directors and studio heads began to envisage African Americans as more than just uneducated servants. Now it was plausible within their collective imagination that a Black actor could play a lawyer or a doctor – and make it believable – because these archetypes now visibly existed across American cities. In this regard, Hollywood was not innovating, but merely reacting to changes happening first within society. This new era would usher in a small group of race-aware white directors and producers who were prepared to cast the new generation of Black stars in roles that had never been seen before – and there was one actor, in particular, whose timing for this would prove to be perfect.

*

In 1939, on Cat Island in the Bahamas, a 12-year-old Black boy was asked by his sister Teddy what he wanted to be when he grew up. 'I told my sister I would like to go to Hollywood and become a cowboy,' the boy replied. He had just seen his first cowboy movie, and was totally mesmerized by it. 'I had no idea Hollywood meant the movie business,' he said. 'I thought Hollywood was where they raised cows.'[9] The boy's name was Sidney Poitier. He was born on 20 February 1927, in Miami, Florida. He was the youngest of seven children born to Evelyn and Reginald James Poitier, who owned a tomato farm in the Bahamas, 60 miles off America's south-east coast, where he was raised. The family was poor, and he grew up without electricity or plumbing. If they needed water, he carried it from a well; if they needed to cook, he would gather bramble to make a fire. He was a child of nature, raised with the ocean, the wind, the darkness, the animals and the island's rocky coastlines. At the age of 15 he left this bucolic paradise and briefly returned to Miami, moving in with his brother's family. Living in Florida brought him his first taste of Jim Crow-era racism. By the age of 16, seeking to escape its harshness,

he moved to New York City, deciding to become an actor. He applied to the American Negro Theatre, but was initially rejected due to his strong Bahamian accent. Poitier trained himself to enunciate like an American by watching television and reading newspapers out loud. In November 1943 he lied about his age and enlisted in the US Army, working with psychiatric patients at a veterans hospital in Northport, New York. The experience traumatized him so much that he faked mental illness himself to obtain a discharge in December of 1944. Now he was free to return to his original ambition, and this time he was accepted by the American Negro Theatre, whose managers recognized his talents and awarded him a leading role in an all-Black Broadway production of *Lysistrata* in 1946.

As Poitier was preparing to enter Hollywood, the last vestiges of the servile roles that had defined Black actors since the beginning of the industry were being played out and rewarded by the Academy. The final gesture took place at the 20th Academy Awards, held at the Shrine Civic Auditorium, Los Angeles, on 20 March 1948. Ronald Colman won Best Actor for *A Double Life*, while Edmund Gwenn took the award for Best Supporting Actor for *Miracle on 34th Street*. But there was another male actor who received an Oscar that evening, and who did not feature on the list of nominees for either of the above-stated categories. His name was James Baskett. The African American starred as Uncle Remus in the Disney live action/animated musical *Song of the South*, released on 12 November 1946. The movie, Disney's first post-war release, was set in the late 19th century, just after the Civil War and the abolition of slavery. It tells the tale of a young boy travelling with his family to his grandmother's plantation, where they meet Remus, an elderly Black labourer at the plantation, and a captivating storyteller. Remus was based on a literary character created by white Southern author Joel Chandler Harris.

Baskett had been employed by Walt Disney since 1940, originally as a voiceover artist for Preacher Crow, one of the characters in *Dumbo* (1941). When he was cast as Remus in 1946, he became the first live actor, and the first African American, to be hired in a leading role by the innovative animation house. He was only 41 years old at the time, but his hair was already grey, and so, together

with some clever make-up and styling, he was able to transform into the elderly Remus, who became famous in the film for the song 'Zip-a-Dee-Doo-Dah'.

Baskett's portrayal of Remus drew contrasting reactions. Actress Ruth Warrick, who also starred in the movie, said, 'The point of the picture is that Uncle Remus was the wise one. He was full of love, joy and humanity. He was the hero. The white folks were kind of stupid and foolish. As far as I'm concerned, this is a very pro-black representation.'[10] The NAACP's Gloster B Current admitted that he found Baskett's performance 'artistic and dynamic'.[11] But other civil rights leaders and sections of the Black press saw Remus as yet another archaic example of an old Southern stereotype that portrayed Blacks as loyal, contented subordinates. Richard B Dier, writing in *The Afro-American*, was 'thoroughly disgusted' by the film for being 'as vicious a piece of propaganda for white supremacy as Hollywood ever produced'.[12] The NAACP and the National Negro Congress boycotted the movie, organizing picket lines outside the major cities where it played. Disney was also criticized for not making it clear that the film was set after the abolition of slavery, leaving many to believe that Remus was a slave working on a Southern plantation.

Despite not formally being nominated for the 1948 Academy Awards, Baskett's performance was lauded by Disney and the mainstream media. On 30 January 1948, Walt Disney himself wrote to Academy president Jean Hersholt, requesting that Baskett be awarded an Honorary Oscar for his portrayal of Remus. Disney described him as 'a very understanding person and very much the gentleman'.[13] Hedda Hopper, gossip columnist for the *Los Angeles Times*, joined in the call for Baskett to receive special recognition. She argued that because *Song of the South* combined live action and animation, Baskett's performance did not fit the established acting categories for an Academy Award, and therefore necessitated an Honorary Oscar. On 20 February 1948, she wrote that he was 'a special actor, and deserved a special award'. Hopper was a powerful and influential figure in Hollywood. Her column was syndicated across 85 metropolitan newspapers and thousands of small-town publications. By the mid-1950s, she had an estimated daily readership of 35 million.

Baskett, as well as Hattie McDaniel (who also starred in the film), had found

a powerful ally in Hopper. Her views nonetheless were racially conservative, and she saw no issue with the servile roles played by Blacks. Indeed, she celebrated them, and defended Baskett and McDaniel against attacks from within the Black community, arguing that the critical voices of the Black press and civil rights leaders were misplaced. Baskett further won Hopper's favour with his criticism of Black protest over the film. 'I believe that certain groups are doing my race more harm in seeking to create dissension, than can ever possibly come out of the *Song of the South*,' he stated.[14] Baskett and McDaniel were accused of being more attached to white Hollywood than they were to their own community. Professionally, this was true. The Black press and the NAACP couldn't get them work, couldn't get them national recognition, couldn't get them Oscars. Only white people could do that.

Public responses to Hopper's Oscar campaign for Baskett included a raft of supporting letters, mainly from white readers. 'Dear Miss Hopper, I'd like to be one of the many fans to cast a vote for James Baskett,' wrote one female reader from Detroit. Hopper even received a letter from Charles Butler, who praised Baskett for bringing 'great happiness to millions of people, as he certainly did a fine piece of work'. Hopper gathered all the letters of support and forwarded them on to the Academy.[15]

Hopper's reach, combined with Disney's letter, proved pivotal. Hersholt presented the proposal to the Academy members, who agreed to the request. Thus, on the night of the Oscars, actress Ingrid Bergman presented Baskett with his Honorary Academy Award – a bronze replica of the gold statuette – for his 'able and heartwarming characterization of Uncle Remus, friend and storyteller to the children of the world'.[16] Baskett, who had been prohibited from attending the film's premiere in Joel Chandler Harris's home town of Atlanta, due to local segregation laws, stepped onto the stage with a big smile to claim the award from the Swedish actress, for what would be the only major film role of his career. Baskett was full of gratitude to Hopper. 'You are responsible for my happiness,' he wrote in March 1948.[17] But his joy was to be short-lived. He fell ill as production on *Song of the South* was drawing to a close, and his condition steadily worsened afterwards. He died of heart problems and

complications from diabetes, less than four months after receiving his Oscar, aged 44.

As Baskett's life ended, new players were entering the stage. In 1948 producer Darryl Zanuck began production on *Pinky* for Twentieth Century Fox. Like *Imitation of Life* before it, the new film dealt with the subject of racial passing. It told the story of Patricia Johnson, a fair-skinned African American who passes for white, and is torn between living comfortably and marrying a white doctor (who is unaware of her racial heritage) or revealing the truth and exposing herself to a life of racism. Johnson's grandmother, Dicey, an illiterate laundry worker, was played by the famed blues, jazz and gospel vocalist Ethel Waters, who had been doubling as a Hollywood actress since 1929. The fascination of these so-called 'race movies' lay in the fact that the light-skinned protagonist's Blackness was non-physical. It hinged on the concept of *interior Blackness*, invisible to the naked eye, and activated only by language. This Blackness had to be stated verbally within the movie, in order for the inevitable, ensuing racism from whites to ignite within the story.

Pinky proved controversial from the start. In *Imitation of Life*, biracial actress Fredi Washington had been cast as the lead, but for *Pinky*, which landed 15 years later, a white actress, Jeanne Crain, was cast instead as the light-skinned African American. This was at a time when Lena Horne, Dorothy Dandridge and Nina Mae McKinney (who actually plays a small role in the film) were available. In casting terms, Hollywood appeared to be going backwards. White privilege was still alive and well.

Of the half-a-dozen movies with racial themes that went into production in the late 1940s, *Pinky* generated the most buzz when it was released on 29 September 1949. It broke attendance records when it opened in New York, and went on to become the fourth highest grossing movie of 1949. But it was not a hit everywhere. The Supreme Court in Marshall, Texas, banned the film on the grounds that the white doctor in the screenplay still loved Johnson, even after learning that she was Black, and also that the movie depicted them embracing and kissing. The decision was subsequently overturned by the US Supreme Court.

Although Ethel Waters played the part of yet another bandana-wearing, forever loyal servant, her performance was noted for its affecting, heartfelt quality. So much so, that on 12 February 1950, when the nominations for the 22nd Academy Awards were announced, her name featured in the Best Supporting Actress category. It was only the second time an African American actor had been nominated – both times for playing maid servants. Crain was also nominated, for Best Actress. Could this have been Lena Horne, Dorothy Dandridge or Nina Mae McKinney, if any of them had been cast instead? In the end, both nominees were beaten on the night – Crain by Olivia de Havilland, in *The Heiress*, and Waters by Mercedes McCambridge, in *All the King's Men*.

Other participants of colour were also starting to be recognized by the Academy. At the 22nd Awards in 1950, Emile Kuri became the first Mexican winner, for Art Direction (Black-and-White), for *The Heiress*. The previous year, Puerto Rican-born José Ferrer had become the first Latino actor to be nominated, for Best Supporting Actor, in *Joan of Arc*. He went one better in 1951 when he won Best Actor for *Cyrano de Bergerac*, also becoming the first Latino actor ever to do so. He was nominated yet again in 1953 for his leading role in *Moulin Rouge*. In the same year, Mexican-born Manuel Antonio Rodolfo Quinn Oaxaca – otherwise known as Anthony Quinn – won Best Supporting Actor for *Viva Zapata!* He won the same award again in 1957, for *Lust for Life*, and was nominated for the third time in 1958, for Best Actor in *Wild is the Wind*. Quinn's hot streak carried on into 1965, when he was nominated once more for Best Actor, in *Zorba the Greek*. The 1950s and '60s turned out to be the best period ever for Latino actors at the Oscars. But it would be almost half a century before they would see another winner.

Latina actors were also making their presence felt. In 1960 Susan Kohner, the daughter of a Mexican mother and an Austrian father, became the first Latina nominee, for Best Supporting Actress in the 1959 remake of *Imitation of Life*, in which she plays a biracial woman who tries to pass for white. The first Latina Oscar was won in 1962 by Puerto Rican star Rita Moreno, for her supporting role as Anita in *West Side Story*. Of the major Puerto Rican characters in the multi-award-winning movie, only Moreno was actually Puerto Rican. The lead,

Maria, was played by Natalie Wood. On Oscar night Moreno was convinced she would not win, and that the Award would go to Judy Garland for her performance in *Judgment at Nuremberg*. When her name was called, she froze with surprise. As she rose to her feet, she was so excited that she struggled to resist the temptation to run up to the podium. Lost for words, she could only muster the briefest response. 'I can't believe it! Good Lord. I'll leave you with that.' It was one of the shortest acceptance speeches in Oscar history. 'The one thing I really thought I should have mentioned was my being an outlier, being a Puerto Rican actress in Hollywood and getting recognized and acknowledged,' she confessed later. 'It would have been moving and so important. But I truly, truly, did not expect to win.' As she went into the wings, Moreno began to cry. The actress Joan Crawford was standing there, and she proceeded to hug the new winner tightly. 'She grabbed me and squashed my face against her bosom. I mean, she was built like a line-backer,' said Moreno. 'She would not let me go. And I kept saying, "I'm not upset!" My face was muffled against her bosom.'[18]

Moreno's Oscar would prove bittersweet. Like Hattie McDaniel and Louise Beavers before her, Moreno was afflicted by typecasting. 'After the Oscar I was convinced producers would come pounding on my door with all sorts of exciting parts,' she said. Instead, she was offered nothing but 'gypsy fortune-tellers, Mexican spitfires, Spanish spitfires – all those "Yankee peeg, you steal me people's money" parts'.[19] She quit the business in disgust, only returning a decade later on the television series *The Rockford Files*, opposite James Garner.

Conditions had begun to change for Asians, too, courtesy of radical shifts in perceptions about them within American society. In the early 1900s they were viewed as degenerate exotics whose customs and religions were alien to those of so-called 'civilized' whites. Congress passed a series of exclusionary acts prohibiting Asian immigrants from becoming US citizens. But things began to shift in the 1940s. During the war the US government was concerned about how Asian discrimination would look, both at home and to its Chinese allies. The exclusionary laws were overturned, and by the 1950s perceptions of Asians had shifted to so-called 'model minorities': industrious, law-abiding, assimilationist Americans with traditional family values.

These changes filtered through to their presence on the silver screen. The 1950s saw them enjoy their best period ever at the Academy Awards, with twelve nominations, six wins and three Honorary Oscars. In 1955 Japanese-born Sanzo Wada became the first Asian to win an Oscar for Costume Design, for the film *Gate of Hell*. Between 1938 and 1966 Chinese-born cinematographer James Wong Howe was Oscar-nominated nine times, becoming the first Asian to win Best Cinematography, for the film *The Rose Tattoo*, in 1956. He won again in 1964 for *Hud*. Honorary Oscars were awarded to Japanese filmmakers Akira Kurosawa, for *Rashomon*, in 1952; Teinosuke Kinugasa, for *Gate of Hell*, in 1955; and Hiroshi Inagaki, for *Samurai, The Legend of Musashi*, in 1956.

At the 30th Academy Awards, on 26 March 1958, supporting performance categories honoured Asian actors for the first time, with two coming from Japan. Sessue Hayakawa was nominated for *The Bridge on the River Kwai*. It marked a return to form for the veteran actor after his career was stalled by anti-Japanese sentiments between the two world wars. Alongside him Miyoshi Umeki became the first Asian to win for Best Supporting Actress, in *Sayonara*. The film told the story of an American fighter pilot (Marlon Brando), who falls in love with a Japanese dancer during the Korean War. Umeki featured as Katsumi, wife of a fellow airman. She played a coy, subservient doll, in line with white Western fantasies. Despite the progress of Asian Americans within society, there were very few parts for them in early post-war films, and those that were available were confined to stereotypes. Umeki's Oscar happened during the same period as other advancements for Asians in the arts. Shanghai-born China Machado became the first Asian model to hit the mainstream when she secured a job as a fitting model with Givenchy in 1956. From there she was photographed by Richard Avedon for *Harper's Bazaar*'s February 1959 edition, less than a year after Umeki's Oscar. The fashion photographer threatened to quit the magazine after they initially objected to him using a non-white model.[20]

Despite these advances, the culture of whitewashing was still central to Hollywood's casting culture. In 1961 Mickey Rooney famously played Japanese landlord, Mr Yunioshi, in yellowface in *Breakfast at Tiffany's*. In *Show Boat* (1951) and *Imitation of Life* (1959), white actors Ava Gardner and Jeanne Crain

respectively were cast in the roles of light-skinned African Americans. In 1963 *Hud*, starring Paul Newman, followed suit. The film was adapted from the 1961 novel, *Horseman, Pass By*, by Larry McMurtry. It features a Black housekeeper called Halmea, whom screenwriters Harriet Frank and Irving Ravetch changed into a white character called Alma, played by Patricia Neal. 'We would have loved to keep her black for the movie,' Frank admitted, 'but in those days you simply couldn't do it, and not because the talent wasn't there – there were at least a half-dozen powerhouse black actresses who could have played that role. But the times weren't ready for it yet . . . '[21] Frank also stated that casting a Black actress in the role was further complicated by the fact that the novel contained an attempted interracial rape scene with Halmea. However, these issues were far from insurmountable. When books are adapted for the screen, everything can be changed, if the screenwriters wish it – not just ethnicity and race, but narratives also. How could it be that the part of a Black maid – a role ubiquitous among Black women in film – could not have been adapted and retained in the movie version?

Whitewashing was a major issue for minority actors, because each role re-assigned to a white actor meant one less chance for them to excel, and possibly be Oscar-nominated, in an arena in which outstanding roles were rare, and where a minority actor might only get one chance in their entire career. During the first 30 years of the Academy, on numerous occasions white actors won Oscars for parts conceived as characters of colour: Patricia Neal won Best Actress at the 1964 Academy Awards for her role as Alma in *Hud*. But in reverse, no Black actor would be considered for a role written for a white character, aside perhaps from Sidney Poitier, circa 1963. The system was rigged – and there was nothing minority actors could do about it. Except wait. For the future.

Long after Hollywood began to permit Blacks and Asians to play themselves on screen, Native Americans were still being portrayed by white actors in redface. Indigenous people were held back the most, and were furthest away from ever getting to the Oscar podium. Who would fight for them? Who would lobby the studios to change their racist casting? They lacked effective advocacy, and so they fell behind. Rock Hudson (*Winchester '73*, 1950), Burt Lancaster (*Apache*, 1954),

Henry Brandon (*The Searchers*, 1956) and Audrey Hepburn (*The Unforgiven*, 1960) were just a few of the white stars who played redface roles in a cluster of productions. Native Americans may have been the inhabitants of the land of America, but in the land of Hollywood they were last in line.

Compared to them, Hollywood's African Americans were doing well – especially newcomer Sidney Poitier. He made his debut in *No Way Out*, a contemporary crime drama in which he played the part of Luther Brooks, a Black junior doctor at a county hospital, who has to treat a virulent racist injured in a gunfight with police. Produced by Darryl Zanuck, and written and directed by Joseph L Mankiewicz, the film was raw in its depiction of white racial hatred and its dire consequences. Poitier's role heralded the arrival of a new archetype for Black men. Gone was the witless, anonymous servant; the lazy, eye-rolling clown; the uneducated menial worker who spoke in dialect. In their place was a smart, clean-cut, well-spoken, educated, middle-class professional, who was ready to stand up to white men. It would have been impossible to cast a Black lead in this type of story during the pre-war years. But now things were changing. And powerful white filmmakers were sticking their necks out to make it happen. Poitier described Zanuck and Mankiewicz as part of a small group of 'filmmakers who had a social conscience'.[22] Poitier felt compelled to play these roles. He felt a moral duty to revise perceptions of Blacks within a society that denigrated them. 'We were considered less than human during those times, half a human being,' he told *Newsweek*. 'There were no other options for me.'[23]

No Way Out was a big hit when it was released in theatres in September 1950. A film that pitted white against Black in such tense, simmering conflict was exciting to contemporary audiences. Reactions veered from stunned silence to prolonged applause. It was also the first movie that Poitier's parents had ever seen in their lives. 'They were absolutely enthralled by what they saw, letting go with, "That's my kid!" and all that,' he recalled.[24] Poitier's film character here, as well as characters he played in subsequent movies, would prove flawed in the sugar-coated perfection to which they aspired. But at this stage it didn't matter. It was impossible for Poitier, the first incarnation of a new archetype, to be everything

to everybody. What was more important, and more practical, in terms of winning Oscars, was that a Black actor had broken free of the crusty old stereotypes, and could now secure leading roles as contemporary characters.

Meanwhile, behind the scenes of Hollywood's productions, African Americans remained noticeably absent. Their involvement was sporadic, and centred mostly around musical composers and arrangers such as Calvin Jackson, Phil Moore (who worked on some 40 films for MGM) and Benny Carter (who worked on *Stormy Weather* for Twentieth Century Fox). Other divisions were also underrepresented. Black screenwriter Carlton Moss (who worked with Frank Capra) and choreographer Marie Bryant (who worked with Betty Grable, Bob Hope, Lucille Ball and Ava Gardner) were two from a very short list. In 1949, when filming began on *No Way Out*, cast member Ruby Dee commented on the lack of African Americans working at Twentieth Century Fox studios. 'We didn't see any black people working there,' she said. 'No technicians, no grips, no electricians, no props people. We didn't see any dark skins in the make-up and wardrobe departments, or as hairdressers. From the minute we entered the gate in the morning till the time we left, we were in an all-white world.' Sidney Poitier had a similar experience: 'I made films when the only other black on the lot was a shoeshine boy.'[25]

Just as Poitier was rising as the epitome of the new kind of Black actor, the woman who started off the whole African American Oscar journey passed away. On Sunday, 26 October 1952, the news broke that Hattie McDaniel had died of breast cancer, aged 59. She had died alone in a private hospital room in San Fernando Valley, after also suffering from diabetes and a heart condition. Condolences poured in from across the country, from everyone from General Dwight D Eisenhower to Clark Gable. Three thousand mourners attended her funeral, many arriving hours before the service even began. Her friend James Cagney was the only white Hollywood star in attendance, but Gable, Claudette Colbert and Walt Disney all sent flowers. The numbers of attendees became so large that the Los Angeles Police Department had to close off four blocks surrounding the church. A procession of 125 limousines made their slow journey towards her final resting place. McDaniel's last wish was to be buried at the

Hollywood Memorial Park Cemetery alongside fellow film stars such as Douglas Fairbanks, Rudolph Valentino and Victor Fleming, but her request was denied – the cemetery was whites only. McDaniel had anticipated this potential problem, and so in her will she had stipulated an alternative. Instead, she was buried at the Rosedale Cemetery, in the Pico Union district of Los Angeles. Despite her being the first Black Academy Award winner – and being applauded and eulogized by over a thousand of her white contemporaries on that historic night – in the end, nothing could overcome Jim Crow.

*

In the same year as Hattie McDaniel's passing, Austrian-born director and producer Otto Preminger began work on a motion picture adaptation of *Carmen Jones*, the Oscar Hammerstein II stage musical. He wanted it to feature an all-Black cast, but he knew the studios would not back such a venture, and so he produced the movie independently, eventually securing funding from Darryl Zanuck at Fox, who insisted that Preminger first get approval of the script from Walter White at the NAACP. In Preminger's version, set during the Second World War, Carmen seduces a young soldier called Joe, but subsequently deserts him for another suitor. Joe then seeks revenge upon his ex-lover. The sex symbol character was a new archetype for a Black woman – the opposite of the sexless mammies and maids of old Hollywood. The role was much sought after, with Diahann Carroll, Joyce Bryant and Eartha Kitt all vying for it. But there was one rising Hollywood starlet who was overlooked completely.

Born in Cleveland, Ohio, in November 1922, Dorothy Dandridge was a child star who, from the age of nine, performed and toured with her sister on the church and club circuit. In 1931 the family moved to Los Angeles, and soon afterwards, seeking new opportunities to advance her daughters' careers, their mother Ruby took them to see Charles Butler at his Central Avenue office. She had previously been warned that her children had no chance of making it in Hollywood, as they were too light-skinned, but nevertheless Butler saw their potential, and signed them onto Central Casting's books. From 1936 onwards Dorothy began securing regular work as an extra and bit-part player, which she fitted in around her touring schedule. Her film career began to take off in earnest

in the 1940s, with a flurry of appearances in quick succession, as directors became entranced by her bewitching allure and stately beauty. In *Bright Road* (1953), she played a schoolteacher, opposite Harry Belafonte. These post-war, postmodern roles were a giant step up from Hollywood's early Black tropes.

In 1952 Dandridge was angered that she had not been invited to audition for the part of Carmen. She complained to her manager Earl Mills, who subsequently secured her an appointment at Preminger's Los Angeles office. But he was initially unconvinced. He thought her too sweet and sophisticated to play a streetwise temptress. 'I'm an actress. I can play a nun or a bitch,' she insisted. Preminger invited her to cast for another role in the film instead, and Dandridge left the audition in a huff. But she was determined to prove Preminger wrong. For her next appointment she returned in the guise of Carmen, wearing a pencil skirt split to the thigh, a low-cut blouse, heavy lipstick, big curls, and a lot of attitude. 'I made myself look like a hussy,' she recalled. Preminger, shocked and delighted at her transformation, did a U-turn and awarded her the part.[26]

The film was released on 28 October 1954. 'Dorothy Dandridge in "Carmen Jones" – Wow!' proclaimed *The Hollywood Reporter*. The Academy was evidently also wowed by her performance, because on 12 February 1955 her name was among the nominations for the 27th Academy Awards. She became the first African American to be nominated for Best Actress. The competition was formidable: Audrey Hepburn (*Sabrina*), Judy Garland (*A Star is Born*), Jane Wyman (*Magnificent Obsession*) and Grace Kelly (*The Country Girl*). But the pre-Oscars buzz in some sections of the press suggested there might be a surprise winner. 'This year's Oscar race may be the biggest upset in history,' proclaimed *Jet* magazine. 'People are betting that Dorothy Dandridge will cop the award.'[27]

They were wrong. Grace Kelly took Best Actress on the night. Black film historian Donald Bogle stated that for a Black actress to even be nominated was tantamount to a victory. If so, it was a victory without any upside for Dandridge, because, like many before her, the nomination did not bring her a windfall of leading roles. 'While experiencing what seemed to be a full acceptance, I encountered not-yetness,' she wrote in her autobiography. 'Whites weren't quite

ready for full acceptance even of me, purportedly beautiful, passable, acceptable, talented, called by the critics every superlative in the lexicon employed for a talented and beautiful woman.'[28]

From the studio lot to the graveyard, Hollywood's exclusionary culture still coursed through its bloodstream. But outside its hallowed gates, segregation was now being challenged across America, and in the place that made the biggest impact – the courts. On 17 May 1954, nine months before Dandridge's Oscar nomination, the landmark school desegregation case, Brown v. Board of Education, ruled that the practice of segregated schools in Topeka, Kansas, was unconstitutional, and therefore should be dismantled. This opened the gates for subsequent civil rights challenges against racism, exclusion and discrimination across every aspect of society. One of the most unforgettable moments in civil rights history occurred on the evening of 1 December 1955, in Montgomery, Alabama, when Rosa Parks, a 42-year-old African American seamstress, who was riding the bus home after a long day at work, refused to comply with state law stipulating that Black passengers must relinquish their seats to white passengers when the bus was full, and that they were required to sit at the back of the vehicle. Parks, refusing to move from her seat, was arrested. Her simple action became the inciting point for the American Civil Rights Movement.

*

On 23 February 1959, the nominations for the 31st Academy Awards were announced. History was made, as Sidney Poitier became the first ever Black actor to be nominated for Best Actor, in *The Defiant Ones*, an action drama produced and directed by Stanley Kramer, in which two escaped convicts from a prison chain-gang – one Black, the other white – are handcuffed together, and must cooperate in order to survive. Poitier and Tony Curtis played the leads. The low-budget movie – which made $2.7 million from costs of $778,000 – performed well at the Oscars, winning for Cinematography and Original Screenplay, and with nominations in seven other categories. Curtis was also nominated for Best Actor alongside his co-star. They were both beaten by British actor David Niven, in *Separate Tables*.

Poitier's groundbreaking nomination highlighted one of Hollywood's biggest

problems: Black men. Since the industry's beginnings, they had been portrayed as servants, clowns, tricksters and renegades. The heroes of Hollywood films were white men, with Black men as supporting subordinates or baddies. Black women, considered less threatening, were afforded an endless supply of roles as dutiful maids and mammies – so much so that this archetype produced their first Academy Award. By contrast, the lowly position of Black men was plain to see in the numbers: there was a 20-year gap between McDaniel's nomination and Poitier's, as the first Black man. Further, there had been three Black female nominees and one winner in that period. These figures suggest that Black men had been deliberately demoted. Could Poitier, in these new types of roles, be the man to finally change that?

The word 'change' in Hollywood often meant simply to 'remake'. In 1958 director Douglas Sirk began shooting a new version of the 1934 classic, *Imitation of Life*, based on the novel by Fannie Hurst, for Universal Studios, with Lana Turner playing the lead. On this occasion the role of housekeeper Annie Johnson was played by Juanita Moore, in what would be her only major film role. Formerly a dancer in the chorus line at The Cotton Club during the 1930s, she was spotted by Charles Butler, who got her work as an extra. She made her film debut in 1939 and featured uncredited as a dancer in a number of early productions. She secured bit-parts throughout the 1940s and '50s, appearing in her first speaking role in *Pinky*, opposite Ethel Waters. She was serious about honing her craft, and enrolled at the Actors' Lab, the famous, non-segregated Method Acting school located at Sunset Boulevard and Laurel Avenue, which was also attended by fellow Black actors Dorothy Dandridge and Lena Torrence, as well as Marlon Brando, James Dean and Marilyn Monroe.

Moore was a talented actress, but not a big name, and so initially the executives at Universal were not keen to cast her in *Imitation of Life*, but producer Ross Hunter insisted that her sweet, kindly demeanour was perfect for the role of Annie. The only adjustment she had to make was to use make-up to cover up a birthmark on her forehead, which she was told made her look South Asian. The film premiered on 19 March 1959 and was number one in the US for two weeks. It went on to become the sixth highest grossing film of that

year, eventually making $6.4 million, against costs of $1.2 million. Moore was not invited to the film's premiere, but she received good news on 22 February 1960 when she was nominated for Best Supporting Actress, becoming the fourth African American female nominee. She was beaten on the night by Shelley Winters, in *The Diary of Anne Frank*. In the end, like many of her Black contemporaries, she was typecast and undervalued by the industry. She appeared in a total of 70 films, mostly as servants. As with other marginalized actors before her, her Oscar nomination didn't have any positive impact on her career – in fact, the opposite. 'The Oscar prestige was fine, but I worked more before I was nominated,' she told the *Los Angeles Times* in 1967. 'Casting directors think an Oscar nominee is suddenly in another category. They couldn't possibly ask you to do one or two days' work.' The few roles she was offered, post-nomination, were the same as before, and so she refused them. 'I'm not bringing the trays in anymore,' she said.[29]

*

Out in the real world, the civil rights revolution was intensifying. On 1 February 1960, four African American college students in Greensboro, North Carolina, refused to leave a 'whites only' lunch counter at Woolworth's after they were denied service. The 'Greensboro Four' – Ezell Blair Jr, David Richmond, Franklin McCain and Joseph McNeil – sparked similar 'sit-ins' across the city and other states, inspired by Gandhi's non-violent protests. Eight months later in New Orleans, six-year-old Black schoolgirl Ruby Bridges was escorted by four armed federal marshals as she became the first student to integrate into William Frantz Elementary School. In 1961 Black and white civil rights activists, known as 'Freedom Riders', took bus trips across America's Southern states to protest against segregation on public transport, and 'whites only' restrooms and lunch counters. They were met with violent attacks from white protestors. On 11 June 1963, Governor George Wallace blocked the doorway at the desegregated University of Alabama, in order to prevent two African American students – Vivian Malone and James Hood – from enrolling. President John F Kennedy sent the National Guard to the campus to break the stand-off. On 15 September 1963, members of the Ku Klux Klan planted a bomb at the 16th Street

Baptist Church in Birmingham, Alabama, just before Sunday service. The blast killed four young African American girls – Addie Mae Collins, Carol Denise McNair, Cynthia Wesley and Carole Robertson – and injured several others. The tragedy drew national attention, sparking outrage and angry protests.

These events influenced Black Hollywood, too. On 9 April 1962, African American actor Caleb Peterson and his organization, the Hollywood Race Relations Bureau, picketed the 34th Academy Awards ceremony at the Santa Monica Civic Auditorium, in protest at the lack of equal opportunities for African Americans within film. That year, as was the case with most that preceded them, there were no Black nominees in any of the acting categories. Peterson's campaign was multi-pronged, and also involved picketing film premieres and targeting productions with little or no Black representation. In the period leading up to the Academy Awards protest, ex-heavyweight champion Joe Louis, in a show of solidarity, pledged not to attend the ceremony if it meant crossing the picket line. Academy president Wendell Corey responded to the boycott by stating that the Academy was not to blame for the industry's racism, as it only presented Oscars and did not make films. He tried to appease Peterson by promising to include a tribute to Black actors within the Awards ceremony, but this didn't satisfy him, and he went ahead with the demonstration. Among the 125 protestors who occupied the red carpet, many held placards proclaiming 'Film Equality For Negroes' and 'Negroes Want a Break'. Twelve of them were arrested for trespassing before the ceremony began. One of them, Cassius Weatherby, was injured after police put him in a chokehold. The prisoners were held until after the ceremony, and were then released. Peterson later tried to sue the Academy for a million dollars, for violation of his right to protest under the First Amendment, but the judge ruled against him, citing that while he was within his rights to picket on the public sidewalk outside the 3,000-seater auditorium, once the red carpet had been laid across that same sidewalk, as permitted under the Academy's lease, he was trespassing.[30]

The following year Peterson became even more militant, threatening to repeat his protest, this time with 500 pickets and a tougher attitude. 'They roughed up one or two of our boys last year and this year if they try it, they're in for a good

fight,' he told *The Chicago Defender*. 'We lay the whole responsibility on the Academy, not the police. If they rough us, there will be violence. This is no Martin Luther King movement.' Peterson's follow-up protest did not take place.[31]

For the NAACP it was clear that they needed a presence in Hollywood itself, in order to give greater focus to the cause. In October 1962 they set up a Beverly Hills/Hollywood Branch, in order to deal specifically with the racism experienced by African Americans in the entertainment industry. Afro-Latino actor and singer Sammy Davis Jr was a co-founder and donor. The new branch soon got to work. On 22 July 1963, the NAACP and the International Alliance of Theatrical Stage Employees (IATSE) met with Hollywood producers and agreed that the studios would employ at least one Black crew member within each Hollywood production. 'The foundation has been laid for what could be the turning point in the negro's stepped-up campaign for greater opportunity in Hollywood,' said attorney Thomas Neusom.[32] But once again, the studio bosses nodded their heads in agreement, and then failed to follow through. Frustratingly, the civil rights leaders had no real power to make them do anything.

<p style="text-align:center">*</p>

In 1962 Hollywood director Ralph Nelson came across a novella by William Edmund Barratt, called *Lilies of the Field* – a simple, sweet saga about a group of refugee German-speaking nuns who build a chapel in the New Mexico desert, with the help of an itinerant labourer and ex-soldier, Homer Smith, whom the nuns believe has been sent by God to assist them. The book was based on the Sisters of Walburga, a group of nuns who had fled Nazi Germany to form a settlement in Colorado. Nelson purchased the film rights and enlisted screenwriter James L Poe to adapt it. Nelson already had Poitier in mind for the part of Smith, and contacted him directly. Poitier agreed immediately. However, the studio, United Artists, were not as keen on the project, and initially turned it down. Nelson persisted, and eventually the studio indulged him, albeit with a tiny budget of $250,000. Nelson believed in the project so much that he put up his California home as collateral. Normally, $250,000 would not be enough to secure both Poitier and Poe, but they agreed to reduced fees. Poitier took $50,000, plus 10 per cent of the gross (after distribution and negative costs), while Nelson

and Poe took $10,000, plus a deferred payment of $40,000. Poe also took 18 per cent of the gross, and Nelson 33 per cent. The rest of the actors worked for $350 per week. Extras and bit-parts were played by anyone Nelson could get his hands on, including his secretary and a group of Mexican construction workers found near the location. Even Nelson, himself an ex-actor, played one of the parts – that of a bigoted contractor.

Poitier and the other cast members rehearsed for a week in secret at Nelson's home, as it was against union rules to work without pay. Then they all flew out to Tucson, Arizona, checked into a local hotel, and filmed the entire production in just 13 days. Nelson was highly organized, with all the scenes captured in two or three takes. During the last few days of shooting, when money got tight, the crew agreed to forfeit a week's salary in exchange for one-hundredth of 1 per cent of the movie, after gross.

Five weeks before the film opened in American theatres, the Civil Rights Movement was reaching boiling point. On 28 August 1963, in Washington, DC, an estimated 250,000 people from across the country gathered to protest against the lack of civil and economic rights available to African American citizens. The 'March on Washington for Jobs and Freedom' featured attendees holding placards aloft that read 'We Demand an End to Police Brutality Now!' and 'No U.S. Dough to Help Jim Crow Grow'. The rally culminated in front of the Lincoln Memorial, where the Reverend Dr Martin Luther King Jr delivered his famous 'I Have a Dream' speech to the massed crowds. Among them were a cadre of high-profile Hollywood stars who had come out in support of the cause. There was Charlton Heston, Marlon Brando, Gregory Peck, Burt Lancaster, Sammy Davis Jr, Judy Garland, James Garner, Paul Newman, Ossie Davis, Harry Belafonte, Paul Robeson, Josephine Baker, Lena Horne, Sidney Poitier and directors Blake Edwards, Martin Ritt and Joseph Mankiewicz. Author James Baldwin and Rosa Parks also attended. Joan Baez, Bob Dylan, Mahalia Jackson and Marian Anderson performed. According to Garner, the FBI called each celebrity individually the night before the event, and warned them to stay away, stating that they could not guarantee their safety. But they paid no heed, and their presence on the day drew the eyes of the world to the civil rights cause.[33]

There was another event that would have an even bigger impact. On 22 November 1963, President John F Kennedy was assassinated. More than any other American leader, he had championed the cause of civil rights, and had brought forward legislation aimed at legalizing equality. His landmark Civil Rights Act, passed in 1964, outlawed discrimination in voter qualification, in employment and within public facilities. His demise was deeply felt in Hollywood, where he had close ties with many in the performing arts. Upon his death, theatres closed, productions were suspended, and actors and crews observed moments of silence. His death, barely three months after the March on Washington, magnified the sense that things had to change, and that people – citizens – had to be the instruments of that change. They had to search within themselves and their consciences for what was right, and they had to be ready to take action to achieve it.

In the wake of these seismic events, *Lilies of the Field* was suddenly seen as a parable of tolerance – a tribute to Black acting talent in a newly race-conscious world. When the nominations for the 36th Academy Awards were announced on 24 February 1964, the film – which grossed a total of $7 million – qualified in five categories, including Best Picture and Best Supporting Actress. Poitier was named in the Best Actor category. It had happened without his input. In the build-up to the announcement, he had refused to campaign for his nomination. 'I'm an actor, not a politician,' he told gossip columnist Sheilah Graham.[34] He faced stiff competition from Albert Finney (*Tom Jones*), Richard Harris (*This Sporting Life*), Rex Harrison (*Cleopatra*) and Paul Newman (*Hud*). Finney had picked up the pre-Oscars awards for Best Actor, and it was he and Newman who were favourites to win.

Hosted by Jack Lemmon, the 36th Academy Awards ceremony began at 7pm on Monday, 13 April 1964, at the Santa Monica Civic Auditorium, Los Angeles. Poitier – dressed in classic black tuxedo with a satin shawl collar, white dress shirt and black bow tie – was seated in the auditorium among the guests, unlike the segregated ceremony of 1940, in which Hattie McDaniel was relegated to the margins. Despite her victory, Poitier did not believe that winning might also be possible for him. Why would he? No Black actor had won an Oscar for almost a

quarter-century. After that amount of time even the strongest person begins to lose faith. Since McDaniel, three talented Black female nominees had come close, but they had all crashed and burned. That was the pattern. To get one's hopes up would be foolish. In fact, Poitier was so sure he would not win that he had considered not attending the event at all. In the end, he decided it would be positive for Black people to see him competing for Hollywood's top accolade. Notably, the Oscars ceremony had been televised live since 1953, and by the end of that decade it had a combined TV and radio audience of 80 million, with a further 100 million worldwide. After Dorothy Dandridge in 1955, Poitier was only the second Black Oscar nominee that Americans and international audiences would have seen in their homes.

While Poitier believed that he had no chance of winning, the buzz before the ceremony among some journalists was that he *would* win – that *he had to win* – in light of the events of the civil rights revolution, and the March on Washington. 'If ever there was a year when the Negro should be honoured, it is this year for obvious reasons,' said gossip columnist Sidney Skolsky. 'It would pour soothing oil on troubled waters.'[35] In *The New York Times*, Murray Schumach wrote, 'For the first time a Negro may win an Oscar for best acting.'[36] So strong was the feeling that Poitier should win that fellow nominee Paul Newman announced that he would skip the ceremony altogether, and support him. 'I'd like to see Sidney Poitier get it,' he added.[37]

On the evening of the ceremony, Poitier was agitated. 'I am absolutely beside myself with nervousness,' he later recalled of that night. 'I begin making promises to myself in my mind. I say: "I can understand that this is an important moment and I have to be here and in fact I want to be here for what it means to us as a people, but I'm never going to put myself through this shit no more – never again under no circumstances am I going to come here again and put myself through this."'[38]

As he sat alone in his seat, he was seized by the possibility that he might actually win the Oscar, and if so, he needed to ensure that his acceptance speech would impress. His inner voice spoke to him: 'Think, Sidney, think, time is of the essence! Whatever I say must be the truth first, and it must be something

intelligent and impressive that will leave the people in that room and the millions watching at home – leave them all duly and irrevocably impressed with the intelligence and decorum of one black actor, Sidney Poitier.'[39]

Actress Anne Bancroft took to the stage to announce the winner of the Best Actor category. As she read out the names of the nominees, Poitier's received the biggest cheer. Then, with a big smile, she announced him as the winner. Poitier rose to his feet with an equally big smile, walked briskly to the stage, and accepted the golden statuette from Bancroft. 'Because it is a long journey to this moment, I am naturally indebted to countless numbers of people,' he said. He thanked the team behind the film, his agent, plus the Academy members. 'For all of them, all I can say is a very special thank you.' It had taken over half a century for a Black actor to reach this point, and then, in a 35-second speech, it was over. But its effects would resonate far beyond the moment.

When compared to Hattie McDaniel's single nomination and victory during the early years of the Academy, Poitier's win capped off an improved set of results overall for African Americans at the Academy Awards. The period between 1941 and 1963 yielded two Oscars and eight nominations, including two of the first for music. Duke Ellington was nominated in 1961 for Best Original Score, for *Paris Blues*, followed by Calvin Jackson in 1964 for *The Unsinkable Molly Brown*. However, although nominations were up, actual Oscar wins were static, and with a sobering 24-year gap between McDaniel's and Poitier's victories.

But 1964 belonged to him. The ensuing celebrations at his victory extended beyond Oscar night. In New York City there were calls for a ticker-tape parade in Poitier's honour. In the end he was invited to City Hall, where he received its highest cultural award, the Handel Medallion, from Mayor Robert Wagner. On 14 May, he was given a hero's welcome in the Bahamas, where he was honoured with a motorcade that drove him from the airport through the streets of downtown Nassau. Poitier waved from an open-top car to thousands of adoring fans who had come out to celebrate the coming of Black Hollywood's new king.

But why was it him? Why was Poitier the one chosen for the crown? There were other talented Black men in Hollywood at the same time, such as James Edwards, and of course Harry Belafonte. 'Something more had to be at play here,'

Poitier reflected in his autobiography, *The Measure of a Man*. 'I had grown up in a culture where unseen forces lurked just out of view, where people looked to "the mysteries" to explain both good fortune and bad.'[40]

In his own post-Oscar analysis of his victory, he was less celebratory of this fortune. Backstage after the Awards ceremony he was coldly realistic about the changes his win would likely yield. 'I like to think it will help someone. But I don't believe my Oscar will be a sort of magic wand that will wipe away the restrictions on job opportunities for Negro actors.'[41] Poitier was fully conscious of the fact that he was now viewed as part of the establishment elite, while his fellow Black actors would quite possibly never be permitted to attain the heights he had. His Oscar, though seen as a mark of progress, also shone a light on how infrequent such victories were for Black actors. The fact that, henceforth, Poitier would spend two isolated decades as Hollywood's only Black male leading man exposed the industry's tokenism, and its institutional racism. There was no lock on the number of white stars the industry was prepared to nurture, but there evidently was on Blacks and other minorities. 'I knew it too, and I couldn't fight that,' Poitier lamented. He was the only one they let through the door – and then it closed and locked behind him. It was a stark reminder to Black actors that Hollywood was not really their world. They were guests – there at the behest of a white hierarchy.

When Poitier was asked about what his Oscar had meant for him as an actor, he said, 'The only real change in my career [has been] the attitude of the newsmen. They started to quiz me on civil rights and the Negro question incessantly. Ever since I won the Oscar, that's what they've been interested in. Period.'[42] Here was the problem. It was the March on Washington that pressed the civil rights agenda firmly into the collective Hollywood psyche, and thereby became the inciting point for Poitier's victory. This distracted the media from his undeniable acting ability. Undoubtedly, Poitier deserved his victory for the quality of his talent, but getting the Academy's white voters to recognize this, *without inducement*, was impossible. A pattern was emerging. In order for a Black actor to win an Academy Award, the timing of their nomination had to coincide perfectly with a relevant event happening somewhere in the world – and that would create, not sympathy

for them, but a *focus* on their obvious but overlooked skills. In 1940, for Hattie McDaniel, it was the Second World War; 24 years later, for Poitier, it was civil rights. The reason the gap between them was so big was because there were no inciting points during that fallow period which would have galvanized white Academy members to *think Black* when voting for nominees. Dorothy Dandridge missed out on an Oscar for this reason. When she was nominated in 1955 for her excellent performance in *Carmen Jones*, the Civil Rights Movement was in its infancy, and had yet to be embraced by Hollywood. It lacked the efficacy that Poitier was able to benefit from a decade later, when the biggest movie stars in the world, now entrenched in civil rights and its objectives, collectively pooled their powers like a band of superheroes, and descended upon the March on Washington. Destiny and success, so often, are about timing – and Dandridge was just off the beat.

The inciting points that had influenced the Oscars succeeded in allowing Black nominees *to be seen*. They needed this, in order to combat the Academy's prevailing inequities. In an ideal world they would have preferred to have been judged quietly and fairly, without external influences, but this was naive. Attention had to be forced. Emotions needed to be stirred. Guilt and compassion and American goodness needed to be awakened in the psyche of Hollywood's white decision-makers. It was the fastest and the most dramatic way to blow the racism out of Hollywood, and for fairness to prevail. Temporarily, at least. Would there ever come a time when a Black actor could win an Oscar without these inducers?

CHAPTER 4

FAIRNESS FATIGUE (1965–1983)

'My success with the Oscar had changed nothing.'
Louis Gossett Jr, *An Actor and a Gentleman*, 2010

At the age of 57, Sir Laurence Olivier decided that he wanted to become a Black man. And not just any Black man. Shakespeare's Black man, Othello. The year was 1964, and the esteemed English actor was preparing to play the title role in the famous play – in blackface. The practice had been mostly outlawed in American productions, but the arts in Britain were behind the times. *The Black and White Minstrel Show* ran on UK television screens until 1978. For this latest production of Shakespeare's play, Olivier set out to perfect his very own Black man. 'The whole thing will be in the lips and the colour,' he told *Life* magazine in May 1964. 'I've been looking at Negroes' lips every time I see them on the train or anywhere, and actually, their lips seem black or blueberry-coloured really, rather than red.' Olivier's rendition of Othello was not a dusky, café-au-lait shade, as it was for Orson Welles when he played the Moor in 1951. Olivier's version was *black*. Shiny, bowling-ball black. In his autobiography he went into graphic detail about the technicalities of his make-up: 'Black all over my body, Max Factor 2880, then a lighter brown, then Negro Number 2 [the name of a shade of make-up], a stronger brown. Brown on black to give a rich mahogany. Then the great trick: that glorious half-yard of chiffon with which I polished myself all over until I shone . . . The lips blueberry, the tight curled wig, the white of the eyes, whiter than ever, and the black, black sheen that covered my flesh and bones, glistening in the dressing room lights.'[1]

Othello was released in American theatres on 2 February 1966, in the midst of the Civil Rights Movement, when sensitivities about Black identity were at

their height, and racist stereotypes in film were still being challenged. US critics balked at what they saw as old-fashioned minstrelsy. *New York Times* columnist Bosley Crowther referred to Olivier's performance as an 'outrageous impression of a theatrical Negro stereotype'.[2] Would Olivier have opted to play Othello in blackface if he had been an American, living in a country where race politics were uppermost in the collective consciousness? The film only played in theatres for two days before it was withdrawn. Nonetheless, the production made a big impression upon Academy voters, as Olivier was nominated for Best Actor at the 1966 Oscars. Today his performance still has its fans among some older members. 'He played a Black man brilliantly,' insisted actor Richard Dreyfuss in a 2023 PBS interview. The 75-year-old star of *Jaws* (1975) also lamented the fact that the good old days of blackface, when a white actor was free to play a Black man, had now been erased by political correctness. 'Am I being told that I will never have a chance to play a Black man?' he asked.[3]

By contrast, there were no nominations in 1966 for actors who were actually Black. Indeed, there had not been any since Poitier's in 1964. The hope that the impetus provided by the Civil Rights Movement, coupled with Poitier's historic Oscar win, would lead to Black actors finally being allowed to play major roles in mainstream productions – including those parts written specifically for them, such as Othello – proved ill-founded. Olivier's privilege in being able to claim the role of Othello, and to appropriate Blackness in the process, was a colonial hijack unique to white actors. Black actors did not have the same freedoms in reverse. It would have been considered ridiculous for a Black actor to canvas to play a white character *as a white man*, complete with straight hair and pale make-up. And yet, a white Shakespearean adopting blackface was considered high art.

Other ethnicities were similarly restricted. Whitewashing meant that the era's films featuring Asian characters, such as *The Face of Fu Manchu* (1965) and *Charlie Chan and the Curse of the Dragon Queen* (1981), were still populated by white actors in yellowface. Asians also found themselves cast as stand-ins for other ethnicities. In the revisionist Western *Little Big Man* (1970), starring Dustin Hoffman, the majority of the Native Americans from the Cheyenne nation were actually played by Asian actors. One of the supporting roles was

played by Aimee Eccles, who was of British and Chinese ancestry. In terms of Oscar nominations, the few gains there were for Asian film professionals were almost all behind the camera – exposing Hollywood's perpetual problem with Asians as lead characters. The only exception during this era was Japanese actor Mako Iwamatsu, nominated in 1967 for Best Supporting Actor for *The Sand Pebbles*. In the same year, Tahitian-born Jocelyne LaGarde also broke records in becoming the first indigenous Polynesian ever nominated for an Oscar, for Best Supporting Actress in *Hawaii*, in what would be her one and only film role.

One method of countering the lack of representation was for minorities to form their own reward systems. In February 1967, the NAACP's Hollywood Branch launched its annual Image Awards. The idea was the brainchild of Toni Vaz, a bit-part actress and stuntwoman who doubled for Cicely Tyson in the *Mission Impossible* television series. She had joined the Hollywood Branch of the NAACP when it launched in 1962, and suggested the idea to its committee. Its remit was to honour outstanding achievements by African Americans in the entertainment field, both behind and in front of the camera. Dozens of categories were incorporated, with each one voted upon by the NAACP membership. Like the Academy Awards, the organization also created its own trophy to present to its winners. Instead of the Oscars' upright golden knight, they devised a silver-plated female holding a globe aloft, while kneeling upon a black wooden plinth. The first ceremony was held on 4 February 1967, when 200 guests descended upon the Beverly Hilton Hotel to honour nominees and the achievements of Sidney Poitier.

His ascendency as an actor was also one of the key focal points of the 1968 Academy Awards. When the nominations were announced on 19 February, two films with racial themes, both starring Poitier, made the list simultaneously. *Guess Who's Coming to Dinner?* was an interracial love story, with Poitier playing a doctor engaged to a middle-class white woman, whom he accompanies home to meet her unsuspecting parents. Alongside was *In the Heat of the Night* – a contemporary crime drama set in the Deep South, about a Black detective who arrives in town to assist a bigoted local sheriff (Rod Steiger) with a murder case. The fact that there were two films with racial themes and Black protagonists

among the nominations was unprecedented – as was the number of Oscar nominations. There were seventeen between them: ten for *Guess Who's Coming to Dinner?* and seven for *In the Heat of the Night*, with both films featured in the Best Picture, Best Actor and screenwriting categories. African American actress Beah Richards was also nominated for Best Supporting Actress in *Guess Who's Coming to Dinner?*, while music maestro Quincy Jones became the first African American musician to be nominated, in two categories, for Best Original Score (*In Cold Blood*) and Best Song ('The Eyes of Love', in *Banning*).

The biggest surprise among the Oscar nominees was that Poitier was not selected for either of the two nominated films in which he had starred – despite the fact that his performance in *In the Heat of the Night* was widely considered to be superior to that in *Lilies of the Field*, for which he had won Best Actor. Poitier's omission was even more notable given the fact that 1967 was the biggest year of his career, with three of his movies in the top twenty. *Guess Who's Coming to Dinner?* was the fourth highest grossing film, taking $57 million domestically at the box office – more than *Bonnie and Clyde*, *The Dirty Dozen* and *You Only Live Twice*. *To Sir, With Love* (Poitier's third film that year) took $42 million, and *In the Heat of the Night* $24 million. Cumulatively, Poitier's movies made $123 million in a single year (the equivalent of $1 billion today), making him the biggest and most bankable star in Hollywood, and smashing the myth that films with Black leads could not make money.

So why was the hottest actor in Hollywood, who had put in the performances of his career, left out of the nominations? Perhaps he suffered from vote-splitting between his two nominated movies, which may have diluted his chances in either film. Or perhaps white voters considered him to be 'uncomfortably powerful' in his autonomous, race-centred roles. Notably, his Oscar win in 1964 was for a less challenging role in which his race was not part of its narrative, and in which he played a labourer bossed around by an abrasive white protagonist – a familiar and accepted racial trope within film history.

Despite Poitier not being among the finalists, 1968 marked the best year ever for Black Hollywood, with multiple nominations in films that attempted to explore the African American experience, and three nominations for acting and

music. There were also a record four Black artists scheduled to appear on Oscar night as presenters or performers: Sammy Davis Jr, Louis Armstrong, Sidney Poitier and Diahann Carroll. It seemed as if things were finally looking up.

But then, something happened that would change everything. At 6.05pm on 4 April, the Reverend Dr Martin Luther King Jr was shot dead. The effects rippled through the culture like the blast-wave from a massive explosion. The martyrdom of the great civil rights leader became America's ultimate inciting point. Only his death would be enough to jolt white America out of its complacency; only by dying could King unlock the American goodness that its citizens somehow knew they possessed, but had repressed.

Institutions across America reacted by granting fresh and fairer opportunities to the same African Americans they had consciously discriminated against before King's death. Many of the changes came fast, particularly within the entertainment field. In the fashion industry, decades of apartheid suddenly gave way to a windfall of work for African American models. Naomi Sims and Donyale Luna became the first to break into the mainstream, with ground-breaking front covers for *Life* magazine and British *Vogue*, respectively. 'The death of King shook everybody a bit and woke them up to the fact that something had to be done,' said Jerry Ford of Ford Models – an agency once nicknamed 'The White House' because of its lack of Black models. 'Negroes aren't temporary. We're all people,' said Wilhemina Cooper of Wilhemina Models.[4] Simultaneously, the Civil Rights Movement had catalysed a drive for self-determination among African Americans, channelled through fists raised in defiance, and the rallying cries of 'Black power' and 'Black is beautiful'. Armed with a new race-awareness, civil rights activists championed the Afro as a symbol of resistance, self-love and connectivity to Mother Africa. Musicians such as James Brown cut off their straightened hairstyles and went natural. Brown's 1968 hit, 'Say It Loud, I'm Black and I'm Proud', instantly became the era's soundtrack.

King died just four days before the Academy Awards ceremony was scheduled to be held in Hollywood. His funeral was planned for the following day, 9 April. Many Hollywood stars, still reeling from news of his assassination, considered it disrespectful for the Oscars to take place before the funeral. In deference to King,

the four African American stars who were scheduled to appear, notified the Academy of their intent to withdraw from the event – instead committing to attend King's funeral in Atlanta. Harry Belafonte, Marlon Brando and Rod Steiger also pulled out. AMPAS president Gregory Peck, faced with a no-show from many of its stars, at what had now become the most racially charged Oscars in history, called an emergency meeting of the AMPAS Board of Governors, who immediately voted to postpone the Awards by two days. This decision was extraordinary in itself. Up to that point in history there had only ever been one event that had stopped the Academy Awards from taking place: a natural disaster in the form of heavy flooding in Los Angeles in 1938. The Oscars did not stop for the Great Depression, they did not stop for the Second World War, but they did stop for King. It was startling that, barely a century after slavery, a Black man and the goodness of his achievements could halt the ceremony – and, further, America itself.

News of the postponement reached the four Black celebrities, and they agreed to attend the ceremony after King's funeral. The rescheduled event commenced on Wednesday, 10 April, at 7pm. Gregory Peck opened proceedings with appropriate solemnity towards the deceased civil rights champion. 'This has been a fateful week in the history of our nation, and the two-day delay of this ceremony is the Academy's way of paying our profound respect to the memory of Dr Martin Luther King Jr . . . We must unite in compassion if we are to survive.'[5]

The Awards were fruitful for the two films starring Sidney Poitier. *Guess Who's Coming to Dinner?* won two Oscars, for Best Actress (Katharine Hepburn) and Best Original Screenplay, while *In the Heat of the Night* scooped five, including Best Picture, Best Adapted Screenplay and Best Actor for Rod Steiger. When he took to the stage, he thanked his co-star Sidney Poitier for 'the pleasure of his friendship, which gave me the knowledge and understanding of prejudice in order to enhance my performance . . . We *shall* overcome.' A big surprise was that Norman Jewison, who directed the film, was overlooked, despite winning Best Picture, which is often an indicator of a win for the director.

King's assassination had no effect on that year's Oscar nominations or winners. His death came long after the final votes were cast. If he had died two

months earlier, the impact could have changed the final result. *In the Heat of the Night* may well have swept the board, with victories for Poitier and Jewison to add to the five that the film actually received. Nevertheless, for Poitier, he would later come to learn that, after winning in 1964, he would never again be nominated for a competitive Oscar. But the situation was worse for other minorities. Little attention was paid to the fact there were no Asians, Latinos or Native Americans in any of the categories at the 1968 awards. The Civil Rights Movement, with its focus on African Americans, did not benefit them. Perhaps they needed to form their own pressure groups?

In 1969 Ray Andrade, a 25-year-old actor, boxer and ex-Green Beret, formed Justicia – Justice for Chicanos in the Motion Picture and Television Industry. Based in East Los Angeles, its mission was to end demeaning and stereotypical depictions of Mexicans in film and TV. The group began by picketing the April 1970 Academy Awards, in protest at the Westerns *Butch Cassidy and the Sundance Kid* (1969), *The Wild Bunch* (1969) and *True Grit* (1969), which depicted Mexicans in negative and insulting guises. Eighty protesters lined the sidewalk outside the venue, carrying placards and shouting, 'Chicano power!' In August they managed to secure a meeting with SAG president Charlton Heston, plus other guild members, including prominent Mexican actor Ricardo Montalbán. The organization gave its full backing to Justicia's cause, promising to lobby the studios to change their policies and eradicate demeaning portrayals of Latino characters. But, once again, nothing came of it.

Some of the complaints about unfair representation came from unlikely quarters. Academy Award-winning British actress Patty Duke, who presented the Oscar for Best Supporting Actor in 1968, complained at the time that 'there wasn't an English name on the list'.[6] Meanwhile in New York, Italian Americans were voicing their own concerns about being unfairly associated with the Mafia within Hollywood movies. The presence of all these factions suggested that American citizenry was fragmenting, disassociating from the homogenous mass commonly referred to as 'society', and splitting off into a myriad of micro independence movements. Women's liberation, gay rights, the introduction of the contraceptive pill, the legalization of abortion, plus anti-Vietnam and 'Ban

the Bomb' protests were all part of it. Everybody was demanding their civil rights – standing up, like Peter Finch in the movie *Network*, and shouting that they were 'not gonna take it anymore'. All this activity marked the beginning of what we now call 'diversity and inclusion'. Logistically, this was a nightmare for AMPAS and for Hollywood. These agencies now had an impossible task – how to satisfy all these 'nations', each demanding to be represented positively, and regularly, within Hollywood film.

Securing change was proving difficult. Not even King's death could melt the icy monolith that was Hollywood's intransigence. The years immediately after his assassination did not, as many had dreamed, hoped and expected, usher in a windfall of opportunities for minorities – either as actors or behind the scenes – that might lead to subsequent Oscar nominations. In 1969 there was only one Black nominee: Quincy Jones for Best Original Song, for the film *For Love of Ivy*. Incredibly, the entire civil rights decade only saw one African American Oscar winner in Sidney Poitier. Ultimately, Hollywood offered gestures and speeches and symbols, but little else. The shock at King's death pushed, *forced*, America into change, but these reactive concessions did not last. How long can change last, if it is forced? History suggests that institutional change only endures when it becomes legislative – when its rules *have to be followed*. This is where King's legacy lies, within the laws he changed. By contrast, when change is left to the discretion of the individual or organization, it often falls away. This was Hollywood's great flaw. Its fairness was optional. And now, fairness fatigue had set in.

*

The 1970s did, however, usher in new endeavours for Hollywood's Black actors. In 1970 Rupert Crosse, who trained at The Actors Studio, became the first African American to be nominated for Best Supporting Actor, for his role as Ned in the screen adaptation of the William Faulkner novel, *The Reivers* (1969). A second nomination that year was awarded to Hugh A Robertson for Best Film Editing, for *Midnight Cowboy* (1969). The following year, James Earl Jones (better known today as the voice of Darth Vader in the *Star Wars* saga) became the first Black actor since Sidney Poitier to be nominated for Best Actor, for his role as boxer Jack Jefferson in *The Great White Hope* (1970).

In 1971 producer/director Melvin Van Peebles's *Sweet Sweetback's Baadasssss Song* and Gordon Parks's *Shaft* kick-started the Black independent film genre known as 'blaxploitation'. Celebrated for its roster of macho, autonomous Black renegades, it was also criticized for championing negative stereotypes centred around violence, drug-dealing and promiscuity. Musically, these films were a departure from the past. Peebles's movie featured soul music by Earth, Wind & Fire, while songwriter, producer and recording artist Isaac Hayes was hired to compose the theme song for *Shaft*. At the age of 29, he had never written music for film before, and so he wasn't mired in its clichés. Before him, movie music was predictable and staid, but Hayes offered a new archetype for what a film score could be, crafting a multi-layered sonic architecture that fused jazz and soul with orchestral arrangements of flutes and strings, together with spoken-word vocals, plus the song's trademark disco-style high-hat and frenetic *wacka-wacka-wacka* guitar riff.

Hayes's music was like a soundtrack to the drive for equality that was still just about alive in America, and that intermittently punctuated the public consciousness. On 20 April 1971, in the landmark US Supreme Court case Swann v. Charlotte-Mecklenburg Board of Education, judges upheld the systematic use of buses to transport multi-ethnic children to schools, in order to implement the racial integration of the public school system that was then law. Further, on 25 January 1972, Shirley Chisholm, the first African American woman elected to Congress, also became the first woman to seek a major party's nomination for President of the United States, when she ran for the Democratic Party's bid. Hampered by racist and sexist opposition, her efforts ultimately failed, but her candidacy drew widespread press coverage, enabling her to raise awareness around important issues of equality, fairness and gender rights. 'The door is not open yet,' she said, 'but it is ajar.'[7]

Perhaps these events influenced the Academy's member base, because the 44th Academy Awards, held on 10 April 1972, made history in featuring its first ever Black presenter – Sammy Davis Jr – who co-hosted alongside Helen Hayes, Alan King and Jack Lemmon. History was made a second time when Isaac Hayes took to the stage to accept the Oscar for Best Original Song. He was the first ever

Black winner in this category, and the first in a non-acting category. He appeared on the podium in the kind of outfit that no one had ever worn to the Oscars before. Rejecting the standard black tuxedo, white shirt and black tie, Hayes was dressed like a character from the film he had just won the Oscar for. He wore a flared purple morning suit with a white trim, fur collar and lapels, plus a matching oversized bow tie on top of a ruffled silk shirt. The look was finished off with his trademark shaved head, scraggly beard and tinted sunglasses. The win marked a huge personal achievement for Hayes – a man who had been orphaned at an early age, and had grown up in poverty, working on farms picking cotton and processing meat.

But his historic victory had not been straightforward. When the 'Theme from Shaft' was first submitted for consideration for the Oscars, some in the Academy's Music Branch were not happy, complaining that Hayes had not actually written down the notes of the song, and therefore they questioned whether or not he should qualify as composer. 'Hollywood tried to shut me out,' said Hayes. It took an intervention from a group of AMPAS composers, led by Quincy Jones and Henry Mancini, to persuade the Academy to accept the song. According to author Emanuel Levy, in *Oscar Fever*, fellow Academy composer David Raksin resigned from the Music Branch 'in disgust'.[8]

African American successes, meagre as they were, nevertheless were more substantial than those of Native Americans, who had consistently fared badly at the hands of Hollywood since its inception. The industry had disrespected, demonized and marginalized them, their traditions and their spirituality. They were cast in a single archetype – that of natives of the Old West, who were savage, violent, sexually deviant, and ultimately disposable. Insulting as these roles were, they were still being played by white and minority actors in redface, long after Blacks and Asians had pushed back against blackface and yellowface portrayals. In cinema terms, there was no place for Native Americans in contemporary American storytelling, and therefore no place for their actors at the Oscars either.

But then, there was an unexpected development. On 23 February 1971, the nominees for the 43rd Academy Awards were announced. A Native American, Chief Dan George, made the list for Best Supporting Actor, for the role of

Cheyenne chief Old Lodge Skins, in *Little Big Man* – at the age of 71. It was the first time a Native American had ever been nominated for an Academy Award. George – real name, Geswanouth Slahoot – was chief of the Tsleil-Waututh nation of North Vancouver, Canada, from 1951 to 1963. A musician, poet and author, he fell into acting at the age of 62, after a white actor playing a Native in redface fell ill on the set of the TV series *Caribou Country*. George's eldest child Robert, who starred in the show, suggested to the director, 'Why not try a real old Indian? I've got one at home.' And so George was hired. Despite this luck, overall Natives were still second choice to play themselves on screen. This was also the case when George was cast in *Little Big Man*. The role was initially offered to Marlon Brando and Sir Laurence Olivier, who both turned it down. It was then offered to Richard Boone, who looked set to do it, but then dropped out at the last moment. George was finally cast, as fourth choice. In the end, the Oscar went to English actor John Mills, in *Ryan's Daughter*. Nonetheless, George had achieved the realistic goal he had set himself when he took up acting – 'to do something that would give a name to the Indian people'.[9]

George also expressed a wish that Native Americans would be more vocal and self-confident about their rights. 'Some of our people stand and wait and don't talk for themselves,' he said, 'but this is becoming a thing of the past. The younger Indians consider themselves equal to the white man.'[10] A dramatic example of this took place at the 45th Academy Awards ceremony on 27 March 1973, when Marlon Brando won Best Actor for *The Godfather*. But, as his name was announced, he did not come to the podium. Instead, a 26-year-old Native activist called Sacheen Littlefeather appeared on his behalf, wearing a fringed buckskin dress and moccasins, and with her dark hair centre-parted into pony tails. She introduced herself as the Apache president of the National Native American Affirmative Image Committee. The Oscars stage had never seen anyone like her before. The bemused audience, plus 85 million viewers watching at home, looked on as she refused to accept Brando's Oscar from presenters Roger Moore and Liv Ullmann. Instead, she made an impassioned speech – scripted by Brando – protesting against the treatment of Native Americans in film and television. She also drew attention to the conflict at Wounded Knee, a Native American

reservation in South Dakota that was under siege from US marshals at the time the Oscar ceremony was taking place.

The audience sat stunned and shocked, their mixed reactions manifesting in a cacophony of gasps, cheers, groans, boos and applause. Littlefeather – who had gained access to the ceremony that evening by using Brando's official invitation – was prevented by time from reading out the actor's lengthy full statement on the night, but it went on to say that 'the motion picture industry has been as responsible as any for degrading the Indian. When Indian children watch television and they watch films, and they see their race depicted as they are in films, their minds become injured in ways we can never know. If we are not our brother's keeper, at least let us not be his executioner.'

After the ceremony Brando was criticized for his actions, both by the press and by some of his peers. 'Actors can get on a soapbox, but I think it's often most eloquent to be silent,' said Rock Hudson, who knew personally all about being silent, after a lifetime in the closet. A more legitimate criticism of Brando was his failure to anticipate how Littlefeather's life would be destroyed in the aftermath of her speech. She worked as a bit-part actress and model, but after the events of Oscar night she was ostracized for the rest of her career. Nude photographs of her, taken for *Playboy* and subsequently rejected some time earlier, were resurrected and published. Simultaneously she claimed to have been smeared by the FBI, and accused them of pressuring the studios not to hire her. She also alleged that she was shot at by an unknown assailant while a guest at Brando's home sometime after the ceremony.[11]

The negative perceptions of her Oscar speech have softened over time. In June 2022, AMPAS, now tuned in to diversity and inclusion, issued a formal letter of apology to her, just four months before her death, aged 75. But there was a further twist, when questions began to emerge in the press about whether or not Littlefeather was actually Native American, as she had claimed. According to her sisters, Rosalind Cruz and Trudy Orlandi, she had lied, and was actually Hispanic (born Maria Cruz, to a father whose family was Mexican). So, was she, or was she not, of Native American heritage? An ancestry DNA test could have answered this question definitively. It is worth noting that genetic studies state

that Latinos living in the US have European, African and Native American genes – and so it may well be that Littlefeather was at least part-indigenous.[12] Either way, her heritage did not detract from her and Brando's intention to raise awareness of the systematic and prolonged racism that Native Americans had endured in Hollywood and beyond.

The 1973 Oscars proved noteworthy, not just on account of Littlefeather's protest, but because they produced a record six African American nominations. Diana Ross made the list for Best Actress, for *Lady Sings the Blues*, as did Cicely Tyson, for *Sounder*. It was the first time two Black actresses had featured together in the Best Actress list. They were the first to appear in this category since Dorothy Dandridge 18 years earlier. Paul Winfield was also nominated for Best Actor in *Sounder*, making it the first time ever that Black actors had featured in both Best Actor and Best Actress categories simultaneously. African Americans in non-acting categories were also recognized. Gil Askey was nominated for Best Adaptation and Original Song, for *Lady Sings the Blues*, while two Black screenwriters became the first ever to be nominated in that category: Lonne Elder III for Best Adapted Screenplay, for *Sounder*, and Suzanne de Passe for Best Original Screenplay, for *Lady Sings the Blues*.

Diana Ross starred in this biopic, as blues legend Billie Holiday. The production was a joint venture between Paramount and Berry Gordy's Motown Records, to which Ross was signed. The film was a big success – nominated for five Academy Awards overall. For the Best Actress nomination, aside from Cicely Tyson, Ross was up against Maggie Smith, Liv Ullmann and Liza Minnelli. As the voting period commenced, Berry Gordy became aware of the customary practice of advertising in the Hollywood trade press in order to reach and influence the Academy's voters. He subsequently took out a series of full-page ads heavily promoting Ross for the Oscar. The ads used stills from the movie, showing her in harrowing scenes, taking drugs and struggling with withdrawal – images some found distasteful within this context. 'I was personally offended,' said African American gossip columnist and Academy member, Walter Burrell. In a further attempt to gain voters' favour, Gordy also

lavished them with expensive gifts and dinners. He was so sure it would all work to his advantage that he publicly named Ross's new poodle 'Oscar'. But, in the end, it did not work. The Oscar went to Minnelli instead, for her performance in *Cabaret*. 'Berry was literally trying to buy the award,' said Burrell. 'The saddest part about it was that Diana might have won if Berry hadn't been so greedy and obvious.'[13]

On a multitude of occasions, and across all areas of filmmaking, women suffered at the hands of Hollywood's patriarchy. El Paso-born Lupe Ontiveros, whose career began in 1976 playing a maid in the *Charlie's Angels* television series, went on to play this same role *150 times* in her career – more than Hattie McDaniel, who did it 74 times. Once typecast like this, breaking out into other roles was impossible. African American actress Diahann Carroll also fell victim to Hollywood's restrictions. In 1975 she became the fourth Black actor to be nominated for Best Actress, for the romantic drama *Claudine* (1974), in which she played a single mother struggling to raise six children in Harlem. Carroll, nowadays probably best known for her star turn as Dominique Deveraux in the '80s mega-soap *Dynasty*, lost out on Awards night to Ellen Burstyn, who played the lead in *Alice Doesn't Live Here Anymore*. Sometime later, when Carroll was asked by reporters why she didn't star in more roles like Claudine, she was scathing about the industry's discrimination. 'Have you seen another film script with a starring role with the character of Claudine?' she asked impatiently. 'I haven't.' She also told reporters, 'I'm sometimes amazed at how few people realize what it takes for a black woman to survive in this business.'[14] More than half a century after the founding of Hollywood, still no Black woman had won Best Actress. And no woman had ever been nominated for Best Director either. This at least changed at the 1977 Oscars, when Italian filmmaker Lina Wertmüller became the first woman ever to receive an Academy Award nomination in this category, for her arthouse movie *Seven Beauties*. It highlighted just how long it was taking for the Hollywood patriarchy to recognize and grant opportunities to female non-acting talent. Change was difficult within the system, even when women were in charge. AMPAS had only ever had two female presidents – Bette Davis (1941) and Fay Kanin (1979–83) – but both were unable to secure fairer

opportunities for women. Davis resigned from her post after just two months, in frustration at the Academy's resistance to her radical proposals for reform.

At the 1977 ceremony there were protests about the fact that there were no African Americans in that year's list of nominees. African American comedian Richard Pryor, who opened the show, chided Hollywood's power players in his inimitable comedic style, for excluding Black talents. Earlier that same evening, in the street outside the front of the venue, there were more protests. Community newspaper publisher Janice McZeal led a picket line, protesting about the lack of Black nominees. Her organization, Blacks in Media Broadcasting Organizers, campaigned to improve the representation of African Americans in the entertainment industry. She contended that, historically, the lack of Black nominees and winners proved that the Oscars were racist. The Los Angeles Police and the Sheriff's Department kept the protestors away from the red carpet and the arriving VIPs. Some Blacks had stayed away in protest, but others decided to attend – among them Eletha Barrett (widow of Oscar winner Peter Finch), Ben Vereen, Cicely Tyson, Tamara Dobson, Pam Grier, Pearl Bailey, Muhammad Ali and Jim Brown, who was also vice-president of the Hollywood Branch of the NAACP. 'We must continue to come to the Awards,' he maintained. 'In order to do battle we have to participate in the fight.' Ultimately, this 'fight' was to increase diversity in the ranks of the AMPAS member base. Black actor Bernie Casey, an active voting member of the Academy, said, 'There are not enough minorities who are members of the Academy, and it's just an industry that has been resistant in many ways to the eventuality of minority people.'[15]

The fight was set to continue, as African Americans invariably found that they were either not nominated at all at the Oscars, or they were nominated but never won. This would become the recurring pattern throughout the late 1970s and early 1980s. Willie D Burton was nominated three times for Best Sound, on *The Buddy Holly Story* (1978), *Altered States* (1980) and *WarGames* (1983). In 1979 Quincy Jones was nominated for Best Adaptation Score, for *The Wiz*, while Lionel Richie made the list in 1982 for Best Original Song, for *Endless Love*. On the acting side, in 1982 Howard E Rollins Jr was nominated for Best Supporting Actor, for *Ragtime*, while in 1984 Alfre Woodard was nominated for Best

Supporting Actress, for *Cross Creek*. For African Americans, Oscar nominations had become 'teasers' – ephemeral promises of victories that never came.

*

In 1965 an aspiring young writer named Douglas Day Stewart underwent rigorous training to become a US naval aviation officer, with the intention of qualifying as a pilot. But he didn't make the cut, and was discharged on medical grounds. Nevertheless, the experience matured him, turning him from a boy into a man. He later decided to write a screenplay based on his time as a naval trainee. He called it: *An Officer and a Gentleman*. It was a romantic drama that told the story of Zack Mayo, a wayward, hard-hearted loner enrolled in naval officer training, whose life is transformed by both a local factory girl and a hard-nosed Marine Corp gunnery sergeant, Emil Foley.

The role of Zack Mayo was originally turned down by John Travolta before finally being offered to Richard Gere. For the part of Foley, director Taylor Hackford was looking to cast a white actor, in line with Stewart's original script. Favourite for the role was R Lee Ermey, a real-life former drill instructor-turned-actor who later became known for his performance in *Full Metal Jacket* (1987). But another actor – a 44-year-old African American called Louis Gossett Jr – was also keen on the part. The Brooklyn-born thespian, a Broadway veteran whose career began on the stage, was a well-known face on US screens since appearing in the hit TV mini-series *Roots*, as the character Fiddler, for which he won an Emmy Award for Best Actor.

Despite the fact that Sergeant Foley was written for a white actor, Gossett's agent, Ed Bondy, managed to get him a copy of the script. 'I knew that playing Emil Foley was my shot,' Gossett noted. It was routine for agents representing Black actors to put them up for roles written for whites, because there were never enough Black-specific parts in Hollywood to keep them working. Bondy attempted to get Hackford to consider Gossett for the role of Sergeant Foley, challenging him on why the character had to be white, as there was no racial specificity within his storyline. After some persuasion Hackford relented, Gossett auditioned for him, and he got the part. Ermey, who allegedly had already been hired at this time, was paid off. The decision to cast Gossett added

a new dynamic to the screenplay. It now became a physical and psychological confrontation between a Black man and a white man. It was like an update of *The Defiant Ones*, where Sidney Poitier faced off against Tony Curtis – except, in this case, the Black man was in charge. Or, as Gossett himself put it, it was 'a black father figure making a man out of a white playboy'.[16]

Gossett was meticulous in his preparation for the role. He joined the Marine Corps drill instructors (DI) division at Camp Pendleton, California, for ten days, where he was put through the same training as real recruits, from 4.30am to 9pm every day, during which time he completed the Iron Man endurance race, as well as practising karate for three hours a day. Gossett was athletic and physically fit to begin with – he had been a basketball, baseball and track star at high school, and had also trained as a paratrooper with the US army – and so he adapted quickly. He also studied with Bill Dower, head of the Marine Corps' drill instructor school, who showed him the ropes of the profession. By the time the film was ready to shoot, 'I showed up as a DI,' said Gossett. 'I wasn't me anymore.'[17] When the 12-week shoot commenced in Washington in late 1981, Hackford was keen to build upon this, and to make Gossett as intimidating as possible to his co-stars, especially Gere, and so he insisted that Gossett remain distant from them while off-camera – so much so that Gossett was put up in a separate condominium, 20 miles away from the other cast members.

The film was released on 13 August 1982, and it was a big hit – the third highest grossing production of 1982, taking $190 million worldwide, from a budget of $7 million. It garnered rave reviews from critics, and Gossett in particular was singled out for praise. 'Mr. Gossett's name will no doubt be mentioned when it comes time to consider nominees for the 1982 Oscar for best supporting actor,' wrote Judy Klemesrud in *The New York Times*.[18] Sure enough, on 17 February 1983, when the nominations for the 55th Oscars were announced, Gossett made the list for Best Supporting Actor, alongside Charles Durning (*The Best Little Whorehouse in Texas*), John Lithgow (*The World According to Garp*), James Mason (*The Verdict*) and Robert Preston (*Victor/Victoria*).

But at the time the nominations were announced, Gossett was going through a personal crisis. He was embroiled in a custody battle with his ex-partner

Christina, over their eight-year-old son, Satie, which ended acrimoniously, with Gossett retaining custody and a restraining order placed upon Christina. Gossett was also feeling increasingly sad, angry and resentful of those around him within Hollywood, and the unfairness and discrimination inherent within the system. He numbed the pain by losing himself in substance abuse – drinking alcohol and freebasing cocaine. 'Whenever that sad reality hit me, I called the dealer and got high,' he recalled. But his negative feelings were wiped away in a flash on the day of the Oscar nominations, when Bondy called to give him the good news. 'Suddenly and unexpectedly, all of my sadness disappeared, and my world seemed filled with nothing but promise and redemption,' he wrote.[19]

The 55th Academy Awards ceremony took place on 11 April at the Dorothy Chandler Pavilion, Los Angeles. There were more Black presenters and performers on the bill that night – Eddie Murphy, Richard Pryor and Carl Weathers – than there were Black Oscar nominees. As Gossett, the sole representative, sat in the audience in his black tuxedo and bow tie he thought – like Poitier in 1964 – that he had no chance of winning, despite the fact that the press tipped him as the odds-on favourite. He had already won the People's Choice Award that year, plus a Golden Globe, and so had contented himself with these honours. He was sure the Oscar would go to James Mason or Robert Preston – so much so that he decided simply to relax and enjoy the show alongside his beloved son Satie, and his best friend and agent, Ed Bondy.

The Oscar for Best Supporting Actor was presented by actors Christopher Reeve and Susan Sarandon. After the introductions, they called out Gossett's name as the winner. The celebratory music started to play, and as the applause erupted, he smiled calmly, rose to his feet and stepped casually to the stage, thinking about what he was going to say. In a speech that lasted just 47 seconds he mentioned his son, thanked Bondy for their 17-year relationship, and paid homage to his parents, his cousin Yvonne, and the spirit of his deceased great-grandmother, who had lived to 117 years old. Holding the trophy aloft in tribute, he told the other four nominees 'this is *ours*', and then quietly left the stage.

It proved to be a successful night for some of Hollywood's other minorities too. Singer-songwriter Buffy Sainte-Marie (of the Piapot Cree nation, although

her exact heritage was disputed in 2023) became the first indigenous person to win an Academy Award as co-writer of Best Original Song, 'Up Where We Belong', from *An Officer and a Gentleman*. But even bigger news on the night was the victory of Ben Kingsley as the first actor of Indian ancestry to win an Academy Award, for Best Actor. The film *Gandhi* swept the board, winning eight Oscars, with Kingsley (birth name, Krishna Pandit Bhanji) beating Dustin Hoffman, Paul Newman, Jack Lemmon and Peter O'Toole to the prize. 'I am custodian of this Award for a lot of people,' said Kingsley during his speech. South Asia had its best night ever, as alongside Kingsley, Bhanu Athaiya became the first Indian woman to win an Academy Award, for Best Costume Design in the film.

However, for African Americans, the night belonged to Gossett. He had achieved a major milestone in becoming the first African American actor to win an Oscar for two decades, and only the third in history. His win was shocking, not simply because of its rarity, but because it was for the type of role that Hollywood had seldom seen, and which in previous years whites had strongly objected to – that of a Black protagonist having authority over a white man. Gossett's Foley not only exercised power over Gere's Zack Mayo, but further, *persecuted and terrorized him*, in order to convert him into a man. Poitier had never gone this far in any of his roles. No Black man had ever gone this far. Gossett himself was very concerned about how this might look to racists out in the real world. 'In "Officer" I had beaten a white man, a popular movie star, fair and square,' he stated. 'Even today I have to be extra careful to stay away from bars. I'm aware that there can always be one hotshot anxious to take me on . . . there were still times when friends who were with me insisted I go out the back door.'[20]

Why did Gossett win the Oscar, playing such a radical role which possibly displeased some of the Academy's more conservative white voters? And how did he achieve it without appearing to be assisted by an overarching inciting point, as previous Black Oscar winners had managed to take advantage of? Perhaps, finally, Black actors were being recognized solely on merit. 'It felt like a huge vote of confidence from my peers for a performance they could not ignore,' Gossett concluded.[21]

Nonetheless, there was something else present within the culture which may have provided a causal nexus for the Academy voters to favour Gossett's incredible performance. The end of the Vietnam War on 29 April 1975 had precipitated a spate of Hollywood war movies that focused both on American heroism on the battlefield and more critical stories about the horrors of war and its detrimental effects upon soldiers. These productions began in the late 1970s, with *Coming Home* (1978), *The Deer Hunter* (1978) and *Apocalypse Now* (1979), and peaked in the 1980s with *Missing in Action* (1984), *Iron Eagle* (1986), *Top Gun* (1986), *Platoon* (1986), *Heartbreak Ridge* (1986), *Full Metal Jacket* (1987), *Hamburger Hill* (1987), *Casualties of War* (1989), *Born on the Fourth of July* (1989) and the *Rambo* series (1982, 1985 and 1988). *An Officer and a Gentleman* slotted neatly into this zeitgeist of stories about American men at war.

Still, for Gossett, winning the Oscar proved to be a muted experience. After the frenetic attention of the ceremony, rather than moving on to the after-parties, he went home, where he fielded a raft of congratulatory phone calls from well-wishers. Then he sat down and watched the LA Lakers on television. Within an hour and a half, he had fallen asleep.

The next morning, he drove into town and walked into his local supermarket. When the shoppers and cashiers saw him, they all stopped and spontaneously burst into a round of applause. The love and appreciation Gossett felt at that moment would prove to have its limits. Like many thespians before him, he fell victim to the famous 'Oscars curse'. His win didn't lead to a windfall of other great roles. It led nowhere. Just as it had for Hattie McDaniel, 43 years earlier. 'I thought I'd get a lot of offers,' said Gossett, 'and they didn't come.'[22] In fact, he didn't work for a whole year after winning his Oscar. He had expected his value to rise with the Award, and with it his wages, as was routinely the case for white Oscar winners. But neither happened. The film ideas he pitched to the studios were all rejected. When offered parts, he would insist on being paid a certain fee, but instead the studios refused, and simply gave the parts to someone else.

Instead of being the gateway to a shimmering life of opportunity and joy, Gossett's Academy Award had become like kryptonite – pulling him down and

weakening him until he was consumed by disappointment, anger and despair. 'I let myself become bitter, resentful,' he said. 'I was my own worst enemy. I said to myself, "What more can I do? Where's the light at the end of the tunnel?" I started to self-destruct.'[23] Again he turned to cocaine to cauterize his pain. Back in the days of his prime he was a disciplined soldier and athlete, but these experiences broke him – and now he spiralled down into madness and sadness.

In his dedication to self-destruction he surrounded himself with thieves, grifters, drug dealers and fellow addicts who would camp out at his home and steal his belongings – diamonds, cameras, guitars, computers and stereo equipment – knowing he could do nothing about it. His evenings were spent in the company of local lap dancers, whom he would hire to stave off his loneliness. It was only when his cousin Yvonne intervened that things changed. She cleared everyone out of his home, and got him to check himself into rehab in Los Angeles. While there, he transformed his life and outlook – and finally got clean.

But the Hollywood process, which had made him, stayed 'dirty'. The period from 1964 to 1983 ushered in more Oscar nominations for African Americans than ever before – 24 in total, with nine in the acting categories. There were three winners overall, but only Gossett won for acting. Afterwards, he was cautious when he said, 'I'm pleased all this is happening, but I hope and pray it's not just a phase.'[24] In fact, that was exactly what it was. Once again, progress was flat. Hattie McDaniel was the sole winner in her era, as was Sidney Poitier 24 years after her, and now – nearly 20 years on from Poitier – there had still only been one winner. With the overall boost in nominations, African Americans thought they were getting closer to the prizes – but, in reality, they were stuck.

HOLLYWOOD BLACKOUT (1984–2002)

'If Hollywood wasn't racist, it wouldn't be American.'
Warrington Hudlin, *People* magazine, 18 March 1996

In 1968 Louis Gossett Jr was stopped by police while driving a white convertible Ford Galaxie 500 along Sunset Boulevard in Los Angeles, on his way to the Beverly Hills Hotel, where he was staying while shooting the movie *Companions in Nightmare*. He was dressed in a colourful Hawaiian shirt, and he had the top of the car down, playing his favourite R&B station on the radio. 'Where do you think you're going, boy?' said the LA county sheriff who pulled him over. Gossett explained that he was an actor, in town doing a movie. The officer said he had stopped him because he fitted the description of a suspect they were looking for. The officer then let him go without a warning or a ticket, and told him to turn his music down and put up the hood on the car. Gossett drove away – only to be stopped again, eight minutes later, by other officers who put him through the same routine. By the end of it all, what should have been a 20-minute drive to the hotel took four hours. But the cops were not done with him yet. After checking into the hotel he was stopped again as he walked on the street, a block from the building. 'Who the hell do you think you are, boy, walking around in this neighbourhood?' one of them said. Once again, they checked all his details, and told him he matched the description of a suspect they were looking for. He told them again that he was an actor, in town to shoot a movie at Universal Studios, but they didn't care. They 'found the idea of a black star a hard pill to swallow', said Gossett. They objected to his success, *his happiness*. They bundled him into

their car and drove him away. After a while the car pulled over, and one of them took Gossett out and handcuffed both his hands around a tree by the roadside. 'This will teach you,' he said. Then they drove away. Gossett was six foot four, weighed 200 pounds and was a martial arts black belt. In another world he could have dealt with these men in a matter of seconds. Instead, he had to let them degrade him. They left him there for three hours. He was humiliated by passers-by, who stared, or jeered, or threw beer bottles at him. Other police cars drove by, ignoring him. He was there so long, he wet his pants. Eventually, the cop returned and released him. He refused to drive him back to the hotel, because he smelled bad, and so he left him to walk. 'In time, I came to understand, this was just the way it was,' said Gossett.[1]

African Americans lived in a country ruled by people who did not want them to rise. This was why the Oscars mattered. But being a Black actor, or winning an Academy Award, did not confer better roles ahead, or acceptance, or equality. America's racism was also Hollywood's racism. Although life had improved immeasurably for Black actors over the preceding 50 years, true freedom remained elusive.

There were restrictions, too, for Hollywood's other actors of colour. Asian artists struggled to find their own spaces. Even when hired to play characters of their own ethnicity, they were still perpetually rendered as side-men, witless clowns and back-up players to white hero figures. Japanese American Pat Morita, as Mr Miyagi, played mentor to budding young martial arts hopeful Daniel LaRusso (Ralph Macchio) in *The Karate Kid* (1984). But Morita, a gifted character actor, imbued the role with his own subtleties, and was rewarded with an Oscar nomination for Best Supporting Actor at the 1985 Awards. For the first time ever, two Asians featured in this category simultaneously. The other was Cambodian-born gynaecologist Haing S Ngor, for *The Killing Fields*. Chosen from more than 300 of his countrymen who had auditioned for the real-life part of Dith Pran – a local translator who had helped a white journalist profile the Khmer Rouge in Cambodia – Ngor had personally been a victim of the brutal regime. His entire family had perished from starvation, and he had been tortured by the Khmer Rouge's guerrillas. He was considered a no-hoper for the Oscar – a

non-actor who had never appeared in front of a camera before – but something in the raw authenticity of his performance touched Academy voters. On 25 March 1985 he made history once more, and in the most dramatic fashion, when, against the odds, he won the Academy Award, beating Morita, John Malkovich (*Places in the Heart*) and Ralph Richardson (*Greystoke: The Legend of Tarzan, Lord of the Apes*). His victory remains one of the biggest upsets in Oscars history.

The obvious way out of Hollywood's restrictions was for artists of colour to initiate their own films. But getting Asian-themed films financed was not easy. In early 2001, Taiwanese American director Justin Lin met with potential investors to bankroll his debut movie, *Better Luck Tomorrow*, only to be told, 'It's an Asian-American cast. It'll never sell,' he recalled to *The New York Times*.[2] 'And a lot of them were Asian-American investors,' he added. In the end, he was offered the money on condition that he cast white actors instead. He refused. Elsewhere, behind the camera, the era produced a cluster of Asian-themed blockbusters that catapulted its technical artists into the Oscars mainframe for the first time. In 1986 Japanese cinematographers Takao Saito, Masaharu Ueda and Asakazu Nakai were nominated for *Ran*, alongside director Akira Kurosawa. In 1988 composers Cong Su and Ryuichi Sakamoto became the first Asians to win an Oscar for Best Original Score, for *The Last Emperor*. In 1993 Japanese costumier Eiko Ishioka won for Best Costume Design, for *Bram Stoker's Dracula*, and the following year Chinese cinematographer Gu Changwei was nominated for *Farewell My Concubine*. The highlight of the era for Asian film was martial arts action adventure *Crouching Tiger, Hidden Dragon*, which in 2001 received ten nominations – a record for a foreign-language film. It won four, for Best Foreign Language Film, Best Cinematography (Peter Pau), Best Art Direction (Tim Yip) and Best Original Score (Tan Dun).

Following on from the Academy Award for Ben Kingsley in *Gandhi*, South Asians made further, though sporadic, breakthroughs. Kingsley would be nominated twice in this period, for *Bugsy* in 1992 and *Sexy Beast* in 2002, while British Pakistani playwright Hanif Kureishi was nominated for Best Original Screenplay in 1987, for *My Beautiful Laundrette*. He became the first person of Pakistani descent ever to make the Oscars shortlist. Five years later, Indian

director and screenwriter Satyajit Ray became the first South Asian ever to receive an Honorary Academy Award for services to film, while in 2000 South Asian American director M Night Shyamalan was nominated for *The Sixth Sense*.

Meanwhile, Indigenous and Latino artists had fallen behind Hollywood's other minority groups. Latinos made slow gains in the technical awards, with just one nomination for Best Director, for Héctor Babenco's 1985 drama, *Kiss of the Spider Woman*, and two for Mexican cinematographer Emmanuel Lubezki (*A Little Princess* and *Sleepy Hollow*). Progress was sparse in the acting categories, too, with only four nominations throughout the era. The sole highlight was Benicio del Toro's 2001 Oscar for Best Supporting Actor, for *Traffic* – the first Latino actor to win an Oscar since Anthony Quinn in 1957. Roles for Latinas were so sparse that some resorted to drastic measures in order to be considered. In 2002, 18-year-old America Ferrera – who would later play the lead in T V comedy *Ugly Betty* – was auditioning for a part in a forthcoming movie, only to be told that the casting directors were not seeking a Latina for the role. 'So I defiantly bleached my hair blond, painted my face white and made the audition tape,' she told *The New York Times*. 'I never heard back. I just remember feeling so powerless. What do you do when someone says, "Your color skin is not what we're looking for"?'[3]

For women of all ethnicities who worked in the entertainment industry, things were just as problematic. At the Oscars they were reduced to small gains in the technical categories. In 1984 Afro-Latina actress and singer Irene Cara won for Best Original Song, for the lyrics to 'Flashdance . . . What a Feeling'. In 1985 Kay Rose became the first woman to win for Sound Effects Editing, for *The River*, while in 1997 Rachel Portman became the first female composer to win for Best Original Musical or Comedy Score, for *Emma*. Outside of the acting categories, this was as far as women were permitted to go in a male-dominated industry. Very few were awarded the opportunity to direct, and only one had ever been nominated.

A 2004 study by SAG put the position of Hollywood's minority artists into full perspective. Roles for Asians in film and television had dropped by 2 per cent, and by 35 per cent for males in prime-time slots. Latino actors fared worse, with

roles dropping by 10.5 per cent, and 31 per cent for males in prime-time positions. Native Americans did worst of all, securing just 1 per cent of all roles. African Americans held the largest slice, at 15 per cent – down from 18 per cent the previous year, but still ahead of the national demographic of 13 per cent. Numbers for women were also down, securing 38 per cent of all roles in 2003. White performers occupied over 73 per cent of roles (the national demographic at the time was 67 per cent). The report offered a number of reasons for the overall decline. 'I would be loath to label it as racism as much as I would be willing to label it playing safe,' said SAG president Melissa Gilbert. 'The long-time assumption that everybody wants to be blue-eyed, blond-haired and trim still persists.' SAG researchers also identified two trends that had affected hiring: the proliferation of TV 'reality' shows featuring non-actors, and the relocating of film productions to cheaper foreign countries, where they hired local talent.[4]

There were further exclusions for minority artists when the nominees for the 58th Academy Awards were announced on 4 February 1986. Leading the field were *Out of Africa* and *The Color Purple,* with 11 each. The latter movie, adapted from the bestselling book by Alice Walker, and directed by Steven Spielberg, was an epic coming-of-age period drama depicting the trials and tribulations of Celie, a young African American girl in rural Georgia in the early 1900s. The production featured an all-Black cast headlined by Danny Glover, Laurence Fishburne, Margaret Avery and Oprah Winfrey, plus a Manhattan-born actor and comedian called Whoopi Goldberg, who, alongside Oprah, was making her big-screen debut. The film's 11 nominations included Best Picture, Best Actress (Goldberg) and Best Supporting Actress (Winfrey and Avery). Film critic Roger Ebert credited Goldberg with giving one of the best debut performances in movie history. 'Here is this year's winner of the Academy Award for best actress,' he predicted confidently.[5] However, there was widespread dismay and shock when Spielberg was not nominated as director – rare for a movie with so many nominations. One rumour was that Spielberg, the most successful director in film history, had been spurned by jealous colleagues within the Academy's Directors Branch.

But there was an even bigger shock at the Academy Awards ceremony on

24 March 1986, when *The Color Purple*, despite its 11 nominations, won nothing. This was unprecedented. Of the 32 other movies in Hollywood history that had attained 11 nominations, only one, *The Turning Point* (1977), had ever emerged empty-handed. Total snubs of films with a high number of nominations have also happened to others. No one knows this feeling more than Martin Scorsese. Three of his films – *Gangs of New York*, *The Irishman* and *Killers of the Flower Moon* – all received ten Oscar nominations, and won nothing.

So what had happened to *The Color Purple*? Later on that evening, at the Oscars after-party at Spago on Sunset Strip, a disappointed Quincy Jones, who had co-produced the film as well as written the score, was asked by reporters what had gone wrong. 'That's the way it is,' he replied, 'and we'll have to do something about it.'[6] The Academy had snubbed *The Color Purple* in the most absolute manner for its cast and crew. It was hard to see how race could not have been a factor when the overwhelming voting membership was white, male and old.

Instead, the Oscars went to *Out of Africa*, which took seven Awards. 'There was a small irony in the fact that the Academy passed over a movie about blacks in a white land to give seven Oscars to *Out of Africa*, a film about whites in a black land,' wrote Ebert.[7] Certainly, some Black critics did not help its cause, denouncing *The Color Purple* for its negative portrayals of Black men as violent abusers; for watering down a lesbian romance that was a key part of the novel; and also for the choice of Spielberg as director. But simultaneously, the same critics said nothing about *Out of Africa*, a film in which tribal Blacks were essentially background extras to its white protagonists in a colonial nostalgia piece.

Perhaps the best agit-prop against Hollywood's unfairness came in the form of its African American comedians. They used the platform of the Oscars to express their feelings during their roles as presenters. In 1977 it was Richard Pryor who took the lead in criticizing AMPAS, while at the 1988 Awards it was Eddie Murphy, the hottest box office star of the moment. Presenting the Oscar for Best Picture, he castigated the Academy for having only awarded trophies to three Black actors in its 70-year history. He noted that when he was first invited to present an award, he told his agent that he didn't want to appear

because of this inequality. He also quipped that Black people only seemed to win every 20 years, and so another one was not due until 2004. Then his expression hardened. 'Black people will not ride the caboose of society, and we will not bring up the rear anymore,' he told the audience. 'I want them to recognize us.'[8] But what real effects did jokes and statements like this really have, aside from making AMPAS senior executives squirm slightly in their seats? Jokes were not inciting points for change. They didn't make anything happen. So what would?

*

In the late 1980s a young Black actor was standing in the parking lot across the street from Spago – the favoured restaurant of Hollywood's A-listers. It was Oscar night, and he watched as a procession of movie stars arrived for the after-party, clutching their golden Oscars and beaming with happiness. 'I want to do that one day,' the man said to himself.[9] He wished for it, like a child in a fairy tale. Perhaps he sensed that he was destined to become one of them, with his own golden Oscar and a table at Spago. Perhaps deep inside he knew that he was the one who would break all records and progress the parts played by Blacks into a realm never seen before.

The man's name was Denzel H Washington Jr. Born on 28 December 1954 in Mount Vernon, New York, he was the middle child of three. His mother, Lennis, was a hairdresser, while his father, Denzel Sr, was a Pentecostal minister. Washington attended Manhattan's Fordham University, and after graduation he studied at the American Conservatory Theatre in San Francisco. His acting career began on the stage, with a series of noteworthy performances in California and New York theatres. His screen debut came in the comedy *Carbon Copy* (1981), and from there his fierce talent catapulted him to national attention in a six-year stint in the long-running television hospital drama, *St Elsewhere*. In 1986 Hollywood came calling, and he was cast as South African activist Steve Biko in *Cry Freedom*, for which he earned his first Academy Award nomination, for Best Supporting Actor.

In early 1989, director Edward Zwick and producer Freddie Fields began casting for a new movie called *Glory* – an American Civil War drama about the

54th Massachusetts Volunteer Infantry Regiment, one of the first all-Black units within the Union Army, and their heroic and bloody fight at the Second Battle of Fort Wagner on 18 July 1863. It was the first major motion picture to tell the story of African American soldiers fighting for emancipation during the Civil War. Morgan Freeman and Cary Elwes were cast as soldiers from the regiment, and Matthew Broderick signed on to play the real-life figure of Colonel Robert Gould Shaw, the 25-year-old white officer who led the group. Denzel Washington was approached to play the key role of Silas Trip, a hard-boiled, cynical runaway slave who enlists. Washington was originally hesitant about accepting the role, as he wanted to avoid doing 'slave films'. 'But the bottom line is that, as a black American, that's my history,' he told *The New York Times* in 1989.[10]

The movie, a joint venture between TriStar Studios and Freddie Fields Productions, premiered in the United States on 15 December 1989, to positive reviews from critics and historians alike. It generated a modest profit, grossing $27 million from a budget of $18 million. Nevertheless, when the nominations for the 62nd Academy Awards were announced on 14 February 1990, the film featured in five categories, with Washington making the list for Best Supporting Actor, alongside Danny Aiello (*Do the Right Thing*), Dan Aykroyd (*Driving Miss Daisy*), Marlon Brando (*A Dry White Season*) and Martin Landau (*Crimes and Misdemeanors*). At the same time, Morgan Freeman was nominated for Best Actor for his role in *Driving Miss Daisy*. Despite the high-quality competition in his category, Washington's agent, Ed Limato, was confident Washington would win. 'Denzel, you're going to win tonight, and we're going to Spago at table one,' Washington recalled him saying. 'We're going to put the trophy in the middle of the table, and we're going to open for business.'[11]

The 62nd Academy Awards opened for business on 26 March, at the Dorothy Chandler Pavilion, Los Angeles. The Best Supporting Actor Award was presented by Geena Davis. Washington was seated close to the stage, next to his wife Pauletta and his mother Lennis, as Davis read out the nominees. Like Limato, Washington had given some thought to winning, and had written an acceptance speech, which he had tucked into the inside pocket of his tuxedo. When his name was subsequently called as winner, he rose calmly,

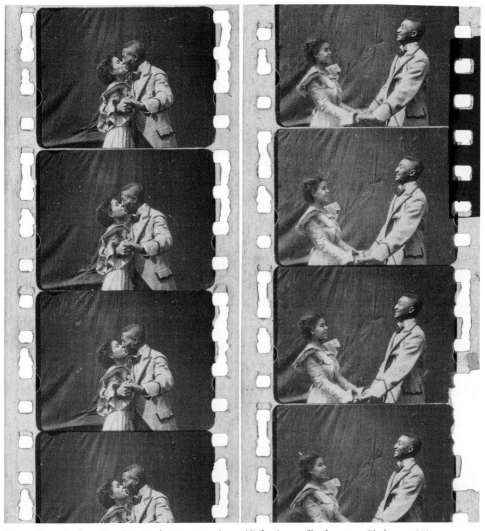

Above: Film strips from *Something Good – Negro Kiss*, the world's first known film featuring a Black cast, 1898.

Above: In *The Birth of a Nation* (1915), D W Griffiths' epic silent film about the American Civil War, Reconstruction and the rise of the Ku Klux Klan, African Americans were depicted either as dumb, contented servants or as brutish renegades seeking violent retribution against whites.

Left: In 1927, Louis B Mayer, the head of MGM, the era's dominant film studio, set up the Academy of Motion Picture Arts and Sciences – not in order to present awards, but to establish a trade organization to mediate labour disputes, promote the development of new production technologies, and market the overall image of the motion picture industry.

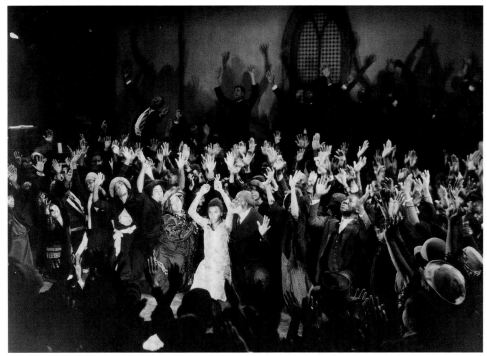

Above: *Hallelujah* (1929), an all-Black MGM musical, featured hundreds of extras recruited from church choirs by Charles Butler, the head of the Black division of Central Casting.

Below: In *Gone with the Wind* (1939), Hattie McDaniel played Mammy, a cantankerous house slave, opposite Vivien Leigh's Southern belle Scarlett O'Hara. In 1940, McDaniel won the Oscar for Best Supporting Actress, making her the first person of colour, and the first Black actor, to win an Academy Award.

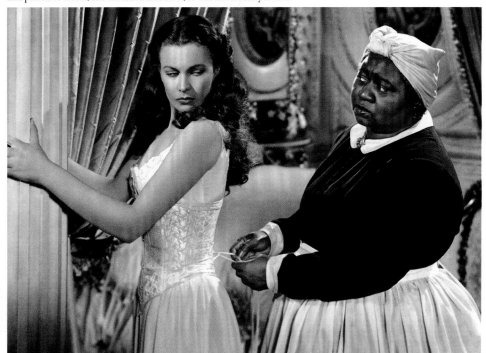

Above: By the mid-1930s, Lincoln Perry, seen here opposite Will Rogers in *The County Chairman* (1935), had become Black Hollywood's first millionaire thanks to his stage persona Stepin Fetchit, a lazy, mumbling dimwit.

Left: In *No Way Out* (1950), Sidney Poitier played a doctor at a county hospital who has to treat a virulent racist injured in a gunfight with police – a Black middle-class professional prepared to stand up to white men.

Above: Dorothy Dandridge was the first African American to be nominated for Best Actress, for her role in the musical *Carmen Jones* (1954), in which she starred opposite Harry Belafonte. The Oscar went to Grace Kelly for *The Country Girl*.

Right: In 1962, Puerto Rican actress Rita Moreno became the first ever Latina to be nominated for an Oscar. She went on to win the award for Best Supporting Actress for her role in *West Side Story* (1961). George Chakiris won Best Supporting Actor for his role in the same film.

Left: Sidney Poitier was the first Black actor to win the Oscar for Best Actor, for *Lilies of the Field* (1963).

Left: Laurence Olivier played the title role in *Othello* (1966) in blackface, opposite Maggie Smith as Desdemona.

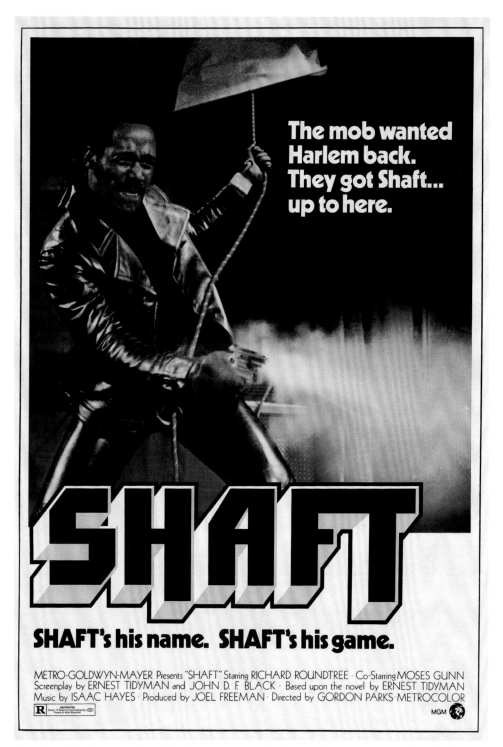

Above: Isaac Hayes became the first African American to win an Academy Award in a non-acting category when his theme from *Shaft* (1971), starring Richard Roundtree, was named Best Original Song.

Above: Future Oscar winner Denzel Washington made his screen debut in the comedy-drama *Carbon Copy* (1981), starring opposite George Segal.

Below: When Louis Gossett Jr won the Oscar for Best Supporting Actor for *An Officer and a Gentleman* (1982), which starred Richard Gere, he was the first Black actor to win an Oscar for two decades.

kissed and embraced his family, and then took the short walk to the podium. He waited for the applause to quieten before he began. The words on the paper revealed key insights to those most instrumental in his rise. He thanked the Academy, then those involved in the film, including Zwick and Fields. He paid homage to the 54th Regiment, thanking 'the Black soldiers who helped to make this country free'. He acknowledged his manager Flo Allen (who had come out of retirement specially to manage his early career), Ed Limato, the late Ruth Aronson from the William Morris Talent Agency (the first agent who believed in him), and his mother, wife and children. He finished by thanking God, and the audience, before finally leaving the stage. As he did so, he left his old acting life behind, and a new one began. The young actor who had dreamed of attending the Oscars after-party at Spago, clutching his own trophy, would now get his wish.

Washington's win was a continuation of Louis Gossett Jr's before him, in that both men won for films about soldiers and war that were made in the post-Vietnam era. The timelines between their two films – 1982 to 1990 – saw America involved in conflicts in Lebanon (1982–4), Grenada (1983), Libya (1986), Panama (1989–90) and Iraq (1990–91). *Glory* formed part of the zeitgeist of war films that peaked in the 1980s and extended into the 1990s with productions such as *Heaven & Earth* (1993) and *Courage Under Fire* (1996), the latter also starring Washington. In terms of capturing the attention of the old white men who made up the vast majority of AMPAS voters, and who loved war films depicting heroic American fighting men, both Washington and Gossett benefitted from starring in the right kind of movies at the right time.

At the age of 36, Washington became only the fourth Black actor to win an Oscar. His victory was significant for another reason, too. Since the 1940s the gap between Oscar wins for African Americans had been two decades. Washington had won *seven years* after Gossett – and in doing so, he had singlehandedly changed Hollywood. His Oscar marked out the year 1990 as the watershed moment which saw the tide begin to turn for Black actors. From now on, the time between their victories would reduce drastically, and they would win with increasing regularity. Washington's victory effectively split the historical

timeline for Black Oscar winners into two categories: before 1990, when there were only three winners, and after 1990, when there were dozens.

A key catalyst for this transformation was that, as society progressed and mindsets evolved, Black actors began securing better (though still infrequent) roles. The servile archetypes of old Hollywood were giving way to a wider and more complex range of characters through which Blacks could finally show the range of their acting abilities, and thereby force their way into contention for Academy Awards. Concurrently, white audiences now found it plausible that Black characters could represent more than slavery's old stereotypes.

This went hand in hand with the gradual changeover of the Academy's base. All its original founder members, who had joined when the organization was at its most exclusionary, were now dead, including its godfather, Louis B Mayer, who had passed away in 1957. A new generation of members were replacing them – and even though they were still almost exclusively white and male, the two-decade cycle of wins for African Americans was broken. This provided the clearest evidence yet that racism in contemporary Hollywood was reducing, albeit slowly. Was 1990 the year that the Academy finally found its heart?

Spike Lee would say no, because that was also the year that his film, *Do the Right Thing*, was snubbed from all but one category, Best Original Screenplay. This proved controversial with certain cinephiles who thought Lee should have been nominated for Best Director and Best Picture as well. It rankled, considering that *Driving Miss Daisy* – which took a considerably more sedate and sentimental view of race relations – secured nine nominations, winning four, including Best Actress and Best Picture. Kim Basinger, who presented the Best Picture segment on the night, went off-script to draw attention to the omission of Lee's film from the running. 'We've got five great films here, and they're great for one reason: because they tell the truth. But there is one film missing from this list that deserves to be on it because, ironically, it might tell the biggest truth of all. And that's *Do the Right Thing*.'

Nevertheless, 1990 and beyond saw new nominations that would previously have been impossible. In 1993 Jaye Davidson became the first openly gay nominee of colour (born in California to a Ghanaian mother and English father), as Best

Supporting Actor for his role as transgender character, Dil, in the crime thriller, *The Crying Game*. Non-American Blacks also began to appear. Black British actor Marianne Jean-Baptiste was nominated for Best Supporting Actress in director Mike Leigh's *Secrets & Lies* (1996). Advances were made behind-the-scenes, too. In 1992 John Singleton, at 24 years of age, became both the youngest and the first African American nominated for Best Director, for his film *Boyz n the Hood* – a coming-of-age drama about three friends growing up in the harsh, crime-ridden streets of South Central Los Angeles. The film – which starred Cuba Gooding Jr, Laurence Fishburne, Regina King, Angela Bassett and Ice Cube – took $58 million at the box office, from a budget of $6.5 million. Singleton's nomination was an extraordinary achievement that has never been equalled, revealing both his talent and his confidence in seizing the director's helm, with no prior experience. When he originally pitched his script to the studios, he only issued copies to those prepared to retain him as director. Columbia Pictures expressed interest, but during a meeting they offered Singleton $100,000 to walk away and hand the project over to a more experienced director. 'I said, "Well, we'll have to end this meeting right now, because I'm doing this movie. This is the movie I was born to make," ' Singleton said in the documentary *Friendly Fire: Making an Urban Legend*.[12] Columbia relented, and Singleton made his movie.

Elsewhere in Hollywood, progress was slower for other minorities. Depictions of Native Americans in film remained sparse throughout. The only high point came in 1990 with the release of *Dances with Wolves* – an epic Western set during the American Civil War, about a white soldier, John Dunbar, who rejects his life and joins a band of Lakota Sioux. Directed by and starring Kevin Costner, the film used actors from the Lakota Sioux nation rather than whites in redface. When the movie opened in theatres it was a massive hit, taking $424 million worldwide, from costs of $22 million. Although the film was criticized for its 'white saviour' aspect (Dunbar quickly becomes leader of the tribe), many Native Americans approved of its narrative and its relatively respectful depiction of their culture. Lakota Sioux leaders honoured Costner at a special ceremony held in Washington, while Albert Whitehat, a Lakota elder who worked as cultural

adviser on the film, ceremonially 'adopted' Costner into his family. The film, nominated for 12 Oscars, won seven, including Best Director, Best Picture and Best Adapted Screenplay. Native American actor Graham Greene was nominated for Best Supporting Actor, for his role as Kicking Bird. He was the first Native artist to be nominated for 20 years – since Chief Dan George in 1971. Greene eventually lost out to Joe Pesci in *GoodFellas*. Once again, the same familiar pattern emerged: Native Americans were seldom nominated, and when they were, they never won.

<p style="text-align:center">*</p>

What would it be like to tell a ghost story from the point of view of the ghost? This was the premise for Hollywood screenwriter Bruce Joel Rubin's new screenplay – a tragi-comic romance about a murdered New York banker called Sam, whose earthbound apparition seeks to save his partner Molly from the clutches of his murderer. A local psychic, Oda Mae, acts as a conduit for communications between Sam and Molly. For two years Rubin unsuccessfully pitched his screenplay to the Hollywood studios until finally it was bought by Paramount. Jerry Zucker was attached as director, and the pair got to work, churning through 19 rewrites in one year before it was ready to shoot.

Patrick Swayze and Demi Moore were cast as Sam and Molly, respectively. The search to fill the comedic role of Oda Mae reached Whoopi Goldberg via a friend who was auditioning for it. It was the biggest role for a Black actress that year – and everybody wanted it. 'Every Black woman and their mother has been out there trying to get this part,' Goldberg recalled. 'People have raised themselves from the grave to try to get this part.' Tina Turner had auditioned, and Patti LaBelle and Oprah Winfrey were among those considered. Goldberg, wondering why she hadn't been invited to try out for the role, called her agent, Ron Meyer, who informed her that Zucker and the film's producers had already rejected her, as they considered her too well-known, and too big a personality. But Swayze had other ideas. 'I just had Whoopi stuck in my head,' he recalled. After six months of unsuccessful auditions, Swayze insisted that he would not do the movie unless he could audition with Goldberg. Zucker relented, and the pair flew out to Alabama, where she was shooting *The Long Walk Home*. They read together, and

'there was this incredible chemistry that happened immediately, and we fell in love with each other', said Swayze. Goldberg was cast.[13]

Filming began in July 1989 in Los Angeles and New York, and the finished production was released on 13 July 1990. Reviews were mixed, but critics praised Goldberg's performance as Oda Mae. 'Why is *Ghost* so good? Whoopi Goldberg – it's that simple,' wrote Tim Robey in *The Telegraph*.[14] The movie became a surprise runaway success, grossing half a billion dollars from costs of just $22 million. When the nominations for the 63rd Academy Awards were announced on 13 February 1991, *Ghost* received five, including Best Picture, Best Original Screenplay and Best Supporting Actress for Whoopi Goldberg. She was up against Annette Bening (*The Grifters*), Lorraine Bracco (*GoodFellas*), Diane Ladd (*Wild at Heart*) and Mary McDonnell (*Dances with Wolves*). Wisely, Goldberg – despite winning the Golden Globe and the BAFTA for her performance that year – didn't get her hopes up about winning, after losing out in 1986.

When it came to choosing an outfit for the upcoming ceremony, Goldberg joked about her limited options. 'I couldn't look glamorous like other people look glamorous,' she told *Variety* in 2021. 'I wasn't thin and I wasn't a white lady, so I had to find my own style.' That meant a figure-hugging, full-length, shimmering black sequinned gown designed by veteran costumier Nolan Miller, who had designed clothes for Elizabeth Taylor, as well as for the long-running television drama, *Dynasty*. She accessorized her look with a silver necklace and matching earrings, and her hair was styled in her signature cascade of braids. 'I looked really good,' she quipped. 'My hair was cool. Dress was cute.'[15]

On 25 March 1991, the 63rd Academy Awards were held at the Shrine Civic Auditorium, Los Angeles. Goldberg was seated near the front of the stage with her brother Clyde and daughter Alex. Her mother, Emma, had opted not to attend, after being in the audience in 1986 and witnessing her daughter's disappointment at losing. While she stayed at home and watched the ceremony on television, along with 42 million other Americans, Goldberg settled hopefully into her seat as the evening's proceedings began.

The Oscar for Best Supporting Actress was presented by Denzel Washington.

He stepped onto the podium and introduced the five nominees. Then he calmly opened the envelope, glanced inside, and without expression said: 'And the Oscar goes to . . . Whoopi Goldberg.' 'Yes!' she cried, her face sparking with surprise and elation. She clenched both fists in feverish triumph, then jumped up excitedly, hugged her family, accepted a congratulatory kiss from actor Andy Garcia, who was seated in the row in front, and then made her way enthusiastically to the stage. The Black male actors who had won in the years before her had all contained their excitement during the big reveal, no doubt silently imploding while projecting a calm exterior as they stepped to the podium. But Goldberg displayed the unbridled exuberance of a sports star who had just won a big game. This was not how she had envisaged it. 'The plan was, if I win, I will walk up, and I will be dignified,' she later said. 'But the plan went right out of the window, because I actually won.'[16] She stepped onto the stage, hugged Washington, and then turned to the audience with a smile that lit up the podium. She wore the weight of history lightly, like a little girl – which is exactly what she was when she had first visualized this moment. 'Ever since I was a little kid, I wanted this,' she began. Indeed, every year during her childhood, she had written and performed an imaginary Oscar acceptance speech, fantasizing about winning the coveted golden trophy one day – and now that dream had come true, and in spectacular fashion. She went on to thank Jerry Zucker, Patrick Swayze and Demi Moore. 'I'm so proud to be here. I'm proud to be an actor, and I'm gonna keep on acting,' she said.

Goldberg became only the second Black actor to win Best Supporting Actress, after Hattie McDaniel in 1940. It had taken half a century for her to get there, and she was fully aware of the significance, and the injustice, of this fact. 'You think about all the people it should have happened to,' she said, referencing actresses Dorothy Dandridge, Pearl Bailey, Diana Ross and Rosalind Cash. 'You couldn't find anybody?' she asked.[17]

Before the ceremony, Goldberg and the other nominees within her category had made a pact that whoever won would treat the others to lunch. Goldberg initially thought it would be Mary McDonnell, but it was she herself who ended up hosting them. Alongside the food, she arranged specially made Oscar statuettes made of chocolate for each of them. 'We all did really good work,' she

said. 'Any one of us could've taken it, and I don't think anybody would've been mad at anybody else.'[18]

Washington's Oscar in 1990 and Goldberg's in 1991 marked the first time that African American actors had won back-to-back awards. Goldberg was to find herself back on the Oscars stage in 1994, as she became the first woman, and the first African American woman, to solo host the show. The 1990 watershed that had ushered in these new milestones for Blacks may have led many to believe that Hollywood's racism problem was finally over.

But at 5.38am on 13 February 1996, any such thoughts proved to be premature, when the nominees were announced for the 68th Academy Awards. All 20 candidates in the acting categories were white. Of the total 166 nominees, only one was Black: Dianne Houston, nominated for Best Short Film (Live Action). For Latino artists, one reason for their complete absence was that their roles were still being whitewashed. In the 1993 film adaptation of Chilean writer Isabel Allende's beloved novel *The House of the Spirits*, Meryl Streep, Glenn Close, Jeremy Irons, Winona Ryder and Vanessa Redgrave were cast in the major roles, along with Spain's Antonio Banderas.

Perhaps the most glaring Oscar snub of 1996 was that of Don Cheadle for his performance as Mouse, Denzel Washington's trigger-happy sidekick in *Devil in a Blue Dress*, the noir mystery adapted from the 1990 novel by Walter Mosley. 'The fact that Cheadle didn't get a nomination is deeply, deeply disturbing,' said African American director, producer and actor Warrington Hudlin.[19] It came after Cheadle was named Best Supporting Actor by both the National Society of Film Critics and the Los Angeles Film Critics Association. It also surprised many cinephiles that Laurence Fishburne (*Othello*), Morgan Freeman (*Se7en*), Angela Bassett (*Waiting to Exhale*) and Denzel Washington were passed over. In the same year, Washington became the first Black man ever to be voted 'Sexiest Man Alive' by *People* magazine. But 'sexy' didn't mean anything if discrimination was preventing him from winning Awards.[20]

For some of the snubbed Black artists, the issue may have been attributable to a lack of promotion of their films by their respective studios. In the case of *Waiting to Exhale*, this definitely harmed the chances of both Angela Bassett and

composer Kenny 'Babyface' Edmonds, whose chart-topping song 'Exhale (Shoop Shoop)' from the film also failed to make the cut. As it turned out, Fox Studios didn't mail out viewing tapes to Academy members for their consideration – an established promotional practice. For TriStar Pictures, although *Devil in a Blue Dress* was critically acclaimed, it flopped at the box office (costing $27 million, but only earning $22 million). The film massively underperformed compared to *Se7en*, that year's other big mystery drama, which cost $34 million but made $327 million. In light of the box office failure of *Devil in a Blue Dress*, TriStar Pictures held back from spending on further promotion. 'What might have been the problem is that they didn't want to invest any more money because they didn't feel that they would necessarily get that money back,' speculated writer/director Carl Franklin.[21]

News of the absence of African American actors from the 1996 nominations drew fresh condemnation, though not from the NAACP or the Black press, but from an unlikely new source – *People* magazine. Just days before the Oscars, the publication's 18 March edition appeared on newsstands with the provocative front-page headline, 'HOLLYWOOD BLACKOUT'. The heading stated: 'The film industry says all the right things, but its continued exclusion of African-Americans is a national disgrace'. The cover featured images of Black stars who had been snubbed that year: Angela Bassett, Denzel Washington, Laurence Fishburne and Whitney Houston.

Year on year, minorities were regularly excluded from the Oscar nominations, and the mainstream press seldom seemed to care, but this was new – a white-owned, celebrity gossip magazine known for its escapist frivolity, highlighting the serious topic of Hollywood racism. These protests usually emanated from within the Black community, but here was a powerful white institution complaining about inequality on behalf of Blacks. America was changing.

In this case, the change agent was *People* editor Landon Jones. He had attended the 1995 Academy Awards, and had noticed that the audience was almost entirely white. He also noted that the seat-fillers – the formally dressed stand-ins whose job it was to temporarily occupy the guests' seats whenever they got up, so TV viewers always saw a full auditorium – were also exclusively white.

These jobs were often awarded to friends and family of the mostly white Academy member base. Finally, Jones noted that the people who came to the stage to receive awards that night were also mostly white. 'I came back to *People* and said, "We need to do a story about this," ' he recalled.[22]

The results were damning. A detailed 3,000-word article concluded that the industry was institutionally racist, from the soundstages right through to the boardrooms. 'Exclusion of minorities has become a way of life in Hollywood,' the article stated. Journalists reported that memberships of the Directors Guild and the Writers Guild were less than 3 per cent Black. They also found that only 2 per cent of stage-hands were Black. African Americans accounted for less than 2 per cent of Local 44, a 4,000-member union of craftspeople and technicians. Of AMPAS's 5,043 members, fewer than 200 (or 3.9 per cent) were African American, despite the fact that they made up 12 per cent of the US population, and 25 per cent of the cinema-going audience. 'Hollywood's creations are the mirror in which Americans see themselves – and the current racially skewed reflection is dangerously distorted,' wrote the article's author, Pam Lambert.

The story provided revealing testimony from some of Hollywood's Black film technicians, and exposed the day-to-day racism they encountered behind the scenes. Sound mixer Russell Williams recounted an incident in which he attempted to board a location truck to retrieve his audio equipment, at which point he was stopped by a white security guard, who thought he was an intruder. 'That kind of stuff happens to me all the time,' he lamented. Williams was the first ever Black double-Oscar winner, for Best Sound, for *Glory* (1989) and *Dances with Wolves* (1990). But this counted for nothing. What mattered in this case was his skin colour. Even as a top professional, he felt that the industry was still trying to limit his progress. 'The more successful you are, the more they hate you. If there is some other way to keep you out of the good jobs and the good seats, they'll find it.'[23] A follow-up piece by *ABC News Washington* highlighted Black cinematographer Bill Hill, who was also a tutor at the University of Southern California. He spoke of an incident in which a white executive arrived on set and removed Black crew members from their roles on a television production, under

the premise of wanting, as the executive himself put it, to 'lighten and brighten the show', said Hill.[24]

The *People* article highlighted what many had been saying for a long time – that the problem was not just AMPAS, but the lack of opportunity within the Hollywood filmmaking process. With an absence of African Americans at executive level, where the big decisions were made, inequalities were inevitable. Minorities were not part of the negotiations and deals made between studio executives, producers, directors and agents, from the corporate offices to the beaches of Malibu and the barbecues of Bel Air's backyards. Hollywood's power fraternity 'has levels of segregation that would not be accepted in IBM or American Express', said Black producer/director/screenwriter Reginald Hudlin.[25] The number of African Americans at vice-president level or higher could be counted on one hand. The only Black faces to be seen regularly at these heady heights were security guards, chauffeurs and cooks.

At the other end of the spectrum, among the unions, nepotism and racism delayed or blocked minorities from entering the industry and progressing. 'Unions are probably the ultimate good ol' boy network in terms of protecting their turf and their people,' said John Mack, president of civil rights group the National Urban League. 'You find father bringing in son.' It was a situation that Shirley Moore, founder of the Alliance of Black Entertainment Technicians, had experienced first-hand. 'It took me eight years to go from stage sweeper to [union] prop master,' she said. 'I could have been a f—in' doctor in that time.'[26] Black filmmakers such as Spike Lee took matters into their own hands by hiring Black crews as a means of fast-tracking them into the system. While shooting *Do the Right Thing* in 1989, he managed to get 11 African Americans into the union.

Others took their complaints to the US Equal Opportunity Commission. Chairman Gilbert F Casellas met with civil rights organizations, film industry representatives and unions in Los Angeles in early 1996, after which he announced an investigation into allegations of discriminatory hiring practices. 'There really does seem to be a problem,' he admitted. 'Some of the grievances I have been told about are blatant and egregious.' While many in Hollywood concurred with his view, few were motivated to do anything about it – although

some did try. In March 1996, the Hollywood Internship Program (HIP) was launched. Sponsored by the city of Los Angeles, it pledged to hire interns from low-income inner-city households, and to give them a start in the movie business. A celebrity launch offered up Chris Farley, David Hasselhoff, Jim Belushi, Jonathan Silverman and Dean Cain. Although its aims were admirable, right from the start there were problems. HIP's admittance criteria were fuzzy. It was unclear who qualified as 'low income', and there was no detail on how many interns the programme would take in, what the age limit was, or what educational requirements might be needed.[27]

In the wake of the *People* article, AMPAS went on the defensive. The 'academy is probably the most liberal organization in the country this side of the NAACP', boasted executive director Bruce Davis in the *Los Angeles Times*.[28] With reference to the absence of Black nominees that year, he said, 'Show me the wonderful performances that have been overlooked.'[29] Davis obviously did not rate the work of Washington, Cheadle, Fishburne, Freeman or Bassett that year. The wider implication behind his statement was more troubling – that the Academy did not have a race problem; the issue was simply that Black actors were not good enough. Time and time again, the Academy's senior executives dealt with its racism by pretending it simply did not exist. There was an underlying sense that they didn't really care about the racism present within their ranks. It didn't affect them and their lives. It didn't stop successful movies from being made. They would have much preferred if minorities would stop complaining, be grateful for what little they had, and accept the world as it was. Fairness fatigue had set in once more.

The thing that would not go away was the imbalance within the Academy's membership. It was a badly administered database, if indeed it could be called that at all. AMPAS didn't collect data on its racial demographics, and so they had no idea how many members were male, female, Black, white, indigenous, Hispanic or other. This was no surprise, given the times. When AMPAS was founded in 1927, diversity was non-existent as a code of conduct. But, since then, 70 years had passed, and the world had modernized. We had colour televisions and Concorde, but the Academy was still stuck in 1927 – in the old boys' club,

where minorities and women were excluded. The organization had become a dinosaur, lumbering along amid the flurry of modernity flashing past its legs. It didn't seem to recognize itself – to see its own disfigurement. On the one hand, its generous intent as a purveyor of accolades and glittering prizes was welcomed and celebrated, while on the other it was a conduit for racism and sexism.

The Academy's intransigence in the wake of the *People* article set it off on yet another collision course with civil rights groups. Three days before the Academy Awards ceremony, Jesse Jackson and his Rainbow PUSH Coalition of activists held a press conference where Jackson called out AMPAS on its inherent racism, and announced plans for a protest against the upcoming Awards. 'It doesn't stand to reason that if you are forced to the back of the bus, you will go to the bus company's annual picnic and act like you're happy,' he said.[30] Jackson's last-minute protest plan was met with dismay and anger by Hollywood's Black elite, who were preparing to attend the ceremony: tuxedos had already been dry-cleaned, evening gowns had been delivered, hairdressers and babysitters and limos had been booked. More importantly, they had not been consulted about what action should be taken on their behalf, if any, or when. Like civil rights leaders of the past who had taken it upon themselves to picket the Oscars, Jackson was seen as meddling. Nevertheless, even if he had consulted with them prior to his planned event, and given them more notice, Hollywood's Black actors would never have joined a picket line. This was the preferred action for non-actors – civil rights organizations and community leaders, those outside 'the family'. Hollywood's insiders preferred to lobby for change from within. But by what means?

Jackson's protest was potentially most embarrassing for three African Americans who were fronting that year's ceremony: Oprah Winfrey, the official red carpet greeter; Whoopi Goldberg, Oscars host; and Quincy Jones, the first African American ever to produce the show. Even though there were no Black Oscar nominees that year, it was seen as ill-judged that Jackson had decided to stage a protest in a year when three prominent Black stars were presenting. In an interview with *Playboy* in January 1997, Goldberg said, 'He [Jackson] basically put me and Quincy in the position of choosing to do this thing we wanted to do and felt was a very positive thing to do, or to stand up alongside him. He put us

in the position of looking like we were kissing somebody's ass.'[31] Jones, who publicly agreed with Jackson's aims, took issue with his methodology and its timing. The two men held a meeting before the ceremony, where Jackson agreed to divert his protest away from the Dorothy Chandler Pavilion, where the Oscars were going to be held. Instead, he agreed to picket the local affiliate offices of the ABC television network, which would be broadcasting the ceremony on the night. Jackson urged all Black Oscar attendees to wear special rainbow-coloured ribbons on their lapels, as a statement of protest against the Academy's inequalities.

The 68th Academy Awards went ahead as scheduled on 25 March. Jackson and his Rainbow PUSH Coalition were situated across town, protesting outside the ABC Television Centre, while others targeted subsidiary stations around the country. Meanwhile, inside the Oscar ceremony itself, Goldberg walked onto the stage and delivered her opening comedic monologue, aiming a salvo at Jackson's last-minute boycott and his request for Black attendees to wear rainbow-coloured ribbons. Of the ceremony's total of seven Black presenters, who also included Sidney Poitier, Will Smith, Angela Bassett, Laurence Fishburne and Naomi Campbell, none complied; the only exception was Quincy Jones. Any opponents to change within the Academy's ranks would have been gleeful that African Americans were divided and arguing among themselves.

The morning after the ceremony, Jackson's protest was pronounced an unmitigated failure. The *Los Angeles Times* called it an 'epic tactical goof'.[32] The Los Angeles picket reportedly attracted only 75 activists, with 300 in Chicago and barely a dozen in Washington. Jackson's efforts were mocked by some white actors. *Saturday Night Live* joked about his failure, and during the ceremony itself Jackson's cause was reduced to a punchline by actor Nathan Lane. 'I just saw Ross Perot outside yelling and screaming,' he said, while presenting an award. 'He wants to know why more nutty billionaires weren't nominated.'[33] Whites felt emboldened in mocking Jackson's efforts, because Blacks had mocked them too.

Peter Bart, editorial director of *Variety*, wrote a stinging rebuke, both of Jackson's campaign and the *People* article, in his 24 March edition. He questioned the validity of the latter's journalism, and suggested that the publication was fit

only for the trash. As far as he was concerned, the Academy was not racist, citing the presence of Goldberg, Jones and Poitier as proof, and, similarly, things were fine at executive level too, with senior Black employees at Time Warner, Disney and Discovery. He also saw no issue with Blacks getting jobs in the film industry, and instead blamed them for not trying hard enough. 'No matter what anyone tells you, Hollywood hires on merit, and the opportunities are there,' he wrote. 'Why aren't more blacks going out for these jobs?' He also stated that racial divisions created by the acquittal of O J Simpson on murder charges in 1995 had eroded white sympathies for race inequities in Hollywood. 'Johnnie Cochran and his client, O.J. Simpson, have sharply reduced the number of good souls around who will go out on a limb to extend a helping hand,' he wrote.[34]

With everyone, from actors to journalists, Black and white, attacking Jackson's ill-conceived protest, the serious underlying issue of Hollywood and the Academy's systemic racism was lost in the melee – reduced to a sideshow played out on the streets beyond the red carpet. Jackson's error was that his protest was hastily compiled, and it was non-collaborative. As it was, it ended up being nothing more than a faint noise from outside Hollywood's gilded gates. There was nothing to boost or sustain Hollywood Blackout after this, and no figurehead to drive it – and so it died, like an old car running out of gas in the middle of a busy freeway.

Looking back, Jackson's protest reflected the opposite polarity: Hollywood's Black elite had no formal strategy of their own to combat the inherent racism they also objected to. The only form of protest they were actually willing to endorse was the weakest one of all – to intermittently boycott the ceremony by not attending. But the decision to stay home and watch the event on TV changed nothing. So, Jackson had failed. But so had they.

<p style="text-align:center">*</p>

For five years, Hollywood writer/director Cameron Crowe had worked on a comedy-drama about a high-powered sports agent who is fired from his job after developing a crisis of conscience. He then strikes out on his own with his one and only client – arrogant NFL star Rod Tidwell. The script, called *Jerry Maguire*, was written for Tom Hanks in the title role, but it switched to Tom Cruise after

Hanks turned it down. In early 1996, Damon Wayans, Alan Payne and Mykelti Williamson were touted to play Tidwell, and Jamie Foxx also auditioned but was rejected. Bronx-born actor and ex-breakdancer Cuba Gooding Jr was put forward by his agent. He was a rising star, having debuted in *Boyz n the Hood* and featured in films such as *A Few Good Men* (1992) and *Outbreak* (1995).

At the first script read-through, Crowe and his producer, James L Brooks, were so impressed with Gooding's vibrant energy and comedic verve that he instantly became the hot favourite. 'We were wildly impressed,' Brooks recalled. 'From that moment,' added Crowe, 'we thought of Cuba as our man of destiny.'[35] Initially there was concern from the studio that Gooding didn't have a football player's physique, and so he bulked up at the gym. By the time he was recalled for a second reading, he suddenly looked the part, and was cast thereafter.

Jerry Maguire was released on 13 December 1996, and was a big box office hit, grossing $273 million against costs of $50 million. Gooding's performance was lauded by critics, and Tidwell's catchphrase 'Show me the money' was immortalized into the pantheon of the most popular lines in movie history. When the nominations for the 69th Academy Awards were announced on 11 February 1997, the film featured in five categories, including Best Picture, Best Actor (Tom Cruise) and Best Supporting Actor for Gooding. When asked about how it felt to be one of the few Black actors ever nominated, he replied: 'Hi, Denzel. Damn, it feels good, brother. Hi, Sidney. Hopefully I'll be there some day.'[36] But there was some tough competition to get through from fellow nominees William H Macy (*Fargo*), Armin Mueller-Stahl (*Shine*), Edward Norton (*Primal Fear*) and James Woods (*Ghosts of Mississippi*).

The day after the nominations were published, the *Los Angeles Times* ran a follow-up piece on Jesse Jackson's 1996 Oscars protest. 'What a non-difference a little more than a year makes,' read the article. It contended that nothing had changed since Jackson's boycott, despite the inclusion of two Black nominees in the latest shortlist. 'These two nominations represent a small step forward, but Hollywood continues a basic whiteout of African Americans and other minorities,' said John Mack.[37] Omitted that year were critically acclaimed performances by Denzel Washington (*Courage Under Fire*), Samuel L Jackson

(*A Time to Kill*) and Eddie Murphy (*The Nutty Professor*). There were also no Latinos or Asian Americans in major contention either, aside from Jessica Yu, nominee – and eventual winner – for Best Documentary Short (*Breathing Lessons*). All this was despite the fact that Blacks and Latinos made up approximately a third of the US cinema-going audience.

Zara Buggs Taylor, executive administrator for employment diversity at the Writers Guild of America at the time, re-stated that the issue was not the Oscars per se, but the discrimination present within the filmmaking process itself. 'If minorities aren't there at the beginning, why should they be there at the end?' she asked. Kweisi Mfume, president and CEO of the NAACP, concurred, concluding: 'I don't think it's racism so much as the lack of opportunities.' Meanwhile, Jerry Velasco, president of the Latino actors' group Nosotros, noted the drop-off in the numbers of Latinos and Asians employed in the industry. 'We need to concentrate on getting the numbers up so that we can be at the Oscars,' he insisted. Jackson and his Rainbow PUSH Coalition were criticized for their lack of follow-up on the issue, although they maintained that it was still on their radar. '[W]e can't depend on Jesse Jackson to continue our fight,' said Velasco. 'Jesse has to realize that if he's not going to go all the way, he shouldn't get it started.' But Sonny Skyhawk, president of American Indians in Film, called for greater collective effort. 'This is not a Jesse Jackson fight,' he said. 'We all have to work together. We need to become a lot more united. Only then will we have power.'[38]

On 24 March 1997, the 69th Academy Awards were held at the Shrine Auditorium & Expo Center, Los Angeles. Gooding and Woods were neck-and-neck favourites for Best Supporting Actor. Gooding had been nominated for a Golden Globe, and he had won the SAG Award along the way. As proceedings commenced, he sat nervously in the audience alongside his wife, Sara. When his category came up, actress Mira Sorvino appeared on stage and recited the names of the nominees. While she opened the envelope, Gooding closed his eyes and bowed his head in hope. Then, when he heard his name, he sighed with relief, kissed Sara, rose to his feet, turned and hugged co-star Tom Cruise, then approached the stage. At the top of the stairs he faced the audience and struck a

momentary victory pose, before continuing to the podium. Gooding knew he was up against the clock, and had to make his speech quickly. He began by thanking Sara, his parents, and God. 'Thank you, Father God, for putting me through what you put me through, but I'm here and I'm happy,' he said. But Oscars speeches were restricted to just 30 seconds, and Gooding's time was up. The closing music started to play. Not to be outdone, he carried on talking, using the orchestra as a backing track, and becoming louder and more animated. 'Okay, the studio, I love you. And Cameron Crowe and . . . Tom Cruise! I love you, brother! I love you, man!' The audience, infused by his energy, began rising to their feet, applauding and cheering. The more he said the word 'love', the more they responded.

But, like so many other winners before him, the love he expressed so passionately went unrequited. Mirroring the misfortune of Hattie McDaniel and Louis Gossett Jr, Gooding did not work for a whole year after winning. 'I was banished to the wilderness,' he told *Page Six*.[39] He also admitted that his progress was hampered by his own stubborn unwillingness to take advice. Crowe had privately advised him only to work with the best directors. 'I didn't listen,' said Gooding. 'It didn't resonate with me, so I said "no" to *Amistad*, I said "no" to *Hotel Rwanda* and the list goes on and on and on . . . Finally, directors were probably afraid to offer me anything.'

Instead, he featured in a host of trashy, forgettable, direct-to-video movies. But he did manage to claw his way back, starring in *Men of Honor* (2000), *American Gangster* (2007), *The Butler* (2013) and *Selma* (2014). However, success did not last. In April 2014, his marriage to Sara, his high-school sweetheart, ended after 20 years. In the aftermath, he lost his way. The effervescent energy and bright light that won him the role of Tidwell, and propelled him to an Oscar, were now suddenly dimmed. He descended into a fog of drinking and womanizing that ended in embarrassment and shame, as he was subsequently accused of multiple counts of sexual misconduct spanning a ten-year period. In 2022, in one case, he pleaded guilty to a lesser charge in order to avoid jail. The following year, a civil case was brought by a woman who accused him of rape in

a Manhattan hotel room in 2013; he settled out of court for an undisclosed sum.[40]

The Oscar, rather than making him, proved to be the precursor to his downfall. For too many of its winners, this coveted golden object had the same effect as the fictional golden ring from J R R Tolkien's *The Lord of the Rings*. Though highly prized, it eventually brought misfortune upon those who possessed it.

*

Gooding's downfall was a far cry from the world occupied by Hattie McDaniel, the grande dame of African American Oscar winners. In 1999 Hollywood's attention briefly swung back to Black cinema's first winner and the legacy she laid down. Back in 1952 she was denied the right to be buried in the Hollywood Memorial Park Cemetery, due to segregation. But the cemetery now had new owners, and they offered McDaniel's family the chance to right the wrongs of the past, and to have her body re-buried there. Her descendants, however, were not keen on digging up her remains, and so instead they agreed to an alternative plan to erect a monument in her honour within the cemetery grounds. On 26 October, her family and friends gathered before the structure – a cylinder of grey-pink granite erected adjacent to the tomb of Douglas Fairbanks. McDaniel's great-nephew Edgar Goff Jr had composed its inscription, which read: 'Aunt Hattie, you are a credit to your craft, your race and to your family.'[41]

*

It was 1995 when actors-turned-screenwriters Milo Addica and Will Rokos penned a romantic drama about a racist death row prison guard who begins a relationship with a struggling widow, unaware that he assisted in the execution of her late husband. The script, called *Monster's Ball*, spent years in development, bouncing from Robert De Niro to Oliver Stone, until it finally settled on the desk of producer Lee Daniels and Lionsgate Films, who enlisted Marc Forster as director. The role of the troubled widow and waitress, Leticia Musgrove, was offered to Angela Bassett and then to Vanessa Williams, before finally finding its way to a 34-year-old ex-model and beauty queen from Cleveland, Ohio, called Halle Berry. Her acting career began in 1991 in Spike Lee's *Jungle Fever*, and she

had gone on to star in *Boomerang* (1992), *The Flintstones* (1994), *Bulworth* (1998) and *Introducing Dorothy Dandridge* (1999), a biopic of the trailblazing 1950s actress, for which she won a Primetime Emmy Award and a Golden Globe.

Monster's Ball arrived at exactly the moment when Berry was tired of being cast for her looks, and desperate to transition into roles with a greater sense of character and creative scope. When she read the script, she was instantly drawn to Musgrove, and the emotional pain and struggles she endured. Berry felt she could bring elements of her own personal hardships to the part. She had witnessed domestic abuse as a child, and had also spent a period in a homeless shelter at the beginning of her acting career in New York. But Daniels was unconvinced that she was right for the role. He was concerned that the way she looked would render the character less believable. Berry was determined to prove him wrong. 'I became obsessed with proving that I could do this, and I had to get this role,' she said.[42] Just like Dorothy Dandridge in 1952 when she was auditioning for the part of Carmen Jones, Berry had to break from her typecasting in order to show the depth beyond her beauty. Eventually, she sidestepped Daniels and appealed directly to Forster, who recognized what she could bring to the role. Berry was cast, alongside Billy Bob Thornton, Heath Ledger, Peter Boyle, Sean Combs and Mos Def.

Meanwhile, on 21 July 1999, *Variety* reported on the script for a film called *Training Day* – a Los Angeles crime thriller about a veteran narcotics detective who introduces a rookie officer to the harsh realities of life on the job. Written by newcomer David Ayer, the manuscript was originally shopped around the Hollywood studios as a writing sample to showcase his work, before eventually being picked up by Warner Bros. Davis Guggenheim was attached to direct, and Samuel L Jackson and Matt Damon were slated to star as veteran detective Alonzo Harris and rookie cop Jake Hoyt, respectively. But the deal fell through early in development, and Antoine Fuqua took over as director, with Denzel Washington and Ethan Hawke brought in to play the LAPD detectives. It was actually Washington's son John David who talked him into doing it, as it was so different from anything his father had done before. Hawke's role was also offered to rapper Eminem, who turned it down in favour of *8 Mile*.

The movie was shot on location in some of what were then Los Angeles's most dangerous neighbourhoods, including South Central, Crenshaw, Watts, Inglewood, Rampart, Echo Park and Lincoln Heights. To prepare for the role Washington and Hawke hung out with local gang members, drug dealers and undercover cops. For Washington, playing the role of Harris – a corrupt, malevolent baddie – was a radical departure from the good guy heroic roles that had made his name. But he adapted seamlessly. 'Watching Denzel bring Alonzo to life was really chilling,' said Ayer. 'It gave me goose bumps. He became so much like Alonzo it was scary.'[43] Washington's role also disturbed the NAACP, who believed that, as Hollywood's leading Black actor, he should only play positive film roles. Ethan Hawke told *The Hollywood Reporter* that during filming, the NAACP paid Washington a visit on set, to challenge him on his decision to play a villain. Washington blasted back at them, 'What, Al Pacino can play a bad guy? Gene Hackman can play a bad guy? I can't play a bad guy? I'm an artist. That's how I lead, not by being some dubious role model, by only playing squeaky-clean people. I'll be a role model by being great at my job.'[44]

On 8 February 2002, *Monster's Ball* was released in North America, taking $45 million from costs of just $4 million. The film received positive reviews, with critical acclaim for Berry, Ledger and Thornton. When the nominations for the 74th Academy Awards were announced on 12 February, Berry became the seventh Black woman to make the list for Best Actress. Also in contention were Judy Dench (*Iris*), Nicole Kidman (*Moulin Rouge!*), Sissy Spacek (*In the Bedroom*) and Renée Zellweger (*Bridget Jones's Diary*). Four months earlier, *Training Day* was released in theatres, and was also a hit, grossing $104 million from a budget of $45 million. It was well-received by critics, who praised the performances of Washington and Hawke. Both actors were also nominated for that year's Awards, Washington for Best Actor and Hawke for Best Supporting Actor. It was the first time in three decades that two Black nominees had featured in the top male and female acting categories. Washington was up against Russell Crowe (*A Beautiful Mind*), Sean Penn (*I Am Sam*), Will Smith (*Ali*) and Tom Wilkinson (*In the Bedroom*).

Halle Berry was convinced she would not win the Academy Award for

Monster's Ball. The Golden Globe for Best Actress – considered the precursor to the Oscars result – had been claimed by Sissy Spacek, who started as favourite for the Oscar. 'I'd pretty much resigned myself to believing, "It's great to be here, but I'm not going to win",' she told *The New York Times*.[45] She was so sure of it that she didn't prepare a speech. The press were also sceptical. '[I]t will take some luck and even more good will from the Academy for "Monster's Ball" to get a chance to go to the Big Dance,' wrote Robert Koehler in *Variety*.[46]

At this point in Washington's career his prodigious talent was so widely admired within Hollywood that whenever he was nominated but failed to win, there was a sense of shock and incredulity among his peers. In 1993, when he was nominated for Best Actor for *Malcolm X*, and subsequently lost to Al Pacino for *Scent of a Woman*, director Spike Lee was so displeased that years later he vented his feelings vicariously through a fictionalized conversation between characters in *She's Gotta Have It*, the Netflix series based on his 1986 film of the same name. In an interview with *Playboy*, Washington himself stated that he was glad not to have won, out of respect for Pacino. 'I didn't want to win that time,' he said. 'I would have felt badly. It was Pacino's time.'[47] In 2000, when Washington was nominated for Best Actor for *The Hurricane*, John Singleton was so sure he would win that he bought three Armani suits for that evening's celebrations, ready to party all night long. But then Kevin Spacey was announced the winner instead, for *American Beauty*. Some speculated that Washington may have lost as a result of the fact that *The Hurricane* omitted some of the more unsavoury details about the life of Rubin Carter, the real-life boxer on whom the movie was based. Washington himself attributed its loss to a lack of promotion by the studio. Regardless, Singleton was not happy. 'I just went home and went to bed,' he said.[48] And the suits went back into the wardrobe.

Less than two weeks after the 2002 nominations were announced, Washington's chances of winning Best Actor were discussed in an article in *Newsweek*. It published an in-depth profile that ran to 3,600 words, entitled 'Will It Be Denzel's Day?'[49] Its author, Allison Samuels, spoke to the movie star about life as a Black actor in Hollywood. 'There is a ceiling for black actors, no doubt about that,' he said. 'I mean, I'm not getting dozens of roles at my door either.

But I try to keep thinking of it as a glass ceiling, one that can be broken at some point. I might not see it or do it, but somebody will.' White Hollywood, however, was generally less optimistic about this assumption. 'Denzel isn't going to get the roles that Russell Crowe gets,' said director Ed Zwick. 'He can't be in "The Insider" or "Gladiator," and that's very limiting to an actor like him. But it's also what makes his career so astonishing, because he has done so remarkably well with those limitations.' To his long-time colleague and friend, Julia Roberts, Washington was the best actor of his generation – but that didn't matter. Race mattered. 'He should be on his third Oscar by now,' Roberts said. 'I mean, did you see "Malcolm f—ing X" and "Hurricane" and Philadelphia"?! I could go on,' she maintained. 'I cannot absorb living in a world where I have an Oscar for best actress and Denzel doesn't have one for best actor.'

Washington himself was more clued-up now about his chances of winning, after losing out in the past. He compared his odds with those of one of his movie idols, Al Pacino, who was nominated eight times straight before finally winning in 1992, for *Scent of a Woman* – ironically beating Washington for *Malcolm X*. 'Hey, at least I'm not 0-8 like Pacino,' he laughed. 'Then I would be screaming bloody murder.'[50] The timing of the *Newsweek* article was perfect, as it came out right in the midst of the Oscars voting season. Could it influence the way the vote might swing?

As it turned out, Russell Crowe's behaviour during awards season may have also influenced the vote in Washington's favour. Crowe had all the momentum heading into the Oscars, having won the Golden Globe, Critics' Choice, SAG and BAFTA awards – but then he self-destructed in dramatic fashion when, in a widely publicized incident, he let loose in an angry tirade against BBC producer Malcolm Gerrie, pinning him against a wall after he edited out part of Crowe's BAFTA acceptance speech from a TV broadcast. He reportedly declared that Gerrie would 'never work in Hollywood'.[51] What effect did Crowe's violent outburst have on the Oscars vote? We will never know for certain.

The 74th Academy Awards were held on 24 March 2002, at the Kodak Theatre at the Hollywood & Highland Center, Los Angeles. The ceremony took place just months after 9/11, and so security was tighter than normal. The show

was presented by Whoopi Goldberg, who was hosting for the fourth time. Halle Berry arrived on the red carpet wearing what has become one of the most iconic gowns in Oscars history. Created by young Lebanese designer Elie Saab, and chosen on the suggestion of her stylist, Phillip Bloch, the top half of the outfit consisted of a see-through mesh bodice adorned with elaborate, strategically placed floral embroidery in green and pink, while the bottom was composed of a full-length asymmetrical silk taffeta skirt in burgundy. The original outfit, designed as part of Saab's 2001 runway collection, did not include the embroidery on the bodice, but its transparency was too risqué for the Oscars, and so the embroidery was added in by Hollywood seamstress Madeleine Aikenberg, in order to cover the Oscar nominee's breasts. Bloch made some additional alterations, too, moving the zipper on the bodice from the back to the side for a cleaner look, and tapering the skirt closer to Berry's body, in order to accentuate her figure. The dress 'was in line with where I was at that time, feeling courageous and bold and wanting to take risks and chances', she later recalled.[52] By wearing the gown Berry also made a bold declaration: *If I'm gonna lose, I'm gonna lose looking good. I'm gonna lose looking better than the winners!*

At 7.50pm the Oscars ceremony made a special presentation – an Honorary Academy Award for Sidney Poitier, in recognition of his accomplishments as an artist, and as an inspiration to a generation of young actors. Introduced by Denzel Washington and producer Walter Mirisch, Poitier stepped onto the stage to cheers and a standing ovation that lasted for a full minute and a half. In his speech, he reflected on arriving 'at the end of a journey that in 1949 would have been considered almost impossible' and thanked the directors, writers and producers whose efforts to change the status quo he and the industry as a whole had benefited from. 'I accept this award in memory of all the African American actors and actresses who went before me in the difficult years,' he said, 'on whose shoulders I was privileged to stand to see where I might go.'

Poitier left the stage to another standing ovation from his Academy colleagues, plus Denzel Washington, for whom Poitier had been a mentor and confidant for 20 years, and whose legacy had opened so many doors for him. It was a fitting close to an era that had seen the first African American win Best Actor, and prove

to Hollywood in the process that a Black artist could be a box office superstar, playing radical new roles that broke with the past.

*

Back among the audience, Halle Berry was seated between her mother, Judith, and husband, Eric Benet, applauding the Poitier tribute. At 9.15pm Russell Crowe appeared on stage to present the Academy Award for Best Actress. As he read out the nominees, Berry's expression was calm and relaxed – accepting of the fact that she was not going to win. But then Crowe opened the envelope and made a shock announcement: 'And the Oscar goes to . . . Halle Berry, *Monster's Ball*.'

'Oh my God! Oh my God! Oh my God!' She repeated it over and over, frozen into her seat in stunned disbelief, her face locked in a taut mask of half-surprise, half-panic. Her entourage were wildly animated around her, gesticulating, clapping, hugging her, kissing her. 'I think I left my body,' she said later.[53] Her manager, seated behind her, broke her out of her trance and ordered her to the stage. She rose unsteadily and made her way, barely remembering to lift her dress clear of her feet to climb the seven steps to the podium – only seven, and yet it had taken a woman of colour 75 years to climb them in order to get to this Oscar. She was trembling as she hugged Crowe, who looked at her and said, 'Breathe, mate, breathe, mate!' She faced the audience, still struggling to believe what was happening. The applause subsided and the audience waited for her words. But none came. The air crackled with suspense and anticipation. For the first 30 seconds she just stared into the audience – mute, breathless, open-mouthed, crying – trying to make sense of the madness. 'Oh my God! Oh my God!' Benet got up and started clapping. Others started clapping, too. Then finally she composed herself; finally she found some words. 'This moment is so much bigger than me,' she began. She paid homage to fellow pioneers Dorothy Dandridge, Lena Horne, Diahann Carroll, Jada Pinkett Smith, Angela Bassett and Vivica Fox, and maintained that her Oscar win was 'for every nameless, faceless woman of colour that now has a chance, because this door tonight has been opened.'

*

As Washington left the stage after presenting Sidney Poitier's Honorary Award, little did he know that he would soon be back on the podium to make history himself. The moment came just 15 minutes after Halle Berry's, as Julia Roberts, presenting the Award for Best Actor, called out the names of the nominees. Seated in the audience, Washington wore a black tuxedo by Giorgio Armani. The fit was uncomfortable, despite the fact that he had had his tailor take three inches out of the back of the jacket. 'Everyone is watching the Academy Awards to see who's going to win, and I'm there squirming,' said Washington. 'I'm squirming not because I'm worried about the award, but because the suit doesn't fit.'[54] But Washington's attention instantly switched as Roberts opened the envelope, smiled, and announced him as the winner. He was calm when he heard his name – his mien colder this time than when he had won his first Oscar in 1990. To have been nominated four times, and only won once, had muted his response. He simply hugged and kissed his wife Pauletta, then walked casually to the stage. Earlier in the build-up to the Awards, Washington had considered not attending, after his disappointment that *The Hurricane* had been passed over in 2000. 'I'm just not going to go.' he told himself. 'In order to protect yourself, you almost have to not care. So that night I didn't care – and of course, they go, "Here." '[55] As Washington glanced at his first Oscar in over a decade, his face creased into a sly grin. 'Two birds in one night, huh?' he said, in reference to the wins by both him and Berry. 'Oh, God is good. God is great.' Then he turned his gaze toward Poitier, seated in the audience with his family. 'I'll always be chasing you, Sidney. I'll always be following in your footsteps. There's nothing I would rather do, sir . . . God bless you.'

*

It was the Blackest Oscars ever, with three Awards, plus an African American compere. It marked the first and only occasion that both lead acting awards had gone to Black artists. But the victories also exposed the historical rarity of such an event. Berry's accolade as the first Black woman to win Best Actress had taken three-quarters of a century to procure, and was illustrative of just how few roles there were for Black female leads, and how they had been systematically relegated to support roles since the days of Hattie McDaniel. Washington was the first

African American to win Best Actor for almost 40 years, underlying a whole generation of Black artists who had been passed over before him. Poitier, the last to win Best Actor before Washington, was himself the first African American to receive an Honorary Oscar for over half a century, proving that even the retrospective legacy awards had eluded Black artists.

Nevertheless, this was a night for rejoicing. When Berry was a child, she had watched the Oscars on television, and was fascinated by the event, while never feeling a part of it. 'There was always a sense of sadness because I didn't see people like me reflected,' she said.[56] But now, suddenly, she *was* reflected. Now her accomplishments, and Washington's, were part of history. It was time to celebrate. At one of the Oscars after-parties that Washington attended, he ran into Allison Samuels. According to *Newsweek*, he gave her a 'five-minute hug', then placed his Oscar firmly into her hand. 'This is partly because of what you wrote,' he said, referring to her pre-Oscars *Newsweek* profile. 'It was a really amazing moment,' she reported.[57] Could Samuels's article really have been the inciting point that influenced the Academy membership to *think Black*, and vote for Washington? In the past, inciting points had been big, societal events such as the Second World War or the Civil Rights Movement. Could a single piece of journalism now be added to this list?

After he won Best Actor, Washington's career continued to flourish – but only up to a point. He was destined to be nominated four more times between 2002 and 2022, but he would not win again in that 20-year period. Neither would Halle Berry. Once again, winning the golden statue did not usher in a windfall of opportunities. '[T]here was no place for someone like me,' Berry told *Variety* in 2020.[58] The fact that she was gifted with talent and beauty – and now an Oscar – did not catapult her into Hollywood's premier league. Such privileges were reserved for the era's white megastars, Julia Roberts, Cameron Diaz, Sandra Bullock and Jodie Foster. 'I thought, "Oh, all these great scripts are going to come my way; these great directors are going to be banging on my door." It didn't happen,' she said. 'It actually got a little harder.' Just like Louis Gossett Jr before her, Berry's Oscar had turned into kryptonite.

Nevertheless, overall the outlook was one of optimism. The advent of more

frequent Black Oscar winners after 1990 was accompanied by an increase in nominations within the four acting categories. The period between 1984 and 2002 produced seven in both the Best Actor and Best Supporting Actor categories, plus three in the Best Actress and five in the Best Supporting Actress categories. This total of 22 nominations represented an increase of 47 per cent on all the previous decades in the Academy's history put together. Plus, its five winners from 22 nominations (23 per cent) exceeded the achievements set over that same period. Judging by these figures, things were undoubtedly better for Black artists. But while 'better' was good, it was not equality. As Hollywood entered a new century, the big question that hung in the air was: would equality ever be achievable?

CHAPTER 6
FAST FLURRY (2003–2014)

'[F]or African-Americans, breaking into Hollywood can be like climbing a mountain of marbles.'
Pam Lambert, *People* magazine, 18 March 1996

On the evening of Tuesday, 30 July 2013, the Academy of Motion Picture Arts and Sciences made a historic announcement on Twitter. Film marketing veteran Cheryl Boone Isaacs had been elected 35th President by the organization's Board of Governors. Isaacs, ex-director of publicity at Paramount Pictures, was an Academy veteran who had joined in 1987, and had served on its Board for 21 years. Moreover, she was the first African American, and only the third woman, ever to head the 86-year-old organization. This latest appointment was a massive moment in the Academy's history. An institution conceived by white men, for white men, now had a Black woman in charge. Louis B Mayer would have been turning in his grave. Isaacs was 'the great Black hope' of Hollywood's ethnic minorities. Her appointment brought with it the dream, the expectation, that the Academy's long-running diversity problem would finally get fixed. But would it?[1]

The double victory of Denzel Washington and Halle Berry at the 2002 Oscars did not usher in the changes that many had hoped for. The very thought was naive. It would take more than this. But how much more? And what did change even look like? Hollywood's women and minorities, in their reluctant stoicism, had seen the doors of opportunity swing open briefly, but then swing back again in their faces. And so they continued their seemingly endless uphill fight for fairness, making modest gains wherever possible.

For the artists of indigenous nations there were no gains at all. They were the forgotten people of Tinseltown and its golden Oscars. Throughout the period

they received only two nominations. In 2004 Keisha Castle-Hughes became the first actor of Maori ancestry to be nominated, for Best Actress in *Whale Rider*. The following year, director Taika Waititi, also of Maori heritage, was nominated for Best Short Film. For Native Americans, once again the pot was empty, with no nominations at all. Latino artists fared only slightly better. In 2003 Mexican Lebanese actor Salma Hayek was nominated for Best Actress, for *Frida*, while Carlos and Alfonso Cuarón were selected for Best Original Screenplay, for *Y Tu Mamá También*. In 2004 Benicio del Toro was nominated for Best Supporting Actor, for *21 Grams*, and Fernando Meirelles made the list for Best Director, for *City of God*.

For Asian actors, getting cast in any mainstream role in a Hollywood production was proving extremely difficult, as Korean American actress Sandra Oh, star of *Sideways*, *Grey's Anatomy* and *Killing Eve*, knew all too well. 'I am not an easy sell,' she told *The New York Times* in 2004. 'I'm not blonde. You can't place me in movies the way you can with certain actors. It's very difficult for my agents. They say to me, "I have a hard time getting you in" and all I want is a shot.'[2] Japanese actor Ken Watanabe was one of the few that Hollywood allowed into its ranks, starring in *Memoirs of a Geisha* (2005), *Batman Begins* (2005) and *Inception* (2010), among others. In 2004 he was nominated for Best Supporting Actor, for *The Last Samurai*.

After the triumph of the 2002 Oscars, things cooled for African Americans in the following two years, with only one actor featuring in the nominations for both years: Queen Latifah, for Best Supporting Actress, in *Chicago*, and Djimon Hounsou, Best Supporting Actor, for *In America*. But things heated up suddenly in 2005, when the nominations for the 77th Academy Awards were released on 25 January, and included five Black nominees. Jamie Foxx became the tenth person to feature in two categories simultaneously: Best Actor, for *Ray*, and Best Supporting Actor, for *Collateral*. Morgan Freeman was nominated for Best Supporting Actor, in *Million Dollar Baby*, while Don Cheadle (Best Actor) and Sophie Okonedo (Best Supporting Actress) were nominated for *Hotel Rwanda*.

Directed by Taylor Hackford, *Ray* – a biographical musical drama of the life of

R&B legend Ray Charles – starred Foxx in the title role. Released in North America on 29 October 2004, it grossed $124 million from a budget of $40 million. For the Oscar, Foxx was up against Cheadle, Johnny Depp (*Finding Neverland*), Leonardo DiCaprio (*The Aviator*) and Clint Eastwood (*Million Dollar Baby*). The latter film – a sporting drama about an aspiring amateur boxer (Hilary Swank) coached to the top by a reluctant elderly coach (Eastwood) – was released in theatres on 15 December 2004, grossing $217 million from a budget of $30 million. Morgan Freeman was cast as Eddie 'Scrap-Iron' Dupris, gym assistant and former boxer. For Best Supporting Actor he was up against Alan Alda (*The Aviator*), Thomas Haden Church (*Sideways*), Jamie Foxx (*Collateral*) and Clive Owen (*Closer*).

As awards season commenced, Foxx didn't take his nominations seriously, believing there was no way he could win. Instead, he toured the circuit partying and drinking. 'I remember going absolutely nuts,' he said. 'I was disrespectful to the process.'[3] Foxx's publicist phoned him and shouted down the line, berating him for his bad boy behaviour, and warning him that he had to drastically change his approach. Unknown to Foxx, Oprah Winfrey was also watching – and she was not amused either. She called him up. 'Oprah told me, "You really have a great chance to do something that is wonderful and the character you played [in *Ray*] touched so many people, but not if you act like this,"' said Foxx. To nudge him back on track, Oprah invited him to a party at Quincy Jones's mansion, to meet one person in particular – Sidney Poitier. When Foxx arrived that evening, Poitier took him to one side and said, 'I watched your performance and I grew two inches. I leave you with one thing: responsibility.' Foxx stared at Poitier silently as his words soaked into his psyche. 'Oh shit!' Foxx said to himself. 'No more after-parties. I got to get my shit together.'

On 27 February, at 5.30pm, the 77th Academy Awards, presented by Chris Rock, commenced at the Kodak Theatre at the Hollywood & Highland Center, Los Angeles. Foxx, wearing a blue pin-stripe suit by Ozwald Boateng, was seated in the audience with his 11-year-old daughter Corinne, smiling and holding hands hopefully. 'If you don't win, Dad, you're still good!' she said to him. Fortunately, things did come good 54 minutes into the show, as Charlize Theron announced him the winner.

'Wow! Wow! Wow!' said Foxx, as he held the trophy aloft in triumph. He paid tribute to Ray Charles, as well as to Sidney Poitier. 'I'm taking that responsibility tonight,' he said, in reference to Poitier's earlier counsel. 'Thank you, Sidney'. He also spoke of his late grandmother, Estelle Marie Talley. 'She still talks to me now, only now she talks to me in my dreams,' he said. 'And I can't wait to go to sleep tonight because we've got a lot to talk about.' As the closing chorus filled the air, Foxx left the stage, relieved and happy that he had not blown his big chance.

Ten minutes later Renée Zellweger stepped on stage to present the Oscar for Best Supporting Actor. When she peeled open the envelope and pronounced Freeman the winner, he raised his eyebrows in a look of muted surprise. Despite his expression, he knew he would win. 'I kind of expected it,' he told *Variety* in 2016. '[T]hat was my fourth nomination. I thought sooner or later they are going to break down. Because since this was supporting and not lead, I figured I could probably manage it.'[4] Freeman's speech was short and gracious. He thanked the Academy, and all those involved in the movie, especially Eastwood and Swank.

Two African Americans had won on the same night, just as they did in 2002, when Denzel Washington and Halle Berry were victorious. Back then, Poitier, Black Hollywood's benevolent patriarch, had been an inspiration for Washington, and now, three years on, he was the force that galvanized both Freeman and Foxx. As a young actor Freeman was motivated to believe that he too could win an Oscar after witnessing Poitier's 1964 Award for *Lilies of the Field*. It had taken him a long time to realize his dream. Despite his prodigious talents, he didn't receive his first Oscar nomination until 1987 – after 20 years as an actor. Following that he had been nominated two more times, without winning. But now he had finally done it. Did it change his career? 'No,' said Freeman. 'It put an adjective in front of my name.'[5]

The following year ushered in more breakthroughs for minorities. African American actor Terrence Howard was nominated for Best Actor, in *Hustle & Flow*, while Jordan Houston, Cedric Coleman and Paul Beauregard, otherwise known as Three 6 Mafia, took the Oscar for Best Original Song. The highlight for Asian artists occurred when Taiwanese filmmaker Ang Lee won Best

Director, for *Brokeback Mountain* – becoming the first Asian ever to win the coveted award. Lee's acclaimed drama about two gay cowboys was also favourite for Best Picture, winning a Golden Lion, a Golden Globe and a BAFTA in the run-up to the Academy Awards. In fact, on Oscar night, so sure were the production's stage personnel that Lee's film would win, that he was instructed to wait in the wings beside the stage after collecting his Best Director award, ready to step back on to collect the Oscar for Best Picture, which was next up. But unfortunately, to his surprise and embarrassment, the film *Crash* won instead, in one of the most controversial Oscar decisions ever. Later on, Lee suggested that the loss was due to homophobia among the old guard of Academy voters – some of whom were open in their distaste for the movie's gay theme. 'I didn't see it and I don't care to see it,' said actor Ernest Borgnine. 'If John Wayne were alive, he'd be rolling over in his grave!'[16] This revealed the depth of the problem with sections of the Academy's voter base. It was peppered not just with racism and misogyny, but homophobia too.

In 2007 the nominations for the 79th Academy Awards were the most diverse ever, and featured two movies – *Babel* and *Letters from Iwo Jima* – in which English was a secondary language. There was a shock when the 20 acting categories revealed five Black actors, plus one Latino and one Asian artist, as well as four other people of colour within the technical categories. Forest Whitaker was nominated for Best Actor, for *The Last King of Scotland*; Will Smith was included in the same category, for *The Pursuit of Happyness*; Jennifer Hudson and Eddie Murphy were nominated for Best Supporting roles, for *Dreamgirls*, plus Willie D Burton for Best Sound and Sharen Davis for Best Costume Design. Djimon Hounsou made the Best Supporting Actor list again, this time for *Blood Diamond*. Alejandro González Iñárritu featured for Best Director, for *Babel*, along with Mexican actor Adriana Barraza, nominated for Best Supporting Actress. Newcomer Rinko Kikuchi, nominated as Best Supporting Actress, for *Babel*, became the first Japanese actress to make the list for half a century. Simultaneously, Iris Yamashita was nominated for Best Original Screenplay, for Clint Eastwood's *Letters from Iwo Jima*.

The high number of nominations for Black artists precipitated the closure of

a secret awards ceremony that had taken place every year since 1981, on the eve of the Academy Awards. The Tree of Life Awards, better known as the Black Oscars, was set up by Albert L Nellum, a Washington DC attorney, and his wife Velma, in response to Black artists being perpetually shut out of the Oscars. Their aim was to recognize and honour annual Black achievements in film. The ceremony was organized by a private group – the Friends of the Black Oscar Nominees. Quincy Jones, Sidney Poitier, Maya Angelou and Cicely Tyson were among those involved in hosting the annual gala. Like the NAACP Image Awards, the acting categories mirrored those of the Oscars. The all-Black ceremony was held in private, and for many years no one outside the community, including the mainstream press, even knew it existed. Black journalists in attendance were expected to leave their notebooks at home. The off-the-record nature of the event allowed Black artists to be more relaxed, open and candid about what they said on stage, knowing they would never be quoted. All of Tinseltown's Black elite attended each year without fail. 'It didn't matter how big you were,' said *Newsweek*'s Allison Samuels, who first broke the story about the awards' existence, 'they came every year. I mean it was an insult not to come.'[7] But not all of Black Hollywood heeded this tradition. In 1997 Cuba Gooding Jr did not attend, and neither did Halle Berry in 2002. There 'was definitely this quiet, like how could she not attend?' said Samuels. 'And I don't know if she understood the importance of it . . .' But now the secret show was over. When the nominations for the 2007 Oscars were published, for the first time in a quarter of a century, the Black Oscars organizers decided to retire the presentation, because they felt that African Americans were now adequately and consistently represented at the Oscars, and so there was no longer the need for a separate ceremony. Were they right? Had real and lasting change finally come?

On 25 February at 5.30pm, 40 million US viewers tuned in to watch the 79th Academy Awards, live from Los Angeles. Forest Whitaker, having won the Golden Globe and SAG awards that season, was favourite for Best Actor for *The Last King of Scotland* – a historical drama based on the dictatorship of Ugandan president Idi Amin in the 1970s. Released to wide acclaim on 12 January 2007, the low-budget production grossed $48.5 million from a budget of $6 million.

Whitaker, who stayed in character as Idi Amin throughout the shoot, had to beat Leonardo DiCaprio (*Blood Diamond*), Ryan Gosling (*Half Nelson*), Peter O'Toole (*Venus*) and Will Smith (*The Pursuit of Happyness*).

Whitaker took a sharp intake of breath when actor Reese Witherspoon took to the stage and announced him the winner. He got up fast, walking purposefully to the stage with an unusual urgency, moving quickly up the stairs. Witherspoon handed him the statue, and after several more long breaths he spoke. 'It wasn't my reality to think I would be acting in movies,' he began. 'So receiving this honour tonight tells me that it's possible, it is possible, for a kid from east Texas, raised in South Central LA, in Carson, who believes in his dreams'. He also acknowledged his ancestors, 'who continue to guide my steps, and God, who believes in us all and who's given me this moment in this lifetime'.

Backstage afterwards, Whitaker confessed that he had felt that he might win, again invoking the spirit of his ancestors. 'I thought something magical was going to happen,' he said. 'Because I could feel the breath on my neck and the tingling on my body. For me it is like my ancestors speaking to me and they are saying to me, "We are with you." '[8]

Sixteen minutes later, George Clooney appeared on stage to announce the winner of the Best Supporting Actress. Like Whitaker, Jennifer Hudson was the hot favourite for her debut acting role as Effie White in *Dreamgirls* – a musical drama about the journey of an R&B girl group in 1960s America, and their manipulative record company boss. The movie opened in American theatres on 15 December 2006, grossing $155 million from a budget of $80 million, and turning Hudson, an ex-finalist on TV talent show *American Idol*, into an overnight sensation. To win the Award she had to beat Adriana Barraza and Rinko Kikuchi (*Babel*), Cate Blanchett (*Notes on a Scandal*) and Abigail Breslin (*Little Miss Sunshine*).

Hudson had arrived on the red carpet that evening wearing a full-length brown Oscar de la Renta gown, plus metallic gold bolero, selected for her by *Vogue* editor-at-large, André Leon Talley, in place of a custom-made outfit by Roberto Cavalli that had been suggested concurrently by celebrity stylist Jessica Paster. Hudson would later confess to disliking Talley's choice – as did the

Oscars fashion mafia, who would later relegate her to the ceremony's worst dressed lists.

But her fashion faux pas was the least of her worries as Clooney read out the names of the nominees for Best Supporting Actress. Hudson sat with her fingers clasped together in anticipation. Then her face jolted in shock when her name was called. 'Look what God can do,' she said as she stood on the podium. 'I didn't think I was going to win, but wow . . . I thank you all for helping me keep the faith even when I didn't believe.' At just 25 years of age, Hudson became the youngest Black woman ever to win an acting Oscar, and the first to do so for a debut role.

By the time Hudson and other members of Hollywood's elite arrived at the *Vanity Fair* Oscar party later that night at Morton's restaurant in West Hollywood, there were multiple celebrations for Black artists, with Willie D Burton also winning for Best Sound. African Americans had won three Oscars – two for acting – from five nominations. Surely, this was the change many had been waiting for? Samuels was cautious. She knew that for Hudson, like many others before her, the aftermath of winning an Oscar might not be fruitful. 'It's such a fairytale for her now, but my constant question is where will she be in a year, because if Hollywood doesn't back it up with roles . . .' Nevertheless, there were signs that a shift was beginning to take place in Hollywood. '[T]he big difference I think now is that you have many more [Black] people in power, many more people in control,' Samuels added.[9]

One of those people was Will Smith. On 8 April 2007, *Newsweek* published an article entitled 'Will Smith: Hollywood's Most Powerful Actor?' It stated that Smith had usurped Hollywood's biggest box office superstars – Tom Cruise, Tom Hanks, Mel Gibson, Johnny Depp and Ben Stiller – with a worldwide career box office of $4.4 billion, making him the film industry's biggest star. 'Will Smith is the only thing in this business – the only thing – that represents a guaranteed opening weekend,' said one industry insider. 'Let's put it this way,' said a Hollywood studio head, 'there's Will Smith, and then there are the mortals.' The 38-year-old actor's star power was measured by his ability to generate an opening-weekend gross of $30 million or more, *for each movie release.*

Smith was unique in being bankable across genres, from sci-fi to comedy to drama. 'The audience has enormous affection for him,' said one studio executive. '[W]e're talking a Tom Hanksian level of likeability.' One industry insider called him 'the black Jimmy Stewart', stating that '[h]e invites the white community in, yet he's credible with the black community. That's a pretty hard trick.'[10] Key to Smith's success was that he curated his roles toward stories with a global appeal, proving the commerciality of Black talent. 'Black artists have for decades had to deal with Hollywood's "big lie": that Black films and artists don't travel,' actor David Oyelowo told *The Hollywood Reporter* in 2022. 'Will Smith himself had a big hand in debunking that lie.'[11] Since *Bad Boys* in 1995, Smith's foreign box office numbers had spiked to more than double those of Denzel Washington. But, ultimately, Smith's power and success would bring with it pressures that were to have a devastating effect on his future.

*

History was not only being made by Blacks in Hollywood, but, more importantly, in the outer world also. On 4 November 2008, 47-year-old Illinois senator and Democratic Party candidate Barack Obama became the first African American president of the United States of America. Obama represented the pinnacle of Black professional achievement. The growth of the Black middle-class had become the biggest factor since Sidney Poitier in changing the types of roles that Hollywood conceived for Black artists, and that could potentially lead to challenges for Oscars. Professional archetypes that white studio executives and cinemagoers thought ridiculous in the 1920s had become standardized. Black lawyers and doctors and businessmen were now accepted on screen. As were Black presidents. Even before Obama, in 1998 Morgan Freeman had played a Black president in *Deep Impact*, before it was considered plausible. According to film producer Lori McCreary, during the film's casting, when director Mimi Leder suggested casting Freeman in the role, a studio executive replied, '[W]e're not making a science-fiction movie; you can't have Morgan Freeman play the president.'[12]

But for veteran Black director, producer and screenwriter Reginald Hudlin, scaling Hollywood's higher echelons was tougher than Obama reaching the highest office in America. 'It's easier for a black person to become president of the

United States than it is to be president of a movie studio,' he told *The Hollywood Reporter* in January 2015.[13] He referenced the fact that among Fortune 500 companies, there were Black chairmen or CEOs at American Express, Microsoft, McDonald's, Merck and Xerox – but when it came to the equivalent positions in Hollywood, people of colour were non-existent.

Women directors in Hollywood were also virtually non-existent. In over 80 years of the Academy Awards, only three had ever been nominated for Best Director – Lina Wertmüller (*Seven Beauties*), Jane Campion (*The Piano*) and Sofia Coppola (*Lost in Translation*) – and none had won. Hollywood was shamefully out of step with the world outside, which had already seen female prime ministers, CEOs and other power-players. But when the nominees for the 82nd Academy Awards were announced on 2 February 2010, there were hopes that things might change. *Avatar* and *The Hurt Locker* led the field with nine nominations each. Directed by Kathryn Bigelow, *The Hurt Locker*, starring Jeremy Renner and Anthony Mackie, was a gritty drama set during the Iraq War, about an army bomb disposal team and their struggles with the psychological after-effects of combat. Released on 4 September 2008, the low-budget production, costing only $15 million, went on to make $49 million at the box office. Among its multiple nominations, the one that most caught the eye was that of Best Director for Bigelow. Her nomination sparked a wave of debate and column inches about the issue of female directors and the disparity in opportunities available to them.

To get to the big prize, Bigelow was up against an incredible field that consisted of her ex-husband James Cameron (*Avatar*), Quentin Tarantino (*Inglourious Basterds*), Jason Reitman (*Up in the Air*) and Lee Daniels (*Precious: Based on the Novel 'Push' by Sapphire*). Daniels's nomination also caught attention. A Black filmmaker had never won Best Director. There was an intense buzz about whether this could be the year that, finally, either the first female director would win, or the first Black director – or perhaps a white male director would win again, as usual.

Precious was nominated in six categories. The film – a contemporary drama about a Black teenager's struggles against poverty and abuse in 1980s Harlem,

New York – was scripted by Geoffrey Fletcher, and featured 25-year-old newcomer Gabourey Sidibe as lead, plus comedian and actor Mo'Nique supporting. Released on 6 November 2009, it grossed $63 million from a budget of $10 million. Alongside Daniels's nomination for Best Director, Fletcher also made the list for Best Adapted Screenplay, as well as Sidibe for Best Actress, and Mo'Nique for Best Supporting Actress. Also in her category were Penélope Cruz (*Nine*), Vera Farmiga and Anna Kendrick (*Up in the Air*), and Maggie Gyllenhaal (*Crazy Heart*).

It was the strongest year for African American nominees since 2007, with six making the list, including Morgan Freeman, up for Best Actor for *Invictus*, and Roger Ross Williams, for Best Documentary (Short Subject) for *Music by Prudence*. As the 82nd Academy Awards commenced on 7 March, there were high hopes of more victories. Mo'Nique was prominent among them. She arrived on the red carpet wearing a royal blue full-length ruched gown, plus a white gardenia in her pulled-back hair. The dress was by Japanese American designer Tadashi Shoji, from his 2010 spring collection. He had become the go-to designer for fuller-figured African American stars such as Oprah and Queen Latifah. Mo'Nique's outfit paid homage to Hattie McDaniel's Oscar style of 1940. The electric blue of Shoji's gown matched the hue worn by McDaniel on the night of her triumph, and the gardenia also mimicked her look. Mo'Nique was drawing attention to a planned McDaniel biopic she was angling to make, having secured the rights from her estate. She felt a deep connection with history's first Black Oscar winner, and even kept a picture of her in her closet in an 8-by-10-inch frame. She also claimed to have communicated with her in the afterlife. 'Spiritually, I've gotten an opportunity to meet and talk with her,' she told *The Hollywood Reporter* in 2015.[14]

As the evening commenced, she settled down in the audience next to her husband, Sidney. Celebrations ignited as Fletcher was pronounced winner of the Award for Best Adapted Screenplay, for *Precious*. 'This is for everybody who works on a dream every day,' he said. 'Precious boys and girls everywhere.' Then, eight minutes later, actor and comedian Robin Williams arrived on stage to present the Oscar for Best Supporting Actress. He opened the envelope and

proclaimed Mo'Nique the winner. She was calm when the news came, as if she knew she would win. 'I just felt Hattie all over me at that moment,' she later recalled.[15] Clutching her Oscar, she thanked the Academy 'for showing that it can be about the performance and not the politics'. Then she finished by paying homage to Hattie McDaniel, 'for enduring all that she had to so that I would not have to'.

What blessings did her Oscar bring? '[I]t gave me a new reality,' Mo'Nique said. 'And it let me know that an award *wasn't* going to change my life.' Instead, her career stalled. Sometime later, Daniels phoned and offered her a reason why: 'Mo'Nique, you've been blackballed.' According to her, Daniels said that Sidney, who negotiated her deals on her behalf, was 'outbidding' her – i.e. demanding too much money. 'There have been people that have said, "Mo'Nique, she can be difficult. Mo'Nique and her husband can be difficult." They could probably be right,' she admitted. She was subsequently approached by Daniels for roles in *The Butler* (2013) and TV drama *Empire*, but they fell through. In a statement given to *The Hollywood Reporter*, Daniels clarified why he thought Mo'Nique had been blackballed. 'Her demands through *Precious* were not always in line with the campaign,' he said. 'This soured her relationship with the Hollywood community.'[16] The subtext here was clear: *if you're tricky, or difficult, you won't work, no matter what colour you are.*

In the build-up to the Oscars, much was made of the fact that Bigelow was competing with her ex-partner for the top awards. On the big night, he was seated directly behind her as the proceedings commenced. Her hair was brushed long and centre-parted, and she wore a shiny fitted full-length silk satin gown with an embroidered bodice, by Yves Saint Laurent. Soon after, Barbra Streisand arrived on stage to present the Oscar for Best Director. 'From among the five gifted nominees tonight, the winner could be – for the first time – a woman,' she began. 'Or, it could be, also for the first time, an African American.' The audience started whooping and applauding. She introduced each candidate, and then there was a hush, as she opened the envelope.

'And the winner is . . . well, the time has come . . .' Bigelow's heart leapt, her lips parted in anticipation. Was it her, or Daniels? Then Streisand finished the

sentence: '. . . Kathryn Bigelow!' 'Oh my God!' said Bigelow, rising to her feet. 'Yes, yes!' said Cameron, seated behind her, as he stood up, applauding. She hugged and kissed her entourage. Jeremy Renner hugged her for the longest time, before ushering her into the aisle for the short walk-up. 'I am so honoured,' said Streisand as she embraced her and handed her the trophy. 'It's the moment of a lifetime,' said Bigelow, as she faced the audience.

The Hurt Locker scooped six Oscars from nine, including Best Picture and Best Original Screenplay. More importantly, a woman had finally won Best Director, after more than 80 years. 'I hope I'm the first of many [women directors], and of course, I'd love to just think of myself as a filmmaker. I long for the day when that modifier could be a moot point,' said Bigelow after the Awards ceremony.[17] But despite the excitement around her breaking the era of male dominance, her Best Director win would prove not to be transformative. Female directors were still grossly underrepresented in Hollywood, and her win would not change that.

There were also celebrations for Roger Ross Williams, who became the first African American to win an Academy Award for Best Documentary (Short Subject). Overall, Black artists won three Oscars from six nominations. Meanwhile, for Lee Daniels, the Awards presented yet another disappointment for a Black director. After more than 80 years, they still could not achieve a win. The wait would continue.

<center>*</center>

After the numerous successes at the Oscars, the nominations and awards for the 83rd event, held on 27 February 2011, contained no Black nominees in the acting categories, exposing the lack of consistency within the system. One year there would be multiple Black nominees, and one or two winners, and another year – nothing. The expectation that there would be nominees and winners *every year* did not play out. For actor Samuel L Jackson, this was bad enough, but he was also upset by the fact that there were no Black men chosen to present Awards in 2011. In an email to the *Los Angeles Times* he wrote, 'It's obvious there's not ONE Black male actor in Hollywood that's able to read a teleprompter, or that's "hip enuf," for the new academy demographic!'[18] When Academy president Tom

Sherak was approached for comment, he maintained that it was the job of the ceremony's producers, Brian Grazer and Don Mischer, and not the Academy, to decide who its presenters were. 'Producers produce the show, end of subject,' he said firmly. Sherak's attempt to disassociate his organization from those hired to produce the Academy's own show was unconvincing. Reflecting diversity onstage should have been a compulsory directive within the brief to any subcontractor charged with producing the event. Without it, there was nothing to ensure that women and minorities would be fairly represented to the millions of viewers who watched the show worldwide.

The inequities within AMPAS and Hollywood continued to attract the attention of the press. The *People* magazine article of 1996, which dissected the state of racism within the industry, was followed by a new report from the *Los Angeles Times*, published on 19 February 2012. This time the story focused on the precise demographic make-up of the Academy's voters. The question the article sought to answer was: who exactly casts the votes for the Oscars? The identity of the Academy's base of 5,765 members was a closely guarded secret, which had led to decades of speculation. 'I don't even know who is a member of the academy,' said actor and member Viola Davis. In order to find out, *Los Angeles Times* reporters interviewed thousands of members and their representatives, and also reviewed resumes, biographies and Academy publications, eventually verifying the identities of over 5,100 voters – more than 89 per cent of the membership. Their findings were startling. The voters were nearly 94 per cent white and 77 per cent male, and with a median age of 62. Voters under 50 constituted 14 per cent of members. Blacks made up just 2 per cent of voters, and Latinos even less than 2 per cent. The report also found that Caucasians made up 90 per cent or more of all the Academy's 15 branches, except for the Actors Branch, which was 88 per cent white. Its Writers and Executive Branches were both 98 per cent white. Of the Academy's 43-member Board of Governors, six were women (14 per cent), while Cheryl Boone Isaacs was the sole Black woman (2 per cent).

Many of the names on the membership list were those one would expect, from Meryl Streep to Sidney Poitier, while others were better known for their TV

appearances, such as Jaclyn Smith of *Charlie's Angels* and Erik Estrada from *CHiPs*. But the active participation of many others had lapsed. Incredibly, it was also not mandatory for voters to actually watch the nominated movies before voting. Members could simply vote for their favourite performers, or for whatever recommendations were made by others. Under the Academy's rules, membership was for life, regardless of whether or not members continued to be involved in movies. Only 50 per cent had participated in productions in the previous two years. Many had not worked in film for decades, while others had left the industry completely – including a bookshop owner, a retired Peace Corps recruiter, and a nun (Mother Dolores Hart, who had joined in 1960 but later rejected Hollywood for the veil, after appearing opposite Elvis Presley in *Loving You* [1957]). Another active voting member – the owner of a cinema distribution firm – was actually in prison in Canada.[19] The list was like a dusty, cobweb-filled attic that had not been cleared out for years.

Academy executives were totally unaware of the state of their own voter roster, and were shocked at the *Los Angeles Times*'s findings. 'When we told the academy that we had independently confirmed the identities of more than 5,100 voters, there was a gasp in the room,' said John Horn, one of the reporters who worked on the story. 'I think they were really embarrassed by the findings of the demographics.'[20] The article provided the first statistical evidence that the Academy had a race, gender and age problem, and that there was a clear bias in determining who won what on Oscar night. Even though actors, directors, writers and technical staff were increasingly diverse, those who voted for them were not. The member base was an exclusive club that did not reflect America. But it was not conceived to do that. More accurately, it reflected *who controlled America*.

For minority artists, the article revealed how little things had changed in the 15 years since *People* magazine's exposé. Black actor and director Bill Duke said, 'The black community sees the academy as an entity that ignores the needs, wants, desires and representation of black directors, producers, actors and writers. Whether it is true or not, that is how it's perceived – as an elitist group with no concern or regard for the minority community and industry. And there doesn't seem to be any desire to change that perception.'[21]

Following on from Kathryn Bigelow's 2010 Oscar win for Best Director, the spotlight was also shone on discrimination against women in Hollywood. Martha Lauzen of San Diego State University examined the 250 top-grossing movies of 2011, and discovered that, while women made up 25 per cent of all of the films' producers, they only constituted 5 per cent of their directors. 'You would think that in this day and age, there would be a little bit more equality across the board, but that's not the case,' said Nancy Schreiber, one of the few female cinematographers among the Academy branch's 206 voting members. 'Being a cinematographer should not be gender-based, and it's ridiculous that it is.'

But former Academy president Frank Pierson, who won an Oscar for his screenplay for *Dog Day Afternoon* (1975), saw nothing wrong with the system just the way it was. 'I don't see any reason why the academy should represent the entire American population. That's what the People's Choice Awards are for,' he said. 'We represent the professional filmmakers, and if that doesn't reflect the general population, so be it.' Denzel Washington took the opposite view, favouring proportional representation to redress the fact that the membership was less diverse than the American cinema-going public. 'If the country is 12% black, make the academy 12% black,' he said. 'If the nation is 15% Hispanic, make the academy 15% Hispanic. Why not?' Mexican actor Demián Bichir was also in favour of changes like this. 'That would mean there would be a lot more roles for Latin actors,' he said, 'and a lot more movies for [Latinx] cinematographers.'

In practical terms, the percentages quoted by Washington were impossible to achieve quickly, as these numbers simply did not exist within the roster of film professionals who could apply for AMPAS membership. This is the point the Academy had been making for some time. 'If the industry as a whole is not doing a great job in opening up its ranks, it's very hard for us to diversify our membership,' said Academy governor Phil Alden Robinson. Tom Sherak was keen to reach out to eligible women and minorities who were not currently members. 'We've been trying to reach out to the constituency and we're looking for help,' he said. 'If you are sitting waiting for us to find your name in our make-believe book and we are going to call you, we are not going to do that. Come to us, we'll get you in. We want you in. That would help us a lot.'

Changes to the list were made in 2004, when the organization began making the names of its invitees public for the first time. More than 1,000 people were invited to sign up in the years after 2004, including African American actors Jennifer Hudson, Mo'Nique and Jeffrey Wright. However, the new recruits were only slightly more diverse than the volume they were joining. Overall, the Academy's composition after the 2004 changes was hardly altered, standing at 93 per cent white and 76 per cent male, and with an average age of 62. As long as the supply of female and minority film professionals was low, balancing the list could only happen by increments. This could take one or two decades to fully implement. There would be no quick fix.

South Asian sound engineer Resul Pookutty was exactly the type of professional AMPAS badly needed. In 2009 he won the Oscar for Best Sound, for *Slumdog Millionaire*. But in the aftermath he was not immediately invited to become an Academy member. Executive director Bruce Davis suggested to the Sound Branch that a wider range of candidates be considered for membership, and he put Pookutty forward for inclusion. The next thing the Indian technician knew, a letter had arrived from the Academy at the studio where he worked, inviting him to join. 'I was literally screaming in the studio,' he said. 'It means a great deal. More than the pride of it, I feel that my whole fraternity in India has been recognized and honoured.' Pookutty's joy was such that he flew all the way from Mumbai to Los Angeles specially to attend the luncheon for new members. Pookutty's enthusiasm personified what joining the AMPAS family really meant to people of colour.

The diversity issues within AMPAS constituted the key challenge that faced incoming Academy boss Cheryl Boone Isaacs when she was elected president in 2013. A long-time Academy insider, she had been on its Board for over two decades, during a core period when protests against inequality were being made and ignored. But as the only Black woman on the Board, there was little she could do. 'I didn't have much power and ability to do any major change,' she told *The Hollywood Reporter*. 'Just little things.'[22] But now she was in charge of its 6,000 members. Women and people of colour among them were watching and waiting to see whether or not she could make any real and lasting changes. 'I knew

that . . . change was coming,' said Halle Berry, reflecting on Boone Isaacs's appointment. On paper, the intention was simple: by diversifying the voting roster, the hope was that it would diversify the types of films, and performers, that could win Oscars. Boone Isaacs's resume suggested that if anyone could revise the Academy's archaic system, it was her. She was well-liked within Black Hollywood, and she had been a diversity champion since her days at Paramount. '[O]ur publicity department was the most diverse department in all of Paramount,' she noted, 'and we really worked very hard . . . to actually look around and see who had potential.' But revising the Academy's membership base was a different and altogether tougher challenge – and one that would meet resistance from some of its more conservative members. According to David Oyelowo, Boone Isaacs faced 'immense internal opposition and pressure' in her efforts to diversify its demographic.[23] A M PA S membership was for life, and so she could not simply get rid of a proportion of those who were over-represented. All she could do was add more to the existing roster.

In the month before her formal appointment was announced, the Academy extended invitations to 276 new film professionals, many of them women and minorities, including actors Jennifer Lopez and Danny Trejo, director Catherine Hardwicke, and new Warner Bros chief executive Kevin Tsujihara – the first Asian American to head a major film studio. These numbers were up on previous years. In 2011 there were 178 new invitees, and 176 in 2012. 'It certainly reads better than it has,' said Boone Isaacs. 'So we are moving in the right direction.'[24] But was it moving fast enough? Even with the new additions, the list was still overwhelmingly white and male. Boone Isaacs, despite her new powers, was limited in what she could do. Where would she find numbers that were significant enough to balance the list, and without compromising on professional standards in the process? It hinged on two factors: identifying and inviting all current artists not yet part of the Academy's membership, and capturing new artists as they came onstream. The second option was dependent upon the speed and commitment of the studios in giving opportunities to diverse new talent, both in front of and behind the camera.

To make Boone Isaacs's task even more complex, she would also soon face new

levels of criticism and accountability from the public, via social media, which was rapidly becoming a powerful new inciting point for change within Hollywood, and indeed the world. The first taster of its influence within the film world came in 2006, when African American women's rights advocate Tarana Burke coined the phrase 'Me Too', in order to assist and empower women who had been the victims of sexual violence. The phrase was devised as a means of letting these survivors know that they were not alone. Ten years later, the movement permeated Hollywood following allegations of sexual abuse against Hollywood producer Harvey Weinstein. Actor Alyssa Milano rallied social media users globally to share their stories of sexual harassment and assault online. Soon, *#MeToo* began trending. In October 2017, allegations against Weinstein by dozens of women were reported in the press, and on March 2020 he was jailed after being convicted of sexual assault.[25]

More online activism followed. On the evening of 26 February 2012, in Sanford, Florida, an unarmed Black teenager called Trayvon Martin was shot dead by George Zimmerman, a neighbourhood watch coordinator in the gated community where Martin was visiting relatives. Zimmerman was subsequently charged with second-degree murder, but was acquitted after claiming self-defence. The widely publicized case, and its outcome, galvanized three female African American activists – Alicia Garza, Patrisse Cullors and Opal Tometi – to create a movement in protest at the racism and unjust killing of Black citizens within the United States. It began on 13 July 2013, with the hashtag *#BlackLivesMatter*.[26] In the years since it was first coined, this has become the most misunderstood phrase of the digital age, widely misinterpreted by those who, ignorant of its origins, took it out of context, to mean that other lives do not matter equally, thereby distorting the intention of the hashtag's original aim and purpose. Nevertheless, its significance was pivotal. People of colour were now armed with a form of global activism that was more effective and far-reaching than manning picket lines, or writing letters to film studios – and it was one that Hollywood would find impossible to ignore.

*

The nominations for the 2012 Academy Awards featured three actors of colour: Viola Davis (Best Actress) and Octavia Spencer (Best Supporting Actress) starred in *The Help*, while Demián Bichir (Best Actor) was nominated for *A Better Life*. *The Help*, written and directed by Tate Taylor, was a period drama about a white female writer and her relationship with two Black maids during the Civil Rights Movement in 1963. Spencer was cast in the role of outspoken maid, Minny Jackson. Released in US theatres on 10 August 2011, it grossed $216 million from a budget of just $25 million. Spencer was favourite for the Oscar, after winning the BAFTA, the Golden Globe and the SAG awards, but she would have to beat a tough field comprising of Jessica Chastain, from the same film, plus Bérénice Bejo (*The Artist*), Melissa McCarthy (*Bridesmaids*) and Janet McTeer (*Albert Nobbs*).

The 84th Academy Awards took place on 26 February 2012. There was a buzz on the red carpet as Spencer appeared before the world's press wearing a shimmering champagne-coloured beaded gown by Tadashi Shoji – designer of Mo'Nique's outfit in 2010. The dress took ten people and a thousand hours to construct, and made Spencer cry when she first laid eyes on it. The film fashionistas loved it, too, and the gown elevated Spencer onto many of the evening's best-dressed lists.

Later on in the auditorium, Christian Bale arrived on stage and announced the nominees for Best Supporting Actress. As he then proceeded to open the envelope and declare Spencer the winner, she put both hands over her face in shock. Dizzy with surprise, she stayed seated, and had to be helped up. When she reached the podium, she was tearful and shaky as she spoke, thanking her family, her agents, the Academy and those she had worked with. 'I share this with everybody,' she said. 'I'm sorry, I'm freakin' out. Thank you, world.' And with that, she turned and stepped gingerly off stage, treading on her train as she went.

<p style="text-align:center">*</p>

In between the fast flurry of acting nominations and wins for Black artists, the frequency with which its older pioneers were being recognized with commemorative Oscars for their longstanding contributions to the industry was also changing with the times. In 1995 Quincy Jones received the Jean Hersholt

Humanitarian Award – an Oscar presented to an 'individual in the motion picture industry whose humanitarian efforts have brought credit to the industry'.[27] In 2011 James Earl Jones and Oprah Winfrey followed Sidney Poitier, as did Harry Belafonte in 2014, in collecting an Honorary Oscar, awarded to an individual 'for extraordinary lifetime achievement, exceptional contributions to the motion picture arts and sciences of any discipline, or outstanding service to the Academy'.[28]

Simultaneously, new developments were afoot in the Academy's Best Director category. Bigelow had won in 2010 as the first woman. Ang Lee had won in 2006 as the first Asian, and again in 2013, this time for *Life of Pi* – becoming the first Asian to win twice. In 2014 Alfonso Cuarón became the first Latino filmmaker to win Best Director, for *Gravity*. But for Black filmmakers this was proving to be the hardest Oscar to acquire. They had only managed three nominations by 2013, and no wins. Black directors had become synonymous with Black stories, and all three nominations were for Black-themed productions – all of which Academy members didn't seem to favour when it came to final voting. By contrast, Cuarón and Lee were seen as filmmakers who could direct stories that did not reflect their own backgrounds, and this has paid off for them at the Oscars.

They may have been assisted by the fact that they had also been less vocal about the industry's inequities than Black directors such as Spike Lee or Ava DuVernay. The Oscar-winning acceptance speeches of both Cuarón and Lee steered clear of anything relating to race or representation. Instead, they politely thanked the Academy and the teams involved in their movies, then smiled and left the stage. They appeared to be less critical, and more grateful. By contrast, African Americans were seen as 'complainers'. In the early 1990s, director Darnell Martin resisted the temptation to meekly accept the financing she had received from white studio executives for her award-winning romantic comedy, *I Like It Like That* (1994). 'The thing they kept saying to me was, "Aren't you grateful? How come you're not grateful?"' she told *The New York Times*. 'I'm like, "Do you ask your white filmmakers that?"'[29] Darnell's stance ended up costing her dearly, as she was shut out of movie-making for many years afterwards. 'As an

African-American woman who speaks up and fights against things that are racist or misogynistic, I felt a very big backlash,' she said. The words that Hattie McDaniel once whispered to Butterfly McQueen in 1939, after she threw a tantrum on the set of *Gone with the Wind*, spring to mind here. 'You'll never come back to Hollywood because you complain too much.'

<center>*</center>

The era witnessed a new generation of diverse actors from across the Black diaspora begin to establish themselves within the profession, resulting in more non-American Blacks breaking into the Oscar nominations. After Marianne Jean-Baptiste in 1997 came Black British actress Sophie Okonedo and Benin-born Frenchman Djimon Hounsou. Following this, when the nominations for the 86th Academy Awards were announced on 16 January 2014, Black British director and artist Steve McQueen made the list for Best Director, for *12 Years a Slave*. Born in London to West Indian parents, McQueen was only the third Black filmmaker ever to be nominated for the Award. Alongside him in the nominations for his film were Chiwetel Ejiofor (Best Actor), a Black British star of Nigerian descent, and Lupita Nyong'o (Best Supporting Actress), who was born in Mexico to Kenyan parents. For the first time ever, three non-American Blacks had made the lists simultaneously, and in a year with no African American representation from its actors.

American Hustle and *Gravity* led the nominations, with ten each. *12 Years a Slave* was second, with nine, including Best Picture and Best Adapted Screenplay, for John Ridley. Produced by actor Brad Pitt, *12 Years a Slave* was a biographical drama based on the memoir of Solomon Northup – a free African American man who was kidnapped in Washington, DC, in 1841 and sold into slavery in Louisiana. Released in the US on 8 November 2013, it grossed $188 million from a budget of just $22 million. The production, widely praised by critics, was favourite for Best Picture after winning the Golden Globe and BAFTA. Nyong'o, who played the role of long-suffering slave Patsey, was also favourite going into the Awards, although the 31-year-old faced stiff competition from Jennifer Lawrence, who had picked up Best Supporting Actress wins at the Golden Globes and the BAFTAS, for her role in *American Hustle*. Also

nominated were Sally Hawkins (*Blue Jasmine*), Julia Roberts (*August: Osage County*) and June Squibb (*Nebraska*).

On 2 March, at the 86th Academy Awards, Nyong'o arrived on the red carpet in a powder-blue georgette silk ballgown with a plunging V-neck and a low-cut back, finished with a flowing pleated skirt with a crystal-beaded trim, by Prada. Her short hair was adorned with a gold and diamond headband, and she wore matching crescent earrings. After doing interviews and posing for the press, she settled down inside the auditorium beside her brother Peter. Soon afterwards, Academy Award-winner Christoph Waltz arrived on stage to announce the Oscar for Best Supporting Actress. After the formalities he opened the envelope and calmly said, 'And the Oscar goes to . . . Lupita Nyong'o.' She jolted, like a startled cat. The shock took her breath, and she let out a short scream of triumph, muffled beneath the applause. She stood, inhaling deeply, and from all around her, the hugs came in – first Peter, then McQueen, then Liza Minnelli, then Pitt, then Ejiofor. She stepped forward, carefully lifting her dress to climb the steps. When Waltz handed her the trophy she was still bristling with emotion, barely able to get her words out. She saluted the spirit of the character she had played in the film, who had endured relentless abuse as a slave, paid special tribute to McQueen, and then finished with a message for children everywhere: 'When I look down at this golden statue, may it remind me and every little child, that, no matter where you're from, your dreams are valid.' Tears welled up as she left the stage to a standing ovation, cradling her Oscar in her arms. Backstage she reflected on how new the whole experience was to her: '[T]his is my first time here and I feel like Willy Wonka in the chocolate factory,' she said.[30]

Later on, the night got even better for *12 Years a Slave* when John Ridley was pronounced winner of Best Adapted Screenplay, becoming only the second Black writer ever to win the Award. 'All the praise goes to Solomon Northup,' he said. 'Those are his words. That is his life.' A few minutes later McQueen's film reached its high point when it was awarded Best Picture by presenter Will Smith, beating *Gravity* and *American Hustle*, its main contenders, plus *Captain Phillips*, *Dallas Buyers Club*, *Her*, *Nebraska*, *Philomena* and *The Wolf of Wall Street*.

McQueen became the first Black director to win Best Picture. He had a

prepared speech in his pocket. He thanked those involved in the film's production, as well as his family, and his mother, Mary, in particular, who was seated at the back of the auditorium. 'Thank you for your hard-headedness, Mum,' he said, as she waved wildly from the back of the auditorium. To conclude, McQueen drew attention to the injustices of forced incarceration. 'Everyone deserves not just to survive, but to live,' he said. 'This is the most important legacy of Solomon Northup. I dedicate this award to all the people who have endured slavery, and the 21 million people who still suffer slavery today.' He then turned around to face his collaborators, and began jumping up and down like an excited child, while they laughed and applauded.

The era saw the best return so far for Black actors, with four Oscars for Black women and three for Black men. Undeniably, this was progress, but still, it was only seven Awards in 11 years (2003–14) – some distance below the achievements of white Oscar winners. It was also the best period for minority and female filmmakers, with four wins for Best Director – although Black filmmakers were not among them. Were they simply just not good enough, or was the bias of the Academy's voter demographic partly to blame? And what of the perpetual inconsistencies in nominations for Black artists? One year they would feature strongly, and the next, nothing. There were growing signs that Hollywood's Blacks were becoming increasingly impatient with the industry's prevailing inequities. 'At a certain point, people just get fed up,' lamented director Barry Jenkins.[31] But what could they do? They had tried everything to redress this. What more could be done? Perhaps what they needed was a new kind of force – something from outside the industry that could galvanize not only Hollywood, but the whole world.

BOILING POINT (2015–2016)

'We are not going to allow the Oscars to continue. This will be the last night of an all-white Oscars.'
Reverend Al Sharpton, 28 February 2016

On Thursday, 15 January 2015, at 5.15am (Pacific Standard Time), the nominees for the 87th Academy Awards were announced at the Samuel Goldwyn Theater, Beverly Hills, California. The event, its atmosphere crackling with anticipation, was presented by Academy president Cheryl Boone Isaacs, actor Chris Pine, and directors JJ Abrams and Alfonso Cuarón. For the first time, nominations for all 24 competitive categories were announced live. Around the world, eager cinephiles tuned in to discover the names and the movies that had made the shortlist. Among the eight nominated films were *The Theory of Everything*, *The Imitation Game*, *Birdman* and *American Sniper*, and the acting nominees included Julianne Moore, Bradley Cooper, Eddie Redmayne, Reese Witherspoon, Mark Ruffalo, Edward Norton, Laura Dern and Meryl Streep.

2,700 miles away, a 46-year-old African American attorney named April Reign was watching the live broadcast from her home in Washington, DC, as she got ready for work. She was a big film fan, and waited with excitement as the names were called. But when all the nominees in the acting categories were announced, she shook her head and sighed with disappointment. All 20 were white. It seemed as though, in terms of diversity and inclusion, Hollywood was going backwards. Reign picked up her mobile, opened her Twitter app, and composed a short tweet: '#OscarsSoWhite they asked to touch my hair'. Then she logged off and went to work.

When she checked her mobile at lunchtime, she got a shock. Her hashtag had gone viral, and was trending globally. At its peak, it clocked up 95,000 tweets per hour, as people shared their frustration and disappointment with the system that had produced an all-white list. Dozens of variants of the end-line to Reign's original hashtag peppered the Twittersphere: '#OscarsSoWhite they wear Birkenstocks in the wintertime' and '#OscarsSoWhite they have a perfect credit score' were among them. Calls for greater diversity and fairness echoed not just across America, but in the UK, Germany, France, South America, New Zealand and many other countries simultaneously. 'They are standing up and saying hey, this is a problem in our country too,' Reign told The Huffington Post. 'I realized . . . that this was bigger than just the Academy, just the Oscars, just the movie industry.'[1] Inadvertently, with just a three-word hashtag, Reign had started a movement.

The 20 all-white nominees once again exposed Hollywood and AMPAS to accusations of racism. 'It really does speak to this disconnect between the industry and America,' said Darnell Hunt, director of African American Studies at UCLA, and co-author of the 'Hollywood Diversity Report', which examined minority appearances in film and television.[2] The focal point of the displeasure in 2015 was the movie Selma. Directed by Ava DuVernay and starring Black British actor David Oyelowo, the film – a biographical drama re-enacting the 1965 voting rights marches led by the Reverend Dr Martin Luther King Jr – was enthusiastically received, grossing $68 million from a $20 million budget. The production was widely expected to receive multiple nominations, but, despite strong reviews, and power-players Oprah Winfrey and Brad Pitt producing, it only featured in the Best Picture and Best Original Song categories, with no Best Actor nomination for Oyelowo, as Reverend King, or Best Director for DuVernay – who would have been the first Black woman ever to make the list. 'I knew that I wouldn't get director,' DuVernay told The New York Times in 2020. 'But I really felt strongly that David would get actor. That really startled me and disappointed me.'[3]

On the morning the nominees were announced, a writer for the entertainment news website Vulture approached Boone Isaacs for comment. They asked, in light

of the absence of Black artists, whether or not AMPAS had a diversity problem. 'Not at all. Not at all,' she replied.[4] Her statement was strangely contradictory. As a two-decade Board member she was fully aware of the Academy's diversity issue, and as president she had actively set about revising the list to be more inclusive. When then asked if she thought *Selma* should have received a greater number of nominations, she was cagey: 'There are a lot of terrific motion pictures, it's a very competitive time, and there's a lot of great work that has been done. I am very happy that *Selma* is included in our eight terrific motion-picture [nominations].' However, privately Boone Isaacs was troubled by *Selma*'s snub, because after the 2015 Academy Awards she invited Oyelowo to her office to talk about his omission from the shortlist, and 'what went wrong then', as Oyelowo reported. 'We had a deep and meaningful [conversation].'[5]

So, what did go wrong? Could it all be attributed simply to racist white voters? In reality, a number of factors were at play. It has been suggested that the film's promotional campaign worked against it: the movie arrived late in the season, and Paramount Pictures didn't send out enough screeners to voters to help build awards momentum. In addition, debates over the film's factual accuracy may have dissuaded voters: some accused the movie of not being true to the pivotal role played by President Lyndon B Johnson in his support of civil rights. Alternatively, perhaps voters simply didn't think the film was good enough. Views about its merits were split along racial lines. 'Was there Oscar-worthy work in *Selma* that was overlooked?' asked Reginald Hudlin. 'Absolutely!'[6] But some white Academy members disagreed. On 18 February 2015, *The Hollywood Reporter* published an interview with an anonymous female voter, who spoke candidly about her views on the film. 'What no one wants to say out loud is that *Selma* is a well-crafted movie, but there's no art to it,' she contended.[7] On this basis, Academy voters saw more 'art' in *12 Years a Slave*, which they had rewarded with two Oscars just 12 months earlier. Perhaps white folks had a greater nostalgic fondness for slavery stories set in the antebellum South than they did for a 1960s civil rights biopic? Hudlin had another theory, suggesting that the white voters who supported *12 Years a Slave*, but rejected *Selma*, may have been suffering from 'racial fatigue'.[8] If true, it

would follow the pattern of previous decades, which had illustrated that fairness to minorities had a shelf life. A short one.

The charge of voter racism also put forward for the film's failure was refuted by *The Hollywood Reporter*'s anonymous interviewee. 'Yes, most members are white males, but they are not the cast of *Deliverance* – they had to get into the Academy to begin with, so they're not cretinous, snaggletoothed hillbillies,' she said. 'When a movie about black people is good, members vote for it. But if the movie isn't that good, am I supposed to vote for it just because it has black people in it?'[9]

In *Selma*'s case, though, there were signs that race had indeed played a role in its failure at the Oscars. The film's New York premiere coincided with the deaths of Eric Garner, a 43-year-old African American murdered by police after being placed in a chokehold in July 2014, and of Michael Brown, an unarmed Black teenager who was shot dead by police the following month. In protest at their murders, DuVernay, Oyelowo and other cast members posed in front of the New York Public Library, wearing 'I Can't Breathe' T-shirts – Garner's last words as his life was forced from his body. But some white Academy members disapproved of the actions of the film's cast and crew. 'I thought that stuff was offensive,' said *The Hollywood Reporter*'s interviewee. 'Did they want to be known for making the best movie of the year or for stirring up shit?'[10] This was a shocking revelation – that certain white voters chose to be 'offended' by Black artists protesting against the brutal murder of their fellow Black citizens by so-called law enforcement officers. This was, and remains, a familiar narrative among many privileged whites – that Blacks should not mix politics and entertainment. But the reality is: this is not a choice – they *are* mixed.

DuVernay's participation also drew the quiet displeasure of some of Hollywood's power-players. 'Studio people had been whispering to me, "You shouldn't have done that,"' she revealed. 'But I would do it all again.'[11] It is hard to imagine directors Ang Lee or Alfonso Cuarón publicly demonstrating against Asian or Latino discrimination in such a manner. Does it explain why they have fared better at winning the Best Director Oscar? Because they have 'behaved' themselves? The double-standard within how DuVernay and Oyelowo were

treated was glaring. White actors such as George Clooney, Angelina Jolie and Sean Penn had been free to be political whenever they chose, without it damaging their careers – but Blacks still had to be careful. They still had to 'know their place'. Ultimately, *Selma*'s cast and crew paid a high price for their 'misbehaviour'. On 4 June 2020, Oyelowo confirmed that their protest had damaged the film's chances with Oscar voters. 'Members of the Academy called in to the studio and our producers saying, "How dare they do that? Why are they stirring S-H-I-T?"' he told *Screen Daily*. '"We are not going to vote for that film because we do not think it is their place to be doing that."' Oyelowo continued, 'They used their privilege to deny a film on the basis of what they valued in the world.'[12] This shameful episode was acknowledged by the Academy itself. They posted a response on their official Twitter account the day after Oyelowo's interview. 'Ava & David, we hear you. Unacceptable. We're committed to progress.'[13] The incident was stark in its irony. *Selma* was a film about the rights of African Americans to protest against racial injustice – and now white Academy members were speaking out against the rights of Black Hollywood to do the same. In doing so, these members had more in common than they realized with those who had opposed Martin Luther King in 1965.

Further reaction to the whitewashed list of Oscar nominees came from African American civil rights leaders. Back in 1996 this was spearheaded by Jesse Jackson, but now it was the Reverend Al Sharpton who took up the baton. On 15 January, following the announcement of the 20 all-white nominees, he issued a statement that read: '[I]t is hard to believe that we have less diversity in the nominations today than in recent history.' He added, 'The movie industry is like the Rocky Mountains: the higher you get, the whiter it gets.'[14] The following week Sharpton held an emergency meeting of the Los Angeles chapter of his organization, the National Action Network (NAN), together with other activist groups, to discuss possible action around the Academy Awards ceremony. Like Jackson in 1996, NAN voted to picket the ceremony on Sunday, 22 February, as Hollywood's stars arrived on the red carpet. NAN's demands were clear. 'The National Action Network is calling for the President of the Academy of Motion Picture Arts and Sciences, Cheryl Boone Isaacs, to accelerate the Academy's push

to be more inclusive,' said spokesperson K W Tulloss. 'It's obvious that the Academy has a diversity problem they are going to have to fix.'[15]

However, their planned protest was dramatically called off at the last minute, at the request of DuVernay, who persuaded Sharpton that direct dialogue with AMPAS chief Boone Isaacs and CEO Dawn Hudson was a more appropriate form of action. And so the 87th Academy Awards proceeded without a hitch. But the politics, though removed from the streets outside the ceremony, found its way inside, in the opening monologue of first-time Oscars emcee Neil Patrick Harris, who walked on stage and quipped, 'Tonight we honour Hollywood's best and whitest – sorry, brightest.'

<p style="text-align:center">*</p>

In the wake of the 2015 whitewash, Boone Isaacs and the Academy faced increasing pressure to reform their membership. On 26 June, they sent out 322 new invitations to a diverse array of film talent that featured women, foreign-born artists and people of colour. The list included David Oyelowo, Gugu Mbatha-Raw, Felicity Jones, Emma Stone, Rosamund Pike, Dev Patel, Bong Joon-ho and Justin Lin. The number was up from the previous two years: 276 new members were invited in 2013, and 271 in 2014. The AMPAS Board was also diversifying. Seventeen out of forty-two members were now female, and new balloting would eventually result in close to 50-50 parity. 'The membership is becoming more and more a reflection of the world at large,' said Boone Isaacs.[16]

As the year drew to a close, there was more good news when director Spike Lee – one of the Academy's most vocal and consistent critics – was finally commemorated for his services to film, with an Honorary Oscar at the Academy's 7th Annual Governors Awards, on 14 November. The presentation was made by Denzel Washington, Samuel L Jackson and Wesley Snipes. Twenty-five years after his movie *Do the Right Thing* was famously snubbed by the Academy, Lee smiled and said, 'It's been a long time coming!' He paid tribute to the AMPAS Board, as well as to Boone Isaacs, who had been instrumental in advocating for his moment of recognition. He thanked her 'for trying to bring some flava up in here'. But was there enough 'flava'? As 2016

loomed, it was a question that Black Hollywood would ponder in ways it had never done before.

*

The nominees for the 88th Academy Awards were announced on 14 January 2016, at 5.30am (PST), by Boone Isaacs, actor John Krasinski, and directors Ang Lee and Guillermo del Toro. For the second year running, all 20 acting nominees were white, with no women featured in the directing or writing categories. The nominations had overlooked acclaimed performances by Idris Elba (*Beasts of No Nation*), Michael B Jordan and Tessa Thompson (*Creed*), Samuel L Jackson (*The Hateful Eight*), Benicio del Toro (*Sicario*), Will Smith (*Concussion*) and Corey Hawkins (*Straight Outta Compton*). The latter film, about the rap group NWA, was recognized only for the work of its white screenwriters, while *Creed*, despite having a Black director and lead, attained just one nomination – for its white star, Sylvester Stallone. Those who had presumed that the Oscar successes gained by minority artists since 2002 marked a game-changer for diversity were wrong. 'I was devastated that the acting nominations were all white,' said Academy CEO Dawn Hudson. 'This feels like an inflection point, almost at a point of crisis.'[17]

For Black Hollywood it was exactly that. *They had reached boiling point.*

14 January

After the nominees were announced, April Reign, disappointed once again at the whitewashed list, re-posted her *#OscarsSoWhite* tweet of 2015. As before, it went viral, this time with an even bigger tsunami of responses. For weeks her hashtag took centre stage across timelines and news headlines, sparking widespread discussions about the lack of diversity and representation in Hollywood and beyond. 'One time you could call a fluke, two times feels like a pattern,' she told *The New York Times*.[18] Singlehandedly, Reign turned the Oscars, which many viewed as nothing but a frivolous, self-congratulatory trophy-fest for the rich, into a global campaign for social justice – a digital civil rights movement – and one that gleaned more global coverage than Jesse Jackson and all the other civil rights leaders had managed, combined. Her hashtag would

become a flag of empowerment for other marginalized groups, spawning a plethora of highly charged catchphrases, such as *#WhitePrivilege*, *#50shadesofwhite* and *#RepresentationMatters*.

15 January

The front page of the *Los Angeles Times* led with the headline 'Where's The Diversity?' alongside pictures of 24 white nominees, plus Mexican Alejandro González Iñárritu – the single non-white face among them, nominated for Best Director for *The Revenant*. 'It's past time for Hollywood to stop defining a great drama as white men battling against hardship,' said the article.[19] But other sections of the press maintained that racism had nothing to do with the exclusion of Black artists that year. Film critic Andrew Gruttadaro of *Complex* magazine came out and stated what many white folks were thinking, but dared not say out loud. 'This year, no black people deserved a nomination.'[20]

16 January

Black Hollywood disagreed – and this time, unlike the 1996 protest, they were prepared to take a stand. Actor Jada Pinkett Smith tweeted: *At the Oscars... people of color are always welcomed to give out awards... even entertain, but we are rarely recognized for our artistic accomplishments. Should people of color refrain from participating [al]together? People can only treat us in the way in which we allow. With much respect in the midst of deep disappointment.*[21]

18 January

Disquiet within the Black film community spread internationally. Over in London, actor Idris Elba, overlooked for his portrayal of a tyrannical warlord in *Beasts of No Nation*, delivered a keynote speech to MPs in the British Parliament about the lack of opportunities for Black actors within film and television – calling for greater diversity in front of, and behind, the camera. 'Talent is everywhere. Opportunity isn't,' he said.[22]

That same day, back in the US, Spike Lee took to Instagram to announce that he would not be attending the Academy Awards. 'How Is It Possible For The 2nd

Consecutive Year All 20 Contenders Under The Actor Category Are White?' he wrote. 'And Let's Not Even Get Into The Other Branches. 40 White Actors In 2 Years And No Flava At All. We Can't Act?! WTF!! . . . As I See It, The Academy Awards Is Not Where The "Real" Battle Is. It's In The Executive Office Of The Hollywood Studios And TV And Cable Networks . . . The Truth Is We Ain't In Those Rooms And Until Minorities Are, The Oscar Nominees Will Remain Li[l]y White.'[23] Lee stopped short of calling for a formal boycott, simply stating that he and his wife Tonya would not attend. Instead, 'I'm going to the Knicks game,' he said on *Good Morning America*.[24] In pulling out, Lee was not protesting against Boone Isaacs – she was someone he admired and respected – but, rather, the institution she worked for.

Others also began to pull out. Jada Pinkett Smith, Will Smith, Ava DuVernay, Tyrese Gibson, Ice Cube, Ryan Coogler and Michael Moore stated that they would not participate. Snoop Dogg posted a video on Instagram, informing his fans that he would also not be attending, or watching at home. 'Somebody asked me, was I gonna watch the motherfucking Oscars? Fuck no! What the fuck am I going to watch that bullshit for?'[25] More diplomatically, Will Smith praised the all-white nominees for their deserving work, before telling *Good Morning America* that Hollywood 'reflects a series of challenges that we're having in our country at the moment' and a broader 'slide towards separatism, towards racial and religious disharmony . . . That's not the America I want to leave behind.'[26] Underneath his words, Smith concealed his own personal hurt and disappointment at being omitted from the list of nominees.

At 7.15pm, over on the West Coast, the Academy responded to events with a statement from Boone Isaacs. 'I am both heartbroken and frustrated about the lack of inclusion,' she wrote. '[I]t's time for big changes. The Academy is taking dramatic steps to alter the makeup of our membership. In the coming days and weeks we will conduct a review of our membership recruitment in order to bring about much-needed diversity . . . the change is not coming as fast as we would like. We need to do more, and better and more quickly.'[27]

Later that evening, at the Sheraton Gateway Hotel, Los Angeles, David Oyelowo was appearing as guest speaker at a gala honouring Boone Isaacs.

Sometime into his tribute, he veered off-script and began criticizing AMPAS. 'The Academy has a problem,' he said. 'For 20 opportunities to celebrate actors of color, actresses of color, to be missed last year is one thing; for that to happen again this year is unforgivable.'[28] He noted that the Academy 'doesn't reflect its president and it doesn't reflect this room . . . it doesn't reflect me, and it doesn't reflect this nation'. He was right, although those in silent opposition to him – and Will Smith also – would only see two sore losers complaining about something that routinely afflicted many white actors too. Undoubtedly, Oyelowo's own personal sense of disappointment at being overlooked for Best Actor in 2015 flowed within the undercurrent of his soliloquy. Nevertheless he spoke for many when he highlighted why the Academy Awards, and winning, really mattered to people of colour. 'We grow up aspiring, dreaming, longing to be accepted into that august establishment [the Oscars] because it is the height of excellence,' he said. 'I would like to walk away and say it doesn't matter, but it does, because that acknowledgement changes the trajectory of your life, your career, and the culture of the world we live in.'

19 January

With a number of Hollywood's Black stars refusing to attend the Awards, actor Tyrese Gibson and rapper 50 Cent questioned whether comedian Chris Rock, the scheduled host that year, should agree to appear. He had an ally in Whoopi Goldberg, who planned to break ranks with the planned no-show, as she had done in 1996. 'Boycotting doesn't work, and it's also a slap in the face to Chris Rock,' she said. 'I find that also wrong. So I'm not going to boycott,' she said.[29] Goldberg was a critic of the intermittent nature of the *#OscarsSoWhite* debate. 'Every year we get all fired up, and then the rest of the year nobody says anything,' she lamented.[30] Alongside Rock and Goldberg, also lined up to feature on stage were a host of Black presenters, including Kerry Washington, Michael B Jordan, Chadwick Boseman, Kevin Hart, Louis Gossett Jr, Common, John Legend, Quincy Jones, Pharrell Williams, Morgan Freeman and Cheryl Boone Isaacs. Rock made light of the whole drama, and indicated that he was rewriting the script for his planned performance, in order to reflect the ongoing diversity issue. In the

build-up he was already cracking jokes on social media. In a humorous trailer for the ceremony, he tweeted: *The #Oscars. The White BET Awards.*[31]

Black artists were not the only ones who were upset about events at the 2016 Awards. White Academy members were displeased too – by the insinuation that they were all racists, and therefore incapable of voting for the best movies simply on merit. Actor and Academy member Penelope Ann Miller, best known for her roles in *Carlito's Way* and *The Artist*, told *The Hollywood Reporter*, 'I voted for a number of black performers, and I was sorry they weren't nominated. But to imply that this is because all of us are racists is extremely offensive. I don't want to be lumped into a category of being a racist because I'm certainly not . . .'[32] She went on to say, 'It was just an incredibly competitive year. I loved *Beasts of No Nation*, and I loved Idris Elba in it – I just think not enough people saw it, and that's sometimes what happens. *Straight Outta Compton* was a great film; I think it just lost some Academy members who are older . . . I think when you make race the issue, it can divide people even further, and that's what I worry about.' Boone Isaacs was sympathetic to the complaints of white Academy members. 'I think that is absolutely unfair,' she maintained. 'I certainly understand the hurt because people they don't even know are making a judgment about them and about their artistic integrity . . .'[33]

21 January

A study published by *The Economist* suggested that, between 2000 and 2016, Black actors were in fact adequately represented at the Oscars, relative to the size of the African American population (12.6 per cent). During the 16-year time period studied, minority actors secured 15 per cent of the top roles, but 17 per cent of the Oscars. The findings, though limited to a narrow section of the Oscars timeline, suggested that voter prejudice at the Academy was not the primary issue, but, rather, the limited presence of Black artists within the movies that Oscar voters had to choose from each year. This reinforced the notion that the greater diversity problem was with the studios, and not AMPAS. The research also revealed that even greater inequities were present among other minorities. The Latino community, despite forming 17 per cent of the US population,

claimed just 3 per cent of all nominations during the same period. Asians and Native Americans were also poorly represented overall.[34]

That same day, Boone Isaacs called an emergency meeting of the 51-member AMPAS Board of Governors at their Beverly Hills headquarters. In a unanimous vote they approved a series of sweeping changes designed to make the membership, its governing bodies and its voting members more diverse. In a press statement released at 8am the following morning, the Board announced the initiative, known as A2020, pledging to double the number of women and diverse members by 2020, and to place new rules and restrictions on lifetime voting rights. Under the new directive these were to be reviewed every decade, and memberships could be revoked for those not active in film for extended periods. The new measures committed to ensuring that women would comprise 48 per cent of the total membership, and diverse groups over 14 per cent. They also promised to launch a global campaign to recruit diverse and qualified new members who had thus far not been identified by AMPAS. In order to increase diversity on the Board, the Academy pledged to create three new Governor seats, nominated by the president.[35]

But A2020 had problems. Some Academy members suggested that the policy of potentially removing voting rights from older, dormant members and replacing them with younger, more diverse groups was ageist, while others maintained that it would have the unintended consequence of squeezing out women and minorities, who found it more difficult to get regular work in Hollywood. The rush to diversify also saw the Academy circumvent its own rules. The intention to add three new seats to the Board usually meant that the nominees, put forward by the Academy's individual branches, stood for election according to a set procedural timetable – but the protocol was fast-tracked. In addition, the overall diversity target numbers for A2020 seemed ambitious. Mathematically it would require new intakes of at least 375 women and more than 130 people of colour each year to meet its targets. Could these numbers be achieved without lowering admissions standards? 'There are enough qualified people,' Boone Isaacs insisted. 'We're going to make it happen.'[36]

The Board had been planning the revisions for months prior to the 2016

Oscar nominations, but took the decision to accelerate their implementation in response to the fierce protests at the all-white list of nominees. 'The Academy is going to lead and not wait for the industry to catch up,' said Boone Isaacs.[37] But the Academy had acted reactively rather than proactively, only mobilizing on the back of unfolding events, and thereby making the initiatives seem like an exercise in damage limitation. But was the pressure to move fast shortcutting important details? Steven Spielberg expressed reservations about aspects of the new guidelines, specifically the potential for revoking the voting rights of dormant older members. '[T]hey have served proudly and this is their industry, too – to strip their votes? I'm not 100 percent behind that,' he said.[38] But Boone Isaacs was riding the crest of a wave. She needed the Board's approval to push her agenda through, and now, after decades of intransigence, they were ready to cooperate – forced by the wall of pressure, rather than by their own good consciences. The revisions, passed unanimously, would have been unimaginable in any other era.

In an interview with the *Los Angeles Times*, April Reign responded to the Academy's plans for change, and her part within it. 'Never say it's just Twitter or that social media can't change things, because I think we're seeing it,' she said.[39] 'My words and the words of so many seem to have resonated with the academy. There were thousands of people using the hashtag. I think this is a really good start toward systemic change . . .' Ava DuVernay also responded. 'One good step in a long, complicated journey for people of color + women artists,' she tweeted. 'Shame is a helluva motivator.'[40]

22 January

Former Academy president Hawk Koch, though critical of the lack of diversity within the system, cautioned that standards should not be dropped in the drive towards greater fairness. 'I do want to make sure that no matter who we bring in, they have the same level of expertise and qualification for membership, that it is not diluted to bring in more women and diverse members, but it stays high,' he said.[41]

Simultaneously, other white Academy members were pushing back against claims of racism in the 2016 nominations. Gerald Molen, Oscar-winning veteran

producer of *Rain Man* (1988), *Schindler's List* (1993) and *Minority Report* (2002), told *The Hollywood Reporter*, 'There is no racism except for those who create an issue. That is the worst kind. Using such an ugly way of complaining. . . Are their noses bent out of shape by the award nominations? Of course. That is normal in a town of egos and red-carpet desires.'[42] Molen then referenced Will Smith, whose acclaimed performance in *Concussion* had been overlooked. 'I understand his disappointment but see no prejudice or racism in his not making it. Who knows, maybe he lost by one vote.' Molen concluded with a stinging rebuke: 'I say to all my co-members: Stop acting like spoiled brats. Look to the next awards show for recognition – if you deserve it.'

Dissent from white Hollywood went deeper. Fifties actor Tab Hunter, in response *to #OscarsSoWhite*, said two words – 'Bull. Shit.' – maintaining that '[i]t's a thinly veiled ploy to kick out older white contributors, the backbone of the industry'. Hunter's partner, producer Allan Glaser, added, '[T]he whole thing started because of Jada Pinkett. I mean, who is she? She's not a movie star.' On the matter of diversity in film, Hunter was blunt. 'If there's no role for a Chinaman, there's no role for a Chinaman!'[43]

Some African American Academy members were also critical of the movement. 'Oscars so white! So what? Do your work. Let your legacy speak and stop complaining,' said director Lee Daniels in *The New York Times*.[44] 'These whiny people that think we're owed something are incomprehensible and reprehensible to me.'

On the morning of 22 January, speaking on the French radio station Europe 1, 69-year-old British actor Charlotte Rampling, nominated for the first time for Best Actress, in the film *45 Years*, stated that the dialogue around the 2016 Oscars lack of diversity was actually 'racist against whites'. She added that, 'We can never know whether it's truly the case, but maybe the Black actors didn't deserve to make it to the final list.' When asked for her views on the possibility that the Academy introduce quotas to ensure diversity, she said, 'Why classify people? We live now in countries where anyway people are more or less accepted. . .What are we going to do? We're going to classify all that to create thousands of little minorities everywhere?'[45] Rampling's comments set Twitter aflame with fierce

criticisms, and by the next day the actor was forced to make a further statement clarifying her comments. 'I regret that my comments could have been misinterpreted,' she told *CBS News*. 'I simply meant to say that in an ideal world every performance will be given equal opportunities for consideration . . . Diversity in our industry is an important issue that needs to be addressed.'[46]

Rampling was not the only white actor to make comments on diversity which they then had to quickly walk back. That same day, Julie Delpy, in an interview at the Sundance Film Festival, said, 'Two years ago, I said something about the Academy being very white male, which is the reality, and I was slashed to pieces by the media. It's funny – women can't talk. I sometimes wish I were African American because people don't bash them afterward.'[47] Her comments about Black women led to an instant backlash, for which she was forced to apologize the following day. 'I'm very sorry for how I expressed myself,' she told *Entertainment Weekly*. 'It was never meant to diminish the injustice done to African American artists or to any other people that struggle for equal opportunities and rights,' she said. 'All I was trying to do is to address the issues of inequality of opportunity in the industry for women . . . We should stay alert and united and support each other to change this unfair reality . . .'[48]

Over in London earlier that morning, while being interviewed on BBC radio, British actor Michael Caine was asked to comment on the debate about Black actors not being nominated. 'You can't vote for an actor because he's Black,' he replied. 'You've got to give a good performance.'[49] Obviously, Caine was right, although the issue at stake was not about voting for an actor because they were Black, but rather, historically at least, not voting for an outstanding performance *because the actor is Black* – or, in the case of Oyelowo and DuVernay, because they are *Black and political*. Asked if his message to non-white actors was to 'be patient', Caine concurred. 'Of course, it will come,' he said. 'It took me years to get an Oscar.'

23 January

'We are a bunch of racists,' said actor Danny DeVito, commenting on the *#OscarsSoWhite* controversy in an Associated Press video filmed at Sundance.[50]

He added that racist tendencies still run through the entire country. Best Supporting Actor nominee Mark Ruffalo agreed, calling out the American system as riddled with 'white privilege racism. That goes into our justice system.'[51] Ruffalo was conflicted about whether or not to attend the ceremony himself. 'If you look at Martin Luther King's legacy, what he was saying was . . . the good people who don't act are much worse than the people, the wrongdoers, who are purposely not acting and don't know the right way.'

25 January

In an interview with *Sky News*, British actor Sir Ian McKellen, when asked about Hollywood's diversity problem, took the opportunity to remind the world that gay actors were also underrepresented. 'It's not only Black people who've been disregarded by the film industry,' said the actor, who is himself openly gay. 'It used to be women; it's certainly gay people to this day.'[52]

26 January

Variety published a correction for its editorial written in 1996 by previous editor Peter Bart, criticizing Jesse Jackson and Black Hollywood over their claims of racism in the film industry. The cover story, entitled 'Shame on Us', acknowledged the legitimate claims by people of colour that Hollywood actively discriminated against them. The industry magazine also admitted that, in terms of employment practice, they were just as guilty as the Hollywood studios they criticized, because they too had low levels of diversity at executive level within their own organization.[53]

27 January

President Barack Obama added his voice to the debate during an interview at the White House for KABC-TV. 'California is an example of the incredible diversity of this country. That's a strength. I think that when everybody's story is told, then that makes for better art. It makes for better entertainment. It makes everybody feel part of one American family . . . As a whole, the industry should

do what every other industry should do – which is to look for talent, and provide opportunity to everybody. And I think the Oscar debate is really just an expression of this broader issue of: are we making sure that everybody is getting a fair shot?'[54]

3 February

The absence of Black nominees for the second year running galvanized talk of reviving the Black Oscars, which was retired in 2007. Gil Robertson, President of the African American Film Critics Association, said, 'I think that we need to become content with the kind of validation [we get from our own] and if other validation comes, great. It's just the whip cream on top.'[55] But others objected to the very existence of Black-only awards. Actress and *Fox News* contributor Stacey Dash, who is of African American and Mexican ancestry, later referred to the Oscars boycott as 'ludicrous', and suggested that Black History Month, as well as the BET Awards and the NAACP Image Awards, should be scrapped. 'We have to make up our minds. Either we want to have segregation or integration,' Dash told *Fox News*. 'And if we don't want segregation, then we need to get rid of channels like BET and the BET Awards and the Image Awards, where you're only awarded if you're Black,' she continued. 'If it were the other way around, we would be up in arms. It's a double standard.'[56]

11 February

In concurrence with a number of other white Academy members, director Steven Spielberg questioned whether racist voters were responsible for Hollywood's lack of diversity. 'I don't believe that there is inherent or dormant racism because of the amount of white Academy members,' he told *The Hollywood Reporter*. Instead, he spoke of the problem being with Hollywood itself. 'I think we have to stop pointing fingers and blaming the Academy. It's people that hire, it's people at the main gate of studios and independents. It's the stories that are being told. It's who's writing diversity – it starts on the page.

And we *all* have to be more proactive in getting out there and just seeking talent.'[57]

17 February
Over in Germany, Spike Lee, attending the Berlin Film Festival, was asked to comment on the membership changes proposed by the Academy. 'If a ruckus had not been raised, I believe the Academy would not have made those changes,' he said. 'It was worth it. A week later they changed everything up.'[58]

21 February
In California, at the Beverly Hilton Hotel, Beverly Hills, Jamie Foxx appeared on stage at the 2016 American Black Film Festival Awards. He poked fun at social media's diversity hashtags, and the complaints from Black actors snubbed at the Oscars. According to *Page Six*, he said, 'Me and Denzel were like, "Hashtag what's the big deal? Hashtag act better." ' The Oscar-winner implied that winning awards for acting didn't matter. 'It's all about the art,' he said. 'Who cares about anything else?'[59]

22 February
A groundbreaking report on diversity within the entertainment industry was published by Professor Stacy L Smith, of the Annenberg School for Communication and Journalism, at the University of Southern California (USC).[60] Smith and her team analysed a total of 414 motion pictures and broadcast, cable and digital series released in 2014–15 by ten leading film studios. They found that '[t]he film industry still functions as a straight, White, boy's club . . .' Of 407 directors surveyed, 87 per cent were white, and 13 per cent were from minority backgrounds. Of the 13 per cent, only two were Black women: Amma Asante and Ava DuVernay. Women and girls comprised less than one-third of all speaking characters in films. In television and digital series, the numbers rose to 37.1 per cent of characters and 42 per cent of series regulars. The report also found few women in senior leadership roles. The female presence decreased relative to the power that certain positions held. Over 50 per cent of

stories featured no Asian speaking characters, and 22 per cent featured no Black characters. Two per cent of speaking characters were LGBT-identified and only seven transgender characters appeared in the content sample – four of whom featured in the same series. LGBTQ+ characters were predominantly white and male. Overall, the report concluded that none of the studios presented a profile of race and ethnicity that reflected proportional representation in the United States.

There were also problems with the types of minor and supporting roles that Black actors were cast in. A report published later that year by Bruce Nash at Numbers.com analysed a database of 160,000 acting credits from 26,000 major US movies. It found that 'gang member' and related roles were disproportionately assigned to Black men. A staggering 62 per cent of all actors who received this credit were Black, despite the fact that they represent 35 per cent of America's gang members, according to statistics from the National Gang Center. These numbers point to typecasting by white directors, producers and casting agents. Blacks were also found to be underrepresented in other types of roles. Only 18 per cent of 'police officers' were Black, while 'doctors' and 'pilots' were 9 and 3 per cent, respectively. These numbers did not reflect real-life demographics.[61]

24 February

While calls for the return of the Black Oscars were being discussed, music mogul and film producer Russell Simmons launched the first-ever All Def Movie Awards at the TCL Chinese Theatre on Hollywood Boulevard. Its purpose was to honour Black talent snubbed by the Academy and to poke fun at the Oscars. In a statement, Simmons said that the show was 'not the Black Oscars, but they could be. This will be a fun, entertaining and hopefully thought-provoking celebration of the uncelebrated.'[62] The ceremony, hosted by actor and comedian Tony Rock, younger brother of Oscars emcee Chris Rock, featured a black carpet in the entranceway, instead of a red one. Alongside prizes for Best Actor (Michael B Jordan), Best Actress (Sanaa Lathan), Best Director (Ryan Coogler) and Best Film (*Straight Outta Compton*), there were honours for Best Bad Muh-fucka

(Denzel Washington), Best Helpful White Person (Christoph Waltz) and Best Black Survivor in a Movie (Ice Cube).

25 February

A study by website FiveThirtyEight analysed the role of so-called 'For Your Consideration' promotional print campaigns that studios run each year to persuade Academy members to vote for their films during Oscar season.[63] The researchers examined 368 advertisements placed in the pages of *Variety* and *The Hollywood Reporter*. They discovered a distinct lack of promotion for artists of colour from their own studios. 'It's clear that many films with a non-white cast did not receive the same kind of studio support that films with white creators did,' said the report's author, Walt Hickey. Out of the 30 most-promoted films of 2015, only nine featured people of colour, and of those, only three secured nominations. The report established a clear causal link between promotion and Oscar nominations and wins.

But the findings were not straightforward. The report also showed that promoting a film can have no effect on nominations at all. In 2015 two Black-oriented films – *Straight Outta Compton* and *Beasts of No Nation* – were supported by the studios (Universal and Netflix, respectively), and yet neither received any nominations for Black artists. *Straight Outta Compton* was heavily promoted for Best Picture, but failed to make the cut. 'For "Beasts," it could be that people were skeptical of a film released primarily on Netflix receiving a top Academy prize, but there's really no way of knowing why it and "Compton" failed to garner the desired nomination,' wrote Hickey. Conversely, that year, several films that received very low levels of promotion garnered big nominations: *Mad Max: Fury Road*, *Room*, *The Big Short* and *The Revenant*, for example. Nevertheless, the report concluded overall that 'a well-funded nomination campaign for minority candidates could be a first step toward greater inclusion'.

The 2016 Hollywood Diversity Report was published on the same day. Issued by the Ralph J Bunche Center for African American Studies at UCLA, it examined films and television shows from the 2013–14 season.[64] It revealed that those productions that reflected America's racial and ethnic demographic

achieved the highest box office and ratings numbers on average. Nevertheless, 'the industry's homogenous corps of decision makers made relatively few of these types of diverse projects, potentially leaving billions in revenue on the table,' stated Dr Darnell Hunt, chairman of the Center. Instead, the report said, the industry focused on films that reflected the Academy's overwhelmingly white, male membership. This was despite the fact that, in 2014, 46 per cent of all movie tickets sold in America were purchased by people of colour. Latinos accounted for 25 per cent of tickets sold, although they only made up 18 per cent of the population. Further, in 2014, the majority of the tickets sold for four of the top ten films were purchased by people of colour. Despite these compelling statistics, the report found that minorities only featured in 12.9 per cent of the lead roles in the 163 films examined for 2014. 'Because minorities collectively accounted for 37.9 percent of the U.S. population in 2014, they were underrepresented by a factor of nearly 3 to 1 among lead roles in the films examined for that year,' wrote Hunt. Women featured in lead roles in 25.8 per cent of the films examined for 2014 – therefore they were underrepresented by a factor of 2 to 1.

26 February
The *Los Angeles Times* published an updated survey of their 2012 report into the Academy's membership demographic. The new research revealed that Oscar voters were 91 per cent white and 76 per cent male. This marked only a slight change from their original survey, which found that the demographic was 94 per cent white and 77 per cent male.[65]

*

Alongside the changes to the Academy's membership, there were also changes to the coveted Oscar statuette itself. In 2016, production of the trophies was switched to New York fine art foundry, UAP Polich Tallix. Specialists in public art and architecture solutions, the firm have worked with leading artists such as Louise Bourgeois, Alexander Calder, Jeff Koons, Richard Serra, Claes Oldenburg and Kehinde Wiley. For three months each year, in preparation for the ceremony, they produce 57 golden statuettes, each one hand-cast in bronze. Over the years small changes and adjustments had been made to the statuette, and the Academy

wished to reinstate some of sculptor George Stanley's original Art Deco detailing. To achieve this, the foundry scanned an original trophy from 1928, plus a modern version from 2015, and merged the two together using 3D modelling technology. Once the new design had been fabricated, the statuettes were transferred to Brooklyn-based specialist electroplating firm, Epner Technology, to receive their reflective 24-carat-gold finish. Prior to the firm being hired, there was a steady flow of trophies being returned to the Academy because the gold-plating was wearing away. Epner use a high-tech process called Laser Gold, which is three times more durable than normal. Among its other applications it is used on NASA spacecraft, weather satellites and the cryogenic cooling systems for the cameras on the James Webb Telescope. The finished trophies, robust enough to survive space travel, are then secretly shipped to Hollywood, where they are stored in a vault until the big night.

28 February

The big night commenced early that Sunday, in a parking lot adjacent to the Dolby Theatre at the Hollywood & Highland Center, Los Angeles. Up to this point much of the protest about the Academy's exclusion of Black artists had taken place online, but at 2pm on the day of the Oscars the protests spilled onto the street, as the Reverend Al Sharpton and NAN staged their planned demonstration. Actions like this had become almost a tradition among America's most aggrieved groups. Throughout the preceding decades, African Americans, Mexican Americans, Jews, Vietnam veterans, gay activists and others had staged protests. The Academy was soaking up more pressure than it ever imagined, from an increasingly diverse population who all wanted to be heard; who all wanted to be represented favourably in film. How would storytelling work if everybody now insisted on not being the 'bad guys' – while being awarded Oscars to boot? Their individualized demands were the antithesis of American society's assumed collectivism. The plethora of protests testified to the extent to which these various groups had split off from this society in search of their own delineations.

In the parking lot, NAN's protestors held banners aloft with the slogans *#OscarsSoWhite* and *#BlackLivesMatter*. From the top of an outdoor staircase

overlooking the crowd, Sharpton led repeated chants of the mantra that had become an integral part of racial justice rallies across America: 'No justice, no peace.' As he spoke he held aloft a mock Oscar statuette cast in white, rather than the usual gold colour – a symbol of the way the Awards favoured white nominees. 'We are not going to allow the Oscars to continue,' he said. 'This will be the last night of an all-white Oscars.' The group called for a nationwide 'tune-out' of the televised ceremony, and threatened to further pressurize the Academy by targeting its advertisers – especially the retailer Kohl's, the award show's new sponsor – to suspend their relationship until the Academy took concrete steps to address its diversity issues.[66]

Over at the Dolby Theatre, the Academy Awards were about to begin. Perhaps NAN's call not to tune in resonated across America, because the ceremony was to record its lowest domestic viewing figures for eight years, at 34.3 million. Nevertheless, Chris Rock walked on stage dressed in a white tuxedo and black tie, and launched into his much-anticipated opening monologue. 'I thought about quitting,' he began, in reference to calls for him to boycott the Awards. 'I thought about it real hard. But . . . they're not going to cancel the Oscars because I quit. And the last thing I need is to lose another job to Kevin Hart!' In a comedy masterclass, his routine covered civil rights, lynching, police murders of unarmed Black citizens, and the racism present within the so-called 'liberal' members of the Academy. He also made fun of Pinkett Smith's boycott. 'Jada boycotting the Oscars is like me boycotting Rihanna's panties. I wasn't invited!' he said.

To conclude, Rock's tone suddenly turned serious, 'What I'm trying to say is, we want opportunity. We want Black actors to get the same opportunities as white actors. That's it. And not just once. Leo [DiCaprio] gets a great part every year. All you [white] guys get great parts all the time. But what about the Black actors?' This comment sparked the loudest applause of his whole routine. The monologue was Rock's finest hour as a comedian, because of what was at stake. He delivered it under the pressure of #OscarsSoWhite, the anger within Black Hollywood, the calls for him to boycott, and the fierce debates about diversity raging from all sides. His performance had no room to fail. It had to be funny, it had to be political, it had to be racial; it had to slap the audience in the face. In the

end, it did all these things, and more. And in doing so, Rock proved that he was right not to boycott the ceremony – because choosing to stay, and to bring the issue right into the room, and into the uncomfortable faces of everybody relevant to the discussion, and in an environment in which they were forced to listen and could not leave, was the most powerful way the message of inequality could be delivered. Was it powerful enough to make change? On its own, no – but as part of a multi-pronged strategy, yes.

But a strategy to benefit whom? Rock's monologue focused solely on discrimination against African Americans. There was no spotlight on Latino, Asian, Native American or LGBTQ+ performers. The opportunity to pull them all into a conversation, which was not simply about Blacks and whites, was lost. Instead, Asians actually became Rock's targets. At one point in the show he set up a joke in which three young Asian children were paraded onstage as accountants, who were 'dedicated, accurate and hardworking'. Then Rock added, 'If anybody's upset about that joke, just tweet about it on your phone that was also made by these kids.' The racial stereotyping provoked a fierce backlash from both Blacks and Asians. African American actor Jeffrey Wright tweeted, 'Rosa Parks didn't boycott for the right to throw other POC's under the bus.'[67] Asian actor and *Star Trek* star George Takei also weighed in. 'We were absolutely aghast,' he said. 'How insensitive and how ignorant. I grew up in prisons behind barbed-wire fences largely because of those stereotypes.'[68]

15 March

AMPAS issued an apology for Rock's mocking of Asians, after a letter of protest signed by 25 prominent Asian Academy members was presented to the organization. Signatories included director Ang Lee, actors George Takei and Sandra Oh, producer Janet Yang, plus former Academy governors Don Hall, Freida Lee Mock and Arthur Dong. The letter demanded answers as to how the inappropriate material found its way into the show, and what measures the Academy were taking to ensure it did not happen again. AMPAS expressed a commitment to ensuring that future shows would be more 'culturally sensitive'.[69]

On the same day, the Academy also announced the latest raft of revisions to

its membership, with Cheryl Boone Isaacs appointing three new non-white governors to its 51-seat Board. They were African American Reginald Hudlin, Latino writer Gregory Nava and Asian American animator Jennifer Yuh Nelson. Prior to their appointment, Boone Isaacs and Asian American cinematographer Daryn Okada were the only two Board members of colour. Six additional Academy members from minority backgrounds, including Mexican actor Gael García Bernal and African American producer Effie Brown, were also appointed to its various committees.[70]

1 May

The racial stereotype that once depicted Asians as mild-mannered and subservient continued to be challenged by the civil rights moves of its new generation. Galvanized by *#OscarsSoWhite*, they fashioned their own digital resistance movement in protest against the whitewashing of Asian film roles that had endured since the beginning of Hollywood. The hashtag *#WhitewashedOUT* was launched by actress and comedian Margaret Cho, publisher Ellen Oh and Keith Chow, editor-in-chief of sci-fi/fantasy blog, The Nerds of Color. It was sparked by the latest crop of whitewashed Hollywood film roles. In *Doctor Strange* (2016), British actress Tilda Swinton was cast as the Ancient One, who was a Tibetan man in the original Marvel comic; Elizabeth Banks played Rita Repulsa in the 2017 *Power Rangers* movie, who was an Asian character in the 1990s TV show; then Scarlett Johansson was cast as Major Mira Killian in the film adaptation of Japanese graphic novel, *Ghost in the Shell* (2017). As the hashtag went live, 60,000 tweets poured in on the first day of protest, as people around the world shared their opinions. '[I]t is time to say "enough is enough," ' declared Cho and Chow. 'Because there already isn't enough Asian representation in films to begin with, we cannot allow the few roles that do exist [to] go to white actors. We're tired of Hollywood acting as though Asian Americans don't exist, and want to let them know that we aren't watching these whitewashed movies.'[71] As well as seeking an end to this form of casting, the group insisted that white actors stop accepting these parts, and start realizing that whitewashed movies are racist by design. 'Movies depicting Asian culture without actual Asian actors are

not only harmful to us and our children, they are bad art. We will not tolerate being ignored and erased by our media.'

29 June

The latest instalment of the Academy's A2020 diversity drive issued a record-breaking 683 invitations to new members. The list consisted of 46 per cent women and 41 per cent people of colour. It included 28 Oscar winners, 98 nominees and 283 international members from 59 countries. The list featured Mary J Blige, Emma Watson, America Ferrera, Tina Fey, Alicia Vikander, Dakota Johnson, Eva Mendes, James Hong, John Boyega, Michael B Jordan, Mahershala Ali and Idris Elba. From the Directors Branch came Ryan Coogler, Cary Fukunaga and Abbas Kiarostami. There were some invitees whose memberships were long overdue, such as veteran Black director Melvin Van Peebles, whose 1971 film *Sweet Sweetback's Baadasssss Song* helped launch the blaxploitation era, and Julie Dash, whose movie *Daughters of the Dust* (1991) became the first feature directed by an African American woman to be distributed theatrically in the US.

2 August

Boone Isaacs had presided over the most tumultuous year in the history of the Academy Awards. Despite enduring fierce criticism from all sides, she had steered AMPAS closer to reform than anyone else in its history. But this had come at a cost. 'I do have my share of hate mail for ruining the organization,' she said.[72] Nevertheless, her position as president was given a vote of confidence by the 54-member Board when was she was re-elected to the post for the fourth consecutive time.

The boiling point of 2016 illustrated just how difficult equality and fairness were to attain. Rather than being a simple matter of proportionality, in practice it was complex, and fraught with clashing views between minority artists themselves, as well as between whites and minorities. Meanwhile, white Academy voters, offended at being branded racists, bristled with repressed resentment, while others staunchly resisted the changes that would reduce their power and prerogatives. As the year drew to a close, many wondered: why was all this

happening now? Why had 2016 been so seismic? There had been numerous occasions in the past when Black actors were left out of the Oscar nominations, and with very little reaction. But in 2016 a number of factors came together to create a perfect storm. From outside Hollywood, April Reign's *#OscarsSoWhite* created a tidal wave of online protest, which was followed up internationally by the press, stretching the debate from the streets right up to the White House. Meanwhile, inside Hollywood, influential Black actors who had previously avoided speaking out finally reached the end of their tolerance, and took a stand, thereby aligning themselves with civil rights protestors for the first time. But none of this would have meant anything without Cheryl Boone Isaacs and Dawn Hudson agitating where it mattered most. All of these factors conspired to make an insular, $42 billion business dramatically change course.

The 2016 boiling point was also a tipping point. But of what kind? Would *#OscarsSoWhite* prove to be Hollywood's ultimate inciting point – more powerful as a change agent than the Second World War or the Civil Rights Movement? The new era would be the most important ever in evaluating if change would hold.

CHAPTER 8

RAINBOW ROAD (2017–2024)

'I don't think the public knows what Oscar means to us. It is one of the most emotional things that can happen to a human being.'
Joan Crawford, Academy Awards ceremony, 8 April 1963

Something unbelievable was about to happen. It was 26 February 2017, the night of the 89th Academy Awards, held at Hollywood's Dolby Theatre. Warren Beatty and Faye Dunaway were about to present the final award of the evening – the Oscar for Best Picture. In contention that year were *Moonlight, Arrival, Fences, Hacksaw Ridge, Hell or High Water, Hidden Figures, La La Land, Lion* and *Manchester by the Sea*. As Beatty opened the envelope and looked at the writing on the enclosed card, he paused. He looked again at the writing. Then he felt inside the envelope, is if to search for another card. Dunaway stared at him, wondering why he was taking so long. Eventually he passed the card to her. She glanced at it, then pronounced *La La Land* the winner. Celebrations ensued as the team behind the film gleefully took to the stage. But almost two minutes into their acceptance speeches, thanking their wives and mentors, there was a commotion. Academy officials were moving about on stage among the winners. Something was wrong. Jordan Horowitz, one of the producers of *La La Land*, stepped up to the microphone, as if he was now the show's compere, and made a surprise announcement. 'There's a mistake,' he said. '*Moonlight* – you guys won Best Picture. This is not a joke. Come up here.' Beatty handed Horowitz the card upon which the winner for Best Picture was written, and he held it up to the cameras, confirming his statement. The audience gasped in a symphony of surprise. They stood up, applauding, as if they were at the theatre watching the climax of a play. The bemused *Moonlight* team gazed around at each other, trying

to comprehend the madness. Their expressions quickly changed to joy as the realization set in, and they hugged each other before stepping onto the podium to replace the *La La Land* team who, embarrassingly, had to hand back their Oscars and leave the stage.

It was the biggest mistake in Oscars history. It had happened because just prior to presenting the Award, Beatty had been handed the wrong envelope. He had received the card for 'Actress in a Leading Role', which read, 'Emma Stone, *La La Land*' – and so Dunaway, glancing at the text, pronounced that film the winner. PricewaterhouseCoopers, the accounting firm that handled the Oscars balloting, took full responsibility. 'We sincerely apologize to "Moonlight," "La La Land," Warren Beatty, Faye Dunaway, and Oscar viewers for the error,' they wrote in a statement.[1] The two partners at the firm who were responsible for the gaffe were subsequently banned from ever working for the Academy again. They had failed to follow their set protocols. Brian Cullinan, the partner responsible for handing over the envelopes to the Awards presenters, was 'distracted' backstage, where he had tweeted (and later deleted) a photograph of Emma Stone with her Oscar, just minutes before handing Beatty the wrong envelope.

For director Barry Jenkins, the mix-up marked a stuttered triumph for his film – a coming-of-age drama about a young, gay, African American man. Nominated in eight categories, the low-budget production – which grossed $65 million from a budget of $1.5 million – became the first film with an LGBTQ+ theme, and an all-Black cast, ever to win Best Picture. The production won three Oscars overall, including Best Adapted Screenplay for Jenkins and screenwriter Tarell Alvin McCraney. 'This goes out to all those black and brown boys and girls and non-gender-conforming, who don't see themselves,' said McCraney.

At the start of the 2017 Oscar season, Hollywood's minority artists had been poised to see what effect, if any, *#OscarsSoWhite* would have on the forthcoming nominations – and it turned out to be a bumper year for them. Overall, more than 20 were in contention across all categories, with seven named (35 per cent) among the actors. 'It makes me feel good to see such a multifaceted group of people get recognized,' said Jenkins.[2] The list featured a record six Black acting

nominees – 30 per cent of the total. The artists were Denzel Washington and Viola Davis (*Fences*), Mahershala Ali and Naomie Harris (*Moonlight*), Ruth Negga (*Loving*) and Octavia Spencer (*Hidden Figures*). Dev Patel, nominated for Best Supporting Actor in *Lion*, became only the third actor of Indian heritage to make the list.

The Oscar for Best Supporting Actor went to Mahershala Ali for his role in *Moonlight* as a drug-dealer-turned-father-figure to a wayward young boy. He stepped onto the podium in a black tuxedo by Ermenegildo Zegna Couture. 'I'm so blessed to have had an opportunity,' he said in his acceptance speech. Viola Davis won Best Supporting Actress for her portrayal of world-weary housewife Rose Maxson, in *Fences*, a 1950s drama about the trials and tribulations of a Black working-class family. Davis graced the stage in a flame-red off-the-shoulder gown with a flowing train, by Armani. In a tearful, intensely heartfelt speech she praised playwright August Wilson (author of *Fences*), and expressed gratitude to director and co-star Denzel Washington. 'Thank you for putting two entities in the driving seat: August and God,' she said. 'And they served you well.'

In a marked improvement from the previous two years, Black actors had achieved two wins from six nominations, while *Moonlight* took three from eight. But to what extent was this upswing the result of *#OscarsSoWhite*? 'It didn't feel like it was the black vote or the diversity vote,' said Ruth E Carter, costume designer on *Selma* and *Black Panther*. '[I]t felt like it was the right vote.'[3] But did 'the right vote' come at the expense of white artists? Notable snubs that year included Amy Adams (*Arrival*) and Tom Hanks (*Sully*), plus directors Martin Scorsese and Clint Eastwood, for *Silence* and *Sully*, respectively. The new reality facing all white artists was, if people of colour were expected to feature *every* year – which was the goal – then they would have to get used to receiving fewer nominations, permanently. Or, to put it another way, power-sharing was going to have to come into effect.

*

Black Hollywood, 'the community', has never been comprised of a single homogenous group, but, rather, a myriad of opinions and divisions. At the

beginning of the film industry, its only Black participants were African Americans, but the modern era has ushered a new generation of Black Brits such as Naomie Harris, Thandiwe Newton, Chiwetel Ejiofor, David Oyelowo, David Harewood, John Boyega and Idris Elba. With a very small pool of roles for Black actors in general, the Black Brits are seen as competitors by African American actors. This was brought into sharp focus in March 2017, when African American actor Samuel L Jackson criticized the casting of Black British actors in African American storylines. In an interview with New York radio station Hot 97, Jackson made reference to director Jordan Peele's horror satire, *Get Out*, which starred Black British actor Daniel Kaluuya as an African American man on the receiving end of 'white liberal' racism. 'I tend to wonder what that movie would have been with an American brother who really feels that,' he said.[4] (Ironically, in 2018 Kaluuya was nominated for Best Actor for the role.) Jackson also focused on Ava DuVernay's *Selma*, which cast David Oyelowo in the role of Martin Luther King. 'There are some brothers in America who could have been in that movie who would have had a different idea about how King thinks,' he remarked. Jackson was unclear about how being an African American automatically inferred better insights into a character than being a Black actor of a different nationality. Nevertheless, others agreed with his perspective. 'There are times that I have watched certain British actors do roles where I feel like there is an authenticity missing,' said LA-based actor and playwright Stacy Amma Osei-Kuffour. 'There are ample American actors to play these parts,' she concluded.[5] Needless to say, these comments did not go down well with Black Brits. 'Black brits vs African American. A stupid ass conflict we don't have time for,' tweeted John Boyega.[6] 'You don't have to be a "brother" to play African American roles,' David Harewood added. 'In fact, sometimes it helps that we can unshackle ourselves from the burden of US racial history.'[7]

When asked why so many Black Brits were cast in African American roles, Jackson replied: 'They're cheaper than us, for one thing . . . And they [casting agents and directors] think they're better trained . . .'[8] The classical training many British actors undergo, at schools such as the Royal Academy of Dramatic Art, is often cited. 'They're well trained,' Spike Lee affirmed to *The Guardian* in 2013.

'They came through on the stage[,] not on a music video or whatever. So their acting's impeccable . . .'⁹ But Jackson's comments about Black Brits sidestepped one of two overarching issues – the first being that casting decisions are not made by actors, but by directors, casting agents and producers. Jackson later amended his statements to encapsulate this reality during an interview with the Associated Press. '[I]t was not a slam against [British actors], it was a comment about how Hollywood works in an interesting sort of way sometimes,' he said. 'We're not afforded that same luxury, but that's fine. We have plenty of opportunities to work.'¹⁰ In the latter part of his comment, Jackson was referencing the fact that, while Black Brits are frequently cast in American productions, African Americans are rarely cast in British ones.

The second, and more subtle, issue at play within Jackson's comments was simply about *who gets the work* in Hollywood. 'When it comes to telling very specific American stories, it can sometimes feel like a slap in the face to the black community,' said actor Devere Rogers, in reference to casting Black Brits in African American roles. 'It's like, we as Americans can't tell our own stories?'¹¹ This is the point. Jackson's statements were about *nationalism* – about being American. Like a protectionist politician, he spoke in defence of the jobs market for homegrown talent, as opposed to 'cheap British imports'. In this regard, Rogers's viewpoint suggests a split narrative – that there is American history, and there is Black history – and that these stories should only be acted by those whose nationalities correspond to each scenario. If this was the case, Denzel Washington would never have played Black South African Steve Biko in *Cry Freedom*, or Will Smith a Nigerian in *Concussion*, and countless other examples. The very idea that nationality should determine what roles diasporic Blacks should be cast in is bizarre, and goes against the very definition of what acting is. These issues reflected the subtle divisions at play within Black Hollywood. Black Brits and African Americans were not all loving comrades, united in the fight for equality against a common white enemy. The Brits were in fact 'the enemy within' – taking American jobs from Americans. And just like any 'migrant' population, the more of them that come to take these jobs, the bigger the potential conflict can get.

There were also strong opinions within the Latino community about who should play the few roles written for them. In past decades it was white actors, but in the modern era Hollywood developed a penchant for casting Spanish stars such as Antonio Banderas, Penélope Cruz and Javier Bardem, who have variously played Mexicans, Cubans, Colombians and Brazilians in a range of productions. In 2021 Bardem was cast as Cuban actor, bandleader and producer Desi Arnaz in the biopic *Being the Ricardos*, for which he was subsequently nominated for Best Actor. News of his casting drew online criticism from those who thought a US Latino actor should have been cast instead. 'I'm an actor, and that's what I do for a living; try to be people that I'm not,' Bardem countered matter-of-factly. 'We should all start not allowing anybody to play Hamlet unless they were born in Denmark[?]'[12] Lola Méndez, writing in *The Independent* online, disagreed. 'Spanish actors can never fully grasp the Latinx experience or properly portray it on-screen the way an actor from the character's nationality would.'[13] But once again, like Jackson, Méndez did not articulate her assumed link between nationality and acting ability. Bardem pointed out the absurdity of the association, as well as his view that minority actors were treated more harshly in this regard than white actors. 'What do we do with Marlon Brando playing Vito Corleone? What do we do with Margaret Thatcher played by Meryl Streep? Daniel Day-Lewis playing Lincoln? . . . What I mean is, if we want to open the can of worms, let's open it for everyone.'[14]

What the dissenting voices perhaps did not know about the casting of *Being the Ricardos* was that Bardem was not the sole option considered for the role, and that the producers at Amazon, makers of the film, did audition a Brazilian and then a Guatemalan actor initially, before finally settling on Bardem. Ultimately, these experiences sharpened his sympathies for the plight of Hollywood's Latino actors. 'I do recognize that there are many underrepresented voices and stories that need to be told, and we should collectively do better to provide access and opportunities for more American Latino stories and storytellers.'[15]

*

On 12 May, one of the most important periods in the Academy's history drew to a close, as Cheryl Boone Isaacs relinquished her post as president, after four years,

and 24 years on the Board. She had served the maximum consecutive term allowed under AMPAS rules. Her journey began as 'the only Black woman in the room', powerless to make change, and finished with her being the organization's most powerful force. During her tenure she had done more to alter the make-up of the Academy than any other person in its history. She had achieved what the entire roster of Academy presidents before her had not been motivated to do. While they acted to preserve the status quo, knowing that it was unfair and biased, and that it favoured older, white males above everyone else, she tore it down before their very eyes. Thanks to her, CEO Dawn Hudson and the support of the Board, AMPAS now had thousands more women and minorities within its ranks – a fact that would have a direct bearing on future Oscar winners, and the trajectory of their careers subsequently. Never in the Academy's history had a president been so loved for their commitment to diversity and fairness. The following year after her departure, at a pre-Oscars gala dinner held in her honour at the Beverly Wilshire hotel, Los Angeles, she concluded her tenure by saying, 'We are a community, we have power, and our power is in our connectedness . . . we all must work together and combine our talents and show all of Hollywood and show America and the world that we have arrived. We are here. Things are changing. And we are going to march on.'[16]

The reforms that Boone Isaacs had set in motion would continue in her absence. On 28 July, the Academy's new president, veteran cinematographer John Bailey, announced 774 new invitees – breaking the Academy's previous record for a second consecutive year. The new class came from 57 countries, and was 39 per cent female, up from 27 per cent in 2016. People of colour made up 30 per cent of the total. The Academy reported a 331 per cent increase in their presence between 2015 and 2017. Among the high-profile new members were Naomie Harris, Gal Gadot, Donald Glover, Riz Ahmed, Priyanka Chopra, Ruth Negga, Omar Sy and Dwayne Johnson. African American directors Barry Jenkins and Jordan Peele joined the Directors Branch.

*

For the second year following #OscarsSoWhite, Black artists featured prominently in the list for the 2018 Academy Awards. The nominations contained four Black

artists in the acting categories (20 per cent). Denzel Washington (*Roman J Israel, Esq*) and Daniel Kaluuya (*Get Out*) were nominated for Best Actor, while Mary J Blige (*Mudbound*) and Octavia Spencer (*The Shape of Water*) were included for Best Supporting Actress. Three African Americans appeared in the writing categories, including director Jordan Peele, who ended up being the only Black artist included in the major categories to win an Oscar that year, for Best Original Screenplay, for *Get Out* – a horror film about a Black man plunged into trouble when he goes to visit his white girlfriend's family. While the spike in nominations was good news for Black artists, it was not so good for other minorities. There were no Asian, Indian, Native American or Latino nominees in the acting categories. Behind the camera, Mexican filmmaker Guillermo del Toro featured for Best Director (*The Shape of Water*), as well as for Best Original Screenplay, alongside Pakistani American comedian and actor Kumail Nanjiani (*The Big Sick*).

The high point of the 2018 ceremony occurred when Frances McDormand was announced Best Actress, for *Three Billboards Outside Ebbing, Missouri*. During her acceptance speech, after thanking her fellow film colleagues, she placed her Oscar down on the floor, looked out into the audience, and asked all the female nominees present to stand up. 'Look around, ladies and gentlemen, because we all have stories to tell and projects we need financed,' she began, to rapturous applause. 'Invite us into your office . . . and we'll tell you all about them.' With all the female nominees in the audience standing, it became glaringly obvious how few of them there were across all the categories – and therefore the extent to which the Oscars were still dominated by men. McDormand concluded with a simple message. 'I have two words to leave with you tonight,' she said. 'Inclusion rider.' And with that, she picked up her Oscar and made her exit, leaving the audience and viewers at home bemused. What was an inclusion rider?

The term was the brainchild of Stacy L Smith of the Annenberg Inclusion Initiative. On the back of her research into the lack of diversity within Hollywood, she had proposed that an addendum be included within the film employment contracts of powerful A-list actors, specifying that the cast and

crew of their upcoming productions be diverse and representative, in order to counter the bias within Hollywood's casting and hiring system. 'The rider is a flexible and adaptable framework that actors/content creators should consider together with counsel prior to signing on to their next project,' wrote Smith.[17] Actor Michael B Jordan was an early adopter of the clause. On Oscar night Smith had no idea that McDormand even knew of her work, or had plans to mention it during her acceptance speech. 'I just found out about it this last week,' the Oscar winner told reporters backstage. 'We're not going back,' she said defiantly. 'That whole idea of women trending, no. No trending. African-Americans trending – no trending. It changes now. And I think the inclusion rider has something to do with that . . .'[18]

McDormand's Award moment followed on from the ceremony's theme highlighting the issue of sexual harassment in Hollywood, in relation to Harvey Weinstein. Show host Jimmy Kimmel opened proceedings by referencing the abuse, and mocking Weinstein within his jokes. In one of the evening's most powerful moments, actors Ashley Judd, Salma Hayek and Annabella Sciorra, all of whom had accused Weinstein of sexual harassment and assault, took to the stage to celebrate female empowerment and to pay tribute to *#MeToo* and *#TimesUp*. The trio introduced a video montage which highlighted the importance of diversity and featured a range of Hollywood figures, including Ava DuVernay. 'These are times that will be long remembered,' she said. 'What will we be remembered for? What did we do?'

On 25 June, what the Academy did was to continue to introduce more new members. A record-breaking 928 invitees were asked to join. They hailed from 59 countries, including South Korea, Algeria and India, and ranged in age from 14 to 86. There were 17 Oscar winners and 92 nominees among them. The new roster consisted of 38 per cent people of colour – increasing their overall representation to 16 per cent – and 49 per cent women, moving their presence to 31 per cent overall. Among them were Tiffany Haddish, Daniel Kaluuya, Mindy Kaling, Dave Chappelle, Daisy Ridley, Amy Schumer, Kumail Nanjiani, Rashida Jones, Hong Chau and Jada Pinkett Smith. Chloé Zhao and Justin Simien joined the Directors Branch, and Kendrick Lamar and Questlove the

Music Branch. The new additions brought the total number of Academy members to 9,226.

But the film roles available to actors of colour were not yet keeping pace. On 31 July a new report by Stacy L Smith at USC Annenberg surveyed 1,100 of the most popular films released between 2007 and 2017, revealing that, despite Hollywood's talk about increasing on-screen diversity, little had changed statistically. The survey found that approximately 71 per cent of all movie characters were white, 12 per cent were Black, 6 per cent were Latinx and 6 per cent were Asian. Less than 1 per cent were from the LGBTQ+ community. Women occupied 31 per cent of all speaking roles. Across 1,200 directors surveyed over 11 years, only 4.3 per cent were female, 5.2 per cent were Black and 3.1 per cent were Asian.[19] 'Those expecting a banner year for inclusion will be disappointed,' said Smith. 'Hollywood has yet to move from talking about inclusion to meaningfully increasing on-screen representation for women, people of colour, the LGBT community or individuals with disabilities.'[20]

<p style="text-align:center">*</p>

In 2019 the nominees for the 91st Academy Awards included five artists of colour (25 per cent) within the acting categories. There were two Black nominees: Mahershala Ali, Best Supporting Actor (*Green Book*), and Regina King, Best Supporting Actress (*If Beale Street Could Talk*). Two Latinas from the Netflix film *Roma* also made the list: Mexicans Yalitza Aparicio for Best Actress, and Marina de Tavira for Best Supporting Actress. Rami Malek became the first actor of Egyptian and Arab heritage to be nominated for Best Actor, in *Bohemian Rhapsody*. Asian actors did not feature, although Asian Canadian filmmaker Domee Shi did make the shortlist for Best Animated Short. Spike Lee (*BlacKkKlansman*) and Mexican Alfonso Cuarón (*Roma*) were nominated in both directing and writing categories, while Barry Jenkins made the list for Best Adapted Screenplay, for *If Beale Street Could Talk*. Fellow Black director Peter Ramsey was also included, for Best Animated Feature, for *Spider-Man: Into the Spider-Verse*.

Best Picture selections were more diverse than usual. *Roma*, filmed in Spanish and Mixtec, was the first foreign-language movie to be nominated since 2013.

Half of the Best Picture nominees featured women or minorities in lead roles. Gay rights groups approved of *The Favourite* for its depiction of a lesbian love triangle, while *A Star is Born* starred a prominent female lead in Lady Gaga. *Black Panther* was the list's most notable inclusion – the first superhero movie ever to be nominated for Best Picture. The science-fiction fable, based on the Marvel Comics character of the same name, tells the story of T'Challa, heir to the futuristic African kingdom of Wakanda, who faces a formidable rival to his nation's throne. Directed and co-written by Ryan Coogler, it became the most successful Black-themed film of all time, grossing $1.35 billion, and challenging the Hollywood stereotype that movies with an all-Black cast could not make serious money. The production received seven nominations, including slots for costume designer Ruth E Carter and production designer Hannah Beachler, creator of the fictional world of Wakanda. She was the first African American ever to be nominated in this category. 'I'm crying one minute then doing a little dance the next second and then crying again thinking of the weightiness of it,' she told *The Hollywood Reporter*.[21]

The 2019 nominations proved to be a milestone for Spike Lee. It was the first time in a 30-year career that he had received a nomination for Best Director. His movie, *BlacKkKlansman*, dramatized the true story of a Black cop who infiltrated the Ku Klux Klan in the 1970s. The film – which grossed $93 million from costs of $15 million – received six nominations, including Best Picture. Lee was happy that, at long last, his work had been recognized by the Academy. '[I]t feels very good,' he told *The New York Times*. 'We're very pleased. We were all watching [the nominations], sitting in bed, jumping up and down. The dog was barking at us – she didn't know what was going on – but it's a good day.'[22] After he had been shunned by Academy voters for decades, Lee's sudden nominations suggested that the changes to its demographic were beginning to take effect. '[T]he membership of the academy today is much more diverse than it was back then,' he noted. '*#OscarsSoWhite* definitely prodded the academy to open up its membership, and that's why I think that you see films by people of color are getting the recognition now that they didn't get in the past.'

Green Book, with five nominations, was one of the films that Lee was up

against. Directed by Peter Farrelly, and starring Viggo Mortensen and Mahershala Ali, it was based on a true story about the relationship between a racist Italian American chauffeur and his passenger, a Black pianist on a tour of the American South in 1962. The film was loved by many for its feel-good portrayal of interracial friendship, but it was disliked by others for its racial clichés, and for what Wesley Morris, writing in *The New York Times*, called 'racial reconciliation fantasies'.[23] Lee was no fan of this type of filmmaking, in which bigots become buddies. The situation was reminiscent of the 1990 Academy Awards, when his movie *Do the Right Thing* was snubbed for Best Picture and Best Director by a more conversative voter base who struggled to relate to the work of the maverick young filmmaker. Instead, *Driving Miss Daisy*, a film with similar nostalgic tonal points to *Green Book*, won Best Picture, plus three other Oscars. At the time, Lee did not hold back in expressing his displeasure. 'Nobody's talking about motherfuckin' *Driving Miss Daisy*,' he told the *Daily Beast* in 2015. 'That film is not being taught in film schools all across the world like *Do the Right Thing* is. Nobody's discussing *Driving Miss motherfuckin' Daisy*.'[24] Fast-forward to the 2019 nominations, and Lee was competing against *Green Book* in a similar face-off – although this time an older, wiser Lee held his tongue. 'I have a policy today where I'm not talking about anybody else's films that were nominated,' he told *The New York Times*. 'But I will acknowledge that comparison [with *Driving Miss Daisy*] has been made, yes.' When pressed further, he laughed and said, 'Can't speak on it. Won't speak on it!'[25]

The Academy Awards ceremony took place on 24 February. For the first time since 1989 the show went ahead without a compere. African American comedian and actor Kevin Hart was originally slated to appear, but he dropped out after initially refusing to apologize for old homophobic tweets of his that had resurfaced. Following on from the controversy at the 2016 Awards, when presenter Chris Rock told racially offensive jokes about Asians, the Academy was under pressure to thoroughly vet its emcees before appointing them, and to control their content in order to avoid onstage controversies. For the Academy the issue was crucially important because TV ratings for the show were on the

slide. Viewing figures for the 2018 Oscars broadcast had plummeted 20 per cent, and the Academy needed to avoid any flashpoints that might further alienate viewers.

The ceremony was a triumph for Black artists. Regina King, winner of the Oscar for Best Supporting Actress, stepped onto the podium in a gleaming white full-length gown with a thigh-high split, by Oscar de la Renta. In a tearful, breathless speech she paid tribute to the film's cast and crew, and to the late James Baldwin, whose 1974 novel the film was based upon. The audience cheered and applauded when she namechecked her mother, who was seated in the audience. 'Mom, I love you so much,' she said. 'Thank you for teaching me that God is always leaning, always has been leaning, in my direction.'

Mahershala Ali, winner of the Academy Award for Best Supporting Actor, strolled on stage in a black couture tuxedo and white Mandarin-collared shirt by Ermenegildo Zegna, accessorized with wire-framed aviator spectacles by Cutler & Gross, and topped off with a bespoke Jinnah-style hat by milliner Gigi Burris. Like King, he gave thanks to a special woman in his life. 'I wanna dedicate this to my grandmother, who has been in my ear my entire life, telling me that if at first I don't succeed, try, try again. That I could do anything I put my mind to.' Ali joined Denzel Washington, Ruth E Carter, Willie D Burton and Russell Williams as the only Black artists to win more than one Academy Award.

Spike Lee, along with his three co-writers (Charlie Wachtel, David Rabinowitz and Kevin Willmott), won Best Adapted Screenplay. As Lee climbed the stairs to the podium, he was already unfolding the sheet of paper that contained his acceptance speech. Aside from winning the Oscar, the other thing that was special about him in that moment was his footwear – a pair of limited-edition, custom-made Nike Air Jordan 3s, in metallic gold, complete with a bespoke heel featuring Lee's '40 Acres and a Mule' production company logo, plus Michael Jordan's 'Jumpman' insignia. But the audience were not looking at Lee's feet as he began to speak. He told of his long ancestral journey to the Oscars podium, beginning with the African Americans brought to the country as slaves; and of his grandmother, Zimmie Shelton Retha, who rose to graduate from Spelman College, despite the fact that her mother was a slave. He spoke of his

grandmother, who saved 50 years of social security checks to send him to Morehouse College, and then on to film school. He finished on a political note, with a reference to the upcoming 2020 presidential election. 'Let's all mobilize,' he said. 'Let's all be on the right side of history. Make the moral choice between love versus hate. Let's do the right thing!'

It turned out to be a record-breaking year for artists of colour, winning a total of 13 Oscars, including seven for African Americans. *Roma* picked up three, including Best Director for Cuarón, while Peter Ramsey and his four co-directors won Best Animated Feature. Domee Shi claimed the Oscar for Best Animated Short, and *Black Panther* won three Awards in the technical categories, with Beachler and Carter breaking new ground as Black female winners in their respective fields. The inciting point that was #*OscarsSoWhite* still appeared to be resonating. Spike Lee was sure of it. 'If it were not for April Reign's hashtag and Cheryl Boone Isaacs being president – the work of two sisters – I would not have an Oscar,' he told *The New York Times*.[26]

African Americans, Latinos and Asians all took home Awards – but at the opposite polarity Native Americans had nothing to celebrate. Throughout Hollywood history they had been the most discriminated against, with very few progressive roles and only two Oscar nominations in almost a hundred years. Actor Wes Studi, a proud member of the Cherokee nation, was one of its few stars, with appearances in films such as *Dances with Wolves, The Last of the Mohicans* and *Avatar*. The Academy, with its new lens on diversity, recognized his contribution to Hollywood at the Governors Awards on 27 October 2019, with the presentation of an Honorary Oscar – the first indigenous American actor to be so honoured. Studi was surprised when he got the call from the Academy inviting him to accept the Oscar, as he thought his work would forever go unacknowledged. 'To be recognized by your peers is a wonderful thing,' he told *Newsweek*. 'It's a great feeling that your efforts have not gone unrecognized.'[27] But honouring Studi inevitably threw light on the bigger question: when would a Native American finally win an acting Oscar? Was there not someone, somewhere, who could carry the hopes and dreams of the Native nations all the way to the Oscars podium?

*

Black Hollywood's celebrations at their record-breaking haul at the 2019 Oscars did not last. When the nominations for the 2020 Awards were published on 13 January, they included just one actor of colour – British Nigerian Cynthia Erivo, for best Actress, in *Harriet* – while eight of the nine Best Picture nominees featured overwhelmingly white casts. Overlooked in the acting categories were Lupita Nyong'o (*Us*), Eddie Murphy (*Dolemite Is My Name*) and Jennifer Lopez (*Hustlers*). Black artists seemed to have gone back to square one. Again. 'The pendulum swings back and forth, as we've seen,' said April Reign.[28] Spike Lee felt it coming. 'After last year's ceremony, I said, "It ain't gonna be like this next year!" It's always feast or famine with us.'[29] Incredibly, film studio heads were also commenting. 'The gender and racial diversity of the nominations continues to be clearly lacking, which continues to be disappointing,' said Thomas E Rothman, chairman of Sony's Motion Picture Group.[30] But wasn't he exactly the kind of person who could change things?

The absence of Black nominees that year brought home a cold truth about the volatile nature of inciting points such as *#OscarsSoWhite* – they don't last. There were, however, other plus points. The Academy proclaimed 2020 the best year ever for women overall, with a total of 62 nominations across all categories. The Documentary Branch included four feature-length films directed or co-directed by women. But when it came to the big prizes in the non-acting categories, women were still lagging behind. They were once again omitted from the Best Director category, leaving Greta Gerwig (*Little Women*), Céline Sciamma (*Portrait of a Lady on Fire*), Lorene Scafaria (*Hustlers*) and Lulu Wang (*The Farewell*) out in the cold.

Nonetheless, there was some good news for Asian artists. South Korean film *Parasite* – a drama-comedy about the intertwined lives of two families, one rich, the other poor – achieved six nominations, including Best Picture. 'The Korean press, they're all very excited. It's almost like a national celebration,' said director Bong Joon-ho.[31] Following on from *Roma*, it marked the second year running that a non-English-speaking film had received both Foreign and Best Picture nominations. Did it reflect the increasingly younger and more globalized nature

of the Academy's member base? *Parasite* eventually won four Oscars, with Bong wining Best Director, Best Original Screenplay and Best Picture. Some thought it should have been more. There was consternation that a film nominated for the top awards featured no Asians in any of the acting categories. Were their performances not good enough? Was voter prejudice to blame? Perhaps it was as simple as voters struggling to assess performances in a foreign language?

Despite this, *Parasite*'s win for Best Picture did not please some of the old-guard conservatives outside of Tinseltown's gates. On 20 February 2020, during a campaign rally in Colorado Springs, President Donald Trump spoke out against *Parasite*'s victory. 'How bad were the Academy Awards this year?' he asked. The crowd erupted with loud boos. 'The winner is a movie from South Korea, what the hell was that all about? We got enough problems with South Korea with trade and on top of it, they give them the best movie of the year.' The crowd cheered when he then went on to say, 'Was it good? I don't know. I'm looking for, like – can we get like *Gone with the Wind* back, please?'[32] Trump's comments were a reaction against diversity, and the power shift it was causing. The same reaction, and the resulting political swing to the right, was also occurring in other countries around the world simultaneously. Their collective 'enemies' were women, people of colour, migrants, LGBTQ+ – anybody who wanted more rights than they traditionally had, anybody who threatened *the old ways*. Trump's opinions contrasted sharply with those of his predecessor, Barack Obama, who, just four years earlier, during *#OscarsSoWhite*, had championed diversity and fair opportunity for all within film. The two presidents held polar opposite views on what modern America should be, and each ideology had its base of supporters. Nevertheless, within Hollywood at least, it was clear which one was in the ascendency.

In 2020 Asians and indigenous artists won five trophies between them, including Maori director Taika Waititi, who took Best Adapted Screenplay for *Jojo Rabbit*. There was a lesson here for Black artists disappointed at not winning that year. Why were they only content with their own successes? Surely, all victories by diverse peoples should be celebrated collectively, and unselfishly? This was the message implied by the Academy's shape-shifting member base, which

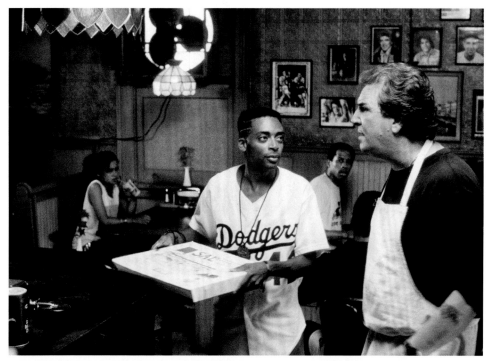

Above: Spike Lee's *Do the Right Thing* (1989) picked up only one Oscar nomination, for Best Original Screenplay, in the year when *Driving Miss Daisy,* with its considerably more sentimental view of race relations, was nominated in nine categories and went on to win the Oscar for Best Picture.

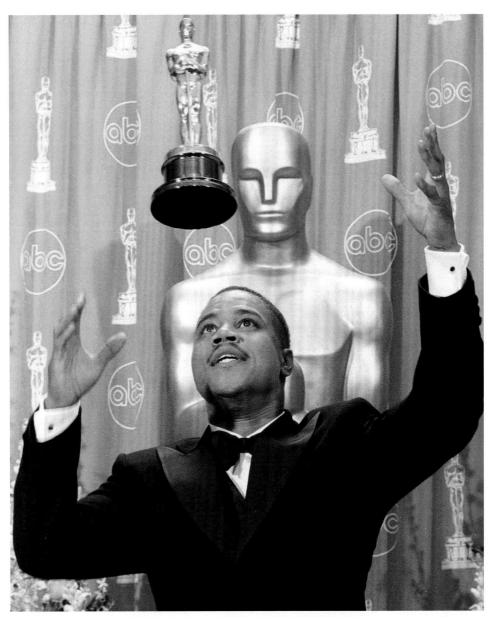

Above: In March 1997, Cuba Gooding Jr won Best Supporting Actor, for *Jerry Maguire.*

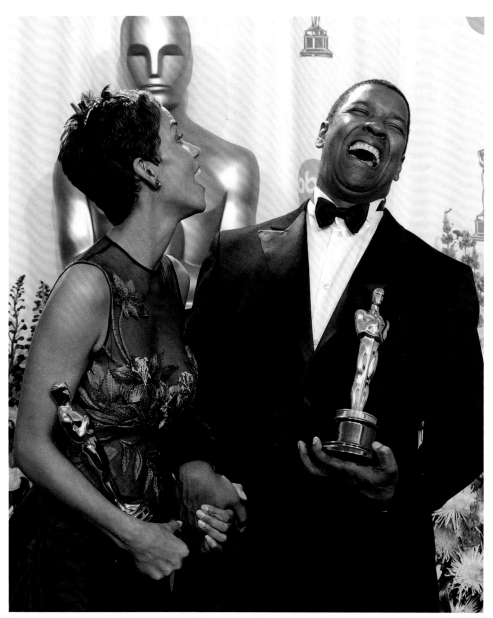

Above: In 2002, Denzel Washington won Best Actor, for *Training Day,* becoming the first Black actor to win two Oscars. Halle Berry won Best Actress for *Monster's Ball* – the first time for a Black actress. This was the first time ever that both lead acting awards went to Black artists.

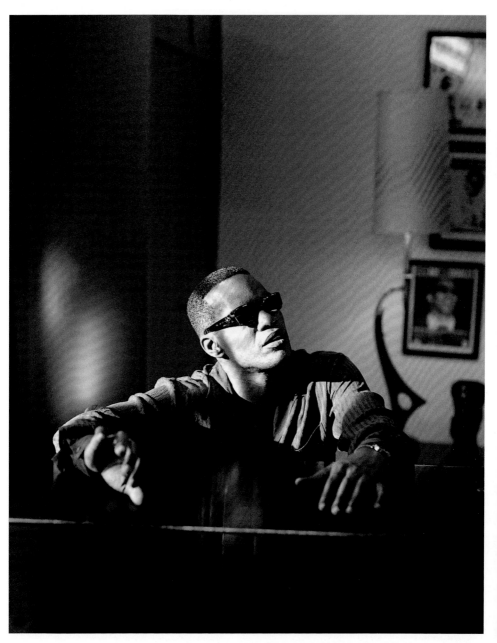

Above: The nominations for the 2005 Oscars featured five performances by Black actors. Morgan Freeman was nominated for Best Supporting Actor, in *Million Dollar Baby*, while Don Cheadle (Best Actor) and Sophie Okonedo (Best Supporting Actress) were nominated for *Hotel Rwanda*. Jamie Foxx won Best Actor for *Ray* (above), but he was also nominated in the Best Supporting Actor Category, for *Collateral*.

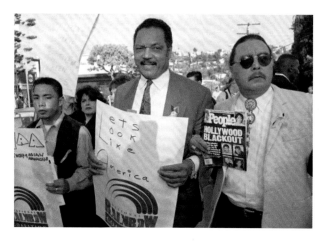

Left: In 1996 – another year with all-white nominees in the acting categories – Jesse Jackson (centre) and his Rainbow PUSH Coalition of activists called out AMPAS on its inherent racism.

Below: In 2015, attorney and film fan April Reign was disappointed with the all-white line-up of nominees in the four acting categories. She composed a short tweet: '#OscarsSoWhite they asked to touch my hair'. And a social media movement began.

Above: In 2013, film marketing veteran Cheryl Boone Isaacs was elected the 35th President of the Academy of Motion Picture Arts and Sciences – the first African American, and only the third woman, to head the organization. She made it her mission to address the Academy's lack of diversity; at the time, an overwhelming proportion of Oscar voters were white and male, with a median age of 62.

Above: In 2020 South Korean filmmaker Bong Joon-ho won Best Director, Best Picture (with producer Kwak Sin-ae, shown here), Best Original Screenplay (with Han Jin-won) and Best International Feature Film for *Parasite*, the first foreign-language film ever to win Best Picture.

Above: In 2024, Piitaaki (Eagle Woman), otherwise known as Lily Gladstone of the Blackfeet nation, became the first Native American ever to be nominated for Best Actress, for *Killers of the Flower Moon*. Emma Stone beat her to the award, and the wait for the first Native American actor to win an Oscar continues.

year on year was becoming ever more diverse and international in nature. On 30 June, AMPAS, headed by new president David Rubin, published its latest list of invitees. It featured 819 film professionals, of whom 45 per cent were women, 36 per cent were from underrepresented ethnic or racial communities, and 49 per cent were international, from 68 countries. There were 15 Oscar winners and 75 nominees among them. The list included Constance Wu, Lulu Wang, Awkwafina, Zendaya, Cynthia Erivo, Eva Longoria, Florence Pugh, Olivia Wilde, James Saito and Teyonah Parris. Earlier that month *Selma* director Ava DuVernay was among six new members elected to the Board of Governors, bringing the total number of women to twenty-six. The Academy's A2020 inclusion goal to double the number of women and people of colour by 2020 had now officially been reached. In total, it had grown by more than 3,000 members since 2016 – a near 50 per cent increase. However, after four years of diversity initiatives, the member base was still 68 per cent male and 84 per cent white. Nevertheless, great strides had been made in a very short time.[33]

But was Hollywood's filmmaking engine keeping pace? The latest report by Stacy L Smith at the Annenberg Inclusion Initiative revealed that change within the filmmaking ecosystem was still taking time to ignite.[34] The research found that 31 of the top one hundred grossing films of 2019 featured an actor of colour as lead or co-lead – up from 27 in 2018. Female leads or co-leads appeared in 43 out of the top one hundred films – up from 39 in 2018. For both groups the figures more than doubled what they were in 2007, when just 13 of the top one hundred films featured people of colour in lead roles, and 20 featured women. By contrast, roles for women and minorities behind the camera had not progressed as significantly. The report showed that 14 per cent of the directors of the highest grossing films of 2019 were people of colour – 5 per cent down on the previous year, while the presence of women directors had climbed since 2011, but still only represented 15 per cent of the total. Despite Kathryn Bigelow becoming the first woman to win Best Director in 2010, female underrepresentation was making further wins even more difficult. Since Bigelow, only one woman, Greta Gerwig, had made the nominees, in 2018 for *Lady Bird*. The report's most significant statistic revealed the make-up of the

heads of the 11 major film studios – those who decide which films get made, and by whom. The data showed that they were 91 per cent white and 82 per cent male. This was the most resilient edifice in Hollywood – a diversity-free zone that would not be broken down.

Forcing change from the outside was the only way. In June 2020 the Academy announced the next phase of its reforms, called Academy Aperture 2025. Beginning in 2022 the Best Picture category was to be set at ten nominees, rather than fluctuating each year. The Academy would also facilitate quarterly online film screenings to allow members to view releases all year round, thereby broadening each film's exposure equally, and ensuring that all eligible films could be viewed easily by members prior to voting. Internally, all Academy governors, branch executives and staff would be subject to mandatory unconscious bias training, repeated annually, and with the option extended to all 9,000 members. AMPAS also pledged to hold special discussion panels, called 'Academy Dialogue: It Starts With Us', aimed at members of the public, featuring conversations about race, ethnicity and history within filmmaking, alongside debates about the changes that needed to occur within the movie-making chain – from screenwriting to the greenlighting of films – in order to better provide opportunities for women and people of colour. A further announcement in September stipulated that, from 2022, all eligible films must meet new representation and inclusion standards in order to qualify for Best Picture. Nominations would be required to feature members of underrepresented racial or ethnic groups in two out of four designated areas within a film's production, including acting roles.

The Academy's proposals were radical, with far-reaching consequences for how films were made, and who would be employed to make them. 'The aperture must widen to reflect our diverse global population in both the creation of motion pictures and in the audiences who connect with them,' said Academy president David Rubin and Academy CEO Dawn Hudson in a press statement. 'The Academy is committed to playing a vital role in helping make this a reality.'[35] But had they gone too far in their commitment to equality and fairness? Not everyone was happy about what was seen by some as the Academy's version of

affirmative action. There were concerns that the reforms would collide with artistic freedoms, in a way that could stifle creativity. 'They make me vomit,' said actor Richard Dreyfuss of the new proposals. 'This is an artform . . . No one should be telling me as an artist that I have to give in to the latest, most current idea of what morality is.' The 75-year-old Oscar winner added, 'You have to let life be life. And I'm sorry, I don't think that there's a minority or a majority in the country that has to be catered to like that.'[36]

<div align="center">*</div>

On 15 March 2021, there was a shock when the nominees for the 93rd Academy Awards were announced. The list was the most diverse of all time, with *nine* artists of colour from the 20 acting nominees – the highest total ever (45 per cent), with three in the Best Actor category alone. For the first time in history, all four acting categories could conceivably be won by a non-white actor. Four films featuring actors or directors of colour were also selected for Best Picture, while two Asian filmmakers were nominated for Best Director. Further nominees featured in the writing and technical categories also. What was happening? Why was there such a sudden influx of diverse talent? Was it the result of the Academy's more inclusive membership list taking effect? Or was there something else in play?

Ten months earlier, on 25 May 2020, a 46-year-old Black man named George Floyd was murdered on a Minneapolis street by white police officer Derek Chauvin. Floyd was initially arrested after a store clerk suspected him of passing a counterfeit 20-dollar bill. Chauvin, one of four officers who arrived on the scene, placed Floyd on the ground and pressed his knee upon his neck for a total of nine minutes and 29 seconds, until Floyd's life was extinguished from his body. His dying words were, 'I can't breathe.' A video of his slow death, shot on a smartphone by Black teenage bystander Darnella Frazier, went viral. The police didn't recognize Floyd as a human being, but people around the world did. Their attention, which at that time was fixed on the coronavirus pandemic, suddenly diverted, as the global meditation that was lockdown made space for them to ponder and consider Floyd's murder in ways they would not have otherwise. Frazier's video sparked outrage, demonstrations and protests against police

brutality directed at Black citizens. *Black Lives Matter*, founded in 2013 in response to the acquittal of Trayvon Martin's murderer, George Zimmerman, became the spearhead for the tsunami of responses to Floyd's death. Corporations around the world, shamed into analysing their own discriminatory cultures, suddenly began to *think Black*. Magazines put Black faces on their covers, just as they did in 1968 after the assassination of Martin Luther King, while others scrambled to make diversity pledges and to grant opportunities to Blacks. This is what it took to get change: the world had to stop, and a Black man had to die – on camera.

The Academy posted a statement on its social media accounts: 'We stand in solidarity with our black members, colleagues, storytellers, artists, and with all black people across our nation because we know Black Lives Matter. The Academy adds its voice to the call for justice. We must shine a brighter light on racism and do our part to step up to this moment.' Simultaneously, the reaction from celebrities within the entertainment industry was fierce. It was the first time since Martin Luther King's March on Washington in 1963 that Hollywood's megastars, Black and white, came out in protest against racism. In those days it was Sidney Poitier, Harry Belafonte, Lena Horne, Marlon Brando, Charlton Heston and Judy Garland in attendance. This time, it was *everybody*, from Beyoncé to Timothée Chalamet – and instead of the protests being in one location, they were global, driven by digital civil rights movements. Celebrities attended protest marches, gave speeches, expressed outrage across social media, donated money to civil rights organizations, bailed protestors out of jail, or simply 'took the knee' in solidarity and defiance.

But could supporting Floyd and *#BlackLivesMatter* potentially damage the careers of Hollywood's Black actors? Remember, some white Academy members did not like it back in 2014 when David Oyelowo and Ava DuVernay mixed entertainment and politics at the New York premiere of *Selma*, by protesting the murders of unarmed Black men by police. NFL quarterback Colin Kaepernick's career was also shuttered after he 'took the knee' in protest against police brutality and racial inequality. The possibility that joining the *#BlackLivesMatter* demonstrations could potentially be career-ending certainly crossed the mind of

John Boyega. 'I don't know if I'm going to have a career after this but, fuck that,' he told the massed crowd at a rally in London's Hyde Park, where he gave a speech.[37]

It was against this backdrop of intense global outrage, trauma and pain over Floyd's murder that the record-breaking numbers of non-white acting nominees were announced in March 2021. Chadwick Boseman and Viola Davis were nominated for Best Actor and Actress, for *Ma Rainey's Black Bottom*; Daniel Kaluuya and LaKeith Stanfield both made the list for Best Supporting Actor, for *Judas and the Black Messiah*; Leslie Odom Jr joined them, for *One Night in Miami . . .*; Andra Day was included for Best Actress, for *The United States vs. Billie Holiday*; Koreans Steven Yeun and Yuh-jung Youn were nominated for Best Actor and Best Supporting Actress, for *Minari*, while British Pakistani Riz Ahmed featured for Best Actor, for *Sound of Metal*. Behind the camera, Chinese filmmaker Chloé Zhao was nominated for Best Director and Best Adapted Screenplay, for *Nomadland*, while Hong Kong director Derek Tsang made the list for Best International Feature, for *Better Days*. African American writer Kemp Powers was nominated for Best Adapted Screenplay, for *One Night in Miami . . .*

The Academy had never seen a list like it. But the big question was: how many Oscars would they actually win? The answer was eight in total – two in the acting categories (Kaluuya and Youn); two in the filmmaker categories (Chloé Zhao, Best Director and Best Picture), and four in the technical and subsidiary categories. Notable in the latter section was *Two Distant Strangers*, by Travon Free and Martin Desmond Roe. The film, which won Best Live Action Short, was influenced by Floyd's death in its subject matter, which told the story of a Black New Yorker who is killed by a police officer, after which he becomes trapped in a Groundhog Day-style time loop where he repeatedly relives the experience.

That year's Academy Awards took place at Union Station, Los Angeles, on 25 April. It was moved from its usual February date and venue, due to restrictions imposed by the COVID-19 pandemic. Under these difficult circumstances, the show struggled to find its audience, and was watched by only 10.4 million

Americans – the lowest numbers since viewership records began. In a stripped-back, re-organized ceremony with greatly reduced audience numbers, Laura Dern presented the Award for Best Supporting Actor to Kaluuya. The British Ugandan stepped up in a black double-breasted suit by Bottega Veneta, accessorized with a Cartier diamond necklace. 'Thank you, God. I can't be here without your guidance and your protection,' he began. 'Huey P Newton, Bobby Seale, the Black Panther Party – they showed me how to love myself. And with that love they overflowed it to the Black community, and to other communities. And they showed us the power of union, the power of unity.'

For her big night at the Oscars, Youn wore a full-length navy-blue dress by Egyptian designer Marmar Halim, which was chosen from 250 outfits procured by her stylist, Alvin Goh. As presenter Brad Pitt called her to the stage to collect her Oscar for Best Supporting Actress, Youn made history as the first South Korean actor ever to win an Academy Award. Her success followed on from the accolades won by her countryman Bong Joon-ho for *Parasite* the year before. 'Mr Brad Pitt, finally, nice to meet you,' she began, looking across the stage at him. 'Where were you while we were filming in Tulsa?' The guests were laughing. The Oscar winner went on to say that her fellow nominees were all winners for the quality they brought to their respective roles, and that she was the one who just happened to have that 'little bit luck' in winning the Oscar.

<p style="text-align:center">*</p>

The nominees for the 94th Academy Awards were announced on 8 February 2022. They included four actors of colour: Will Smith (*King Richard*) and Denzel Washington (*The Tragedy of MacBeth*) featured for Best Actor, while Ariana DeBose (*West Side Story*) and Aunjanue Ellis (*King Richard*) were nominated for Best Supporting Actress. African Americans made up 20 per cent of the total. Best Director featured Jane Campion (*The Power of the Dog*) as only the eighth woman ever to make the list, and the only one to do so twice, the first being in 1994, for *The Piano*. For Best Actor, Smith and Washington faced stiff competition from Javier Bardem (*Being the Ricardos*), Benedict Cumberbatch (*The Power of the Dog*) and Andrew Garfield (*Tick, Tick . . . Boom!*). But it was Smith who emerged as clear favourite after winning the

Golden Globe, BAFTA, Critics Choice and SAG awards for his performance in the biographical sports drama, as the father and coach of tennis prodigies Venus and Serena Williams.

As the Awards show commenced on the evening of 27 March, Smith was seated close to the stage together with his wife Jada, who was dressed in an emerald-green couture gown by Jean Paul Gaultier. Smith wore a black mohair three-piece suit by Dolce & Gabbana. Three-quarters of the way through the ceremony, guest presenter Chris Rock stepped on stage to present the Award for Best Documentary Feature. He looked into the audience and honed in on Pinkett Smith – just as he had done at the 2016 Oscars. In an unscripted joke, he poked fun at her shaved head. (In 2018, she had, in fact, been diagnosed with alopecia, an auto-immune condition that causes hair loss.) 'Jada, I love you,' said Rock. '*G.I. Jane 2* – can't wait to see you!' The quip referenced actress Demi Moore, who had shaved her head to play the role in the original 1997 movie. At first, Smith appeared to find Rock's joke funny, and laughed – but Pinkett Smith, unamused, was stone-faced. She was disappointed that Rock had targeted her again. According to her, they had apologized to each other shortly after their disagreement in 2016. 'So I actually thought that we were good, that the hatchet was buried between us,' she later told *People*.[38]

But then something extraordinary happened. Smith's expression suddenly hardened. He got up, stepped onto the stage and began walking purposefully towards the unsuspecting comedian. Rock was still giggling as Smith approached. Barely breaking his stride, Smith pulled back his right hand and struck Rock across the face. The slap was so hard that the thud of its bass reverberated through Rock's microphone. 'Wow! Oh, wow!' said the stunned comedian. 'Will Smith just smacked the shit out of me!' Smith walked back to his seat. The audio on the American television broadcast was suddenly cut. The audience, shocked and confused, wondered if what they had just seen was real, or part of the comedy. Even Pinkett Smith was unsure. 'I thought, "This is a skit,"' she said. 'I was like, "There's no way that Will hit him."'[39]

Back in his seat, Smith was now visibly angry. He shouted up at Rock. 'Keep my wife's name out your fuckin' mouth!' 'Wow, dude,' Rock replied. 'It was a *G.I.*

Jane joke.' 'Keep my wife's name out your fuckin' mouth!' Smith repeated. Rock stared at him in silence, then finally said, 'I'm going to, okay?' Smith had lost something within himself – and not in that moment, but somewhere before, sometime in his earlier life. The audience was silent. No one knew what to do. No one had ever seen anything like it before. There was no protocol for violence on stage at the Oscars – or for screaming obscenities afterwards. What was this madness? This was not the Will Smith we knew. The violence and profanity were most shocking coming from him – the once goofy, lovable, super-funny Fresh Prince of Bel Air; the one with the sticky-out ears; the Black man that cinema-goers loved the most; the one white men wouldn't mind their daughters marrying. Of all the people, this was the one with the dark interior, the secret torment, the gangsta rage. It was pure Shakespeare.

The incident appealed to rapper 50 Cent. Gleefully, he posted on Instagram, 'Slap the shit out of Chris, 😂 The world is over. LOL.'[40] In Smith's moment of radical insanity, however, all the worst racial stereotypes about Black men were beamed into the homes of 17 million Americans watching the broadcast, plus many millions more globally across 225 countries and territories. *Black men are innately violent and emotional.* The 'angry Black man' stereotype was not a stereotype now – it was true, it was modern, it was live on TV for all to see. All of Sidney Poitier's teachings about being a role model for the race, about knowing one's *responsibility*, went up in flames. Instead, Smith showed us something else – that sometimes, *with great power comes great irresponsibility.*

Back on stage, Rock, still reeling with shock, tried to compose himself. 'That was er . . . the greatest night in the history of television,' he said, looking back to camera. The telecast hurriedly cut to a commercial break. Denzel Washington and Tyler Perry rushed over to Smith and pulled him aside for a private conversation. '[We said s]ome prayers,' said Washington. 'I don't wanna say what we talked about. But there but for the grace of God go any of us. Who are we to condemn?'[41] Rock came off stage and tried to speak to Pinkett Smith, much to her husband's displeasure. 'Chris came down to the end of the stage and tried to apologize to me,' she recalled. 'He said, "I didn't mean you any harm." I said, "I can't talk about this now, Chris."'[42]

The show restarted, but it couldn't really restart. The focus of the entire production, the whole engine, and the eyes of its guests, had now switched to Smith – his needs, his pain, his problems. The Academy's officials allowed it. He was permitted to return to his seat and to wait to see if he would win an Oscar. Twenty minutes later, he did just that. In what seemed like a surreal moment, Smith was back on stage, as Uma Thurman, John Travolta and Samuel L Jackson announced him the winner of the Academy Award for Best Actor. Unexpectedly, Smith received a standing ovation from many in the audience. Others sat silently, appalled. Actor Jim Carrey was one of them. 'I was sickened by the standing ovation,' he told Gayle King on *CBS Mornings*. 'Hollywood is just spineless en masse.'[43] Sean Penn was another: 'Why are you guys standing and applauding his worst moment as a person?'[44]

Smith was tearful as he accepted his Oscar. 'I know to do what we do, you gotta be able to take abuse . . . to have people talk crazy about you. . . .to have people disrespecting you, and you gotta smile and you gotta pretend like that's okay,' he said. The actor then addressed his violent outburst, apologizing to the Academy as well as to his fellow nominees, but he stopped short of apologizing to Rock. 'Art imitates life. . . But love will make you do crazy things.' Wasn't love supposed to be the antidote to violence, not its catalyst?

Smith became only the fifth Black artist ever to win Best Actor, following Sidney Poitier, Denzel Washington, Jamie Foxx and Forest Whitaker. But none of them had claimed the trophy quite like this. The immediate aftermath was just as bizarre, as Smith and those around him seemed to behave as if nothing had happened. He posed for the Oscars press corps, smiling alongside his wife, while proudly holding his Oscar, and later on, at the after-party, he danced and sang along to his own hit song, 'Getting' Jiggy Wit It'. When Smith finally arrived home that night, he sat in the kitchen with his nine-year-old nephew, who had stayed up late to greet him. As the boy sat on his uncle's lap clutching his Oscar, he turned to him and asked, 'Why did you hit that man, Uncle Will?'[45]

*

The next day Smith posted a public apology via his 67 million Instagram followers. 'Violence in all of its forms is poisonous and destructive,' he wrote. 'My

behavior at last night's Academy Awards was unacceptable and inexcusable. Jokes at my expense are a part of the job, but a joke about Jada's medical condition was too much for me to bear and I reacted emotionally.' He went on to apologize to Rock. 'I would like to publicly apologize to you, Chris. I was out of line and I was wrong. I am embarrassed and my actions were not indicative of the man I want to be.' He also apologized again to the Academy, as well as to the producers of the show, the attendees, his fellow nominees, viewers around the world, and to the Williams family.[46]

This, Smith's second apology, though well-meaning, only increased the focus on him, and not on the ceremony's other winners. Among the minority nominees, Troy Kotsur became only the second deaf actor to win an Oscar when he took home Best Supporting Actor, for *CODA*. Ariana DeBose won Best Supporting Actress for her role as Anita in Steven Spielberg's revival of *West Side Story*, becoming the first openly queer woman of colour ever to win an Oscar. The 31-year-old Afro-Latina, dressed in a red two-piece gown by Valentino, delivered a heartfelt acceptance speech. 'Even in this weary world that we live in, dreams do come true,' she said. 'So, to anybody who has ever questioned your identity . . . or you find yourself living in the grey spaces, I promise you this: There is indeed a place for us.'

To what extent was this 'place' now damaged by Smith's violence? David Oyelowo was worried. 'My fear is that this unfortunate incident, which has us all processing, will have a negative effect on the ongoing push for inclusion,' he told *The Hollywood Reporter*.[47] One could imagine this secret, whispered narrative: *Why should white Hollywood help Blacks ascend if it ends in violence and profanity? None of this would have happened if we'd kept Blacks out of the Oscars.*

The drive towards inclusivity for Black artists that began with Hattie McDaniel in 1940 had ended in violence on the podium, between African Americans themselves, in Hollywood's version of what was once called 'Black-on-Black violence'. But history tells us that this is often what happens when the downtrodden rise up and get power. Success can be dangerous.

Celebrity reaction to the slap veered from those appalled by it, to those who supported it. Oscar co-hosts Wanda Sykes and Amy Schumer both described the

event as 'sickening'.[48] Rapper Nicki Minaj tweeted, 'You just got to witness in real time what happens in a man's soul when he looks over to the woman he loves & sees her holding back tears from a "little joke" at her expense... while y'all seeing the joke he's seeing her pain.'[49] Actress Tiffany Haddish saw virtue in Smith's violence. '[T]hat's what your husband is supposed to do, right? Protect you,' she told *People* magazine. '[F]or me, it was the most beautiful thing I've ever seen because it made me believe that there are still men out there that love and care about their women, their wives.'[50]

Serena Williams took a pause, waiting a year before she spoke to the press about the incident. On *CBS Mornings* she expressed disappointment that Smith's actions had 'overshadowed' the film, but overall she took a compassionate view. 'I'm the kind of person that's like, I've been there, I've made a mistake, it's not the end of the world. We're all imperfect and we're all human, and let's just be kind to each other.'[51]

By contrast, Sean Penn was scathing of Smith. 'He was so fucking good in "King Richard",' he told *Variety*. 'So why the fuck did you just spit on yourself and everybody else with this stupid fucking thing?' he said. 'Why did I go to fucking jail for what you just did? And you're still sitting there?'[52] Penn was referencing a short jail term he did in 1987 for punching an extra on a film set. His comment illustrated an extraordinary turnaround in American perceptions of power and race. Here was a white man complaining about a Black man getting away with violence. But since the beginning of America it has been white men – law enforcement officers, in particular – who have gotten away with violence against Blacks, Native Americans, Mexicans and others. In his complaint, Penn suddenly got the briefest glimpse into what it felt like to be an American Black man.

In the aftermath, the Academy was heavily criticized for allowing Smith to remain in the theatre, and to accept his Oscar. 'What happened onstage was fully unacceptable, and the response from our organization was inadequate,' said Academy president Janet Yang.[53] In response, AMPAS created a new 'crisis team' to be on hand during future ceremonies to quickly address any potential real-time emergencies.

On 1 April, Smith resigned from the Academy. In his statement, he said:

'I betrayed the trust of the Academy. I deprived other nominees and winners of their opportunity to celebrate and be celebrated for their extraordinary work. I am heartbroken.'[54] On 8 April, the Academy confirmed that it was revoking Smith's membership, and in addition banning him from all AMPAS events, including the Oscars, for a period of ten years.

Jim Carrey was vocal about what he thought should happen next. 'I'd have announced this morning that I was suing Will for $200 million,' he said, 'because that video is going to be there forever – it's going to be ubiquitous . . . You do not have the right to walk up on stage and smack somebody in the face because they said words.'[55]

In July 2022, in an emotional video posted on YouTube, Smith apologized for the third time to everyone affected by his actions, including his children, Rock's mother and Questlove, who won the Oscar for Best Documentary Feature directly after the altercation, and once again to Rock himself, offering to meet and talk whenever the comedian was ready. In response to the question about why he didn't apologize to Rock during his Oscar acceptance speech, he said, 'I was fogged out by that point. It's all fuzzy.'[56]

If it is true that traumatized people cause trauma, then what was the trauma that triggered Smith? He provided some insight four months later, when he appeared on *The Daily Show*, for what amounted to his fourth capitulation. 'I was going through something that night, you know? . . . It was the little boy that watched his father beat up his mother, you know? All of that just bubbled up in that moment. That is not who I want to be.'[57] Smith had already outlined his father's brutality towards his mother in his autobiography, *Will*, published the previous year. 'I saw her spit blood. That moment in that bedroom, probably more than any other moment in my life, has defined who I am.' He went on to note: 'Within everything that I have done since then – the awards and accolades, the spotlights and attention, the characters and the laughs – there has been a subtle string of apologies to my mother for my inaction that day. For failing her at the moment. For failing to stand up to my father. For being a coward.'[58] But, in truth, a frightened little boy who does not confront a violent grown-up is not a coward. He's a frightened little boy.

If the slap was triggered by Smith re-living the trauma of his nine-year-old self, and his desire to defend those he loved, there seemed to be something else in the mix too – he and Rock had a long-standing feud. In his YouTube address, when discussing his motivation for striking Rock, he said, 'I made a choice on my own, from my own experiences, from my history with Chris. Jada had nothing to do with it.' Pinkett Smith corroborated the statement, stating that the incident was 'their stuff that they had before I even came into the picture'.[59]

There was also another, more mysterious tangent to the whole affair. Did Smith receive prior warning of what would befall him at the 2022 Oscars? On 22 January, two months prior to the ceremony, Smith appeared on David Letterman's Netflix show, *My Next Guest Needs No Introduction*, where he confessed to taking, over a two-year period in Peru, 14 rounds of ayahuasca – a powerful psychoactive botanical beverage, made from the leaves and vines of the *cawa* plant, and used in traditional ritualistic medicine among Amazonian tribes. Smith described it as the 'most hellish psychological experience' of his life. In his altered mind-state he claimed to have seen visions of his career, home and family slipping away from him. 'I started seeing all of my money flying away, and my house is flying away, and my career is going away, and I'm trying to grab for my money, and my career and my whole life is getting destroyed. This is my fear, and I'm in there, but I'm wanting to vomit,' he recalled.[60] Among believers, ayahuasca is known to be a portal into the spirit realm. Was Smith's vision a premonition? A warning? Was his Oscars meltdown the catalyst for the troubled future he foresaw?

This 'troubled future' has afflicted many Oscar winners. For Smith, like Louis Gossett Jr, Cuba Gooding Jr and Halle Berry before him, the Oscar he had so coveted, proved to be kryptonite. Winning it brought misfortune, like J R R Tolkien's golden ring. As if possessed by the ring's dark power, the very moment Smith's hand connected with Rock's face, the actor's crown, which he had painstakingly built over three decades of box office blockbusters, came crashing down like that of a king in a Shakespeare tragedy.

As for Chris Rock, throughout the post-mortem surrounding the incident, he joked about the slap, on one occasion stating that it had even restored his

hearing. But, as is always the case, behind the jokes and bravado, there was pain. His close friend and fellow comedian Leslie Jones revealed the extent to which Rock was disturbed and humiliated by his experience. 'It really affected him,' Jones told *People*. '[H]is daughters, his parents, saw that [the slap]. He had to go to counseling with his daughters.'[61] Jerry Seinfeld also connected with Rock at that time. 'He was a little shook from that event,' he said.[62] In fact, Rock was so shaken that he turned down an offer to appear in Seinfeld's Netflix feature debut. Looking back at the slap, Jones joked with Rock about what he should have done when he saw Smith approach him on stage. 'I was like, "Chris, when he got up why didn't you run?",' she said. 'I would've been running around that stage like "Will, calm down. Jada, call your man!"'[63]

Rock was praised for his restraint, refusing to press charges after Smith's assault, and for not suing him, as Carrey suggested, as compensation for a humiliating video that will never go away. But, upset a world-class stand-up comedian at your peril – because they are sure to get their revenge in their next show. This is exactly what Chris Rock did in his March 2023 Netflix comedy special, *Selective Outrage*. Rock addressed the slap within the performance, stating that he was 'not a victim'. He said, 'You'll never see me on Oprah or Gayle, crying. I took that hit like Pacquiao.'[64]

Rock revealed that the Oscars joke he had first told about Pinkett Smith at the 2016 Awards was driven by an incident that occurred during her efforts to boycott the ceremony after her husband and other Black actors were snubbed from the nominations. Rock alleged that Pinkett Smith pressured him to boycott the show. 'She said, me, a fucking grown-ass man, should quit his job because he [Will Smith] wasn't nominated for *Concussion*.' Rock, angered by this, consequently decided to make her the butt of his jokes at the ceremony. 'She started this shit,' he said. 'Nobody's picking on her.'[65] Pinkett Smith later admitted not recognizing the pressure Rock was under at the time. 'I probably should have called him and gone, "Hey, are you okay?"' she told *People*.[66]

Smith's conduct at the 2022 Oscars was simultaneously the worst moment in the history of the Academy Awards, and the worst moment in the history of

Black Hollywood. But Smith's public apology was the greatest ever from a celebrity – because he did it a total of *four times*, which is three more than superstars usually bother with, and each was conducted in the most raw and heartfelt manner, blaming no one but himself. Clearly, his behaviour weighed heavily upon his heart. Cynics would say that the four apologies merely reveal the desperation of a fading star, anxious to be loved again, but others might see a man of great courage and integrity, keen to make amends for his human, and very public, mistakes. Perhaps he is both. Would he rise again? Russell Crowe and Sean Penn, after dispensing violence at different points in their lives, kept their careers. Would Smith get to keep his? Would he ever be forgiven? America loves a flawed hero – but usually only the white ones.

<div align="center">*</div>

At the 2023 Academy Awards, as in 2020, it was Asian artists who shone, with four nominations. The list featured three from the film *Everything Everywhere All at Once*: Michelle Yeoh (Best Actress), Ke Huy Quan (Best Supporting Actor) and Stephanie Hsu (Best Supporting Actress). Hong Chau was nominated for Best Supporting Actress, for *The Whale*. The nominees also included two Black actors: Angela Bassett, for Best Supporting Actress, in *Black Panther: Wakanda Forever*, and Brian Tyree Henry, for Best Supporting Actor, in *Causeway*. Overall, six artists of colour (30 per cent) appeared in the acting category.

Everything Everywhere All at Once was the big film of the Awards season, with 11 nominations, including Best Picture and Best Director for Daniel Kwan and Daniel Scheinert. On Awards night, 12 March, the motion picture swept the board, winning seven Oscars, including Best Picture, Best Director and Best Original Screenplay. In a dramatic double victory, both Michelle Yeoh and Ke Huy Quan won their categories. As Ariana DeBose read out Quan's name, she started to cry. When Quan heard his name, he started crying too. Stunned and elated, the Vietnamese-born actor climbed the podium to accept his award. He was only the second Asian actor ever to win the category, after Cambodian Haing S Ngor for *The Killing Fields*, almost 40 years earlier. Wearing a black single-breasted tuxedo by Giorgio Armani, he kissed his trophy several times before

speaking. 'My journey started on a boat. I spent a year in a refugee camp and somehow I ended up here, on Hollywood's biggest stage. They say stories like this only happen in the movies,' he said. The crowd cheered and applauded.

As the nominees for Best Actress were read out by Jessica Chastain, Yeoh received the biggest cheer. Then when she was subsequently proclaimed the winner, the audience erupted. She had beaten Cate Blanchett, Michelle Williams, Ana de Armas and Andrea Riseborough to the big prize, becoming the first Asian ever to win the category, and the first Malaysian to win an Academy Award. She stepped on stage in a shimmering single-shouldered sequinned gown in metallic silver, by Balenciaga, paired with matching leaf-shaped earrings by Cindy Chao, and black opera gloves. 'For all the little boys and girls who look like me, watching tonight, this is a beacon of hope and possibilities,' she began. 'This is proof that: dream big, and dreams do come true. And ladies, don't let anybody tell you you are ever past your prime. Never give up.'

But what kind of history was it? The kind that would repeat itself, with more and more victories by artists of colour? Or would it lead nowhere? There had been big gaps in Asian Oscar victories over the years, just as there once were for African Americans. Native Americans had waited the longest time. But their hopes were raised in October 2023 when a rare thing happened – the release of a film about them and their culture. *Killers of the Flower Moon*, directed by Martin Scorsese, was a period drama set in 1920s Oklahoma, based upon a true story about Native American Mollie Burkhart of the Osage nation, whose family members were murdered in an attempt to steal their oil-rich land. The film starred Robert De Niro, Leonardo DiCaprio, and Lily Gladstone as the Native American lead. To coincide with the film's release, a new diversity report was published by Stacy L Smith at the Annenberg Center. She examined the presence of indigenous American actors across 1,600 top-grossing films released between 2007 and 2022. The study scrutinized 62,000 speaking roles, and concluded that less than 0.25 per cent went to Native characters. The report also showed that the majority of Native men and women featured in the sample had worked only once across the 16-year period. 'Put simply, there is no career

sustainability for Native actors in Hollywood,' Smith stated. Across the sixteen-year timeframe, the overall volume of Native roles stood at just 1 per cent, and of the movies studied, only one had a Native actor in the lead role. 'Lily Gladstone's role in *Killers of the Flower Moon* is quite literally an anomaly in Hollywood,' she concluded.[67]

Things were the same for the Latino community. 'They are anomalies, these moments where Latinos get to shine,' said actor America Ferrera. The star of the 2023 blockbuster, *Barbie*, noted that Latinos – despite being the largest minority group in America, constituting 20 per cent of its population – remained unrepresented, and that the power structures responsible had not shifted. 'It's very hard to change when the systems that remain are still set up to benefit people who've always been in positions of power,' she said. 'We have to see a power shift . . .'[68] Ferrera, who was born in California to Honduran immigrants, was aware of being a part of the film industry's system that only allowed one minority star through at a time. 'I'm the first Latina to win an Emmy in a lead category. I'm still the only one and that brings me no joy,' she told *The New York Times*.[69]

*

Something new occurred when the nominees for the 96th Academy Awards were announced on 23 January 2024. Across all categories, the nominees were the most diverse so far – Black, Latino, Native American and LGBTQ+ artists all appeared in the acting categories, with other artists of colour prominent in other sections. Overall, seven artists of colour (35 per cent) were included among the actors – a 5 per cent increase on 2023. Three films led by actors of colour – *American Fiction*, *Killers of the Flower Moon* and *Past Lives* – were also nominated for Best Picture. African Americans featured strongly in the acting categories, with five nominees: Colman Domingo (*Rustin*) and Jeffrey Wright (*American Fiction*) both made the list for Best Actor, while Sterling K Brown made Best Supporting Actor (*American Fiction*). Da'Vine Joy Randolph (*The Holdovers*) and Danielle Brooks (*The Color Purple*) were nominated for Best Supporting Actress. America Ferrera represented Latinas, making the list for Best Supporting Actress, in *Barbie*, while gay actress Jodie Foster was nominated for Best Supporting Actress for playing a gay character, in *Nyad*. Most notably, Gladstone

featured for Best Actress in *Killers of the Flower Moon*. She was the first Native American ever to be nominated in the category. 'In college, Lily Gladstone studied the history of Native American actors in Hollywood. Now, she's making it,' wrote Kyle Buchanan in *The New York Times*.[70] Others were making it, too, albeit with less fanfare, as across the non-acting segments there were nominations for Japanese, Korean, Taiwanese, Bangladeshi and Indian artists. Back in 1929, at the very first Academy Awards ceremony, such a diverse list would have been impossible. Now, less than a century later, it was a firm reality.

There was a buzz around Gladstone in the run-up. The actor, whose father is Native American (Blackfeet and Nez Perce) and whose mother is white, hails from the Blackfeet Reservation of north-western Montana. She was widely praised for her performance in Scorsese's drama, and was favourite for the Oscar after winning the New York Film Critics Circle and the Golden Globe, where, in her acceptance speech she spoke partly in the Blackfeet language. Did these victories have wider implications? 'I'm hopeful because of the way things are trending now,' she told *The New York Times*. 'We're telling our own stories, or we have a really heavy hand in shaping how stories about us are told.'[71] Many cinephiles, in and out of Hollywood, championed her pitch for the Oscar. 'The Hollywood community has the chance to recognize the extraordinary talent and bravery of Lily Gladstone this awards season,' said Stacy L Smith. 'This is [a] chance to make history . . . Gladstone's performance is worthy of Oscar gold.'[72]

On Oscar night, Gladstone arrived on the red carpet in a gown which befitted the specialness of the occasion, and which paid tribute to her indigenous roots. Her custom dress was co-created by Gucci's creative director, Sabato De Sarno, and Native designer Joe Big Mountain of the Ironhorse Quillwork label. The midnight-blue velvet gown featured a floor-length matching cape adorned with 216 handcrafted flower petals. The exquisite quillwork was carried out by a team of indigenous artists from the Oneida reservation in Wisconsin. 'It's so brilliant, I cried,' said Gladstone of the first time she tried on the gown.[73]

As she made her way inside the auditorium, with her cape trailing behind her, like a young queen, there was great anticipation about the most diverse Oscars of

all time, and her potential part in its finale. Christopher Nolan's *Oppenheimer* swept the board, winning seven Academy Awards from 13 nominations, including Best Picture and Best Director, plus two of the acting categories. One win that eluded the production was Best Supporting Actress: Da'Vine Joy Randolph, the favourite during the run-in, beat Emily Blunt, Jodie Foster, America Ferrera and Danielle Brooks to the prize, for her performance as Mary Lamb, head cook at an elite New England boarding school, in *The Holdovers*. Even before her name was announced, she had begun to cry. She approached the podium wearing a shimmering pale-blue sequinned gown by Louis Vuitton, finished with off-the-shoulder feathered sleeves. 'God is so good,' she began, as tears ran down her face. 'You know, I didn't think I was supposed to be doing this as a career.' The audience cheered and applauded when she said, 'For so long I've always wanted to be different, and now I realize I just need to be myself. And I thank you, I thank you for seeing me.'

Towards the end of the evening, the penultimate award, for Best Actress, was presented by Sally Field, Jessica Lange, Jennifer Lawrence, Charlize Theron and Michelle Yeoh. As they introduced the nominees, those in the auditorium, and watching around the world, wondered – was this the moment, at last, when a Native American would win an Academy Award, after waiting almost one hundred years?

It was not to be. Instead, in the night's biggest upset, it was Emma Stone who took the winner's walk to the podium, for her role in *Poor Things*. '[T]he Academy Awards missed out on the opportunity to rectify an ugly part of Hollywood's history,' wrote *Newsweek*'s Billie Schwab Dunn.[74] Some Oscar pundits suggested that Gladstone had campaigned in the wrong category, questioning whether her part was a lead or a supporting role, and speculating that she may have fared better in the Best Supporting Actress category instead. But even if she had done so, and had beaten Randolph to the Oscar, what would Hollywood have done with her afterwards? Follow-up projects for actors of colour, which are equivalent in stature to their Oscar-winning films, are notoriously hard to come by. 'As we have seen with other milestone wins, including when Graham Greene was nominated back in the 1990s, nothing much changed,' said arts journalist Jesse Wente, a

First Nations Canadian. 'We have not seen some great growth in the production of Black or Hispanic films just because actors from those communities get an Oscar.'[75]

Nevertheless, as Gladstone left the Awards ceremony that evening, and made her way to the after-party, she was smiling and feeling good about the mark she had made upon the culture, and her community in particular. 'Feeling the love big time today, especially from Indian Country,' she tweeted the following day. 'Kittō"kuniikaakomimmō"po'waw – seriously, I love you all.'[76]

The period between 2017 and 2024 was both the most shocking and progressive in Oscars history. There was unbridled drama on the Oscars podium, and anti-racism protests on the streets. Rapid and dramatic changes were sparked within the Hollywood film family, with a record-breaking total of 23 Oscars for artists of colour, including 11 across the acting categories. The diversity on show among the nominees and winners was startling, as members of the LGBTQ+ community, Muslims and Black Brits featured alongside Koreans, Malaysians, Chinese, Vietnamese, Japanese, Bangladeshis, Indians, Pakistanis and now a Blackfeet Native. They didn't all win, but they were there in the room. The ceremony had never seen a collection like it. Hattie McDaniel, the woman who started it all, would have been amazed if she could have witnessed what had happened to the ceremony since the whites-only segregated affair of her day. On that night in February 1940, when she picked up her trophy, she was also the Academy's sole representative of what is today called 'diversity'. Now the road is rainbow-coloured. Every person of colour who has won an Academy Award since her victory, or who will ever win in the future, owes her a debt, because she was the first one through the door – the 'atmosphere processor' – and therefore the one who suffered the most, so that today's winners would not have to.

EPILOGUE: SHARED SPACES

'Never let a serious crisis go to waste.'
Rahm Emanuel, former White House chief of staff,
Obama administration

The Academy of Motion Picture Arts and Sciences' journey towards diversity and inclusion has been driven at different points throughout its hundred-year history by events outside it. These *inciting points* have directly influenced the minds of Academy voters during Oscars season, and thereby affected who won. For Hattie McDaniel, the first Black actor to win an Award, in 1940, the inducement was the Nazi invasion of Europe, and the ensuing Second World War; for Sidney Poitier's victory in 1964, it was the Civil Rights Movement; for Louis Gossett Jr (1983) and Denzel Washington (1990), it was the aftermath of the Vietnam War and other subsequent American military conflicts; for Washington's second Award, in 2002, it was a perfectly timed *Newsweek* profile by journalist Allison Samuels; for Mahershala Ali, Viola Davis and Barry Jenkins in 2017, it was *#OscarsSoWhite*; and for Daniel Kaluuya, Travon Free, Yuh-jung Youn and Chloé Zhao in 2021, it was George Floyd, the coronavirus and *#BlackLivesMatter*, combined.

These events made Academy members *think Black* – just like advertising agencies persuaded people to think Coke, think Nike, think Budweiser or think Visa. But the inducements that affected the Oscars were much more hardcore than mere ads, because they were real. They cut through because they were somehow relevant to the Black experience, and because their effectiveness relied on *shock*. Within the history of the Academy, the highest ever number of nominees for actors of colour was nine (45 per cent) in 2021, following the

murder of George Floyd. No other inciting point in history has moved the needle more than this event, which combined Floyd's death, *#BlackLivesMatter* and the coronavirus lockdown in a three-pronged laser that converged upon a single point within the collective consciousness, focusing the world's attention like nothing ever seen before.

In order for apathy to shift in people, their attention had to be forced. *Badness* had to happen somewhere in the world, and be brought into their homes via their devices, before compassion and fairness would unlock within them. The themes of this 'badness', within the different events that affected Academy voters between 1940 and 2021, were *war, murder and racism*. The Black actors who won Oscars at these junctions did not do so directly because of the inciting points, but, rather, because these circumstances forced attention upon their deserving talents, in a manner that may not have occurred otherwise. Black artists benefitted from their perfect timing. This was not their design. It was simply their fate.

The nature of the inciting points that have affected the Oscars has changed over the timeline. During the last century they were defined by dramatic physical events in the outer world, but in the 21st century they became digital. *#OscarsSoWhite* and *#BlackLivesMatter* became global movements in the same time as it took to light a match, and expanded until they were gorged with enough firepower to force action from within Hollywood. In the previous era it was the civil rights leaders and the press that carried the totem of protest, but now it was citizen agitators who roused global attention with just a few perfectly timed words composed from the comfort of their own homes. It was easy compared to street protests and picket lines. And it was Black women who were at the forefront of the digitized fight for fairness and racial justice that spawned *#MeToo*, *#BlackLivesMatter* and *#OscarsSoWhite*. April Reign, the unassuming architect of one of them, was not a Hollywood power broker; she was just like the heroes in many of the movies she loved to watch – an ordinary person who had acted at exactly the right moment in time.

But unfortunately the problem with all inciting points, whether physical or digital, is that *they fade*. They *force people to care*, which can lead to change, but only for a short while, because forced caring is transient. In the end, the efficacy

of each inducer ebbs away, and the focus given to minority Oscar nominees subsides – until the next inducer comes along, years later. However, for the period in which their energy burns brightly, things happen. In this case, minorities won Oscars. Without the inducers, they would have won on far fewer occasions than they did.

And so, what is the summary of one hundred years of inciting points and campaigning? Between 1940 and 2024, Black artists won a grand total of 69 Oscars, including those awarded to groups, and those given to artists who have won more than once. In the acting categories they have won 23 times (12 men, 11 women). At the close of the last century there had only been six actor winners in 73 years (four men, two women), but in the first quarter of this century alone there were 17 (eight men, including Mahershala Ali's double victory, and nine women). Even though the overall number of wins is low compared to whites, the frequency of victories is now greatly accelerated. It was 1990 that proved to be the turning point in this regard, when Denzel Washington won Best Supporting Actor for *Glory*. The pinnacle of achievement for Black actors came in 2002, when Halle Berry and Washington won for Best Actress and Best Actor, respectively.

Nevertheless, for Black artists, glaring issues remain. Berry is still the only African American actor to have won Best Actress (from a total of 14 nominations). This speaks volumes about the dearth of opportunities for Black female leads in Hollywood, compared to those available to white leading actresses. The development line for Black leading ladies is flat, with scarcely any movement in one hundred years. Oscar-friendly lead roles for Black male leads have also been difficult to procure. Like Berry, Washington, whom *The New York Times* voted 'the greatest actor of the 21st century (so far)', has not won an Academy Award for almost a quarter-century, despite multiple nominations.[1]

The ten other Oscar wins for Black women have all been in Best Supporting Actress roles. With only one win for Best Actress, many Black actresses have now resigned themselves to the idea that their only chance of winning is within this category. Furthermore, a large proportion of the roles that have led to these victories have involved playing maids and slaves. Academy voters appear to prefer

honouring Black women in the guise of servants who are subservient to senior white characters. In 2024 the latest, Da'Vine Joy Randolph, played a fuller-figured cook at a boarding school, in *The Holdovers*. This archetype was established in 1940, with Hattie McDaniel's portrayal of Mammy, the house slave, in *Gone with the Wind*. Since then, Ethel Waters, Juanita Moore, Alfre Woodard, Octavia Spencer and Lupita Nyong'o, among others, have either been nominated or won for playing servile characters. This is not their fault. They take what work they can get, and try to make it shine. It is Hollywood's power-brokers that have not let Black women out of this box. These executives remain stuck in the distant past, still struggling to visualize Black women as they are now – as contemporary characters living progressive and complex lives outside the kitchen. By contrast, Black male actors have fared better, with five Oscar wins for Best Actor, and seven for Best Supporting Actor, across a broader spectrum of archetypes, playing characters in positions of authority. It is Black women who therefore have borne the bigger brunt of discrimination among Black actors over the past one hundred years.

Meanwhile, Black filmmakers have only won two Oscars for Best Picture: *12 Years a Slave*, in 2014, and *Moonlight*, in 2017. But in the directors' category they have won nothing. They have been nominated only six times – the first in 1991 (John Singleton), and the last in 2019 (Spike Lee). No Black female director has ever been nominated. The lack of progress in this area is the biggest problem of all for Hollywood's Black artists. Black directors are underrepresented generally across the filmmaking landscape, and too few Black films are made, year on year, and so the options are limited during voting season. All six nominations for Black directors have been for Black movies: *Boyz n the Hood*, *Precious*, *12 Years a Slave*, *Moonlight*, *Get Out* and *BlacKkKlansman*. This contrasts with Asian and Latino directors such as Ang Lee and Alfonso Cuarón, who have won Best Director both for white-themed movies as well as for productions that reflect their own cultures. Lee has won for films about ancient Chinese fantasy (*Crouching Tiger, Hidden Dragon*), as well as white gay cowboys (*Brokeback Mountain*). In order to win, should Black directors start doing the same? Or will the Academy's voter reforms result in more votes for Black movies?

Black directors face other problems, too. In terms of winning Oscars, filmmakers such as Spike Lee and Ava DuVernay have been held back by being outspoken about racism both inside and outside of Hollywood. DuVernay's film, *Selma*, was downgraded by some Academy voters after her protests against the police murders of Eric Garner and Michael Brown. In order to win Oscars in Hollywood, it is not enough to be good. One also has to be 'well-behaved'. If DuVernay had compromised her beliefs, and had been grateful, apolitical and mild-mannered, perhaps she would have got the nomination for *Selma*.

These issues only serve to underline the importance of the presence of Black and other diverse films. One of the key narratives centres around the fact that not enough Black films get made each year, despite recent successes such as *Creed*, *Us* or *Get Out*. Concern still lingers about whether they will make money. Of course, the economic objective of all films is to turn a profit, but Black films should not be penalized for not doing so. Why should a Black film have to make money in order to exist? The vast majority of movies that have lost money in the entire history of Hollywood have been made by white filmmakers, and starred white actors – and yet no one is suggesting that they should not continue to be supported. But Black films are expected to turn a profit *every time*, in order to justify more of them being made. Hollywood thereby raises the bar for Black film, but keeps it low for white productions. This in effect is a form of racism, because Black films and their directors are not *free to fail* in the same way as white ones. This is another facet of white privilege – *the right to fail without consequence.* 'White people get more bites of the apple,' said Black director Theodore Witcher, whose film, *Love Jones* (1997), made $12.7 million from costs of $7 million. 'You can fail three, four times and still have a career. But if you're black, you really can only fail once,' he noted.[2] Traditionally, this has been the rule, not just in Hollywood, but throughout society. From Jackie Robinson to Barack Obama, performance and conduct levels for Blacks have been set higher as a condition of their acceptance.

*

Asian actors have fared badly at the Academy Awards, winning only five Oscars (three women, two men) in total. In the Best Actress category, Michelle Yeoh was

the first and only winner, in 2023. For Best Actor there has been one nomination, in 2021, and no wins. The Best Supporting Actress category has seen two wins from five nominations – the first in 1958 (Miyoshi Umeki), and the most recent in 2021 (Yuh-jung Youn). The Best Supporting Actor category has yielded two wins from six nominations – the first in 1985 (Haing S Ngor), and the most recent in 2023 (Ke Huy Quan). These numbers show the extent of the perpetual exclusion of Asians from the filmmaking process across all acting categories. The few Oscars they have managed to procure have been spaced out across many decades, with nothing in between. The high point for Asian artists came in 2023, when Yeoh and Quan both won trophies for *Everything Everywhere All at Once*, in the Asian equivalent of Berry and Washington's momentous victory in 2002. With big changes afoot in Hollywood, would these Asian victories now pave the way for more regular wins? Rewards have been better for Asian directors, with ten nominations for Best Director between 1966 and 2023, and five wins (50 per cent). This is a contemporary phenomenon, with five nominations occurring since 2020, and all their victories happening within the last two decades. Ang Lee has been the most successful, with two wins from three nominations.

Latino actors have also only won five Academy Awards (four men, one woman). They have been nominated five times for Best Actress, beginning in 1999, but with no winners. For Best Actor there have also been five nominees, and just one win, back in 1951 (José Ferrer). In the Best Supporting Actor category there have been six nominations and three victories – the last of which (Benicio del Toro) was two decades ago. There have been six nominations for Best Supporting Actress, with only one win, in 1962. The latest entrant is America Ferrera, nominated in 2024, for *Barbie*. As with Asian actors, Hollywood has grossly ignored Latino talents, and resisted casting them in mainstream roles as progressive citizens living challenging lives. Latino filmmakers have fared better, nominated for Best Director eight times between 1986 and 2019, and have won on five occasions (62 per cent). Like Asian filmmakers, their ascendency is a modern phenomenon, with all five Oscars occurring in a five-year period between 2014 and 2019. Mexicans Alfonso Cuarón and Alejandro González Iñárritu have been most successful, with two Oscars each.

By contrast, South Asian actors have only won a single Oscar – Best Actor, for Ben Kingsley's *Gandhi*, in 1983. They have only had three nominations in this category. There was one nomination for Best Actress (Merle Oberon, back in 1936), three for Best Supporting Actor, and none for Best Supporting Actress. Only one South Asian has ever been nominated for Best Director, M Night Shyamalan, in 2000.

Native Americans have fared worst of all, with no Oscars. They have attained one nomination for Best Actress, Lily Gladstone, in 2024, and two nominations for Best Supporting Actor, in 1971 and 1991. There have been no nominations for Best Actor, Best Supporting Actress or Best Director. Their role in Hollywood film has remained unchanged for over a century. Native Americans only play Native American characters. Gladstone, in *Killers of the Flower Moon*, is the latest. In film and casting terms, Hollywood does not recognize the existence of Native actors as part of mainstream society.

Meanwhile, gender discrimination has become Hollywood's biggest issue at the Oscars. Openly gay Oscar winners are almost non-existent, while only three women have won Best Director from just eight nominations. Kathryn Bigelow's historic first win, in 2010 for *The Hurt Locker*, did not open the floodgates for more female successes. Worse than this, at the bottom of the discriminatory pile are women of colour, who have the lowest numbers of all for acting, directing, screenwriting and behind-the-scenes Oscar wins. Filmmaking today is still about men promoting and rewarding themselves.

Overall, among people of colour, African Americans have fared best after almost a century of the Oscars. A clear hierarchy has emerged within this grouping, with Blacks at the top and Native Americans at the bottom. Black artists have focused almost entirely upon their own agenda of achievement at the Academy Awards, rather than the needs of the collective of diverse peoples across ethnicity, gender and disability. In this regard they have been as selfish as white Hollywood – and thus, the opportunity to lead a coalition of unity, as Hollywood's most accomplished minority, has been lost. This has left a collection of siloed groups, each looking out for themselves in the fight for representation. Some Asian artists have spoken out against what they see as whites and Blacks

carving out spaces for themselves. 'If you watched the Oscars the word diversity seemed to mean black and white,' said *Star Trek* star George Takei, in reference to the 2016 Oscars.[3] This was the same event in which emcee Chris Rock included a racially offensive joke about Asians. It showed that certain African Americans had reached a position of power that meant that they too could now deride other people of colour, just as white folk once derided them. The counter-view, of course, is that Rock, as a comedian, gets to deride everybody.

Diversity within contemporary film has become a complex kaleidoscope, with sub-layers that run deep. Before 1997 Black Oscar winners were exclusively African American, heterosexual and Christian. Then came Lupita Nyong'o (a Mexican-born Kenyan); Daniel Kaluuya (a Black Brit of Ugandan heritage); Mahershala Ali (Muslim); and Ariana DeBose (a queer Afro-Latina). Today they are joined by a myriad of other diverse artists and their own sub-layers. Under the Academy's new rules for inclusion, how will Hollywood accommodate them all, as each 'nation' demands their slice of Tinseltown pie? How will they represent them fairly and consistently, and in a manner that will lead to regular Oscar nominations? And how will race and gender issues affect the future of the Oscar categories themselves? Some have called for all gender identification to be removed from the acting categories, leaving just one gender-neutral award for Best Actor and Best Supporting Actor. Critics of this idea argue that it would mean fewer Awards, which could be counter-productive within a system which is already discriminatory. At the opposite polarity, others have called for the inclusion of even more categories as a means of accommodating the plethora of diverse groups – something conservatives hate. With these issues, the Academy is grappling with the same problems that exist within society, as it too struggles to navigate the demands of these modern independents. Within Hollywood, one thing is certain: from now on, filmmaking will never be simple again.

Neither will the places where film productions come from. Hollywood's position as the Oscars' dominant force is now being challenged by a roster of outsiders. The competition from the streaming networks, particularly Netflix, is fierce. Theirs is a 21st-century model which is more diverse, less racist and more creative than the older Hollywood system, and they have thereby secured the

participation of the industry's biggest names. They have been braver than Hollywood in promoting stories about women, LGBTQ+, disability and the diverse, multicultural lives of people of colour. In a short space of time, their rewards have been substantial. To date, Netflix has received 152 Oscar nominations in total – including a record 36 in 2021 – and has won 23 Oscars, while in 2022 Apple TV+ became the first streamer ever to win Best Picture, for *CODA*. Purists may not like the fact that streamers produce movies to watch at home rather than in cinemas, and that they get to qualify for the Oscars with very limited cinema runs, but nevertheless, as a counterpoint to a Hollywood that has been reluctant to embrace change, they are a key outlet for diverse artists and inclusive storytelling.

Running parallel, the precedents set by *Roma* and *Parasite* prove that stories from outside the white worlds of Hollywood and Europe, and rendered in non-English, can take the top prizes, instead of being restricted simply to the Best International Feature Film category. Their cut-through represents a new phenomenon in cinema, which is specific to the last five years or so, and which speaks of the changes afoot within the tastes and tolerances of a new generation of movie-goers and Academy voters, as well as to the rise of self-funded foreign studios emerging from places such as China and South Korea. Donald Trump may not like it, but this is no bad thing, as these films are for a new, progressive and inclusive generation, rather than an old, intransigent one. They are a perfect fit for a rapidly diversifying Academy, and a key signifier that the world, and not just America, is rich with captivating stories, fronted by non-white faces, that are waiting to be told. Going forward, the spotlight will be on other non-Western nations to follow the progress made by recent Asian and Mexican productions. The participation of all of them will be crucial in providing additional solutions to the problem of minority exclusion. For example, where is Nigeria's Nollywood, or India's Bollywood, in this mix? The Indian media and entertainment industry generates $26 billion in annual revenues, and produces 2,000 films per year, and yet none of them reach the Oscars.[4]

But this brave new diverse world may yield problems among those set to lose out the most from the changes. From now on, how will the perpetual presence of

non-white Oscar nominees and winners be received by white artists? The 20 acting nominations used to belong exclusively to them, but this is no more. Inevitably, it means a reduction in their supremacy. They will have to accept less, and share more. Will they be happy to do this? Hopefully, yes, because living in a more equal world is a good thing. But it is also human nature to react against losing what one once had. Some Hollywood film folk may approve of diversity, but not at their expense – not if it means they lose work, or recognition, or money, to someone else.

The reaction against this shifting power dynamic manifested strongly in 2016, when *#OscarsSoWhite* revealed some of the previously concealed grumbles that Hollywood's white artists had about the persistent complaining from Black artists whenever they were omitted from the nominations, or when they were nominated but didn't win. Their contention was that many more white nominees than Black knew the pain and disappointment of losing out on the big night – and yet, mostly, they did not shout and complain about it. Many have lost multiple times. Britain's Peter O'Toole, for example, famously nominated eight times, won nothing. Denzel Washington has expressed a similar point, regarding Al Pacino's eight nominations before finally winning for *Scent of a Woman*: 'Does Pacino blame racism against Italian Americans? It's too easy.'[5] The fact is, when a Black actor is not nominated, the reason cannot be racism *all the time* and without regard for any other possibilities. To call racism by default is a *trauma response*. Residual sensitivities created by a harsh history of discrimination and exclusion are easily triggered, and so racism has been causally assumed.

However, the data suggests that race has indeed been a major factor. Black actors and directors have been the disproportionately high recipients of poorly marketed movies, thereby harming their chances on Oscar nights. Blacks who have been politically outspoken have been downgraded compared to white artists such as Marlon Brando, Sean Penn or George Clooney. Most of all, the Oscars voting system has traditionally been biased in favour of whites. When they lose, they do so within a system racially designed in their favour, and so they have less to complain about than people of colour, who lose within a system which until very recently was over 90 per cent white, male and old. This demographic has

presided over the ethnicity of the vast majority of the artists who have ever won Oscars. Many whites in Hollywood have assumed that the majority-white roster is essentially progressive and liberal enough to ignore race, or politics, and simply vote for the best film or performance. While this may be true for some, the general idea has been challenged by Black artists, who believe that racism – including a preference for storylines that reflect white culture – unfairly penalizes their work. Research appears to back up the suggestion that whites are less interested in films they consider to be 'Other', and that contain majority-Black casts. Journalist and film historian Mark Harris puts it another way: 'The older, white, male votership doesn't hate women, gays, black people. They're just not as interested in their/our stories.'⁶ As the Academy's voting demographic re-balances itself, with increasing numbers of women and people of colour year on year, things may finally change.

*

Over the years, a number of Hollywood's artists, from Viola Davis to Steven Spielberg, have pointed out that the blame for the industry's lack of diversity lies not with the Academy itself, but earlier in the food chain – with the directors, producers, casting directors, screenwriters and studio heads who make films happen and control who appears in them. But who are these people? They are also members of the Academy – and so *the Academy is to blame* – or, rather, those who belong to it. Every year on Awards night, women and people of colour sit in the audience right next to the very people who discriminate against them. They drink and dance with them at the after-parties. This is the weird thing: the discriminators and the victims all hang out together. And so the problem is, how hard can you rail against your own colleagues, employers and sometimes friends? In this case, the old mantra of 'keeping one's enemies close' does not work. Being close to your enemies makes you soft.

This is why, over time, the interventions of civil rights leaders, and, more recently, April Reign's *#OscarsSoWhite* have been so pivotal to progress. These agitators were not Hollywood insiders. They did not have lunch with film people, and their careers did not depend on not offending them, and so their attacks were free to be ferocious. *#OscarsSoWhite* channelled global public anger

directly at Hollywood and its exclusionary policies in a manner that its Black actors and other artists could never have done themselves. This could only have been achieved by the proverbial 'barbarians' at the gates of the Hollywood studios, rattling the metalwork and screaming through the bars.

While the progress made by these measures has been of great significance, it has only gone so far. Throughout its history, one major reason Hollywood has resisted Black demands for equality is because the industry does not need Black actors and technicians to survive. If Black people and other minorities did not exist, there would still be a profitable film industry. Today, movies about white men taking on adversity, and featuring no Black characters, continue to make many hundreds of millions of dollars at the global box office – with much of the profit coming from cinemagoers of colour, who evidently have no problem paying to see movies in which their own ethnicities are not represented. The picture is very different in industries that rely heavily on Black talent in order to exist. Sports and music provide good examples. Take Black folk out of the NBA, or American football, or track and field, or British football's Premier League, and those sports cease to exist. Similarly, take Black artists out of the history of contemporary music, and there is not much left there either. Compared to Hollywood, Black people have thrived and become numerous and powerful in these industries because of the fundamental reliance upon their talent. Black actors, by contrast, feature in film more for cultural and artistic reasons, rather than out of functional necessity. They are non-essential to the mainstream product, and are therefore dispensable in an industry that puts money first. 'It's a white industry,' said Chris Rock matter-of-factly. 'Just as the NBA is a black industry. I'm not even saying it's a bad thing. It just is.'[7]

In this arena, fairness from those in power becomes optional, and commitments to diversity unstable. Out in the real world, it is legislation that corrects this, and the Academy's version – their new rules on diversity and inclusion – is the change agent designed to protect those whom the industry deems as non-essential, but who morally, culturally and politically deserve their place at the table. The new qualifying criteria for Best Picture, alongside the reforms to the voting roster, have been met with unanimous approval among

artists of colour and many others. The idea that adding thousands of new minorities to the list will enrich the types of films and actors that win on Awards night, thereby ending the multi-decade bias that favoured white males, is much needed, as long as the quality of the output is there to support it. This is the issue of concern for many. 'Mounting pressure could induce Academy members to overrate minority cinema. Newcomers specifically recruited to boost ethnic prospects might prove particularly susceptible,' wrote journalist David Cox in *The Guardian*. 'The achievements of the genuinely outstanding among them could be tarnished. In the wider community, resentment could be stoked.'[8] Whether this actually happens or not remains to be seen. The original all-white, male roster had its own longstanding issues too, and the new voting mix, though fairer, will not be perfect. Ultimately, Hollywood only has itself to blame for the enforced changes, and for any potential issues it might incur. They have had ample opportunity – *one hundred years* – to embrace diversity, the latter part of which has seen the industry fail to keep pace with the progress of women and minorities in the world at large: Black presidents, female prime ministers, etc. Hollywood resisted change, and now change has been forced upon it – and this is never as smooth as when change is implemented voluntarily and systematically over time.

On 4 May 1927, when the Academy of Motion Picture Arts and Sciences was founded by MGM boss Louis B Mayer, America was segregated, and so was his new organization. All of its 36 founders were white and 33 of them were men. Diversity did not exist. Discrimination against people of colour was standard, and normalized. Today the picture is radically different. The Academy now boasts over 11,000 members from more than 70 countries, 34 per cent of whom are female and 19 per cent of whom are from underrepresented ethnic and racial communities. The organization has been transformed from the one Mayer envisaged. Just as segregation has ended in society, so too has it ended here. But its imprint remains. Non-white artists are thus far strictly limited in what they can achieve in terms of Oscar nominations and wins. But change is coming fast, and the future is unavoidably diverse. How much of the Oscars cake should each group have? The objective should not be the supremacy of any single group over

others, but the formation of a shared space in which everybody – Black, white, East Asian, South Asian, Latinos, indigenous, LGBTQ+, women and others – is regularly included, rewarded and collectively celebrated for their work, in the true meaning of diversity. Right now this is an ideal, a dream – but, as so many Oscar winners have said in their acceptance speeches, sometimes dreams do come true.

TIMELINE

1898

The first known motion picture featuring African American actors is made. *Something Good – Negro Kiss* lasts just 29 seconds.

1909

12 February

The National Association for the Advancement of Colored People (NAACP) is founded. As part of the civil rights organization's remit, it advocates on behalf of Black actors to end their derogatory portrayals on screen.

1911

The Hollywood film industry begins in Los Angeles, California, with its first studio site on Sunset Boulevard. Non-white actors are barred within segregated America. Roles intended to represent them are played by white actors.

1914

Black actors appear in Hollywood movies as extras, confined to roles as servants.

12 February

Hollywood's first feature-length motion picture – Cecil B DeMille's silent Western, *The Squaw Man* – features Lilian St Cyr, otherwise known as Red Wing of the Winnebago nation. She is Hollywood's first Native American actress.

10 August

Actor, singer and musician Sam Lucas becomes the first African American to star in a feature film – an adaptation of Harriet Beecher Stowe's novel, *Uncle Tom's Cabin*.

1915

African American filmmakers, determined to challenge Hollywood's racial stereotypes, begin making their own independent movies.

13 December
Japanese actor Sessue Hayakawa becomes Asia's first Hollywood star, appearing in Cecil B DeMille's *The Cheat*.

1918

Hayakawa forms his own production company specializing in Asian movies. The organization produces 23 silent films before folding in 1921.

1922

The governments of Mexico, Honduras and Costa Rica send letters of protest to the Hollywood studios, objecting to derogatory portrayals of Latinos in film.

1923

30 September
Mexican actor Ramon Novarro becomes Hollywood's first Latino star, appearing in *Scaramouche*.

1924

The *Baltimore Afro-American* reports that 250 African American actors are working in Hollywood studios as extras.

1925

4 December
The Central Casting Corporation launches, formalizing the hiring of extras in Hollywood movies.

1927

4 May

The Academy of Motion Picture Arts and Sciences (AMPAS) is founded as a non-profit by Metro-Goldwyn-Mayer (MGM) chief Louis B Mayer. All 36 founder members are white. Only three of them are female.

11 May

At an inaugural banquet held at the Crystal Ballroom of the Biltmore Hotel, Los Angeles, 230 additional AMPAS founders are added. The list includes the organization's first Mexican member, Ramon Novarro.

MGM art director Cedric Gibbons designs the Academy Award statuette on the night, sketching the prototype on one of the hotel's linen napkins.

October

Central Casting launches an African American division, run by agent Charles Butler. He will go on to discover Hollywood's first roster of Black Oscar nominees – Hattie McDaniel, Louise Beavers, Juanita Moore and Dorothy Dandridge.

20 November

Lincoln Perry, otherwise known as Stepin Fetchit, becomes the first Black actor to receive an on-screen credit in a Hollywood feature, for the film *In Old Kentucky*.

1928

AMPAS has a total of 362 members.

Nina Mae McKinney and Lincoln Perry become the first Black actors to sign Hollywood studio contracts, with MGM and Fox, respectively.

Cedric Gibbons hires Los Angeles sculptor George Stanley to transform his prototype sketch of the Academy Award statuette into three-dimensional form. The finished trophy is cast in gold-plated bronze.

1929

16 May

The first Academy Awards ceremony is held in the Blossom Room of the Hollywood Roosevelt Hotel, Los Angeles. The 15 winners are informed three months in advance.

1931

May

African American actress Hattie McDaniel arrives in Los Angeles and signs up with Charles Butler at Central Casting. She plays mammies and maids, earning $7.50 per day (about $150 today).

1933

30 June

The Screen Actors Guild (SAG) is formed. Actor Clarence Muse is its sole African American member. Hattie McDaniel follows in 1934.

1934

The Academy Awards of Merit are publicly referred to as Oscars for the first time. AMPAS officially adopts the term in 1939.

1935

Charles Butler books $460,000 worth of work for African American actors – $8.5 million today.

1936

7 February

Merle Oberon becomes the first person of colour to be nominated for an Academy Award, for Best Actress, in *Dark Angel*. The actor conceals her Indian (South Asian) heritage, instead passing for white.

1938

3 March

The Academy Awards ceremony is postponed due to flooding in Los Angeles. It is rescheduled for 10 March.

1939

Chinese American actor Bessie Loo joins Central Casting, becoming Hollywood's first Asian agent. She subsequently starts her own firm, the Bessie Loo Talent Agency.

26 January

Hattie McDaniel stars as Mammy, as shooting begins for the Civil War epic, *Gone with the Wind*.

1 September

After Nazi Germany's invasion of Poland, the Second World War begins.

15 December

McDaniel and the film's other Black cast members are banned from the Atlanta premiere due to segregation.

1940

11 February

Hattie McDaniel becomes the second person of colour, and the first Black actor, to be nominated for an Academy Award, for Best Supporting Actress.

The war triggers metal shortages, and the Oscar statuettes are temporarily cast in plaster instead.

29 February

The 12th Academy Awards ceremony is held at the Ambassador Hotel, Los Angeles. The venue is segregated, and McDaniel is only permitted to attend by special arrangement.

McDaniel wins Best Supporting Actress. She is the first person of colour, and the first Black actor, to win an Academy Award. She also becomes AMPAS's first African American member.

1941
20 January
Actress Bette Davis becomes the first female president of AMPAS. She resigns in frustration two months later, following resistance to her ideas for reform.

1945
2 September
The Second World War ends.

1948
20 March
African American actor James Baskett becomes the second person of colour, and the second Black actor, to win an Academy Award – an Honorary Oscar for his role as Uncle Remus in Disney's live action/animated musical, *Song of the South*.

1949
10 February
Puerto Rican-born José Ferrer is the third person of colour, and the first Latino actor, to be Oscar-nominated, for Best Supporting Actor in *Joan of Arc*.

1950
12 February
Ethel Waters becomes the second Black actor to be nominated for Best Supporting Actress, for *Pinky*.

23 March
Mexican-born Emile Kuri becomes the third person of colour, and the first Latino artist, to win an Academy Award, for Best Art Direction (Set Decoration), for *The Heiress*.

21 September
Sidney Poitier stars as Dr Luther Brooks in *No Way Out*, breaking Hollywood's racial stereotype of Blacks only playing servants.

1951
29 March
José Ferrer becomes the first Latino actor to win an Academy Award, for Best Actor in *Cyrano de Bergerac*.

1952
20 March
Japanese director Akira Kurosawa wins an Honorary Foreign Language Film Award, for *Rashomon*. He is the first Asian to receive an Academy Award.

26 October
Hattie McDaniel dies of breast cancer, aged 59. Her request to be buried alongside her fellow actors at the Hollywood Memorial Park Cemetery is denied, as the graveyard is segregated.

1953
19 March
Mexican-born Anthony Quinn wins Best Supporting Actor, for *Viva Zapata!*

1954
17 May
The Brown v. Board of Education court ruling desegregates schools in Kansas, opening the door for other legal challenges against racism and exclusion.

1955
12 February
Dorothy Dandridge becomes the first Black actor to be nominated for Best Actress, for *Carmen Jones*.

30 March
Teinosuke Kinugasa wins an Honorary Foreign Language Film Award, for *Gate of Hell*. Sanzo Wada wins Best Costume Design.

Emile Kuri wins Best Art Direction (Colour), for *20,000 Leagues Under the Sea*. He becomes the first Latino double-Oscar winner.

1 November
The Vietnam War begins.

1 December
Rosa Parks sparks the Civil Rights Movement, after refusing to give up her seat to a white passenger on a bus in Montgomery, Alabama.

1956
21 March
Hiroshi Inagaki wins an Honorary Foreign Language Film Award, for *Samurai, The Legend of Musashi*.

James Wong Howe wins Best Cinematography (Black-and-White), for *The Rose Tattoo*.

1957
27 March
Anthony Quinn wins Best Supporting Actor, for *Lust for Life*. He is the first Latino actor to win two Academy Awards.

29 October
AMPAS founder Louis B Mayer dies of leukemia.

1958
18 February
The first Asian actors feature among the Oscar nominees: Japanese-born Miyoshi Umeki as Best Supporting Actress, for *Sayonara*, and Sessue Hayakawa as Best Supporting Actor, for *The Bridge on the River Kwai*.

Filmmaker Mehboob Khan becomes the first Indian to be Oscar-nominated, for Best Foreign Language Film, for *Mother India*.

26 March
Miyoshi Umeki is named Best Supporting Actress, becoming the first Asian actor to win an Academy Award.

1959

23 February
Sidney Poitier becomes the first Black actor to be nominated for Best Actor, for *The Defiant Ones*.

1960

22 February
Juanita Moore is the fifth Black actor to be Oscar-nominated, for Best Supporting Actress in *Imitation of Life*.

Susan Kohner is the first Latina to be nominated for Best Supporting Actress, in the same movie.

1961

27 February
Producer Ismail Merchant becomes the second Indian to be Oscar-nominated, for Best Live Action Short Subject, for *The Creation of Woman*.

1962

26 February
Puerto Rican actress Rita Moreno becomes the first ever Latina to be Oscar-nominated, for Best Supporting Actress in *West Side Story*.

No Black artists feature among the acting nominees. This draws criticism from African American actor Caleb Peterson and his organization, the Hollywood Race Relations Bureau (HRRB).

9 April
Caleb Peterson and the HRRB picket the Oscars in protest. Twelve protestors are arrested and held until after the ceremony.

Moreno wins Best Supporting Actress – the first Latina to win an Academy Award.

22 October
The NAACP opens a Beverly Hills/Hollywood Branch, specializing in campaigning for the rights of African Americans in the entertainment industry.

1963

28 August
An estimated 250,000 people attend the March on Washington for Jobs and Freedom. The Reverend Dr Martin Luther King Jr gives his 'I Have a Dream' speech in front of the Lincoln Memorial. The march is attended by a host of Hollywood stars, including Sidney Poitier, Harry Belafonte, Paul Robeson, Josephine Baker, Lena Horne, Charlton Heston, Marlon Brando, Gregory Peck and Paul Newman.

1964

13 April
Sidney Poitier becomes the first Black actor to win Best Actor, for *Lilies of the Field*.

James Wong Howe wins Best Cinematography (Black-and-White), for *Hud*. He becomes the first Asian double-Oscar winner.

1967

Three films starring Sidney Poitier feature in the box office top 20: *Guess Who's Coming to Dinner?*, *In the Heat of the Night* and *To Sir, With Love*. Cumulatively they gross $123 million ($1 billion today), making him the biggest movie star in the world that year.

4 February
The NAACP launches its own annual ceremony, the NAACP Image Awards, as a counterpoint to the predominately white Oscars.

1968
4 April
The Reverend Dr Martin Luther King Jr is assassinated.

King's funeral, planned for 9 April in Atlanta, clashes with the Academy Awards, scheduled to take place in California a day earlier. Sammy Davis Jr, Louis Armstrong, Sidney Poitier, Diahann Carroll, Harry Belafonte, Marlon Brando and Rod Steiger withdraw from the Oscars in order to attend.

For only the second time in history, the Awards are rescheduled, on this occasion in deference to King. The new date is 10 April.

10 April
In the Heat of the Night wins five Oscars, including Best Picture.

Edward Carrere wins Best Art Direction, for *Camelot*.

1970
16 February
Rupert Crosse becomes the first African American to be nominated for Best Supporting Actor, for *The Reivers*.

7 April
Mexican actor Ray Andrade and his protest group, Justicia, picket the 42nd Academy Awards in opposition to demeaning portrayals of Chicanos in three nominated Westerns, *Butch Cassidy and the Sundance Kid*, *The Wild Bunch* and *True Grit*.

1971
23 February
Geswanouth Slahoot, otherwise known as Chief Dan George of the Tsleil-Waututh nation, becomes the first Native American actor to be nominated for an Academy Award, for Best Supporting Actor in *Little Big Man*.

1972
10 April
Sammy Davis Jr becomes the first African American to host the Oscars.

Isaac Hayes becomes the first African American to win an Academy Award in a non-acting category, for Best Original Song ('Theme from Shaft'), for *Shaft*.

Manuel Arango wins Best Documentary Short Subject, and Best Live Action Short Film, for *Sentinels of Silence*.

1973
12 February
A record six African Americans are nominated for Oscars. Diana Ross makes the shortlist for Best Actress for *Lady Sings the Blues*, as does Cicely Tyson for *Sounder*. It is the first time two Black actors have featured in this category. Paul Winfield is also nominated for Best Actor in *Sounder*, making it the first time that Black performers have been included in both the Best Actor and Best Actress categories.

27 March
At the 45th Academy Awards, Marlon Brando is named Best Actor for *The Godfather*. Native American activist Sacheen Littlefeather appears on stage on his behalf and reads an impassioned speech protesting against the treatment of Native Americans in film and television.

1975
29 April
The Vietnam War ends.

1977

10 February

Italian filmmaker Lina Wertmüller becomes the first woman to be nominated for Best Director, for *Seven Beauties*.

25 March

All the nominees in the acting categories are white. In protest, the Oscars are picketed by campaign group Blacks in Media Broadcasting Organizers. Inside the ceremony, Oscars host Richard Pryor criticizes Hollywood's perpetual exclusion of Black artists.

1978

3 April

Richard Chew wins Best Film Editing, for *Star Wars*.

Yuki Yoshida wins Best Live Action Short Film, for *I'll Find a Way*.

1981

As a counterpoint to the exclusion of Black artists from the Oscars, Washington DC attorney Albert L Nellum and his wife Velma launch the Tree of Life Awards, otherwise known as 'the Black Oscars', to honour Black achievements in film. Quincy Jones, Sidney Poitier, Maya Angelou and Cicely Tyson are involved in hosting the annual gala.

30 March

The Academy Awards ceremony is postponed for 24 hours following the shooting of President Ronald Reagan.

1982

A spate of war movies are released in the post-Vietnam era, including *An Officer and a Gentleman* (1982) and *Glory* (1989). They appear against the backdrop of further US military conflicts in Lebanon (1982–4), Grenada (1983), Libya (1986), Panama (1989–90) and Iraq (1990–91).

1983

11 April

Louis Gossett Jr wins Best Supporting Actor for *An Officer and a Gentleman*: he is the first Black actor to win an Oscar for two decades. Singer-songwriter Buffy Sainte-Marie is the first indigenous artist (Piapot Cree nation) to win an Academy Award, for Best Original Song in the film.

Ben Kingsley wins Best Actor for *Gandhi* – the first actor of Indian ancestry to win an Academy Award. Bhanu Athaiya becomes the first Indian woman to win an Oscar, for Best Costume Design in the film.

1984

9 April

Irene Cara becomes the first African American woman to win an Academy Award in a non-acting role, for Best Original Song ('Flashdance . . . What a Feeling'), for *Flashdance*.

1985

6 February

Haing S Ngor becomes the first Asian to be nominated for Best Supporting Actor, for *The Killing Fields*.

25 March

Ngor becomes the first Asian to win Best Supporting Actor.

Stevie Wonder wins Best Original Song ('I Just Called to Say I Love You'), for *The Woman in Red*.

Prince wins Best Original Song Score, for *Purple Rain*.

1986

4 February

The Color Purple receives 11 Oscar nominations. At the 58th Academy Awards ceremony it wins nothing.

24 March

William Hurt becomes the first actor to win an Oscar for playing a transgender character, taking Best Actor for *Kiss of the Spider Woman*.

Ruth Prawer Jhabvala wins Best Adapted Screenplay, for *A Room with a View*.

Luis Puenzo wins Best Foreign Language Film, for *The Official Story*.

Lionel Richie wins Best Original Song ('Say You, Say Me'), for *White Nights*.

Emi Wada wins Best Costume Design, for *Ran*.

1987

30 March

Marlee Matlin becomes the first deaf actor to win an Academy Award, for Best Actress, in *Children of a Lesser God*.

Herbie Hancock wins Best Original Score, for *Round Midnight*.

October

Cheryl Boone Isaacs, Director of Publicity at Paramount Pictures, becomes a member of AMPAS.

1988

11 April

Cong Su and Ryuichi Sakamoto win Best Original Score, for *The Last Emperor*.

1989

29 March

Willie D Burton wins Best Sound, for *Bird*.

1990

26 March

Denzel Washington wins Best Supporting Actor, for *Glory*. It marks a watershed, breaking the two-decade gap between Oscar victories for Black actors; from now

on, Black artists will win with increasing regularity. Russell Williams II wins Best Sound, also for *Glory*.

Akira Kurosawa wins an Honorary Academy Award.

1991
13 February
Grahame Greene of Canada's First Nations (Oneida) becomes the second Native American to be nominated for an Academy Award for Best Supporting Actor, for *Dances with Wolves*.

25 March
Whoopi Goldberg wins Best Supporting Actress for *Ghost*.

Russell Williams II wins Best Sound, for *Dances with Wolves*. He becomes the first Black double-Oscar winner.

Steven Okazaki wins Best Documentary Short Subject, for *Days of Waiting: The Life & Art of Estelle Ishigo*.

1992
19 February
John Singleton becomes the first African American to be nominated for Best Director, for *Boyz n the Hood*. At 24, he is the youngest ever nominated in the category.

30 March
Director/screenwriter Satyajit Ray becomes the first Indian filmmaker to receive an Honorary Academy Award for services to film.

1993
17 February
Jaye Davidson becomes the first Black, openly gay nominee, as Best Supporting Actor for his role as transgender character, Dil, in *The Crying Game*.

29 March

Eiko Ishioka wins Best Costume Design, for *Bram Stoker's Dracula*.

Doug Chiang wins Best Visual Effects, for *Death Becomes Her*.

1994

Jane Campion becomes the second woman to be nominated for Best Director, for *The Piano*.

1995

27 March

Freida Lee Mock wins Best Documentary Feature, for *Maya Lin: A Strong Clear Vision*.

1996

13 February

The nominations are announced for the 68th Academy Awards. All 20 candidates in the acting categories are white. Of the total 166 nominees, only one is Black.

13 March

People magazine's 'Hollywood Blackout' issue, dated 18 March, hits newsstands, highlighting the industry's systemic racism against African Americans.

22 March

In protest at the all-white nominees, the Reverend Jesse Jackson and his Rainbow PUSH Coalition call for a last-minute boycott of the Oscars. Black artists refuse.

25 March

Jackson pickets local TV stations televising the Oscars. Host Whoopi Goldberg criticizes Jackson's boycott.

Luis Bacalov wins Best Music – Original Score, for *Il Postino* (The Postman).

Eugenio Zanetti wins Best Art Direction, for *Restoration*.

1997

24 March

Cuba Gooding Jr wins Best Supporting Actor for *Jerry Maguire*.

Jessica Yu wins Best Documentary Short Subject, for *Breathing Lessons: The Life and Work of Mark O'Brien*.

29 August

A new DVD rental service called Netflix launches.

1998

23 March

Chris Tashima wins Best Live Action Short, for *Visas and Virtue*.

1999

AMPAS membership has grown to approximately 5,500 members.

9 February

Ian McKellen becomes the first openly gay man to be nominated (Best Actor), for portraying a gay character, in *Gods and Monsters*.

21 March

Keiko Ibi wins Best Documentary Short Subject, for *The Personals: Improvisations on Romance in the Golden Years*.

2001

25 March

Benicio del Toro wins Best Supporting Actor for *Traffic*. He is the first Latino actor to win an Oscar for 50 years.

Ang Lee wins Best Foreign Language Film, for *Crouching Tiger, Hidden Dragon*. Tan Dun wins Best Original Score; Timmy Yip, Best Art Direction and Set Decoration; and Peter Pau, Best Cinematography.

2002

12 February
The nominees for the 74th Academy Awards are announced. Denzel Washington features for Best Actor, for *Training Day*, while Halle Berry is included for Best Actress, for *Monster's Ball*. It is the first time in 30 years that two Black nominees feature in the top male and female acting categories.

24 February
Newsweek publishes a 3,600-word profile on Denzel Washington. 'Will It Be Denzel's Day?', written by journalist Allison Samuels, hits newsstands during Oscars voting season.

24 March
Denzel Washington wins Best Actor, becoming the first Black actor to win two Oscars. Halle Berry wins Best Actress – the first time for a Black actress. This is the first time ever that both lead acting awards have gone to Black artists. Sidney Poitier receives an Honorary Academy Award.

Brigitte Broch wins Best Art Direction (Set Decoration), for *Moulin Rouge*.

2003

23 March
Hayao Miyazaki wins Best Animated Feature, for *Spirited Away*.

Luis Resto wins Best Original Song ('Lose Yourself'), for *8 Mile*.

Beatrice De Alba wins Best Makeup, for *Frida*.

2004

27 January
Keisha Castle-Hughes becomes the first actor of indigenous ancestry (Maori) to be nominated for Best Actress, in *Whale Rider*.

29 February

Hammond Peek wins Best Sound Mixing, for *The Lord of the Rings: The Return of the King*. He becomes the first indigenous artist (Maori) to win an Academy Award.

6 October

A study by SAG reveals that film roles for Asian actors have fallen by 2 per cent, and by 10.5 per cent for Latinos, while for African Americans they have declined by 3 per cent. White performers feature in over 73 per cent of all roles.

2005

16 January

AMPAS begins publishing its annual list of new members. Maggie Gyllenhaal, Scarlett Johansson, Ken Watanabe and Keisha Castle-Hughes feature among 127 new invitees to add to the existing roster of 5,880 members from 30 countries.

27 February

Jamie Foxx wins Best Actor for *Ray*, and Morgan Freeman wins Best Supporting Actor for *Million Dollar Baby*.

Jorge Drexler wins Best Original Song ('Al otro lado del río'), for *The Motorcycle Diaries*.

2006

Women's rights advocate Tarana Burke coins the phrase 'Me Too', in support of female victims of sexual violence.

5 March

Ang Lee becomes the first Asian filmmaker to win Best Director, for *Brokeback Mountain* – a love story about gay cowboys. Preceding this, discrimination based on sexual orientation, and restrictions on same-sex marriage, are being challenged in the US courts. Gustavo Santaolalla wins Best Original Score, for the film.

Frayser Boy, Juicy J and DJ Paul win Best Original Song ('It's Hard Out Here for a Pimp'), for *Hustle and Flow*.

Hammond Peek wins Best Sound Mixing, for *King Kong*. He becomes the first indigenous artist (Maori) to win two Oscars.

5 July
Rachel Weisz, Ving Rhames and Terrence Howard feature among 120 new AMPAS members.

7 September
Amazon launches its streaming service.

2007
16 January
Netflix begins its streaming service.

23 January
The nominations for the 79th Academy Awards are announced. The acting categories contain seven artists of colour (35 per cent), including five Black artists.

With Black actors now appearing to be adequately represented, the Black Oscars are cancelled.

25 February
Forest Whitaker wins Best Actor for *The Last King of Scotland*, and Jennifer Hudson wins Best Supporting Actress for *Dreamgirls*.

Ruby Yang wins Best Documentary Short Subject, for *The Blood of Yingzhou District*.

Willie D Burton wins Best Sound Mixing, for *Dreamgirls*. He becomes the third Black double-Oscar winner.

Guillermo Navarro wins Best Cinematography, for *Pan's Labyrinth*; Eugenio Caballero wins Best Art Direction.

Gustavo Santaolalla wins Best Original Score, for *Babel* – his second Academy Award.

8 April
Newsweek proclaims Will Smith Hollywood's biggest box office star, with career earnings of $4.4 billion, beating Tom Cruise, Tom Hanks, Mel Gibson and Johnny Depp.

18 June
Jennifer Hudson, Chiwetel Ejiofor, Antoine Fuqua and Eddie Murphy feature among 115 new AMPAS members. The following year, Marion Cotillard, Jet Li and Ruby Dee are among 105 new members.

2009
22 February
Yōjirō Takita wins Best Foreign Language Film, for *Departures*.

Kunio Katō wins Best Animated Short Film, for *La Maison en Petits Cubes*.

A R Rahman wins Best Original Score, for *Slumdog Millionaire*; and A R Rahman and Gulzar win Best Original Song ('Jai Ho'). Rahman becomes India's first double-Oscar winner. Resul Pookutty wins Best Sound Mixing, also for *Slumdog Millionaire*.

30 June
Viola Davis, Jeffrey Wright, Taraji P Henson and Tyler Perry feature among 134 new AMPAS members.

2010
7 March
Mo'Nique wins Best Supporting Actress, for *Precious*; Geoffrey Fletcher wins Best Adapted Screenplay.

Kathryn Bigelow becomes the first woman to win Best Director, for *The Hurt Locker*.

Juan José Campanella wins Best Foreign Language Film, for *The Secret in their Eyes*.

Roger Ross Williams wins Best Documentary Short Subject, for *Music by Prudence*.

Nicolas Schmerkin wins Best Animated Short Film, for *Logorama*.

25 June
Zoe Saldana, Mo'Nique, Saoirse Ronan and Lee Daniels feature among 135 new AMPAS members. The following year, Beyoncé, Wes Studi, Jennifer Lawrence and Mila Kunis are among 178 new members.

2011
27 February
Audrey Marrs wins Best Documentary Feature, for *Inside Job*.

Shaun Tan wins Best Animated Short Film, for *The Lost Thing*.

12 November
James Earl Jones receives an Honorary Academy Award.

2012
19 February
The *Los Angeles Times* publishes an in-depth investigation into the demographic of the Academy's member base. They reveal that the 5,000-member roster is 94 per cent white and 77 per cent male, with a median age of 62. Blacks make up 2 per cent, and Latinos less than 2 per cent. Of the Academy's 43-member Board of Governors, six are women (14 per cent), while Cheryl Boone Isaacs is the sole Black woman (2 per cent).

26 February
Octavia Spencer wins Best Supporting Actress for *The Help*.

TJ Martin wins Best Documentary Feature, for *Undefeated*.

Sharmeen Obaid-Chinoy wins Best Documentary Short Subject, for *Saving Face*. She becomes the first artist of Pakistani heritage to win an Academy Award.

2013
24 February
Ang Lee wins Best Director for *Life of Pi*; Claudio Miranda wins Best Cinematography.

28 June
Ava DuVernay, Jennifer Lopez, Sandra Oh and Lucy Liu feature among 276 new AMPAS members. A year earlier, Octavia Spencer, Demián Bichir, Michelle Yeoh and Kerry Washington were included among 176 new members.

13 July
The acquittal of George Zimmerman for the fatal shooting of unarmed Black teenager Trayvon Martin galvanizes Alicia Garza, Patrisse Cullors and Opal Tometi to create a movement in protest at racism and the unjust killing of Black citizens in America. It begins with a hashtag, *#BlackLivesMatter*. This goes viral, bringing the issue into the public consciousness.

30 July
Two weeks later, the first Black president of AMPAS, Cheryl Boone Isaacs, is elected.

2014
2 March
Alfonso Cuarón becomes the first Latino filmmaker to win Best Director, for *Gravity*. He also wins Best Film Editing. Emmanuel Lubezki wins for Best Cinematography.

Steve McQueen becomes the first Black director to win Best Picture, for *12 Years a Slave*; Lupita Nyong'o wins Best Supporting Actress; and John Ridley wins Best Adapted Screenplay.

Robert Lopez wins Best Original Song ('Let It Go'), for *Frozen*.

26 June
Lupita Nyong'o, Hayao Miyazaki and Pharrell Williams feature among 271 new AMPAS members.

8 November
Hayao Miyazaki receives an Honorary Academy Award.

2015

15 January
The nominations are announced for the 87th Academy Awards. All 20 candidates in the acting categories are white. Special attention is drawn to the omission of *Selma* from the list – in particular, its lead, David Oyelowo, and director Ava DuVernay. It is later revealed that some Academy members objected to their political stance over the recent murders of Michael Brown and Eric Garner by police, and so refused to vote for the film.

April Reign tweets *#OscarsSoWhite*, in protest at the 20 all-white nominees. Her tweet goes viral. A social media movement begins.

Later that day, Al Sharpton issues a statement in response to the all-white nominees: 'The movie industry is like the Rocky Mountains: the higher you get, the whiter it gets.'

22 February
A planned protest at the Oscars by Sharpton is called off at the last minute, after DuVernay persuades him that direct dialogue with AMPAS will be more effective.

Alejandro González Iñárritu wins Best Director and Best Picture, for *Birdman*; Iñárritu, Nicolás Giacobone and Armando Bó win Best Original Screenplay; Emmanuel Lubezki wins for Best Cinematography. Iñárritu dedicates his win to his fellow Mexicans, urging that they be treated with 'dignity and respect' in the United States.

Tom Cross wins Best Film Editing, for *Whiplash*.

James Lucas wins Best Live Action Short Film, for *The Phone Call*.

John Legend and Common win Best Original Song ('Glory'), for *Selma*.

26 June
David Oyelowo, Boon Joon-ho, Dev Patel and Gugu Mbatha-Raw feature among 322 new AMPAS members. Of the total, 46 per cent are women, 41 per cent are people of colour and 41 per cent are international members, from 59 countries.

14 November
Director Spike Lee receives an Honorary Oscar at the Academy's 7th Annual Governors Awards.

2016
14 January
The nominations are announced for the 88th Academy Awards. For the second year running, all 20 candidates in the acting categories are white.

April Reign reposts her *#OscarsSoWhite* tweet in protest. Once again it goes viral. The international press take up the story.

In the days that follow, Spike Lee, Jada Pinkett Smith, Will Smith, Idris Elba, Ava DuVernay, David Oyelowo and President Barack Obama speak out about the omission of Black artists from the nominees. Some decide to boycott the Awards ceremony, which is to be presented by Chris Rock, who faces pressure to pull out.

22 January
Some white artists, such as actor Charlotte Rampling and producer Gerald Molen, push back against *#OscarsSoWhite*. Rampling calls the movement 'racist against whites'. She later claims that her comments were misinterpreted.

AMPAS announces plans to boost diversity within its membership. The initiative, called A2020, pledges to increase female representation to 48 per cent,

and diverse groups to over 14 per cent, by 2020. The Academy begins seeking out new invitees among women, foreign-born artists and people of colour who have been involved in major productions.

22 February
A report by the Annenberg School for Communication and Journalism, at the University of Southern California (USC), reveals that out of 407 directors surveyed in 2014–15, 87 per cent were white, and 13 per cent were from ethnic minority backgrounds. Of the 13 per cent, only two were Black women: Amma Asante and Ava DuVernay.

24 February
Music mogul and film producer Russell Simmons launches the All Def Movie Awards to honour Black talent snubbed by the Academy, and to poke fun at the Oscars.

28 February
Al Sharpton leads a protest rally. He urges film fans not to watch the Oscars broadcast that evening.

At the 88th Academy Awards, Chris Rock pokes fun at the boycott and those who tried to persuade him to join. He mocks Jada Pinkett Smith, accusing her of only advocating for the boycott because her husband Will was not nominated that year. Rock concludes by maintaining that Black artists be awarded the same opportunities as whites.

Later in the broadcast, Rock and presenter Sasha Baron Cohen spark controversy by telling a racially offensive joke about Asians.

Alejandro González Iñárritu wins Best Director, for *The Revenant*; Emmanuel Lubezki wins for Best Cinematography. In his acceptance speech, Iñárritu calls for an end to racial inequality and prejudice.

Asif Kapadia wins Best Documentary Feature, for *Amy*.

Sharmeen Obaid-Chinoy wins Best Documentary Short Subject, for *A Girl in the River: The Price of Forgiveness*. She becomes the first artist of Pakistani heritage to win two Oscars.

Pato Escala and Gabriel Osorio win Best Animated Short Film, for *Bear Story*.

15 March
Objections to Chris Rock's Oscar night joke are raised by 25 Asian members of the Academy, including director Ang Lee and actors George Takei and Sandra Oh. AMPAS issues a formal apology.

The same day, three minority governors join the AMPAS Board: African American director/producer/screenwriter Reginald Hudlin, Latino writer Gregory Nava, and Asian American animator Jennifer Yuh Nelson.

1 May
Galvanized by *#OscarsSoWhite*, actress Margaret Cho, publisher Ellen Oh and Keith Chow, editor of sci-fi/fantasy blog The Nerds of Color, launch *#WhitewashedOUT* in protest against the whitewashing of Asian film roles.

29 June
Idris Elba, Greta Gerwig and America Ferrera feature among 683 new AMPAS members. The oldest is 91-year-old Mexican actor Ignacio López Tarso. The list includes 28 Oscar winners and 109 nominees. Of the total, 46 per cent are women, 41 per cent are people of colour and 41 per cent are international members, from 59 countries.

2 August
Cheryl Boone Isaacs is re-elected for a fourth term as AMPAS president, beating several anti-reform candidates who stood against her diversity initiatives.

12 November
Jackie Chan receives an Honorary Academy Award.

2017

24 January

In the year immediately after *#OscarsSoWhite*, more than 20 candidates of colour make the overall list of Oscar nominees, including seven in the acting categories (35 per cent). Dev Patel, nominated for Best Supporting Actor, in *Lion*, becomes only the third Indian actor to make the list.

Bradford Young becomes the first African American cinematographer to be nominated for an Academy Award, for *Arrival*.

Joi McMillon becomes the first African American female editor to be nominated for an Academy Award, for *Moonlight*.

26 February

Viola Davis wins Best Supporting Actress, for *Fences*.

Mahershala Ali wins Best Supporting Actor, for *Moonlight*. The film also wins Best Picture for director Barry Jenkins, and Best Adapted Screenplay for Jenkins and Tarell Alvin McCraney. It is the first film with an LGBTQ+ theme and an all-Black cast to win Best Picture.

Ezra Edelman wins Best Documentary Feature, for *OJ: Made in America*.

Joanna Natasegara wins Best Documentary Short Subject, for *The White Helmets*.

7 March

Samuel L Jackson criticizes the casting of Black British actors in African American film roles.

12 May

After four terms in charge, Boone Isaacs steps down as president of AMPAS.

28 June

Priyanka Chopra, Maggie Cheung and Barry Jenkins feature among 774 new AMPAS members. The list includes 28 Oscar winners and 109 nominees. Of the total, 39 per cent are women, 30 per cent are people of colour and 30 per cent are international members, from 57 countries.

5 October
#MeToo reaches Hollywood, as the press reports on allegations of sexual misconduct by film producer Harvey Weinstein.

11 November
Charles Burnett receives an Honorary Academy Award.

2018
23 January
Kumail Nanjiani is nominated for Best Original Screenplay, for *The Big Sick*. He is the first artist of Pakistani heritage ever to make the list.

4 March
The 90th Academy Awards are female-focused, highlighting the issue of sexual harassment in Hollywood.

Frances McDormand wins Best Actress for *Three Billboards Outside Ebbing, Missouri*. In her acceptance speech she champions the work of women artists in film, and makes reference to an 'inclusion rider' – a new contractual clause pioneered by Stacy L Smith of USC Annenberg, which allows actors to stipulate the hiring of diverse crews for the films in which they appear.

Jordan Peele wins Best Original Screenplay for *Get Out*.

Guillermo del Toro wins Best Director and Best Picture, for *The Shape of Water*; Paul D Austerberry wins for Best Production Design.

Sebastián Lelio wins Best Foreign Language Film, for *A Fantastic Woman*.

Kobe Bryant wins Best Animated Short Film, for *Dear Basketball*.

Kazuhiro Tsuji wins Best Makeup and Hairstyling, for *Darkest Hour*.

Robert Lopez wins Best Original Song ('Remember Me'), for *Coco*.

25 June
Daniel Kaluuya, Jada Pinkett Smith and Léa Seydoux feature among 928 new AMPAS members. The list includes 17 Oscar winners and 92 nominees. Of the total, 49 per cent are women, 38 per cent are people of colour and 49 per cent are international members, from 59 countries.

31 July
The latest report by Stacy L Smith reveals that, from 1,100 films released between 2007 and 2017, approximately 71 per cent of movie characters were white, 12 per cent were Black, 6 per cent were Latino and 6 per cent were Asian.

18 November
Cicely Tyson and Lalo Schifrin receive Honorary Academy Awards.

2019
22 January
Roma becomes only the fifth movie to be nominated both for Best Picture and Best Foreign Language Film. It is also Netflix's first Best Picture nomination.

24 February
Mahershala Ali wins Best Supporting Actor for *Green Book*. He becomes the second Black actor to win two Oscars.

Regina King wins Best Supporting Actress for *If Beale Street Could Talk*.

Rami Malek becomes the first actor of Egyptian and Arab heritage to win Best Actor, for *Bohemian Rhapsody*.

Alfonso Cuarón wins Best Director, Best Cinematography and Best Foreign Language Film, for *Roma*. It is Mexico's first ever foreign-language Oscar.

Kevin Willmott and Spike Lee win Best Adapted Screenplay for *BlacKkKlansman*.

Peter Ramsey wins Best Animated Feature, for *Spider-Man: Into the Spider-Verse*.

Elizabeth Chai Vasarhelyi and Jimmy Chin win Best Documentary – Feature, for *Free Solo*.

Domee Shi wins Best Animated Short Film, for *Bao*.

Hannah Beachler wins Best Production Design, for *Black Panther*; Ruth E Carter wins Best Costume Design for the same film.

Across all categories, 13 people of colour take home Oscars, including seven African Americans.

1 July
Lady Gaga, David Harewood and Letitia Wright feature among 842 new AMPAS members. The list includes 21 Oscar winners and 82 nominees. Of the total, 50 per cent are women, 29 per cent are people of colour and 29 per cent are international members, from 59 countries.

The Academy announces that people of colour now make up 16 per cent of its membership, up from 8 per cent in 2015. Women make up 32 per cent, up from 25 per cent in 2015.

27 October
Wes Studi of the Cherokee nation (real name ᏫᎥ ᎤᏚᎵ) becomes the first Native American to receive an Academy Award – an Honorary Oscar for services to film. He has appeared in over 30 movies, including *Dances with Wolves* and *The Last of the Mohicans*.

1 November
Apple launches its streaming service, Apple TV+.

2020
January
The coronavirus pandemic begins.

3 January
The latest report from Stacy L Smith at USC Annenberg reveals the make-up of the heads of Hollywood's 11 major film studios – those who decide which films get made, and by whom. The data shows that they are 91 per cent white and 82 per cent male.

9 February
South Korean filmmaker Bong Joon-ho wins Best Director, Best Picture (with Kwak Sin-ae), Best Original Screenplay (with Han Jin-won) and Best International Feature Film, for *Parasite*. The movie is the first foreign-language film ever to win Best Picture.

Taika Waititi becomes the second indigenous artist (Maori) to win an Academy Award, for Best Adapted Screenplay, for *Jojo Rabbit*.

Matthew A. Cherry and Karen Rupert Toliver win Best Animated Short Film, for *Hair Love*.

Kazu Hiro wins Best Makeup and Hairstyling, for *Bombshell*.

20 February
President Donald Trump denounces the Academy's choice of *Parasite* as Best Picture winner, on the grounds that the film is from South Korea.

12 March
Harvey Weinstein is convicted of sexual assault and rape. He is sentenced to 23 years in prison.

13 March
Trump declares a national emergency due to the coronavirus pandemic. States begin issuing stay-at-home orders and other restrictive measures to curb the spread of the virus.

25 May
George Floyd is murdered by Minneapolis police officer Derek Chauvin, sparking global outrage and demonstrations. The hashtag *#BlackLivesMatter* goes viral.

AMPAS issues a statement in support of the movement.

12 June
AMPAS presents the next phase of its reforms, called Academy Aperture 2025. Beginning in 2022 the Best Picture category is to be set at ten nominees. New facilities for viewing nominated films are proposed, plus diversity training for Academy executives. A further announcement stipulates that all eligible films must meet new representation and inclusion standards, in order to qualify for Best Picture.

30 June
AMPAS announces that it has reached its target to double the number of women and people of colour among its membership by 2020. More than 3,000 new members have joined since 2016. The new member base is now 68 per cent male and 84 per cent white.

Yalitza Aparicio, Cynthia Erivo and Eva Longoria feature among 819 new AMPAS members. The list includes 15 Oscar winners and 75 nominees. Of the total, 45 per cent are women, 36 per cent are people of colour and 49 per cent are international members, from 68 countries.

2021
28 February
The Academy Awards ceremony is postponed due to the coronavirus pandemic. The new date is 25 April.

15 March
The first Awards season following George Floyd's murder yields the highest-ever number of actors of colour within the Oscars shortlist: nine in total (45 per cent).

Riz Ahmed becomes the first actor of Pakistani heritage to be nominated for an Academy Award, for Best Actor, in *Sound of Metal*.

Netflix secures a record 36 nominations across 17 films.

25 April
Daniel Kaluuya wins Best Supporting Actor for *Judas and the Black Messiah*.

Yuh-Jung Youn becomes the first South Korean actor to win an Academy Award, for Best Supporting Actress, in *Minari*. She is the first Asian to win an acting Oscar for 36 years.

Chloé Zhao wins Best Director for *Nomadland*. She is the first female Asian director and the first woman of colour to win Best Director.

Travon Free wins Best Live Action Short Film, for *Two Distant Strangers*.

Jon Batiste wins Best Original Score, for *Soul*.

Jaime Baksht, Carlos Cortés and Michelle Couttolenc win Best Sound, for *Sound of Metal*.

Dernst Emile II, H E R and Tiara Thomas win Best Original Song ('Fight for You'), for *Judas and the Black Messiah*.

Mia Neal and Jamika Wilson win Best Makeup and Hairstyling, for *Ma Rainey's Black Bottom*.

1 July
Steven Yeun, Leslie Odom Jr and Issa Rae feature among 395 new AMPAS members. The list includes 25 Oscar winners and 89 nominees. Of the total, 46 per cent are women, 39 per cent are people of colour and 53 per cent are international members, from a total of 49 countries.

2022

8 February

Javier Bardem is nominated for Best Actor for his role as Cuban band leader Desi Arnaz in *Being the Ricardos*. Bardem is criticized online for being a Spanish actor in a Latino role.

Denzel Washington is nominated for Best Actor, for *The Tragedy of Macbeth*. He is the most nominated Black artist in Oscars history, featured on ten occasions. He also joins Laurence Olivier, Paul Newman, Michael Caine, Katharine Hepburn, Jack Nicholson, Meryl Streep and Frances McDormand, as one of eight actors nominated across five decades.

25 March

Samuel L Jackson and Euzhan Palcy receive Honorary Academy Awards.

27 March

At the 94th Academy Awards ceremony Will Smith sparks outrage after assaulting host Chris Rock on stage, following a joke that Rock told about Smith's wife, Jada.

Smith wins Best Actor for *King Richard*.

Ariana DeBose wins Best Supporting Actress for *West Side Story*. She is the first openly queer woman of colour to win an Oscar.

Troy Kotsur wins Best Supporting Actor for *CODA*. He is the second deaf actor to win an Academy Award, and the first for 35 years.

Jane Campion wins Best Director – the third woman ever to do so – for *Power of the Dog*.

Ryusuke Hamaguchi wins Best International Feature Film, for *Drive My Car*.

Ahmir 'Questlove' Thompson and Joseph Patel win Best Documentary Feature, for *Summer of Soul*.

Aneil Karia and Riz Ahmed win Best Live Action Short Film, for *The Long Goodbye*.

28 March
Will Smith publicly apologizes on Instagram for his violent conduct at the Oscars. On 1 April, he resigns from the Academy.

8 April
AMPAS bans Smith from attending all its events, including the Oscars, for a period of ten years.

28 June
Billie Eilish, Ariana DeBose and Caitríona Balfe feature among 397 new AMPAS members. The list includes 15 Oscar winners and 71 nominees. Of the total, 44 per cent are women, 37 per cent are people of colour and 50 per cent are international members, from a total of 53 countries.

2 August
Hollywood producer Janet Yang becomes the first Asian president of AMPAS. She is the fourth woman to hold the post.

2023
24 January
The nominations for the 95th Academy Awards feature six actors of colour (30 per cent), including a record-breaking four Asians.

12 March
Michelle Yeoh wins Best Actress, and Ke Huy Quan wins Best Supporting Actor, for *Everything Everywhere All at Once*. Co-director Daniel Kwan wins Best Director, Best Picture and Best Original Screenplay.

Guillermo del Toro wins Best Animated Feature, for *Guillermo del Toro's Pinocchio*.

Kartiki Gonsalves and Guneet Monga win Best Documentary Short Subject, for *The Elephant Whisperers*.

M M Keeravani and Chandrabose win Best Original Song ('Naatu Naatu'), for *RRR*.

Judy Chin wins Best Makeup and Hairstyling, for *The Whale*.

Ruth E Carter wins Best Costume Design, for *Black Panther: Wakanda Forever*. She becomes the first Black woman to win two Oscars.

28 June
Taylor Swift, Ke Huy Quan, Keke Palmer and Kazuo Ishiguro feature among 398 new AMPAS members. Of the total, 40 per cent are women, 34 per cent are people of colour and 52 per cent are international members, from 51 countries.

15 July
AMPAS releases details of the make-up of its senior executives. 71 per cent are female and 42 per cent are from underrepresented ethnic or racial backgrounds.

17 October
Following the release of *Killers of the Flower Moon*, Stacy L Smith publishes a special report on the presence of indigenous Americans in film. She reveals that 0.25 per cent of speaking roles were awarded to Native Americans from a survey of 1,600 movies. Overall they featured in just 1 per cent of the total.

18 November
Angela Bassett receives an Honorary Academy Award.

2024
AMPAS's new diversity compliance rules take effect. All films must now meet two out of four inclusion standards in order to qualify for Best Picture.

23 January
The nominees for the 96th Academy Awards are the most diverse to date: Black, Latinx, Native American and LGBTQ+ artists feature in the acting categories, with other artists of colour prominent in other sections. Overall, seven actors of colour (35 per cent) are present.

Colman Domingo becomes the first openly gay Afro-Latino male to be nominated for playing a gay character – civil rights activist Bayard Rustin, in *Rustin*.

Piitaaki (Eagle Woman), otherwise known as Lily Gladstone of the Blackfeet nation, becomes the first Native American ever to be nominated for Best Actress, for *Killers of the Flower Moon*.

10 March
Da'Vine Joy Randolph wins Best Supporting Actress, for *The Holdovers*.

Cord Jefferson wins Best Adapted Screenplay, for *American Fiction*.

Hayao Miyazaki and Toshio Suzuki win Best Animated Feature, for *The Boy and the Heron*.

Kris Bowers wins Best Documentary Short Film, for *The Last Repair Shop*.

Takashi Yamazaki, Kiyoko Shibuya, Masaki Takahashi and Tatsuji Nojima win Best Visual Effects, for *Godzilla Minus One*.

Emma Stone beats Lily Gladstone to Best Actress: the wait for the first Native American actor to win an Oscar continues.

*

The Academy of Motion Picture Arts and Sciences began with 36 members – 92 per cent white men and 8 per cent white women. As of 2023 it has approximately 10,800 members, of which 67 per cent are male, 33 per cent are female, 81 per cent are white and 19 per cent are people of colour.

NOTES

1. THE TAINT OF TINSELTOWN (1898–1929)

1. Amanda Morris, 'Golden Age of Hollywood Was Not So Golden for Women', *Northwestern Now* (Northwestern University), 1 April 2020.
2. M J McMahon, 'The Black Actor: Still the Help?', *Variety*, 1 August 2016 (online).
3. '100 Years in Post-Production: Resurrecting a Lost Landmark of Black Film History', MoM A.org, October 2014.
4. Thomas Cripps, *Slow Fade to Black: The Negro in American Film, 1900–1942*, Oxford University Press, 1977, p. 108.
5. Los Angeles Times Staff, 'A Brutally Honest History of Latinos in Hollywood', *Los Angeles Times*, 13 June 2021 (online).
6. Charlene Regester, 'African American Extras in Hollywood during the 1920s and 1930s', *Film History* (Indiana University Press), vol. 9, no. 1 (1997): 96.
7. Meghan Dubitsky, 'Central Casting and the Golden Age of Hollywood', CentralCasting.com, 3 December 2018.
8. 'Hattie McDaniel Speaks Mind on "Slip of Lip"', *The California Eagle*, 4 May 1944, p. 6.
9. Jill Watts, *Hattie McDaniel: Black Ambition, White Hollywood*, Amistad, 2005, p. 113.
10. Scott Eyman, *Lion of Hollywood: The Life and Legend of Louis B Mayer*, Robson Books, 2005, p. 117.

2. AMERICAN GOODNESS (1930–1940)

1. John Franchey, 'Magnificent Mammy', *Screen Life*, June 1940, p. 77.
2. 'Screen Director Asks for Extras: Gets Office Wrecked', *The Chicago Defender*, 31 December 1932, p. 6.
3. '3,000 Extras in Tarzan and his Mate', *Baltimore Afro-American*, 22 July 1933, p. 10.
4. Hattie McDaniel, 'What Hollywood?', *Los Angeles Times*, 11 February 1940, p. A6.
5. Anthony Holden, *The Oscars: The Secret History of Hollywood's Academy Awards*, Abacus, 2016, p. 134.

6. Charlotta Bass, 'Imitation of Life: A Better Picture', *The California Eagle*, 7 December 1934, p. 1.
7. 'Oscar Statuette', Academy of Motion Picture Arts and Sciences, Oscars.org.
8. Variety Staff, 'Imitation of Life', *Variety*, 31 December 1933 (online).
9. 'Color Bars Louise Beavers from Film Award', *The Pittsburgh Courier*, 2 March 1935, p. A8.
10. Chappy Gardner, 'Beavers Has Lost Screen Award', *The Pittsburgh Courier*, 2 March 1935, p. A9.
11. Ibid.
12. *Gum Saan Journal*, vol. 30, no. 1 (2007): 49.
13. Ibid.
14. Robert Osborne, *Academy Awards Illustrated: A Complete History of Hollywood's Academy Awards*, ESE California, 1969, p. 71.
15. Veronica Chambers, 'Lives Well Lived: Fredi Washington; The Tragic Mulatto', *The New York Times Magazine*, 1 January 1995, Section 6, p. 27.
16. 'Central Casting Bureau: On the Lot and in the Street', *The California Eagle*, 31 January 1936, p. 8.
17. Thomas Cripps, *Slow Fade to Black: The Negro in American Film, 1900–1942*, Oxford University Press, 1977, p. 166.
18. Ibid., p. 225.
19. Margaret Mitchell, *Gone with the Wind*, Avon Books, 1936, p. 25.
20. Leonard J Leff, 'David Selznick's *Gone with the Wind*: "The Negro Problem"', *The Georgia Review*, vol. 38, no. 1 (Spring 1984): 156.
21. Susan Myrick, *White Columns in Hollywood: Reports from the GWTW Sets*, Mercer University Press, 1982, p. 49.
22. This quote and its variants have appeared extensively in articles on Hattie McDaniel, although its original source is unclear. A variation was quoted by Donald Bogle in *Toms, Coons, Mulattoes, Mammies and Bucks: An Interpretive History of Blacks in American Films*, Continuum, 1990, p. 82.
23. 'Hattie McDaniel Defies Critics in 1947 Essay: "I Have Never Apologized"', *The Hollywood Reporter* [1947], 19 February 2015 (online).
24. Victoria Koehl, 'How Clark Gable Fought for his Black "Gone with the Wind" Co-Stars on Set', CheatSheet.com, 9 March 2023.

25. Max Alexander, 'Once More, the Old South in All its Glory', *The New York Times*, 29 January 1989, Section 2, p. 13.

26. Eldridge Cleaver, *Soul on Ice: Selected Essays*, Jonathan Cape, 1969, p. 13.

27. Ethel Waters, with Charles Samuels, *His Eye is on the Sparrow: An Autobiography by Ethel Waters*, Doubleday, 1951, p. 258.

28. 'Predicts Picture Will Be Worse Than "Birth of a Nation"', *The Pittsburgh Courier*, 4 February 1939, p. 21.

29. Judy Cameron and Paul Christman, 'The Art of Making "Gone with the Wind"', *New York Amsterdam News*, 20 May 1939, p. 99.

30. Telegram from David O Selznick to Howard Dietz, 30 November 1939, Box 178, Folder 12, David O Selznick Collection, University of Texas, Austin.

31. Al Lean, 'I'm Stronger Than You Think', *The Denver Post*, 15 April 1941, p. 1.

32. Telegram from Selznick to Dietz, 30 November 1939.

33. Evelyn Keyes, *Scarlett O'Hara's Younger Sister: My Lively Life in and out of Hollywood*, Lyle Stuart Inc., 1977, p. 32.

34. Frank S Nugent, 'The Screen in Review', *The New York Times*, 20 December 1939, p. 31; *The Hollywood Reporter*, 13 December 1939 (online); John C Flinn Sr, 'Gone with the Wind', *Variety*, 19 December 1939 (online).

35. 'Gone with the Wind – A Study in Black and White', *The Pittsburgh Courier*, 27 January 1940, p. 10; 'Gone with the Wind is Praised; Pro and Con', *The Chicago Defender*, 6 January 1940, p. 6.

36. Frank S Nugent, 'Review: "Gone with the Wind" – Recalling Civil War and Plantation Days of South', *The New York Times*, 28 December 1939, n.p.; 'Hattie McDaniel Continues to do Brilliant Work', *The California Eagle*, 28 December 1939, p. 15.

37. Edwin Schallert, 'Miss McDaniel Scores a Cinematic Breakthrough', *Los Angeles Times*, 29 December 1939, p. A7.

38. Jill Watts, *Hattie McDaniel: Black Ambition, White Hollywood*, Amistad, 2005, p. 146.

39. Ellis Amburn, *Olivia de Havilland and the Golden Age of Hollywood*, Lions Press, 2018, p. 117.

40. Anthony Breznican, 'Olivia de Havilland Got Early Word Hattie McDaniel Defeated her at the Oscars', *Vanity Fair*, 27 July 2020 (online).

41. Holden, *The Oscars*, p. 157.

42. The Associated Press, 'De Havilland Remembers "Gone with the Wind"', Today.com, 18 November 2004.
43. 'Fay Bainter: Self – Presenter of 1939 Oscars for Supporting Roles', *Calvacade of the Academy Awards*, 29 February 1940: imdb.com.
44. See the Academy Awards Acceptance Speech Database, at Oscars.org, for 'more than 1,500 transcripts of onstage acceptance speeches given by Academy Award winners and acceptors'.
45. Breznican, 'Olivia de Havilland Got Early Word'.
46. 'Hattie McDaniel's Success as First Negro to Win Oscar Shows Best Always Do', *New York Amsterdam News*, 8 June 1940, p. 1.
47. Shirley Burden, 'Hattie McDaniel Tells of Slights and Honors', *The Denver Post*, 15 April 1941, p. 18.
48. Steve Garbarino, 'Chris Rock's America', *Details*, August 2012, p. 98.
49. Jimmie Fidler, 'Gone with the Wind Pleases', *Nevada State Journal*, 20 December 1939, p. 10.
50. Seth Abramovitch, 'Oscar's First Black Winner Accepted her Honor in a Segregated "No Blacks" Hotel in LA', *The Hollywood Reporter*, 19 February 2015 (online).

3. THINK BLACK TO WIN (1941–1964)

1. 'The Stories Behind the Stones', CemeteryGuide.com, 6 January 2015.
2. Letter from David O Selznick to Walter White, 20 June 1938, Box 185, Folder 16, David O Selznick Collection, University of Texas, Austin.
3. Walter White, *A Man Called White: The Autobiography of Walter White*, University of Georgia Press, 1995, p. 3.
4. Letter from Eleanor Roosevelt to 'Whom It May Concern', 17 February 1942, NAACP general office files.
5. Letter from Walter White to [journalist] Sara Boynoff, 12 March 1942, NAACP general office files.
6. Ibid.
7. 'Wendell Willkie Luncheon', 18 July 1942, NAACP general office files.
8. Clarence Muse, 'Walter White is a "Committee of One" in his Fight for Negro Rights', *The Pittsburgh Courier*, 12 August 1942, p. 6.
9. Sidney Poitier, *The Measure of a Man: A Spiritual Autobiography*, Harper, 2000, p. 18.

10. Bill Lohmann, 'The South Shall Rise Again', *Daily News, Extra*, 17 November 1986, p. 30.

11. Memo from Gloster Current to Walter White, 22 November 1946, NAACP Manuscript Division, Library of Congress.

12. Jennifer Frost, *Hedda Hopper's Hollywood: Celebrity Gossip and American Conservatism*, NYU Press, 2011, p. 144.

13. Steven Watts, *The Magic Kingdom: Walt Disney and the American Way of Life*, University of Missouri, 2001, p. 279.

14. John L Scott, 'James Baskett Speaks Out', *The Hollywood Reporter*, 14 March 1947, n.p.

15. Jennifer Frost, 'Hedda Hopper, Hollywood Gossip, and the Politics of Racial Representation in Film, 1946–1948', *The Journal of African American History* (University of Chicago Press), vol. 93, no. 1 (2008): 45–6.

16. For more on Ingrid Bergman's Oscar presentation to James Baskett, see 'Disney Academy Award Stories – Part Two', CartoonResearch.com, 26 March 2021.

17. Frost, 'Hedda Hopper': 47.

18. Dave Karger, *50 Oscar Nights: Iconic Stars and Filmmakers on their Career-Defining Wins*, Running Press, 2024, p. 64.

19. Anthony Holden, *The Oscars: The Secret History of Hollywood's Academy Awards*, Abacus, 2016, p. 290.

20. Vanessa Friedman, 'China Machado, Breakthrough Model Until the End, Dies at 86', *The New York Times*, 19 December 2016 (online).

21. William Baer, 'Hud: A Conversation with Irving Ravetch and Harriet Frank, Jr', *Michigan Quarterly Review* (University of Michigan), vol. XLII, no. 2 (Spring 2003): n.p.

22. Poitier, *The Measure of a Man*, p. 101.

23. Allison Samuels, 'Will It Be Denzel's Day?' *Newsweek*, 24 February 2002, pp. 55–61.

24. Poitier, *The Measure of a Man*, p. 18.

25. Donald Bogle, *Bright Boulevards, Bold Dreams: The Story of Black Hollywood*, One World, 2006, p. 292.

26. Dorothy Dandridge and Earl Conrad, *Everything and Nothing: The Dorothy Dandridge Tragedy*, Abelard-Schuman, 1970, p. 157.

27. *The Hollywood Reporter*, 2 November 1954, p. 2; *Jet*, 10 March 1955, p. 60.

28. Donald Bogle, *Dorothy Dandridge: A Biography*, Harper Collins, 1997, p. 129; Dandridge and Conrad, *Everything and Nothing*, p. 155.

29. Chris Lee, 'Juanita Moore, Actress Oscar-nominated for "Imitation of Life," Dead at 99', *Los Angeles Times*, 1 January 2014 (online).

30. Ellen C Scott, 'Most Timely: Hooray for Hollywood: Black Actors Protesting Oscar Racism is Nothing New', *The Common Reader* (Washington University, St Louis), 26 January 2016.

31. *The Chicago Defender*, 11 March 1963, p. 16.

32. Steven Gaydos and Tim Gray, 'A Telling Look Back at the Century-Old Quest for Diversity in Entertainment', *Variety*, 23 February 2016 (online).

33. Ted Johnson, 'When Brando Marched with Heston: How *Variety* Covered the March on Washington', *Variety*, 27 August 2013 (online).

34. Michael Schulman, 'The Meaning of Sidney Poitier's Historic 1964 Oscar', *The New Yorker*, 12 January 2022 (online).

35. 'White Gold: Race and Representation at the Oscars', IndieWire.com, 29 October 2007.

36. '36th Oscar Awards Ceremony is on TV Tonight from Coast', *The New York Times*, 13 April 1964, p. 34.

37. Holden, *The Oscars*, p. 269.

38. Ibid., p. 270.

39. Schulman, 'The Meaning of Sidney Poitier's Historic 1964 Oscar'.

40. Poitier, *The Measure of a Man*, p. 61.

41. Schulman, 'The Meaning of Sidney Poitier's Historic 1964 Oscar'.

42. 'White Gold: Race and Representation at the Oscars'.

4. FAIRNESS FATIGUE (1965–1983)

1. Laurence Olivier, *On Acting*, Weidenfeld & Nicolson, 1986, pp. 158–9.

2. 'The Screen: Minstrel Show "Othello": Radical Makeup Marks Olivier's Interpretation', *The New York Times*, 2 February 1966, p. 24.

3. *Firing Line with Margaret Hoover*, PBS, 5 May 2023.

4. Michael Gross, *Model: The Ugly Business of Beautiful Women*, Bantam Press, 1995, pp. 198, 200.

5. Gerard Molyneaux, *Gregory Peck: A Bio-Bibliography*, Greenwood Press, 1995, p. 236.

6. Anthony Holden, *The Oscars: The Secret History of Hollywood's Academy Awards*, Abacus, 2016, p. 286.

7. Shirley Chisholm, *The Good Fight*, Amistad, 1973, pp. 3–4.
8. Emanuel Levy, *Oscar Fever: The History and Politics of the Academy Awards*, Continuum, 2001, p. 23.
9. 'Chief Dan George, 82, Dies: Appeared in "Little Big Man"', *The New York Times*, 24 September 1981, Section D, p. 27.
10. Ibid.
11. Michael Schulman, 'Revisiting Sacheen Littlefeather's Shocking Appearance at the 1973 Oscars', *The New Yorker*, 27 September 2022 (online).
12. Am J Hum Genet, 'A Genomewide Admixture Map for Latino Populations', NIH National Library of Medicine, June 2007.
13. Holden, *The Oscars*, p. 312.
14. Richard Natale, 'Diahann Carroll, "Julia" and "Dynasty" Star, Dies at 84', *Variety*, 4 October 2019 (online).
15. Ronald E Kisner, 'Oscar Epilogue: Black Presenters, Pickets, Guests', *Jet*, 14 April 1977, p. 58.
16. Louis Gossett Jr and Phyllis Karas, *An Actor and a Gentleman*, Wiley, 2010, pp. 186, 189.
17. Dave Karger, *50 Oscar Nights: Iconic Stars and Filmmakers on their Career-Defining Wins*, Running Press, 2024, p. 126.
18. Judy Klemesrud, 'Earning Sergeant's Stripes for a Movie Role', *The New York Times*, 25 July 1982, Section 2, p. 1.
19. Gossett Jr and Karas, *An Actor and a Gentleman*, p. 194.
20. Ibid., p. 190.
21. Ibid., p. 195.
22. Glenn Collins, 'Lou Gossett Jr Battles the Hollywood Stereotype', *The New York Times*, 19 February 1989, Section 2, p. 33.
23. Ibid.
24. Allison Samuels, 'Colorblind at Last?' *Newsweek*, 11 February 2007 (online).

5. HOLLYWOOD BLACKOUT (1984–2002)

1. Louis Gossett Jr and Phyllis Karas, *An Actor and a Gentleman*, Wiley, 2010, pp. 5–14.
2. Melena Ryzik, 'What It's Really Like to Work in Hollywood', *The New York Times*, 24 February 2016 (online).
3. Ibid.

4. Lorenza Muñoz, 'Acting Jobs Decline for Latinos, Asians', *Los Angeles Times*, 7 October 2004 (online).

5. Roger Ebert, 'The Color Purple', RogerEbert.com, 20 December 1985.

6. Dorothy Gillia, 'After the "Purple" Shutout', *The Washington Post*, 26 March 1986, p. C1.

7. Roger Ebert, 'The Night "The Color Purple" Lost', *Chicago Sun-Times*, 30 March 1986, p. 12.

8. Walter Leavy, 'Eddie Murphy's Princely Role', *Ebony*, July 1988, p. 35.

9. Oprah Winfrey, 'Oprah Talks to Denzel Washington', *O The Oprah Magazine*, January 2008, p. 156.

10. Glenn Collins, 'Denzel Washington Takes a Defiant Break from Clean-Cut Roles', *The New York Times*, 28 December 1989, Section C, p. 13.

11. Glenn Whipp, 'Denzel Washington Tackles Shakespeare and Life's Fourth Quarter with Grace', *Los Angeles Times*, 8 March 2022 (online).

12. Todd Williams (dir.), *Friendly Fire: Making an Urban Legend*, Columbia TriStar Home Entertainment, 2003.

13. 'Ghost (Oda Mae Brown's role casting)', TV interview, 13 June 2011 (YouTube).

14. Tim Robey, 'Why is Ghost So Good? Whoopi Goldberg – It's That Simple', *The Telegraph*, 26 June 2020 (online).

15. Angelique Jackson, 'Reflections of an EGOT Winner: Whoopi Goldberg on "Ghost" and the 30th Anniversary of her Oscar Triumph', *Variety*, 21 April 2021 (online).

16. Dave Karger, *50 Oscar Nights: Iconic Stars and Filmmakers on their Career-Defining Wins*, Running Press, 2024, p. 210.

17. Ibid., p. 211.

18. Alexia Fernández, 'Whoopi Goldberg Took her Fellow Oscar Nominees to Dinner after Winning: "We All Did Really Good Work"', *People*, 21 April 2021 (online).

19. Pam Lambert, 'What's Wrong with This Picture?', *People*, 18 March 1996, p. 51.

20. Kate Hogan, 'All the Sexiest Man Alive Covers', *People*, 8 November 2023 (online).

21. 'Hollywood Blackout: Racism in Hollywood (1996)', *ABC News Washington*.

22. Esther Breger, 'The "Hollywood Blackout" at the 1996 Academy Awards', *The New Republic*, 29 January 2016 (online).

23. Lambert, 'What's Wrong with This Picture?', pp. 42–52.

24. 'Hollywood Blackout: Racism in Hollywood (1996)', *ABC News Washington*.

25. Lambert, 'What's Wrong with This Picture?', p. 46.

26. Ibid., p. 49.

27. Ibid., p. 52.
28. Greg Braxton, 'Jackson Plans Oscar Protest', *Los Angeles Times*, 17 March 1996 (online).
29. Sharon Waxman, 'Hollywood Reeling from Article's Accusation of Racism', *The Washington Post*, 11 March 1996 (online).
30. Braxton, 'Jackson Plans Oscar Protest'.
31. David Sheff, 'Playboy Interview: Whoopi Goldberg', *Playboy*, January 1997, p. 54.
32. Howard Rosenberg, 'Real Drama? It Didn't Come from Ribbons', *Los Angeles Times*, 26 March 1996 (online).
33. Janet Maslin, 'Energy, Gallantry, Graphics and Glamour at the Oscars', *The New York Times*, 27 March 1996, Section C, p. 13.
34. Peter Bart, 'H'wood Hiring is Not a Black-and-White Issue', *Variety*, 24 March 1996 (online).
35. Steve Oney, 'Making the Shift From "Boyz" to Man', *The New York Times*, 5 January 1997, Section 2, p. 11.
36. Variety Staff, 'Backstage at the Oscars', *Variety*, 24 March 1997 (online).
37. Greg Braxton, 'Hollywood in the Year 1 AJJ (After Jesse Jackson)', *Los Angeles Times*, 12 February 1997 (online).
38. Ibid.
39. Mara Siegler, 'Cuba Gooding Jr's "Trash" Films Helped him Learn How to Direct', *Page Six*, 28 February 2018 (online).
40. Colin Moynihan, 'Cuba Gooding Jr Will Serve No Prison Time After Plea in Sex Abuse Case', *The New York Times*, 13 October 2022 (online).
41. Jill Watts, *Hattie McDaniel: Black Ambition, White Hollywood*, Amistad, 2005, p. 279.
42. Karger, *50 Oscar Nights*, p. 40.
43. 'Training Day: Production Information', Cinema.com.
44. Tim Appelo, 'Ethan Hawke on Stage Fright, Denzel Washington: "Don't F—With Him, Man" (Q&A)', *The Hollywood Reporter*, 8 February 2015 (online).
45. Sarah Bahr, 'Oscars Rewind: For Halle Berry, a Bittersweet Breakthrough', *The New York Times*, 24 March 2022 (online).
46. Robert Koehler, 'Monster's Ball', *Variety*, 13 December 2001 (online).
47. See Michael Fleming, 'Playboy Interview: Denzel Washington', *Playboy*, December 2002, pp. 67–74.
48. Allison Samuels, 'Will It Be Denzel's Day?' *Newsweek*, 24 February 2002 (online).
49. Ibid.

50. Ibid.
51. Guardian Unlimited Staff, 'Crowe Apologises for BAFTA Tirade', *The Guardian*, 4 March 2002 (online).
52. Karger, *50 Oscar Nights*, p. 42.
53. Isabel Wilkerson, 'Halle's Shining Moment', *Essence*, April 2002, p. 160.
54. See Fleming, 'Playboy Interview: Denzel Washington'.
55. Josh Rottenberg, 'Denzel Washington Reflects on his Past', *Entertainment Weekly*, 8 January 2010 (online).
56. Karger, *50 Oscar Nights*, p. 39.
57. Newsweek Staff, 'Bylines', *Newsweek*, 7 April 2002 (online).
58. Ramin Setoodeh, 'How Halle Berry Fought her Way to the Director's Chair', *Variety*, 9 September 2020 (online).

6. FAST FLURRY (2003–2014)

1. 'Cheryl Boone Isaacs Elected Academy President', Oscars.org, 30 July 2013.
2. Hilary De Vries, 'All That Korean Rage, Unbottled', *The New York Times*, 17 October 2004 (online).
3. Zack Sharf, 'Jamie Foxx Was an "Embarrassment" During "Ray" Oscar Season, Until Oprah and Sidney Poitier Intervened – Tribeca', IndieWire.com, 23 April 2018.
4. Ramin Setoodeh, 'Morgan Freeman on Oscars Diversity: It Starts with Industry, Not the Academy', *Variety*, 23 February 2016 (online).
5. Ibid.
6. Advocate.com Editors, 'SAG to Honor Basher Borgnine', *Advocate*, 20 August 2010.
7. Farai Chideya, 'Black Oscars Come to an End', npr.org, 23 February 2007.
8. Reuters, 'Forest Whitaker Wins Oscar for Idi Amin Role', Reuters.com, 9 August 2007.
9. Chideya, 'Black Oscars Come to an End'.
10. Sean Smith, 'Will Smith: Hollywood's Most Powerful Actor?', *Newsweek*, 8 April 2007 (online).
11. David Oyelowo, 'Guest Column: David Oyelowo on the Will Smith Slap, the Intersection of Race and Bias', *The Hollywood Reporter*, 7 April 2022 (online).
12. Melena Ryzik, 'What It's Really Like to Work in Hollywood', *The New York Times*, 24 February 2016 (online).

13. Reginald Hudlin, ' "Django Unchained" Producer on "Selma" Oscar Snubs: Did Voters Have "Racial Fatigue"? (Guest Column)', *The Hollywood Reporter*, 21 January 2015 (online).

14. Seth Abramovitch, 'Mo'Nique: I was "Blackballed" After Winning my Oscar', *The Hollywood Reporter*, 19 February 2015 (online).

15. Ibid.

16. Ibid.

17. Mandalit del Barco, ' "Hurt Locker" Wins Best Picture, Director', npr.org, 8 March 2010.

18. John Horn, Nicole Sperling and Doug Smith, 'From the Archives: Unmasking Oscar: Academy Voters are Overwhelmingly White and Male', *Los Angeles Times*, 19 February 2012 (online).

19. Ibid.

20. Audie Cornish and Melissa Block, 'New Academy President Pushes for More Diverse Voting Members', *Code Switch*, npr.org, 27 February 2014.

21. Horn, Sperling and Smith, 'From the Archives: Unmasking Oscar'.

22. Scott Feinberg, 'Cheryl Boone Isaacs Feted by Hollywood's Black Community at Pre-Oscars Dinner', *The Hollywood Reporter*, 28 February 2018 (online).

23. Oyelowo, 'Guest Column'.

24. John Horn and Doug Smith, 'Diversity Efforts Slow to Change the Face of Oscar Voters', *Los Angeles Times*, 21 December 2013 (online).

25. #MeToo movement, 'History & Inception', metoomvmt.org.

26. #BlackLivesMatter, 'Herstory', blacklivesmatter.com.

27. 'The Jean Hersholt Humanitarian Award', Oscars.org.

28. 'The Honorary Award', Oscars.org.

29. Reggie Ugwu, ' "They Set Us Up to Fail": Black Directors of the '90s Speak Out', *The New York Times*, 3 July 2019 (online).

30. 'Oscars 2014: In Quotes', *BBC News*, 3 March 2014.

31. Reggie Ugwu, 'The Hashtag That Changed the Oscars: An Oral History', *The New York Times*, 9 September 2020 (online).

7. BOILING POINT (2015–2016)

1. Lilly Workneh, 'Meet April Reign, the Activist Who Created #OscarsSoWhite', huffingtonpost.co.uk, 28 February 2016; '#OscarsSoWhite Creator April Reign Explains Why Diversity Isn't Enough', The Root, 7 February 2020 (YouTube).

2. Steven Zeitchik and Lorraine Ali, 'Oscars 2015: Diversity is the Biggest Nomination Snub', *Los Angeles Times*, 15 January 2015 (online).

3. Reggie Ugwu, 'The Hashtag That Changed the Oscars: An Oral History', *The New York Times*, 9 September 2020 (online).

4. Kara Warner, 'Academy President Cheryl Boone Isaacs on *Selma* Snubs, Lack of Diversity', Vulture, 15 January 2015 (online).

5. Stephen Galloway, 'David Oyelowo Goes Off on Oscars: "I Am an Academy Member and It Doesn't Reflect Me"', *The Hollywood Reporter*, 18 January 2016 (online).

6. Reginald Hudlin, '"Django Unchained" Producer on "Selma" Oscar Snubs: Did Voters Have "Racial Fatigue"? (Guest Column)', *The Hollywood Reporter*, 21 January 2015 (online).

7. Scott Feinberg, 'Oscar Voter Reveals Brutally Honest Ballot: "There's No Art to 'Selma,' 'Boyhood' 'Uneven"', *The Hollywood Reporter*, 18 February 2015 (online).

8. Hudlin, '"Django Unchained"'.

9. Feinberg, 'Oscar Voter Reveals Brutally Honest Ballot'.

10. Ibid.

11. Ugwu, 'The Hashtag That Changed the Oscars'.

12. Ben Dalton, 'David Oyelowo Calls for BAFTA Changes: "It cannot be a road trip for Hollywood"', *Screen Daily*, 4 June 2020 (online).

13. The Academy, Twitter, 5 June 2020.

14. 'Statement by Rev. Sharpton Blasting the Lack of Diversity in Today's Oscar Nominations', National Action Network, 15 January 2015.

15. Dominic Patten, 'Oscars: Al Sharpton-Led Activist Group Planning Protest Sunday', *Deadline*, 20 February 2015 (online).

16. Tim Gray, 'Academy Invites Record 322 New Members in Push for More Oscar Diversity', *Variety*, 26 June 2015 (online).

17. Stephen Galloway, 'Academy CEO on Oscars' Diversity: "This Feels Like an Inflection Point"', *The Hollywood Reporter*, 20 January 2016 (online).

18. Ugwu, 'The Hashtag That Changed the Oscars'.

19. Los Angeles Times Staff, 'Where's The Diversity?', *Los Angeles Times*, 15 January 2016 (online).

20. Andrew Gruttadaro, 'No POC Deserved to Be Nominated for an Oscar This Year (But That's Not the Point)', *Complex*, 15 January 2016 (online).

21. Jada Pinkett Smith, pt. 1, Twitter, 16 January 2016.

22. 'Idris Elba Urges Greater Diversity in Media', *BBC News*, 18 January 2016.

23. Spike Lee, '#OscarsSoWhite . . . Again', Instagram, 18 January 2016.

24. 'Spike Lee to Attend Knicks Game Instead of Oscars', *CBS News*, 20 January 2016.

25. Snoop Dogg, 'Fuck da. Oscars', Instagram, 19 January 2016.

26. 'Will Smith Explains #OscarsSoWhite Controversy', *Good Morning America*, 19 January 2016.

27. 'Statement from Academy President Cheryl Boone Isaacs', Oscars.org, 18 January 2016.

28. Galloway, 'David Oyelowo Goes Off on Oscars'.

29. Hilary Lewis, 'Whoopi Goldberg on Oscars' Diversity: Black Movies Not Being Made; She Won't Boycott Awards', *The Hollywood Reporter*, 19 January 2016 (online).

30. Lindsay Kimble, 'Whoopi Goldberg on Oscar Diversity Controversy: "We Have This Conversation Every Year and It Pisses Me Off"', *People*, 19 January 2016 (online).

31. Chris Rock, 'The #Oscars. The White BET Awards', Twitter, 15 January 2016.

32. Scott Feinberg, 'Academy Members Defend their Oscar Votes: "To Imply We are Racists is Extremely Offensive"', *The Hollywood Reporter*, 20 January 2016 (online).

33. Janice Min, '#OscarsSoWhite: Academy Chiefs Reveal Behind-the-Scenes Drama That Led to Historic Change (Exclusive)', *The Hollywood Reporter*, 27 January 2016 (online).

34. JT, 'How Racially Skewed Are the Oscars?' *The Economist*, 21 January 2016 (online).

35. Press release, 'Academy Takes Historic Action to Increase Diversity', Oscars.org, 22 January 2016.

36. Cheryl Boone Isaacs, 'Cheryl Boone Isaacs on Creating a More Diverse Academy', *Los Angeles Times*, 26 February 2016 (online).

37. Press release, 'Academy Takes Historic Action to Increase Diversity'.

38. Scott Feinberg, 'Steven Spielberg Supports Diversity in Academy, "Not 100 Percent Behind" Current Plan, Calls for Limits on Oscar Campaigning (Exclusive)', *The Hollywood Reporter*, 11 February 2016 (online).

39. Tre'vell Anderson, 'Q&A: #OscarsSoWhite's April Reign to the Academy: "Thank you for listening. Now, what's next?"', *Los Angeles Times*, 22 January 2016 (online).

40. Ava DuVernay, 'Shame is a helluva motivator', Twitter, 22 January 2016.

41. Rebecca Keegan, 'Kicking It Into "High Gear," Academy President says Oscar Changes Are "The Right Thing to Do"', *Los Angeles Times*, 22 January 2016 (online).

42. Paul Bond, 'Oscar-Winning Producer Denounces "Spoiled Brats" Crying "Racism"', *The Hollywood Reporter*, 22 January 2016 (online).

43. Michael Schulman, 'Shakeup at the Oscars', *The New Yorker*, 19 February 2017 (online).

44. Joe Coscarelli, 'With "Star," Lee Daniels Tries to Expand an Empire', *The New York Times*, 28 December 2016 (online).

45. Rachel Donadio, 'Charlotte Rampling Says Oscars "Boycott" is "Racist Against Whites"', *The New York Times*, 22 January 2016 (online).

46. 'Charlotte Rampling Clarifies Oscar Racism Remarks', *CBS News Sunday Morning*, 22 January 2016.

47. Sharon Waxman, 'Julie Delpy Says Hollywood Dumps on Women Most: "I Sometimes Wish I Were African American" (Video)', *The Wrap*, 22 January 2016 (online).

48. Jessica Derschowitz, 'Oscars: Julie Delpy Sorry for Hollywood Diversity Comments', *Entertainment Weekly*, 23 January 2016 (online).

49. Nick Robinson, 'Michael Caine: "You Can't Vote for an Actor Because he's Black"', *Today*, BBC Radio 4, 22 January 2016.

50. 'DeVito: "We Are a Bunch of Racists"', Associated Press, 23 January 2016 (online).

51. Charlie Stayt, 'Oscar Nominee Mark Ruffalo Says he May Boycott Awards', *BBC Breakfast*, 21 January 2016.

52. 'McKellen: Gay Actors Disregarded in Hollywood', *Sky News*, 25 January 2016.

53. Claudia Eller, 'Shame on Us', *Variety* via Twitter, 26 January 2016.

54. David Ono, 'KABC Exclusive: President Obama Discusses Oscar Diversity', *ABC7 News*, 27 January 2016.

55. Tre'vell Anderson, 'There's Talk About Bringing Back the Black Oscars', *Los Angeles Times*, 3 February 2016 (online).

56. 'Stacey Dash on Outrage over Lack of Oscars Diversity', *Fox News*, 4 February 2017.

57. Feinberg, 'Steven Spielberg Supports Diversity in Academy'.

58. 'Oscars 2016: Boycott Vindicated says Spike Lee', *BBC News*, 17 February 2016.

59. See Ben Child, 'Jamie Foxx: Black Stars – Including Will Smith – Need to #actbetter to Win Oscars', *The Guardian*, 24 February 2016.

60. Stacy L Smith, Marc Choueiti and Katherine Pieper, 'Inclusion or Invisibility? Comprehensive Annenberg Report on Diversity in Entertainment', USC Annenberg, 22 February 2016.

61. Zachary Crockett, '"Gang Member" and "Thug" Roles in Film are Disproportionately Played by Black Actors', *Vox*, 13 September 2016 (online).

62. Mia Galuppo, 'Russell Simmons Plans Awards Show Days Before the Oscars', *The Hollywood Reporter*, 11 February 2016 (online).

63. Walt Hickey, 'Hollywood Studios Barely Promoted Non-White Actors and Films', FiveThirtyEight, 25 February 2016.

64. Dr Darnell Hunt, '2016 Hollywood Diversity Report: Busine$$ as Usual?', Ralph J Bunche Center for African American Studies at UCLA, 25 February 2016.

65. '91% White. 76% Male. Changing who Votes on the Oscars', *Los Angeles Times*, 26 February 2016 (online).

66. Nicky Woolf, 'Al Sharpton: "This Will Be the Last Night of an All-white Oscars"', *The Guardian*, 29 February 2016 (online).

67. Jeffrey Wright, Twitter, 1 March 2016.

68. Rebecca Keegan, 'George Takei, Ang Lee and Other Asian Academy Members Protest Oscars Jokes', *Los Angeles Times*, 15 March 2016 (online).

69. Ahiza Garcia, 'Academy Apologizes for Chris Rock's Jokes About Asians', *CNN Business*, 15 March 2016.

70. Gregg Kilday, 'Academy Announces New Governors Reginald Hudlin, Gregory Nava, Jennifer Yuh Nelson', *The Hollywood Reporter*, 15 March 2016 (online).

71. Keith Chow, '#WhitewashedOUT Twitter Chat with Margaret Cho to Kick Off AAPI Month', thenerdsofcolor.org, 1 May 2016.

72. Ugwu, 'The Hashtag That Changed the Oscars'.

8. RAINBOW ROAD (2017–2024)

1. 'Statement from PriceWaterhouseCoopers', Oscars.org, 27 February 2017.

2. Brooks Barnes, 'Oscar Nominations 2017: 14 for "La La Land," and 6 for Black Actors', *The New York Times*, 24 January 2017 (online).

3. Reggie Ugwu, 'The Hashtag That Changed the Oscars: An Oral History', *The New York Times*, 9 September 2020 (online).

4. Gwilym Mumford, 'Samuel L Jackson Criticises Casting of Black British Actors in American Films', *The Guardian*, 8 March 2017 (online).

5. Sam Levin, 'Black American Actors Slighted as Brits Nab Roles: "We Can't Tell our Own Stories?"', *The Guardian*, 9 March 2017 (online).

6. Mumford, 'Samuel L Jackson Criticises Casting'.

7. David Harewood, 'Samuel L Jackson is My Hero. But he's Wrong about Us British Actors', *The Guardian*, 13 March 2017 (online).

8. Mumford, 'Samuel L Jackson Criticises Casting'.

9. Gary Younge, 'Spike Lee on Oldboy, America's Violent History and the Fine Art of Mouthing Off', *The Guardian*, 1 December 2013 (online).

10. Yahoo Movies UK, 'Samuel L Jackson Attempts to Clarify "Black British Actors" Remarks at Kong Premiere"', yahoo!movies, 9 March 2017.

11. Levin, 'Black American Actors Slighted'.

12. Rebecca Keegan, 'Nicole Kidman and Javier Bardem on the Pressures of Being a Ricardo', *The Hollywood Reporter*, 15 December 2021 (online).

13. Lola Méndez, 'Javier Bardem and Penelope Cruz Need to Stop Playing Latinx Roles', *The Independent*, 10 February 2022 (online).

14. Keegan, 'Nicole Kidman and Javier Bardem'.

15. Ibid.

16. Scott Feinberg, 'Cheryl Boone Isaacs Feted by Hollywood's Black Community at Pre-Oscars Dinner', *The Hollywood Reporter*, 28 February 2018 (online).

17. Stacy L Smith, 'The Inclusion Rider: Legal Language for Ending Hollywood's Epidemic of Invisibility', in 'Annenberg Inclusion Initiative', USC Annenberg.

18. Sara M Moniuszko, 'What is an "Inclusion Rider"? Frances McDormand's Oscars Speech was a Call to Action', *USA Today*, 5 March 2018 (online).

19. Stacy L Smith, et al., 'Inequality in 1,100 Popular Films: Examining Portrayals of Gender, Race/Ethnicity, LGBT & Disability from 2007 to 2017', USC Annenberg, July 2018.

20. USC Annenberg Staff, 'Happy to Fire, Reluctant to Hire: Hollywood Inclusion Remains Unchanged', usc.edu, 31 July 2018.

21. Carolyn Giardina, 'Oscars: "Black Panther"s' Hannah Beachler Becomes First African-American Production Design Nominee', *The Hollywood Reporter*, 22 January 2019 (online).

22. Reggie Ugwu, 'Spike Lee Reacts to his First Best-Director Nomination', *The New York Times*, 22 January 2019 (online).

23. Wesley Morris, 'Why Do the Oscars Keep Falling for Racial Reconciliation Fantasies?', *The New York Times*, 23 January 2019 (online).

24. Marlow Stern, 'Spike Lee Blasts "Selma" Oscar Snubs: "You Know What? F*ck 'Em"', *Daily Beast*, 15 January 2015 (online).

25. Ugwu, 'Spike Lee Reacts'.

26. Ugwu, 'The Hashtag That Changed the Oscars'.

27. Billie Schwab Dunn, 'Oscars 2024 Failed to Rectify Hollywood's Ugliest Story', *Newsweek*, 11 March 2024 (online).

28. Ugwu, 'The Hashtag That Changed the Oscars'.

29. Ibid.

30. Brooks Barnes and Nicole Sperling, 'Oscar Nominations 2020: "Joker" Leads with 11 Nods; Three Others Get 10', *The New York Times*, 13 January 2020 (online).

31. Reggie Ugwu, ' "Parasite" Director Bong Joon Ho on Making Oscar History', *The New York Times*, 13 January 2020 (online).

32. Vivian Ho, 'Donald Trump Jabs at Parasite's Oscar Win Because Film is "From South Korea" ', *The Guardian*, 21 February 2020 (online).

33. Press release, 'Academy Surpasses Goal to Double Number of Women and Underrepresented Ethnic/Racial Communities by 2020', Oscars.org, 30 June 2020.

34. Stacy L Smith, Marc Choueiti and Katherine Pieper, 'Inequality Across 1,300 Popular Films: Examining Gender and Race/Ethnicity of Leads/Co Leads from 2007 to 2019', USC Annenberg, 3 January 2020.

35. Press release, 'Academy Establishes Representation and Inclusion Standards for Oscars Eligibility', Oscars.org, 8 September 2020.

36. *Firing Line with Margaret Hoover*, PBS, 5 May 2023.

37. Alex Ritman, 'John Boyega Delivers Impassioned Speech at London Black Lives Matter Protest', *The Hollywood Reporter*, 3 June 2020 (online).

38. Jason Sheeler and Benjamin VanHoose, 'Jada Pinkett Smith Says Chris Rock Asked her Out on a Date amid Rumors she and Will were Divorcing (Exclusive)', *People*, 13 October 2023 (online).

39. Tommy McArdle and Jason Sheeler, 'Jada Pinkett Smith Says she Thought Oscars Slap Was "a Skit" . . . "Until I Realized it Wasn't" (Exclusive)', *People*, 13 October 2023 (online).

40. Curtis Jackson, Instagram, 27 March 2022.

41. Bruce Haring, 'Denzel Washington on Will Smith Oscars Slap: "Who Are We to Condemn?" ', *Deadline*, 2 April 2022 (online).

42. Sheeler and VanHoose, 'Jada Pinkett Smith Says Chris Rock Asked her Out on a Date'.

43. Gayle King, 'Oscars Overshadowed', *CBS Mornings* via Twitter, 29 March 2022.

44. Stephen Rodrick, 'Sean Penn's Crusade: Why he's Risking it All for Ukraine, Furious at Will Smith and Ready to Call Bulls—on Studios' AI Proposals', *Variety*, 13 September 2023 (online).

45. Trevor Noah, 'Will Smith: *Emancipation*', *The Daily Show*, 28 November 2022.

46. Will Smith, Instagram, 29 March 2022.

47. David Oyelowo, 'Guest Column: David Oyelowo on the Will Smith Slap, the Intersection of Race and Bias', *The Hollywood Reporter*, 7 April 2022 (online).

48. Ellen DeGeneres, 'Wanda Sykes Shares her Account of the Oscars', *The Ellen Show*, 30 March 2022; Naman Ramachandran, 'Will Smith Slap: "Still Triggered and Traumatized," Says Amy Schumer', *Variety*, 30 March 2022 (online).

49. Nicki Minaj, Twitter, 28 March 2022.

50. Charmaine Patterson and Mia McNiece, 'Tiffany Haddish Says Will Smith Stood "Up for his Wife" at Oscars: "Most Beautiful Thing I've Seen"', *People*, 28 March 2022 (online).

51. Gayle King, 'Life after Tennis: Serena Williams . . .', *CBS Mornings*, 1 February 2023.

52. Rodrick, 'Sean Penn's Crusade'.

53. Pete Hammond and Patrick Hipes, 'Movie Academy President Addresses Will Smith Oscar Slap: AMPAS Response "Inadequate"', *Deadline*, 13 February 2023 (online).

54. Scott Feinberg, 'Will Smith Resigns from Academy after "Inexcusable" Actions at Oscars', *The Hollywood Reporter*, 1 April 2022 (online).

55. King, 'Oscars Overshadowed'.

56. Will Smith, Instagram, 29 July 2022.

57. Noah, 'Will Smith: *Emancipation*'.

58. Will Smith and Mark Manson, *Will*, Century, 2021, p. 9.

59. Smith, Instagram, 29 July 2022.

60. Joey Nolfi, 'Will Smith Saw his Career Destroyed in "Hellish" Ayahuasca Trip Before Oscars Slap', *Entertainment Weekly*, 24 May 2022 (online).

61. Janine Rubenstein, 'Leslie Jones Says Will Smith Oscars Slap "Really Affected" Chris Rock: It Was "Humiliating" (Exclusive)', *People*, 14 September 2023 (online).

62. Zack Sharf, 'Jerry Seinfeld Asked Chris Rock to Parody the Will Smith Oscars Slap in "Unfrosted," but Rock "Was a Little Shook" from it and "Wasn't Up to Perform"', *Variety*, 9 May 2024 (online).

63. Rubenstein, 'Leslie Jones Says Will Smith Oscars Slap "Really Affected" Chris Rock'.

64. Chris Rock, 'Selective Outrage', Netflix, 4 May 2023.

65. Ibid.

66. Sheeler and VanHoose, 'Jada Pinkett Smith Says Chris Rock Asked her Out on a Date'.

67. Stacy L Smith, 'Native American Characters Are Nearly Invisible in Top Films', USC Annenberg, 17 October 2023.

68. Laura García and Beatriz de la Pava, 'America Ferrera: We Are Still Just Fighting to be Visible', *BBC News*, 27 November 2023.

69. Carlos Aguilar, 'America Ferrera and the "Barbie" Monologue We All Talked About', *The New York Times*, 1 January 2024 (online).

70. Kyle Buchanan, 'Lily Gladstone Won't Let Hollywood Put her in a Box', *The New York Times*, 6 January 2024 (online).

71. Sarah Bahr, 'Lily Gladstone on her History-Making Oscar Nomination', *The New York Times*, 23 January 2024 (online).

72. Smith, 'Native American Characters Are Nearly Invisible in Top Films'.

73. Christian Allaire, ' "It's Not Just Mine": Lily Gladstone on her Historic Oscars Nod and Powerful Red-Carpet Look', *Vogue* (UK), 10 March 2024 (online).

74. Schwab Dunn, 'Oscars 2024 Failed to Rectify Hollywood's Ugliest Story'.

75. Ibid.

76. Lily Gladstone, X, 12 March 2024.

EPILOGUE: SHARED SPACES

1. Manohla Dargis and A O Scott, 'The 25 Greatest Actors of the 21st Century (So Far)', *The New York Times*, 25 November 2020 (online).

2. Reggie Ugwu, ' "They Set Us Up to Fail": Black Directors of the '90s Speak Out', *The New York Times*, 3 July 2019 (online).

3. Rebecca Keegan, 'George Takei, Ang Lee and Other Asian Academy Members Protest Oscars Jokes', *Los Angeles Times*, 15 March 2016 (online).

4. Naman Ramachandran, 'Indian Media & Entertainment Industry Surpasses Pre-Pandemic Levels to Reach $26 Billion, Report Reveals', *Variety*, 4 May 2023 (online).

5. See Michael Fleming, 'Playboy Interview: Denzel Washington', *Playboy*, December 2002, pp. 67–74.

6. Mark Harris, Twitter, 14 January 2016.

7. Chris Rock, 'Chris Rock Pens Blistering Essay on Hollywood's Race Problem: "It's a White Industry" ', *The Hollywood Reporter*, 3 December 2014 (online).

8. David Cox, '#OscarsSoWhite: Who is Really to Blame for the Oscars' Lack of Diversity?', *The Guardian*, 26 February 2016 (online).

BIBLIOGRAPHY

Amburn, Ellis, *Olivia de Havilland and the Golden Age of Hollywood*, Lyons Press, 2018

Arogundade, Ben, *Black Beauty: A History and a Celebration*, Pavilion, 2000

Berry, S Torriano, with Venise T Berry, *The 50 Most Influential Black Films: A Celebration of African-American Talent, Determination, and Creativity*, Kensington Publishing Corp, 2001

Bogle, Donald, *Brown Sugar: Eighty Years of America's Black Female Superstars*, Da Capo, 1980

Bogle, Donald, *Toms, Coons, Mulattoes, Mammies and Bucks: An Interpretive History of Blacks in American Films*, Continuum, 1990

Bogle, Donald, *Dorothy Dandridge: A Biography*, Harper Collins, 1997

Bogle, Donald, *Bright Boulevards, Bold Dreams: The Story of Black Hollywood*, One World, 2006

Carter, Graydon, and David Friend, *Vanity Fair's Hollywood*, Thames & Hudson, 2000

Chisholm, Shirley, *The Good Fight*, Amistad, 1973

Cleaver, Eldridge, *Soul on Ice: Selected Essays*, Jonathan Cape, 1969

Cripps, Thomas, *Slow Fade to Black: The Negro in American Film, 1900–1942*, Oxford University Press, 1977

Cripps, Thomas, *Making Movies Black: The Hollywood Message Movie from World War II to the Civil Rights Era*, Oxford University Press, 1993

Dandridge, Dorothy, and Earl Conrad, *Everything and Nothing: The Dorothy Dandridge Tragedy*, Abelard-Schuman, 1970

Eyman, Scott, *Lion of Hollywood: The Life and Legend of Louis B Mayer*, Robson Books, 2005

Frost, Jennifer, 'Hedda Hopper, Hollywood Gossip, and the Politics of Racial Representation in Film, 1946–1948', *The Journal of African American History* (University of Chicago Press), vol. 93, no. 1 (2008)

Frost, Jennifer, *Hedda Hopper's Hollywood: Celebrity Gossip and American Conservatism*, NYU Press, 2011

Gossett Jr, Louis, and Phyllis Karas, *An Actor and a Gentleman*, Wiley, 2010

Gross, Michael, *Model: The Ugly Business of Beautiful Women*, Bantam Press, 1995

Holden, Anthony, *The Oscars: The Secret History of Hollywood's Academy Awards*, Abacus, 2016

Jackson, Carlton, *Hattie: The Life of Hattie McDaniel*, Madison Books, 2023

Karger, Dave, *50 Oscar Nights: Iconic Stars and Filmmakers on their Career-Defining Wins*, Running Press, 2024

Leff, Leonard J, 'David Selznick's *Gone with the Wind*: "The Negro Problem" ', *The Georgia Review*, vol. 38, no. 1 (Spring 1984)

Levy, Emanuel, *Oscar Fever: The History and Politics of the Academy Awards*, Continuum, 2001

Mapp, Edward, *African Americans and the Oscar: Decades of Struggle and Achievement*, Scarecrow Press, 2008

Mitchell, Margaret, *Gone with the Wind*, Avon Books, 1936

Myrick, Susan, *White Columns in Hollywood: Reports from the GWTW Sets*, Mercer University Press, 1982

Olivier, Laurence, *On Acting*, Weidenfeld & Nicolson, 1986

Osborne, Robert, *Academy Awards Illustrated: A Complete History of Hollywood's Academy Awards*, ESE California, 1969

Osborne, Robert, *85 Years of the Oscar: The Official History of the Academy Awards*, Abbeville Press, 2013

Poitier, Sidney, *This Life: An Autobiography*, Hodder and Stoughton, 1980

Poitier, Sidney, *The Measure of a Man: A Spiritual Autobiography*, Harper, 2000

Regester, Charlene, 'African American Extras in Hollywood during the 1920s and 1930s', *Film History* (Indiana University Press), vol. 9, no. 1 (1997)

Scott, Ellen C, *Cinema Civil Rights: Regulation, Repression and Race in the Classical Hollywood Era*, Rutgers University Press, 2015

Smith, Will, and Mark Manson, *Will*, Century, 2021

Thomson, David, *Showman: The Life of David O Selznick*, Abacus, 1993

Waters, Ethel, with Charles Samuels, *His Eye is on the Sparrow: An Autobiography by Ethel Waters*, Doubleday, 1951

Watts, Jill, *Hattie McDaniel: Black Ambition, White Hollywood*, Amistad, 2005

Watts, Steven, *The Magic Kingdom: Walt Disney and the American Way of Life*, University of Missouri, 2001

White, Walter, *A Man Called White: The Autobiography of Walter White*, University of Georgia Press, 1995

ACKNOWLEDGEMENTS

For your generous support and help, thanks to: Zak Arogundade, Michael Bowers, Paul Broadhurst, Greg Bunbury, Ian Cummings, Eleanor Curtis, Trevor Davies, Sarah Hirigoyen, Catherine Jones, Shari Last, Mary Morris, Richard Russell, David Shelley, Fleur Sinclair and the team at Sevenoaks Bookshop, Carla Smith, Alex Stetter and Jenny Wilson.

PHOTO CREDITS

Courtesy of the USC HMH Foundation Moving Image Archive; 2a Keith Corrigan/Alamy Stock Photo; 2b Bettmann/Getty Images; 3a Album/Alamy Stock Photo © King Vidor Productions/MGM; 3b Everett Collection/Shutterstock © Selznick International Pictures/ MGM; 4a Everett Collection/Mary Evans © 20th Century Fox; 4b Everett Collection/Alamy Stock Photo © 20th Century Fox; 5a Collection Christophel/Alamy Stock Photo © Otto Preminger Films/20th Century Fox; 5b Album/Alamy Stock Photo; 6a Gene Lester/Getty Images; 6b Everett Collection/Alamy Stock Photo © BHE Films/National Theatre of Great Britain/Eagle Lion Films; 7 Photo12/Alamy Stock Photo © MGM; 8a Photo12/Alamy Stock Photo © Hemdale/RKO Pictures/AVCO Embassy Pictures; 8b Ronald Grant Archive/Mary Evans © Lorimar Productions/Paramount Pictures; 9a Photo 12/Alamy Stock Photo © 40 Acres and a Mule Filmworks/Universal Pictures; 9b Maximum Film/Alamy Stock Photo © 40 Acres and a Mule Filmworks/Universal Pictures; 10 Reuters/Sam Mircovich/Bridgeman Images; 11 Doug Mills/Associated Press/Alamy Stock Photo; 12 Cinematic Collection/ Alamy Stock Photo © Bristol Bay Productions/Anvil Films/Universal Pictures; 13a Frederick M. Brown/AFP via Getty Images; 13b Amy Harris/Associated Press/Alamy Stock Photo; 14 ZUMA Press/Alamy Stock Photo; 15 John Angelillo/UPI/Shutterstock; 16 BJ Warnick/ AMPAS/AdMedia/Newscom/Alamy Stock Photo

INDEX

Page numbers in italic text indicate an entry in the Timeline section of the book.

Pookutty, Resul, 165, *272*

Poor Things (2023), 235

Portman, Rachel, 116

Portrait of a Lady on Fire (2019), 215

Power of the Dog, The (2021), 222, *286*

Power Rangers (2017), 197

Powers, Kemp, 221

Precious (2009), 158–60, 240, *272*

Preminger, Otto, 78, 79

Presley, Elvis, 163

Preston, Robert, 107, 108

PricewaterhouseCoopers, 202

Primal Fear (1996), 135

Prince, *264*

Production Code, 9

Pryor, Richard, 105, 108, 118, *263*

Public Enemy (1931), 32

Puenzo, Luis, *265*

Pugh, Florence, 217

Purple Rain (1984), *264*

Pursuit of Happyness, The (2006), 153, 155

Quan, Ke Huy, 231–2, 242, *287, 288*

Queen Latifah, 150, 159

Questlove, 209, 228, *286*

Quinn, Anthony, 3, 72, 116, *257, 258*

Quo, Beulah, 39

Rabinowitz, David, 213

Rae, Issa, *285*

Ragtime (1981), 105

Rahman, A R, *272*

Rainbow PUSH Coalition, 132–4, 136, *267*

Rainer, Luise, 40

Raksin, David, 100

Rambo series (1982, 1985, 1988), 110

Rampling, Charlotte, 186–7, *276*

Ramsey, Peter, 210, 214, *281*

Ran (1985), 115, *265*

Randolph, Da'Vine Joy, 233, 235, 240, *289*

Rashomon (1950), 74, *257*

Ravetch, Irving, 75

Ray (2004), 150–2, *270*

Ray, Satyajit, 116, *266*

Reagan, Ronald, 42

Redgrave, Vanessa, 127

Redmayne, Eddie, 173

Red Wing, 8, *251*

Reeve, Christopher, 108

Reign, April, 173–4, 179–80, 185, 199, 214, 215, 238, 247, *275, 276*

Reitman, Jason, 158

Reivers, The (1969), 98, *261*

Renner, Jeremy, 158, 161

Resto, Luis, *269*

Restoration (1995), *267*

Revenant, The (2015), 180, 192, *277*

Rhames, Ving, *271*

Rice, Thomas Dartmouth, 6

Richards, Beah, 94

Richardson, Ralph, 115

Richie, Lionel, 105, *265*

Richmond, David, 82

Ridley, Daisy, 209

Ridley, John, 170, 171, *274*

Riseborough, Andrea, 232

Ritt, Martin, 85

ABOUT THE AUTHOR

Ben Arogundade is an award-winning author, journalist and broadcaster from London. His writing has featured in *The Times*, *Guardian*, *Evening Standard*, *Elle* and *GQ*, among others. He has authored and edited 12 works of fiction and non-fiction, including *Black Beauty: A History and a Celebration*, which was honoured by the New York Public Library and adapted into a three-part BBC documentary. He also writes and presents radio shows for the BBC World Service.

arogundade.com